PANDORA'S BOX

PANDORA'S BOX

HOW GUTS, GUILE, AND GREED UPENDED TV

PETER BISKIND

WM

WILLIAM MORROW
An Imprint of HarperCollinsPublishers

HarperCollins books may be purchased for educational, business, or sales promotional use. For information, please email the Special Markets Department at SPsales@harpercollins.com.

FIRST EDITION

Designed by Bonni Leon-Berman

Library of Congress Cataloging-in-Publication Data

Names: Biskind, Peter, author.
Title: Pandora's box : how guts, guile, and greed upended TV/ Peter Biskind.
Description: First edition. | New York : William Morrow, an Imprint of HarperCollins Publishers, 2023. | Includes index. | Summary: "Bestselling author of Easy Riders, Raging Bulls and Down and Dirty Pictures, cultural critic Peter Biskind turns his eye toward the new golden age of television, sparked by the fall of play-it-safe network TV and the rise of boundary-busting cable followed by streaming, that overturned both-based on exclusive, candid, and colorful interviews with executives, writers, showrunners, directors, and actors"—Provided by publisher.
Identifiers: LCCN 2023030841 (print) | LCCN 2023030842 (ebook) | ISBN 9780062991669 (hardcover) | ISBN 9780062991683 (epub)
Subjects: LCSH: Television programs—United States—History. | Cable television—United States—History. | Streaming technology (Telecommunications)—United States.
Classification: LCC PN1992.3.U5 B577 2023 (print) | LCC PN1992.3.U5 (ebook) | DDC 791.45/750973—dc23/eng/20230727
LC record available at https://lccn.loc.gov/2023030841
LC ebook record available at https://lccn.loc.gov/2023030842

ISBN 978-0-06-299166-9

23 24 25 26 27 LBC 5 4 3 2 1

To Betsy and Kate as always

CONTENTS

INTRODUCTION: BROADCAST BLUES

How the cable minnows swam circles around the network sharks, until the streaming whales swallowed them all.

"You couldn't kill a dog," recalls *Sopranos* writer Robin Green, reflecting on her years laboring in the vineyards of network television. "The character loses the sympathy of the audience." Remember the outcry that greeted the scene in *The Godfather* where the horse's head ends up in the bed of Jack Woltz, never mind the scores of humans garroted, shot, stabbed, or otherwise consigned to sleep with the fishes.

Cruelty to animals was just one of the many no-no's viewers would never see on TV during the high tide of the broadcast era. Nor would they see extreme violence, nudity, or sex nor hear the infamous seven dirty words—"shit," "piss," fuck," etc. Should two characters, invariably straight, exchange more than a peck on the cheek, the camera would discreetly pan away to, say, burning logs in a fireplace. The mantra was "See no evil, hear no evil, speak no evil." The result was that TV had become a "vast wasteland," as John F. Kennedy's FCC chairman Newton Minow memorably put it in 1961. Why? Because of the sponsors who paid the bills, aided and abetted by the FCC.

Copying the sponsor-based business model used by radio in the 1920s and '30s, their shows, analogous to the four quadrant blockbusters produced by the movie studios, were meant for everyone. The programming may have been free, but the not-so-hidden cost was high: terminal blandness. Fiercely protective of their brands, jittery advertisers whose primary goal was to sell Camels, Cheerios,

and Chevrolets wanted TV's doctors and lawyers happily married, not fighting in divorce court. They wanted their cops and cowboys delivering the bad guys to justice, not beating, framing, or otherwise abusing them.

Each network had a department called Broadcast Standards and Practices that made Hollywood's old Production Code read like *Lady Chatterley's Lover.* It policed its shows, even preventing married couples from sleeping together in the same bed. Belly buttons were hidden, and Elvis Presley was never televised below the waist on *The Ed Sullivan Show.* The plainer the vanilla, the richer the ice cream, aka the profits. The networks competed with one another in a race to the bottom. The watchword that defined "the idiot box" was "lowest-common-denominator programming."

Thus it was that the first golden age of live TV became a measureless tract of hard, cracked soil, inhospitable to intelligent life, populated solely by reruns of old movies, dumb and occasionally fixed quiz shows, as well as placid, family-friendly sitcoms with canned laugh tracks that, like flat stones skipping across the surface of a pond, rarely touched upon the issues that roiled the depths beneath it.

For most of its history, network television played defense rather than offense—that is, it was less interested in creating shows that gave viewers a reason to watch than in shows that gave them a reason not to watch. As allegation-prone Kevin Spacey explained back in 2014, providing the context for the unscrupulous character he played in *House of Cards*, "At that time, the most important thing was not to offend anybody and have characters that audiences would like." If the result was ineffably dull shows whose Wonder Bread characters never swore; never expressed a political opinion; never entered a place of worship other than a church; never lusted after somebody else's wife or husband or, worse, someone of the same sex; never had a baby out of wedlock or, gasp, an abortion—so be it. Kevin Reilly was a young executive managing creative affairs at NBC. "Network television had all these rules you were supposed to abide by, like, the good guy always wins," he recalls, evoking the reaction to the pilot of *Seinfeld*: "'Oh, that's not what we do. It's fun for us, but the real people will never get it.'"

The umbrella of consensus that sheltered the network audience from the hard rain of reality was held aloft by a bipartisan coalition of moderate East Coast Eisenhower Republicans and conservative Midwestern Democrats that governed the country throughout the postwar era. So-called extremists—naysayers, rebels, dissidents, whatever—were unwelcome, and they appeared in network shows only as gangsters, juvenile delinquents, or "Injuns." They were deprived of context—backstories that might make them other than two-dimensional bad guys.

When premium cable came along in the 1980s, thanks to Home Box Office (HBO), it replaced sponsors with subscribers. In contrast to the sponsor-driven networks that broadcast over public airways, cable companies built their own transmission systems; consequently, the FCC had little to no power over their content. By subscribing, viewers voluntarily invited cable programs into their homes. Moreover, the emergence of cable coincided with the breakdown of consensus culture that occurred in the Vietnam/Watergate era.

By 1977, to be exact, cable subscribers could see and hear George Carlin speaking those seven dirty words in their living rooms—a modest achievement, to be sure, but there was more to come. A lot more, a second golden age of TV that we are lucky enough to be more or less living in today, courtesy of the deluge of streaming services. "Golden age," of course, is a tired cliché flung about with little discrimination, so we'll call this second one the era of "Peak TV," a phrase coined by John Landgraf, CEO of the cable channel FX, who estimated there were a record 559 scripted originals in 2022.

Maybe the complex relationship between network, cable, and streaming is best compared to a three-stage rocket, with network the first stage, cable the second, and streaming the third. It seemed to be well on its way to the stars.

Once upon a time, the reflexive response to a book about TV might have been a shrug, as in, "Ho-hum, it's only TV." The auteurism of the 1960s that elevated studio directors and commercial

filmmaking to the level of high art might have played itself out, but it did succeed in cloaking movies with the mantle of respectability.

In the 1960s and 1970s, movies became "film" or even "cinema," but thanks to today's superhero monoculture, they have slid backward to where they started—just movies. Now, says director David Fincher, movies "have become physics porn. The feature business has no patience for characterization. They're not so much about the people, they're about 'When does the entire city explode?'" Consequently, many high-profile American filmmakers, not only Fincher but Martin Scorsese, Spike Lee, Steven Soderbergh, Ava DuVernay, Jordan Peele, et al.—have fled to the small screen, sucking the lifeblood out of the studios, which are on their way to becoming no more than feeders for the streaming services.

Soderbergh was the ur-independent filmmaker of the '90s, a gangly kid from Baton Rouge who tiptoed into Sundance in 1989 with *Sex, Lies, and Videotape*, and emerged with a hit that won him the Palme d'Or at Cannes the same year, making him, at twenty-six, the youngest solo director to do so. Subsequently, he has been a prolific filmmaker working with nearly all the studios, cablers, and streamers, and has become a trenchant analyst of the business.

As early as 2013, Soderbergh announced his (short-lived) retirement from movies, explaining, "It's become absolutely horrible the way the people with the money decide they can fart in the kitchen, to put it bluntly . . . When I was growing up, there was a sort of division: respect was accorded to people who made great movies and to people who made movies that made a lot of money. And that division doesn't exist anymore: now it's just the people who make a lot of money." He added, "The audience for the kinds of movies I grew up liking has migrated to television. I just don't think movies matter as much anymore." Soderbergh went where the audience was. He made *The Knick* for Cinemax, a division of HBO.

The water cooler conversations of the prepandemic era have since become our only conversation, thanks to social media. Witness the blizzard of words devoted to analyzing, recapping, and speculating

about the final season of *Game of Thrones*, the last episode of which boasted of 19.3 million viewers. Jon Snow, Daenarys Targaryen, and the Lannisters were household names, and the episodes were our bread and circuses.

Nor is this solely an American phenomenon. Other countries have made series that equal or surpass the best American productions, like *Peaky Blinders*, *Line of Duty*, *The Crown*, and *Slow Horses* from England; *Spiral* and *A French Village* from France; *Money Heist* from Spain; *My Brilliant Friend* from Italy; *Fauda* from Israel; *Borgen* from Denmark, as well as so-called Nordic noir like *The Bridge*, also from Denmark. Altogether, these shows have created the brave new world of Peak TV.

It is no exaggeration to say that the sweep and depth of HBO's shows, followed by those of the basic cable channels, propelled TV into shouting distance of the great nineteenth-century novels. As Glenn Close put it, when she was working on FX's *Damages*, "I feel like we're kind of a 21st Century version of what Dickens was in the 18th Century, 19th Century. And so that's where the excitement is; I think we're on the cutting edge of this new, what I really think, is an art form." Indeed, when David Milch was blowing minds as an undergraduate at Yale, he fully intended to be a novelist, following in the footsteps of his illustrious mentor Robert Penn Warren, who refused to allow a TV set in his home, as though it were some "crouching beast," in Milch's words, cited in Brett Martin's excellent book, *Difficult Men*. It's no accident that Milch never did write the Great American Novel but created *Deadwood* instead.

Oh, and by the way, while shooting the pilot of FX's *The Shield*, director Clark Johnson spotted a pack of stray dogs; he grabbed some salami from the craft services table, threw it into the frame, and yelled "Shoot the dog!" as the dogs ran to the food. Later, in the same show, a cop throttles a cat, and in *House of Cards* Spacey's Frank Underwood kills a dog in the very first scene of the pilot. True, these animal slayers are not good-bad guys, like Tony Soprano or Raylan Givens in *Justified*, nor good-bad gals like Nancy Botwin in *Weeds*

nor the entire cast of *Orange Is the New Black*; they're just plain bad. And neither *The Shield* nor *House of Cards* endorses cruelty to animals, but neither are they afraid to use it to express their jaundiced view of human nature. As the Hound says to Sansa Stark in *Game of Thrones*, "The world was built by killers, so you'd better get used to looking at them."

"IT'S NOT TELEVISION. IT'S HBO."

SEEDING THE WASTELAND

How HBO's new business model enabled Michael
Fuchs to build an anti-network that turned into a new
template for TV.

The moment was ripe. A long time coming, network television was
finally enjoying something of a renaissance at the century's end,
thanks to the likes of Norman Lear, Grant Tinker, Mary Tyler
Moore, and others like them, who made shows like *All in the Family*,
St. Elsewhere, *Cheers*, *The Practice*, and especially a handful of dark,
innovative cop shows. Kevin Spacey saw a memo written by NBC
executives after they aired the pilot of Steven Bochco's *Hill Street
Blues*. They complained that there were "too many characters, too
many plot lines, characters who weren't very good at their jobs, and
their personal lives were a mess," he recalls. "It was like a blueprint
for what made every show successful since *The Sopranos*. If the NBC
executives had had their way, the road from then to now would never
have been paved."

Dreadful as network TV was, cable was originally devised not as
an alternative, but as mother's little helper, as it were, a way to bring
The Red Skelton Show, say, and *Lassie*, to areas that had a hard time
getting them—big cities like New York where the over-the-air signals
bounced off skyscrapers like ping-pong balls, as well as the suburbs
and small towns all over America where the signals were weak.

In 1971, Charles Dolan founded Sterling Manhattan Cable, which would deliver programming via cable. It could also provide sporting events and Hollywood movies to subscribers who would pay a monthly fee to see them uncut and commercial-free. Time Inc. acquired 20 percent of Dolan's company in 1973, folded it into Time's video group, and relaunched it as Home Box Office, but it bled money building expensive microwave relay towers across the country so that it could become a national service. Time's chairman and CEO Andrew Heiskell quipped, "If I had finished Harvard Business School, I might have known enough never to start HBO at all."

In May 1972, Dolan hired Gerald Levin, a bright, hyperarticulate lawyer of thirty-three, to be his financial officer and then VP of programming. Levin came from humble enough origins, and his Time colleagues never let him forget them. His father ran A. Levin Butter & Eggs, in South Philadelphia. While Time's Ivy League graduates strutted in their bespoke suits, he distinguished himself by conspicuous underconsumption, buying off-the-rack at a discount from Robert Hall.

Time was very much a white-shoe firm, and its executives derided their counterparts at HBO as money-grubbers, whereas they pursued a higher calling: handmaidens, as they saw it, to the public weal. Of course, "money-grubbers" was Fairfield County code for "Jews." Despite his intellect and silver tongue, Levin's ashes-and-sackcloth act didn't play well at Time. With his diminutive stature, narrow shoulders, and receding chin, he couldn't quite shrug off the stink of the shtetl. Heiskell, six five, handsome, and WASPy, once referred to Levin as "a snake-oil salesman."

Then, in 1975, Levin transformed the industry. He talked the Time board into dumping the towers, and instead forking over $6.5 million to hitch a ride on a satellite—in this case, RCA's new SATCOM 1, which had just been launched—and broadcast the "Thrilla in Manila" heavyweight fight between Muhammad Ali and Joe Frazier from the Philippines. In the blink of an eye, it transformed HBO from a novelty to a national service, with three hundred thousand subscribers in sixteen states.

Beyond that, Levin's move to satellite recast him as a legend within the company, paving the way for his eventual ascent to the top. "It was sort of a turning point for me and maybe Time Inc.," observed a nonplussed Dick Munro, who succeeded Heiskell as CEO in 1980. He recalled a meeting with financial analysts at the Harvard Club: "Suddenly, the whole meeting began to be HBO-oriented. Magazines were ignored." On the other hand, Time's stock shot up, which was all that mattered.

If Time made a hire that transformed HBO, it was Michael Fuchs, who joined the company in September 1976. Fuchs was a tough kid raised on the streets of the Bronx. He had gone to law school to get out of the draft, but he lost his deferment and ended up in basic training, so basic there were no doors in the latrines. This would shape his attitude toward his future employer: "There were guys at HBO that had to go home to go to the bathroom. Me? I'm like, I could shit in the middle of Times Square."

Fuchs had zero experience, but the hire was not as dumb as it seemed. "I knew nothing," he recalls. "But they knew nothing. 'In the kingdom of the blind . . .'" He and Levin couldn't have been more different. Where Fuchs was larger than life, Levin was smaller. Whereas Fuchs sucked up all the air in a room, Levin, in Fuchs's words, was "like a stealth personality. He walked into a room and you didn't feel a ripple."

At the time, HBO was, as Fuchs describes it, "barely alive. It had just gone up on satellite, but satellite hadn't taken hold yet. We had no listings, no publicity, just a guide that went out once a month in the mail." He saw his job as counterprogramming the networks. Fuchs felt they were "homogenized, fake. We were looking for stuff that the networks couldn't go near." Explaining why there was no original programming on his agenda, he says, "HBO was based on theatrical films initially, so people were used to seeing the most expensive pieces of entertainment in the world. I wasn't going to dilute our programming with little pieces of shit."

Counterprogramming the networks with no money meant stand-up comedy (the young Steve Martin, Robin Williams, et al.), concerts, live

sports, and documentaries, run by Sheila Nevins, whom Fuchs poached from CBS in 1979. Nevins eventually made something like 1,200 of them for HBO, and over the course of her career she won more than thirty Emmys and fifteen Peabodys.

Nevins was a red diaper baby who grew up on New York's Lower East Side. "When I first met Michael, he was going to play tennis with somebody. He was wearing shorts, sneakers, and his feet were up on the desk and I could see into his crotch. I thought, *This is the kind of job where people play tennis in the middle of the day.* At CBS men wore ties and suits in the editing room." Moreover, she liked him: "He was funny, said strange things, was anti-corporate and misbehaving."

"'Documentary' meant serious, intelligent, college, economics, Washington. It didn't mean entertainment," continues Nevins. She was commissioning films about gays, feminists, Osama bin Laden, medical curiosities, all sorts of things. And they were entertaining. "There was no competition," she recalls. "I could have been doing crap, it wouldn't have mattered." Best of all, documentaries were cheap, which gave her total freedom. There was nobody to say, "No!" She made them; HBO aired them. "They just gave me the ball," she says. "They were doing things that cost millions and millions of dollars. I was a $1.98."

Fuchs subscribed to the conventional wisdom that the networks programmed for women, so HBO would program for men. He recalls, "That was a big part of boxing for us, because boxing tickets were expensive and to certain people one boxing event a month was worth the price of buying HBO." But even with something like boxing, its coverage was better than the networks'. No sponsors meant no cutting between rounds to a Buick ad, for example. Instead, it had a camera in the corners of the ring so viewers could see and hear the trainers talking to the fighters, squeezing the blood out of their eyes and using styptic pencils on their cuts. Not to mention the fact that he paid heavyweight champion Mike Tyson, who flaunted his bad-boy image, $26.5 million to keep him fighting on HBO.

So far as sex went, there was more than enough to keep the testosterone flowing. "Randy guys were a major part of our demographic,"

Fuchs goes on. "Initially, when people thought of pay TV, one of the things was, 'Oh, we can see nudity and we can hear profane language,' and yes, we took advantage of some of that." Nevins says, "I was free to do sex shows that people could jerk off to. Good for them. Why not?" Among her documentaries were several sex-themed series: *Real Sex*, *Taxicab Confessions*, *G-String Divas*, and *Pornucopia: Going Down in the Valley*, featuring Stormy Daniels.

HBO also showed the famous French burlesque shows from Moulin Rouge and Casino de Paris. "I thought I'd died and gone to heaven, standing there with seventy naked girls, and fuckin' beautiful French women," Fuchs remembers. "I get a salary, too?" Wags at the networks, riffing on HBO's slogan, quipped, "It's not TV. It's porn."

HBO eventually dipped its toe into made-for-TV movies. The mantra was, "Make noise, make noise, make noise," so it could get off the TV page, but in the beginning, it couldn't even get onto the TV page. "We were in this place where faded stars like Jimmy Stewart or Bette Davis would bring us their vanity projects," says a former HBO publicist. When she pitched a B-list star to *The Tonight Show*, "They would say, 'Are you serious? Why the fuck would we want to have one of your stars? We're *The Tonight Show*. We don't care about these people.'"

Fuchs quickly rose to VP of programming and offered his old job to Bridget Potter, a bright, ambitious Brit. She had nearly twenty years of experience working at NBC and CBS. Potter declined the offer at first. She recalls, "It was easy to turn HBO down, because they were like the dregs." She continues, "They weren't saying, 'Oh, we could be smarter. Oh, we could be better.' They were saying, 'Oh, we could be dirtier.'" Sam Cohen, a powerful New York agent who represented blue-chip clients like Mike Nichols, told her, "If you go to HBO, you're leaving the business. What they're doing is disgusting, it's bad, it's cheap, forget it." Potter took the job anyway, because Fuchs told her she could do anything she wanted, while at the networks she could do nothing she wanted.

Potter got along with Fuchs. "I liked Michael. He had a charismatic personality. He convinced programming executives that he

knew more about the business side than the business executives, and he convinced the business executives that he knew more about programming than the programming executives. But the truth was, he didn't know much about either. He was posing as a programming genius, but the programming was not genius. He loved doing nightclub stuff—Totie Fields, Buddy Hackett, Henny Youngman. He loved this HBO Theater, old turkeys right from Broadway, just abysmal."

For his part, Fuchs liked Potter. Still, HBO was a boys' club, and Potter was not a boy. In the senior management meetings, there were maybe two women and thirteen men. "I found it all very difficult," she continues. "The guys were in the Michael Fuchs business. They would go shopping with him, and they would play tennis with him, and they would travel with him. If he would suddenly go to LA, they would all go to LA. I couldn't and didn't do that." She had to go home every night to her family. But each morning she read the sports section of the papers so she'd have something to talk about with the guys.

Needless to say, there was a lot of intra-office sex. As one woman who worked at HBO during that period described it, "It didn't have a rape culture like Miramax, but it was a 'happy' place where shy, rich, probably married dorks could run amok, fulfill their fantasies of money, power, and access to female bodies. Higher-ranking women inside the company felt they were safe, but you'd see your colleagues chatting up the assistants, actresses, and so on, and you knew they could be prey."

One of those higher-ranking women was Nevins, who took a more casual view of sex in the workplace. As she puts it, the younger women were brought up by Gloria Steinem, the older women, like herself, by Helen Gurley Brown. That meant "I read *Cosmo* like it was Spock for babies and I dressed and did everything she told me. I bought cosmetics. I bought a push-up bra. I unbuttoned the second button where you see the cleavage."

Nevins thought "being touched by a man inappropriately was part of the rules of the game." Speaking of another employer, she says she got hired as a PA by sleeping with the boss. "It meant nothing to me.

Nothing. Zero." Looking back at HBO, she says, "I didn't approve or disapprove. Did anyone die on the cutting room floor? Nobody was getting shot. Nobody was getting murdered. As long as there was air-conditioning and the lights stayed on, I was happy to stay there for a long time."

By 1984, Fuchs had become CEO. He was ruthless and tenacious, the enemy no one wants to have. Fuchs didn't try to be liked. He was notorious for his fierce, pugnacious, take-no-prisoners management style. He himself admits, "I had a big mouth. I accepted that people found me arrogant. I liked to give it back. I'm a pusher. I have been fired from almost every job I've had." Adds Potter, "His code of ethics was basically *The Godfather.* He would quote it constantly, not in an 'Aren't I clever' way, but like a true believer. He demanded complete loyalty. There was a cult of personality in the place. If you didn't drink the Kool-Aid, you weren't going to last. He had no modesty. He did not want to be second-guessed on anything, ever. That was part of his idea of himself as a prince, and in his own mind, HBO was his court."

Good times finally arrived in the early 1980s. By 1981, HBO was able to expand its service to twenty-four hours a day, seven days a week. Two years later, it boasted 13.5 million subscribers, an increase of two million over the previous year. So far as Time was concerned, the tail was wagging the dog. The video group accounted for two-thirds of its profits. Dollars were inbound so fast the counters couldn't keep track of the beans.

When there was money to spend at HBO, it went for what was euphemistically called morale-building, which is to say, partying. Says one marketing executive, "We'd have parties at the Bel Air Hotel, or they'd cordon off the Malibu Country Club. It really was velvet handcuffs. If there's one thing that's a through line, it's excess. Excess was the key to our success."

According to another source, the long list of perks included "the seemingly bottomless expense account; the private dining rooms on

the fifteenth floor of the HBO building off Bryant Park in New York City, where you could schmooze talent and impress your friends; the private on-site gym that even provided you with workout clothes; the corporate retreats at posh resorts, where we were encouraged to spend half the day getting massages or playing golf; the limos, the lunches, the inevitable upgrades to first class on commercial flights. And those were just the perks at my level. They increased exponentially as you went up the ladder, until you reached the baronial echelon of Michael Fuchs, who had the use of a corporate jet and a fully staffed mansion in Acapulco" that belonged to Warner Bros.

The source continues, "If you didn't do cocaine, or at least smoke dope, there was something wrong with you. You were definitely not hip enough to work there. It was not considered a problem, it was medicinal relief. We used to buy drugs from a guy out in front of the Time-Life Building. We'd get high at lunchtime and go back to work." One woman who traveled back and forth between New York and LA is said to have avoided taking drugs through airport security by simply FedEx-ing coke to herself.

Then HBO hit a wall. Along came the VCR, seemingly out of nowhere, that obliterated HBO's prime selling point: showcasing uncut, uninterrupted Hollywood movies. As subscriptions dwindled, a bank of dark clouds settled over the company. The picture looked so bleak that McKinsey & Company, the EMT of management consulting, was hired to give the business model a hard look. At a meeting with the McKinsey team, Levin stood up and asked, "Have you ever seen a business that was at this kind of crossroads?" One of the consultants answered, "Atari," a legendary instance of a fast-growing, envelope-pushing Wall Street darling that collapsed overnight. Everyone in the room blanched.

There was, however, a silver lining. The easy availability of movies on tape created an opening for original programming. "The movie companies had far too much leverage over us because they were almost our only source of product," Fuchs recalls. "Our original programming gave us leverage against the studios."

Potter beefed up original programming by hiring Chris Albrecht, a former stand-up comic and sometime agent, as senior VP in

June 1985, at a salary of about $50,000. He was in charge of developing series, and headed up the LA office in Century City. Albrecht was an appealing man with a Cheshire Cat grin that under stress became more vulpine than feline. When he started to lose his hair he opted for the Vin Diesel look, the shaved dome.

Fuchs acknowledged that Albrecht was a good programmer, but he feared his LA executives were too easily snowed by Hollywood glitz. "I didn't trust the West Coast office. They would buy everything," he says. Fuchs likes to point to *Band of Brothers* and *The Pacific*, both produced by Tom Hanks's company after he left HBO, as examples. "HBO spent hundreds of millions of dollars [on those shows], because Chris was taking Pilates lessons at Tom Hanks's house. A two-hundred-million-dollar Pilates class!" (According to Albrecht, Hanks took Pilates lessons at *his* house.)

Fuchs's dislike of the West Coast office was reciprocated. After he killed *In Living Color* (which went on to become a hit for Fox), Albrecht said, "We're not really in the television business. We were in the . . . 'what Michael likes' world and 'what we could convince him to do' world."

HBO continued to fiddle with original productions. *The Hitchhiker*, which ran from 1983 to 1991, was a supernatural thriller, shot in Canada on a shoestring. "Michael loved *The Hitchhiker*," recalls Potter. "But it was really dreadful. The rule was, [every episode] had to have sex." Inside HBO, it was known as *"The Twilight Zone* with tits."

Much, much better than *The Hitchhiker* was *Tanner 88*, an eleven-part half-hour political satire, pegged to the 1988 presidential contest between Michael Dukakis and George Bush the Elder. Potter wanted Garry Trudeau to make it, but he would only do it with Robert Altman, who agreed. But Altman was famous for biting the hand that fed him, and HBO's hand was too plump to resist. "I cannot tell you how frightening the whole thing was," Potter says. "Altman was a pig, he was just horrible to me. He was learning computer

editing, using *Tanner* as an experiment. If it flopped, he was still going to be 'Bob Altman,' but I was going to be out of a job."

Tanner 88 didn't attract many viewers, but it did attract press, and the kind of buzz Potter was after: "People inside the business started to see that they could come to HBO with projects that weren't commercial, that weren't low comedy, that weren't about people who were having sex with strangers and dying."

Potter was, as she puts it, "pushing every minute to be provocative. The buzzwords that would fly around our office were 'adult,' 'smart,' 'new,' 'fresh.'" She was always asking, "Could a network do this show?" If the answer was "Yes," HBO walked away. In 1991, it won its first Emmy for a made-for-TV movie, *The Josephine Baker Story*, which displayed the HBO trademarks: sex and politics. Emmys, by the way, although they may seem silly, serve to attract subscribers, talent, product placement, and advertising.

August 15, 1992, marked the debut of *The Larry Sanders Show*, a half-hour that ran weekly for six seasons until March 15, 1998, and became HBO's first successful series. The talented but very fucked-up Garry Shandling had an idea for a show loosely based on a comic much like himself. Think *Seinfeld*. Think *Curb Your Enthusiasm*. Drawing on his experience as guest host of Johnny Carson's *The Tonight Show*, he realized that the backstage Sturm und Drang might be a better target for his caustic wit than the anodyne chitchat that went on in front of the camera.

Poorly disguised as Larry Sanders, he played an enfant terrible at the center of a late-night talk show. Himself a vain, needy, and supremely self-centered stand-up comic unpopular with cast and crew, Shandling played a vain, needy, and supremely self-centered talk show host unpopular with cast and crew.

Unlike features, where writers are often treated like scum, television is a writer-driven medium. Shandling, naturally, was the head writer on the show. A forty-three-year-old man who turned self-hatred into an art form and insecurity into late-night poetry, he had a nervous, twitchy presence signaled by a trademark wince that

quickly faded into a grimace, suggesting a mix of laughter and pain that was all his own.

American viewers had never seen a sitcom quite like this one. It pulled back the curtain of this network staple to reveal a writhing ball of vipers comprised of celebrity divas and brain-dead network executives awash in a sea of ego, coke, and sex. Even the better network offerings set in a media milieu like *The Mary Tyler Moore Show* or *Lou Grant* never left blood on the floor the way *Larry Sanders* did every Sunday night.

"Self-deprecating" is a term that doesn't begin to do Shandling justice. "Self-flagellating" is more like it. He once observed, "Nobody can write better jokes putting me down than me." Among other things, Shandling targeted his here-today, gone-tomorrow sex life, and his relationship difficulties. He would quip, "My friends tell me that I have an intimacy issue—but I don't think they know me."

Although *Larry Sanders* was an instant success, it was by no means all raves, laughs, and profits. Shandling inspired intense loyalty in some, equally intense loathing in others, and sometimes both at the same time in still others. Jenji Kohan, who would later create *Weeds* and *Orange Is the New Black*, recalls that after she pitched an idea to him, her agent told her not to get her hopes up, because Shandling didn't like working with women. Indeed, *Will & Grace* and *Frasier* writer Janis Hirsch described him as "a passively malignant emperor" who presided over a "misogynistic writers room where women were called 'slits' and where on one occasion, a flaccid penis was placed on my shoulder, you know, just for laughs." She continues, "My mantra became, 'I won't cry until I get home.'" She amended it to "I won't cry until I get into the parking lot," which became "I won't cry until I get into the stairwell," which morphed into "Fuck, I'm crying."

Kevin Reilly, who felt like a fish out of water at NBC, had always been protected by his boyish good looks—an angular face topped by a scrub brush of red hair. He once said, "My whole life, I've felt like I could walk in the door with a bloody head in my hand, and somebody would go, 'Oh, look at that clean-cut guy! What a nice boy!'"

In 1994, two years after *Larry Sanders* had launched, Reilly landed at Brillstein-Grey, Shandling's management company, as head of TV. He recalls, "Bernie [Brillstein] was a great, old-time Hollywood character, full of life, full of love. Brad Grey, who managed Shandling, was the exact opposite. Together, Brillstein and Grey were best personified, as a creative once dubbed them, as 'Santa Claus and his evil elf.'"

Shandling occasionally deigned to visit the offices, where the vibe was *Walk softly. We produce it, wink, wink, but let Garry do his show.* Reilly was a fan but disliked him, calling him "an enormously talented, personally tortured, self-indulgent dick." One day, he remembers, "Brad called me down, and he said, 'Garry's here, and he wants to tell you about an idea.' I sat down across from Garry, and he didn't even look at me. Brad pitched me his half-baked thing about his limo driver. I went, 'Well, that sounds great. I'd love to. Do you have a sense of when you'd like to dig into this?' Garry looked at me like I just called his mother a bad word. Then he threw up his arms like he was going to vomit. I had said the worst thing you could ever say to him, which was, 'When are you going to actually do this?'"

Eventually, Shandling fired Grey as his manager, or Grey fired Shandling as his client. The two ended up suing each other, prompting David Geffen's famous warning to Grey, "Never invite your artists to your house if it's bigger than theirs."

During the finale at the end of May 1998, a boatload of Shandling's friends, including Jim Carrey, Tom Petty, Jerry Seinfeld, Carol Burnett, et al., paid tribute. Shandling's tribute to his cast and crew, who had endured his abusive behavior for six years, was different. "Before anyone could have a glass of champagne, Garry just walked off that sound stage and was gone," recalls director Todd Holland. "He didn't say goodbye. He didn't say thank you. He didn't say anything to anybody . . ."

The extracurricular controversies that swirled around Shandling were manna from heaven for HBO, however, and *Larry Sanders* confirmed its reputation for daring to go where no other service would. It was rewarded with fifty-six primetime Emmy nominations, and three winners. HBO, however, did not own *Larry Sanders*, which was

produced by Columbia Pictures Television. This meant that HBO could not exploit the show in syndication, and from then on, it was determined to own all its shows.

While HBO was chalking up its early successes, behind the scenes, a storm was brewing in the boardrooms of Time Inc. and Warner Communications Inc. (WCI) that would have profound consequences for HBO. Back in February 1987, a momentous meeting had taken place between Nick Nicholas, who had become CEO of the former in 1986, and Steve Ross, CEO of the latter. WCI was rebounding from the collapse of Atari, which had forced Ross to sell off some of its divisions. Ross was a builder, not a wrecker, and Fuchs knew that Nicholas was wary of a takeover that would probably entail a thorough housecleaning. He figured that by far the better option was to merge with WCI. (According to Nicholas, the idea for the merger originated with him, not Fuchs.)

As Fuchs tells it, he and Nicholas made the short walk from the Time-Life Building at 1271 Sixth Avenue near Rockefeller Center, over to the WCI Building at 75 Rockefeller Plaza. He remembers, "I start giving Ross my spiel, and when he heard the word 'talent,' he cut me off and started telling me how he was using the Warners plane to ferry Amy Irving to the Hamptons to see Steve Spielberg. He never heard a fuckin' word I said." After they concluded their sales pitch, Fuchs continues, "Steve walked us to the elevator. He had his arms around us like we were kids, and he said, 'Listen, if you guys are back in town, come by again.' It was like we were bumpkins from Kansas. The elevator doors closed, and I said, 'Nick, does he realize we're a block and a half away?'"

Ross was only too happy to be romanced by Time, and before long the two companies were holding hands. On January 10, 1990, Time and WCI concluded the deal. From Time's point of view, however, the Warner executives got rich and took over the new company that Time itself had paid for. Ross was the CEO, while Time's Nicholas, his ostensible co-equal, was effectively marginalized.

Fuchs in particular was unhappy. To him, it was like Chutes and Ladders, and he felt like he was going down the chute. "They were pissing all over us," he recalls. "Nick had really lost his way." He continues, "Nick spoke to the senior management, and I blew a fucking gasket. I heard that Bridget Potter called Nick to tell him, 'You were right, I thought that Michael was [way out of line].' "

Fuchs decided he had to hitch himself to a different star, and that star was Jerry Levin. The two had long been close, and he thought of himself as Levin's consigliere. In the bitter battles over TV rights between the studio heads who feared that HBO, by far their biggest customer, was getting too powerful, Fuchs felt Levin was letting them intimidate him. Compared to Jerry, "I felt that I was the attack dog Jew who could respond to these guys," he recalls. "I would call him up and I'd tell him, 'Listen, Jerry, you got to understand people like Barry [Diller] and Sid [Sheinberg]. They're not gentle. Here's a phrase that they're very used to and would serve you well. It's *Fuck You!*' "

Fuchs felt he had guided Levin as he rose up through the executive ranks of the company. The year before, in October 1989, he met Levin at the Plaza Athénée on East Sixty-Fourth Street in New York. Ross had prostate cancer. It was no secret to insiders that he was dying, putting the issue of succession squarely on the table. Nicholas was set to be the next in line. According to Fuchs, he urged Levin to go for Ross's position. "[Jerry] called the board members from my office," he recalls. "I wrote scripts for him. Jerry told me on more than one occasion that 'We're going to run the company—you and me— you're going to be my COO.' "

This was the beginning of the bruising battle over control of Time Warner. Nicholas, however, also regarded Levin as an ally. But in 1992, going behind his back, Levin secured a promise from Ross to fire his friend and make him co-CEO, which Ross did on February 19, 1992, while Nicholas was on a family vacation, skiing in Vail.

Levin readily admitted his deceit in an interview with *Fools Rush In* writer Nina Munk: "It is absolutely true that I plotted the departure of Nick Nicholas after working with him for twenty years. And I

don't have justifications for it other than I'm a strange person." Ross died on December 20, 1992. Levin replaced him.

If Levin promised to make Fuchs COO, he didn't deliver. Indeed, after promoting him to run Warner Music, he fired him on November 17, 1995. "He was an arrogant and vindictive bully who tried to intimidate grown men into subservience," said a Warner Music executive in *The Los Angeles Times*, a characterization with which Fuchs would probably agree.

According to Fuchs, "Jerry was like Stalin. He didn't want Trotsky anymore. It was almost like Jerry had to sever me because I knew too much about him. You don't want anyone near you who knows who you are. It's like having a mirror following you around. He really played me. Remember the replicants in *Blade Runner*? If I had walked into Jerry's office and he was taking his face off, I swear to God, I wouldn't have been surprised. This was a bloodless, heartless guy. To take down people more powerful than him in terms of personality, is probably incredibly exciting. I always tell people it's the only way he can get an erection."

One of Fuchs's final acts at HBO in 1995, before he himself left, was firing Potter. He had never forgiven her siding with Nicholas against him. "I think that stayed in my head a little bit," he admits. He replaced her with Albrecht. Says Fuchs, "Chris was good, but he was too volatile, too crazy. I couldn't trust him. He got the job by default."

Potter's view of the drama in the executive suite differs, unsurprisingly, from Fuchs's. She thought it was always about his father. "Every man who was his boss, he got rid of." She continues, "Michael's eyes got bigger and bigger, and he began to try to get Jerry Levin fired. Jerry caught him. This was the pattern of Michael's career there. Fuchs's story is a Greek tragedy."

Fuchs left HBO in 1995 with a $100 to $150 million golden parachute. Reflecting on his rise and fall, he says, "HBO was an insurgency. I was an insurgent, an intruder into the world of established television. It was a perfect fit for me, so that when I lost my job there, it really knocked me off balance, because I had convinced myself over

those twenty years that I had found a unique situation for myself. I built Time Inc.'s most important division. That job was the most fun I ever had in my life."

He goes on, "My mistake back then was that I thought that I was family. What happened to me—I had my career crunched at the apex. I was forty-nine fuckin' years old. I was the heir apparent. Grown people shouldn't go through that." HBO was the one and only job of Fuchs's career. When he lost it, he says, "They broke my fuckin' heart."

Fuchs was replaced by Jeff Bewkes. A spindly numbers cruncher from an affluent Connecticut family who had checked all the boxes that would please Time Inc.—Deerfield Academy and Yale—he rose quickly through its executive ranks. He had been hired in 1979 to persuade hotels to adopt HBO. By 1995, he was the CEO of HBO, and thirteen years later, after Time Inc. and Warner Bros. merged, he became CEO of Time Warner. Recalls Fuchs, "Jeff was never an entertainment guy. I had dinner with him when he got the job. He started with an attitude that this was going to be his big financial score. And he said that when he retired, he would sell the company. Money was a big deal to him. I learned that Jeff was about Jeff."

Different as he was from Fuchs, Bewkes initially supported his predecessor's reluctance to develop original programming. As he describes it, "HBO may have been on a mission to change television, but the key thing everybody forgets is that we didn't have much money to make hour-long dramatic series. Only NBC, ABC, and CBS could do that." More, "the networks used tens of millions of dollars of free promotion money [for their new shows]," Bewkes continues. "Instead of selling a Levi's ad, you put on an ad for *West Wing*. We had no promotional dollars."

Still, although far from ready to go head-to-head with the networks, Bewkes finally took the plunge, which Albrecht was only too happy to do. "Chris was the right guy to take over the programming in 1995," says Potter. "He knew no fear." Potter had long wanted to

do a show set in prison, another venue that the networks wouldn't touch. Since Fuchs had let her go, she figured it would never happen, but Albrecht thought it was a good idea, and hired her to work on it. He also hired Tom Fontana to write and run it.

Tom Fontana grew up in Buffalo, and was sixteen when the bloody uprising occurred in Attica, only thirty miles away, whetting his own appetite to do a prison show. "Both the actual riot and the takeover by the state police seemed sort of bizarre, like, 'What the fuck?'" he recalls.

Fontana had been nurtured by the networks, writing for *St. Elsewhere* and executive-producing *Homicide: Life on the Street* along with Barry Levinson. Yet, like most of the writers who migrated to cable, he had a healthy sense of the idiocy of broadcast television. Working for the networks made him feel, as he put it, like a "beaten child." He continues, "I was told that audiences wanted to be comforted before they went to bed." Needless to say, he had no luck with his Attica project. "I tried various ways to develop a palatable version of a show, but the response was always, 'It's too depressing.' 'What do you mean I can't [show] his dick? It's not his whole dick, it's just the tip of his dick!'"

According to Fontana, former NBC president Warren Littlefield actually ran one of his pilots by his twelve-year-old son and asked his opinion. Fontana developed another show for NBC called *The Philanthropist*, about a wealthy man who faces a tragedy in his life. "They had approved all our script outlines, but one day, they literally said to me, 'We want this to be like *Iron Man*,' because *Iron Man*, also about a philanthropist, had just become a hit movie. They fired me, and then they hired the guy who had done *The Six Million Dollar Man*, whom they had fired from the *Six Million Dollar Man* reboot. Then they hired me again, but by that point all the people who had fired me had been fired. So the new people coming in were going, 'We want the show you want to do.' I was like, 'Okay.' And the only reason we didn't get picked up is because president of NBC Entertainment, Jeff Zucker, said, 'I'm putting Jay Leno on at ten o'clock every night, and your show is a ten o'clock show, so it's over.'"

Meanwhile, a friend of his met with Albrecht in LA, and called him while he was in Baltimore shooting *Homicide*. "He said," recalls Fontana, "'Get your ass out to California, there's somebody stupid enough to buy your prison show.'" Albrecht asked Potter to work with Fontana. "I was worried about Tom, because he had done network TV, and any time that we worked with someone who worked with network TV we ended up with crap," she says. "I realized very quickly that Tom just wasn't thinking the right way—the HBO way." She took him to visit a prison in New Jersey. "My biggest surprise was that almost every single male in a maximum security prison is stunning," she continues. "Because they work out, and dress in a way that is extremely provocative. I was wearing a skirt. So every time I walked up a flight of stairs I was looking at all these gorgeous men who were looking up my skirt."

Skirtless, Fontana was, on the other hand, freaked out by what he saw. "I never wrote anything down, never recorded anything," he remembers, because "I was afraid that if they got out, they might come looking not just for residuals, but for my blood. People told me things like, 'I hated this guy, and I worked in the kitchen, so I crushed glass and I put it in his food.'

"'Didn't that take a long time?'

"'I'm in prison, what else do I have but time?' What became more and more hilarious to me was that whenever I used something that really happened in a prison, like the guy who stuck the spoon up the other guy's ass, or the COs putting a rat in the solitary confinement cell with a prisoner, people would say to me, 'Tom, only you would think up something like that. You're so twisted.'"

Eventually, Albrecht gave Fontana a million dollars and told him to shoot the pilot. Albrecht didn't seem to mind that most of the characters were hateful, or that under the opening credits, Fontana ran a shot of the word "OZ" being tattooed on an arm. When he learned that the arm belonged to Fontana, he thought, *If this guy is ready to bleed for the show, he's probably a good guy to be in business with.* Fontana used to wear a T-shirt with a picture of a dog licking

its genitals, under the banner "Because I Can!" which pretty much summed up the attitude of the show.

Fontana recalls, "One of the things that Chris said to me that totally liberated me from broadcast television was, 'I don't care if the characters are likable as long as they're interesting.' No network or studio executive would ever say that. Chris also said, 'What's the one thing that you're never allowed to do on broadcast television?,' and I said, 'Kill the lead in the pilot,' and he said, 'Do it.'" Fontana took him at his word, and set the lead character on fire at the end of the first episode. He continues, "I refer to those things as 'Holy fuck! moments,' when the audience goes, 'Holy fuck, did you see that?' and calls their friends."

Once freed from the tyranny of network rules, creatives like Fontana took advantage of the programming flexibility provided by cable. "I didn't have to jack everything up before each commercial so the audience goes, 'Ooooh,' guaranteeing that they come back after that Tampax ad—because there were no commercials," he explains. "I was able to look at the narrative in a completely different way, which allowed each episode to have its own rhythm for the length of time that story needed to live. That liberated me."

Oz premiered in 1997 and ran for six seasons, until 2003. There had been nothing even remotely like it on American television, and nothing ever since. Fontana once said, "The things I'm getting away with, I should be arrested for." It wasn't only the buttons he pushed or the boundaries he broke that made the series so unique. It was that he somehow managed to humanize the parade of freaks that comprised the prison's flora and fauna, so that viewers came to empathize with the characters, even the worst Aryan Nation thugs, one of whom burns a swastika into the butt of another with the red-hot tip of a lit cigarette. *Oz* demonstrated that viewers would stick around and watch characters no matter how distasteful they were, so long as they were compelling.

It's difficult to overstate the lasting impact of the show. Says Albrecht, "*Oz* showed what was possible to do on television. It blew

the doors off." He continues, "Tom and Barry Levinson were a little like Lewis and Clark, looking down at the Pacific going 'Holy crap, we made it.'"

Fontana adds, "The kind of risks that are being taken now stem directly from the risks we took with *Oz*. It reduced the fear factor that afflicted executives. It's the courage of the show on all levels, not just in the writing, but in the acting and the directing—that's what has carried on over time. *The Sopranos* overshadowed it—deservedly so—but people tend to say, 'Oh, [the golden age of] television started with *The Sopranos*.' It's only in the last few years that people go, 'No, it started with *Oz*.'" In short, no *Oz*, no *Sopranos*.

HBO was on a roll. *Oz* was followed the next year by *Sex and the City*. Instead of men behind bars, it featured women in bars. It was created by another network refugee, Darren Star (*Melrose Place*, *Beverly Hills 90210*), and shot at Silvercup Studios in Queens. The fourth episode of the first season contained the notorious "up-the-butt" scene, as it was affectionately called, wherein the four women around whom the show revolved squabble over the pros and cons of anal sex in the back of a cab. "When I went to talk to Chris Albrecht I mentioned this scene—and for me it was like a litmus [test] of how he was going to react and what their attitude would be toward the show," Star explains. "He's going to think it's really funny or throw me out of the room." Albrecht, being Albrecht, thought it was funny.

When *Sex and the City* premiered in 1998 AIDS had made sex scary, but the worst seemed to be over, and Star thought, *Let sex be fun again*. "So many of the comedies out there, the humor came from euphemisms, and things you couldn't say, the comedy came from wink, wink," he observes, adding, "I wanted to do a [comedy] where there were no boundaries . . . an adult, R-rated show about sexual relationships from a female point of view."

Loosely based on the sex columns of Candace Bushnell published in *The New York Observer*, Sarah Jessica Parker played Carrie Bradshaw (the Bushnell character), alongside Cynthia Nixon, Kim Cattrall,

and Kristin Davis as her friends. The show displayed HBO's signature disregard for the proprieties of the networks, flouting the rules laid down by Standards and Practices. It dealt directly with taboo subjects like cancer, STDs, and homosexuality, and experimented with interviews with real New Yorkers who periodically broke the fourth wall by addressing the audience directly about issues the show raised.

Sex and the City allowed viewers to eavesdrop on the four glaringly white women discussing their erotic preoccupations with the frankness heretofore reserved for women's groups, therapists' offices, and, most apt, men's locker rooms. Like men, the women were often caught behaving crudely, talking dirty, boasting about the scalps they had taken, even comparing the size, architecture, and piquancy of their partners' private parts, both male and female. It was full of dick jokes and caricatures, albeit amusing ones, of men: Mr. Big, Dirty Talking Guy, Tiny Penis Guy, Ball Fondling Guy, Utter Asshole, Mr. Pussy, and so on.

HBO only pushed back twice. Star recalled an episode in Season 1 ["The Monogamists"] he wrote where Charlotte (Kristin Davis) was dating a guy who wanted her to give him blow jobs all the time and "was always pushing her head down." The guy had a golden retriever who was always with him. In one scene, Charlotte has had enough, given her last blow job. She berates her boyfriend for objectifying her, and stalks out. In a scene that was shot and cut, when she returns, "His golden retriever [is] going down on him," continues Star, adding, "For some reason Chris Albrecht thought that was crossing a line . . . He thought it was bestiality, and I don't think he got the joke." (For enquiring minds, there was no actual canine fellatio. A tennis ball was buried in the actors' crotch, and the dog went for it. In another version of the story, peanut butter played a role.) A second scene that was sanitized featured condoms and a statuette of the Virgin Mary in the same drawer. The condoms stayed but the Virgin Mary disappeared.

Sex and the City ended its run in 2004. Although the show broke new ground by devoting itself to material off-limits to the networks,

old ground was very much in evidence behind the scenes. Heather Kristin, Kristin Davis's stand-in, describes a scene in which Charlotte was examined by a gynecologist. "I had to spread my legs in a set of stirrups and hold the position until everything was ready for filming," she recalls. "When the director and stars left for a meeting, a member of the crew duct-taped my feet to the stirrups. Others in the crew laughed, made crude comments about my body and took Polaroids. I wanted to rip the tape off and run screaming out of Silvercup Studios. Instead, I lay there knowing I had a job for another day and health insurance through the Screen Actors Guild." Eventually, she "couldn't take it anymore," and she quit. Kristin also alluded to an "alpha male actor," who, pointing to another stand-in, remarked, "I want *that one* tied up, gagged, and brought to my trailer." She subsequently identified him as Chris Noth, and recalled, "The first time the 'alpha male actor' slid his hand down my back and over my butt . . . 'That's your spot, sweetie,' Noth said, inching even closer."

Prompted by the 2021 sequel, called *And Just Like That . . .*, which included a few scenes featuring Chris Noth, according to *Variety*, several women came forward in one month accusing the actor of sexual assault. In a press conference, the last one to speak out claimed that Noth invited himself up to her apartment, got her up against the kitchen counter, and began "slobbering all over me . . . and pushed my hands down towards his penis." She said he called her the following day warning her that if she ever went public about it, "He would blacklist me in the business." According to *The New York Post*, a former girlfriend of his once got a restraining order against him after he "punched [her] in the chest and ribs," and allegedly made repeated threats to kill her. An account in *The Hollywood Reporter* accused him of raping another woman, aged twenty-two, from behind. She required stitches. Noth denied all the allegations against him, calling them "categorically false."

Sex and the City provoked extreme reactions, ranging from high praise to nasty put-downs. *The New Yorker*'s Emily Nussbaum, in a review far better than the show itself, called it "sharp, iconoclastic

television," and "a bold riff on the romantic comedy." That was particularly true beginning with the third season, when Michael Patrick King took over. Some feminists embraced the show for dramatizing the clash between second- and third-wave feminism, the so-called "lipstick feminists" who rejected the puritanism of their Andrea Dworkin–ized predecessors, approving accessories like makeup.

Contrarily, others denounced it for its definition of that empowerment: women behaving like men, not to mention wild-in-the-aisles-of-Bloomingdale's consumerism, epitomized by the title of an episode in the last season called, "A Woman's Right to Shoes," wherein Carrie admits spending $40,000 on shoes. *Sex and the City* treats it as just cute whereas, by way of contrast, in an episode of *SMILF*, when Connie Britton spends $26,000 for a Birkin bag, it's a critique of her class and character. One feminist wrote that *Sex and the City* is "to feminism what sugar is to dental care." *Entertainment Weekly* summed up the show's ethos: It "taught us that no flower is too big, no skirt too short, and no shoes too expensive."

Whatever lessons *Sex and the City* did or did not convey, it racked up consistently high ratings and was a near-instant success. Twelve and a half million viewers watched the final episode, an audience large enough to get the attention of the networks. It went into worldwide syndication in approximately forty countries, and sold briskly on DVD. Over the course of the six seasons, it was nominated for more than fifty Emmys, winning seven.

Sex and the City might never have found its way to the small screen had the testosterone-based analysis of the demographics of cable viewers still been guiding HBO. In any event, it revealed that HBO had been turning its back on half its potential audience.

"BE A GOOD CATHOLIC FOR 15 FUCKING MINUTES"

Chris Albrecht took a flyer on David Chase, allowing him to fashion his own story into *The Sopranos*, a touchstone for almost every drama that followed.

The Sopranos might not have inaugurated HBO's golden age, but the series defined it, completing its journey from a fighting-and-fondling irritant to the networks into the Rolls-Royce of cable. Like *Oz*, its impact cannot be overstated. Perhaps the ultimate compliment came from NBC's president Robert Wright, who sent out fifty-odd tapes to industry insiders during the third season that contained an episode in which Ralphie Cifaretto (Joe Pantoliano, aka Joey Pants) beats Tracee, his pregnant goomar, to death. In the accompanying letter, he complained, "It is a show which we could not air on NBC because of the violence, language and nudity."

David Chase felt that Wright was virtually inviting the FCC to try to censor his show. "It was an attack," he says. "There was a lot of envy that we had freedom, while they were crippled by Standards and Practices." Mulling his response, Bewkes, then HBO's president and COO, says, "I thought about calling [Wright], and then I thought, 'No, what am I going to say?' He hung himself. Isn't there an old saying, 'Don't shoot a guy who's killing himself?'" Chase, too, understood

that in its own way, Wright's complaint was high praise. He says, "It made me happy."

Oz was beginning its third season when *The Sopranos* premiered in 1999. Like *Oz*, it is confined to a "world," a prison, of sorts. In *Oz*, the prison is literal; in *The Sopranos*, it is figurative—cultural and geographical, a small patch of a small state, New Jersey, but in both instances it constrains and defines the characters.

The Sopranos is about mobsters who make their living on the wrong side of the Hudson River, Jersey's gray flatlands, in the shade of Manhattan's towering skyscrapers, an enduring reminder that no matter how many envelopes they collect, its mobsters are small-timers, skimming city contracts, hijacking semis full of booze or cigarettes, betting on sports or, most famously, running a not-ready-for-primetime strip club, the Bada Bing, whose pole dancers have left their best days behind them. The Broadway of this scrap of Jersey is Bloomfield Avenue, a shabby thoroughfare lined with mini-malls, single-story working-class bars, nail parlors, and Italian restaurants with names like Roma or DaVinci's, the walls of which are hung with black-velvet paintings. In other words, *The Sopranos* is more *Goodfellas* than *Godfather*. Almost all the characters reflect this, have chips on their shoulders, feel slighted, short-changed by life.

The Sopranos goes places where no other show had gone. When it tears itself away from the Sopranos' family kitchen, it luxuriates in extreme behavior. In Season 2, Richie Aprile (David Proval) crushes a character between two cars, runs him over, backs up, and runs him over again, meanwhile wearing a self-satisfied grin for a job well done. In another ugly, not-the-networks scene, Tony's sister Janice shoves a dildo up Ralphie's ass.

Often, Chase's choices were dictated by the bitter taste left by the world of broadcast TV. As Matthew Weiner, who joined the show in November 2002, before the fifth season after Chase read his spec script for *Mad Men*, explains, "There are things in *The Sopranos* . . . that are just 'fuck you's' to network TV."

Chase was already fifty-four years old in 1999 when *The Sopranos* first saw the light of day. He is a slender man, with deep-set eyes, a broad expanse of forehead, and a mouth that alternates between wry amusement and a frown, as if he has bitten into a lemon. He has the chalky pallor of someone who seldom ventures outdoors. Of Italian extraction (the family name was DeCesare), he plays his cards close to the vest, lives very much in his head, listens as much as he speaks, except for the occasional explosion of laughter, because above all, he's funny, displaying a dry, sardonic, cutting wit.

A severely truncated version of Chase's career goes like this: When the idea for *The Sopranos* finally floated to the surface, he had been writing network television for some twenty years. He had come of age in the late 1960s and 1970s, and had grown up watching the great films of Federico Fellini. After film school at Stanford, he was cast onto the mean streets of Hollywood, desperate to write features, but none of his scripts sold. Instead, he ended up writing television, for which he had nothing but contempt.

Finally clambering out of the river of sewage that was the nightly network lineup, he made it into the big time when he became a writer on a heavily plotted series called *The Rockford Files*. The nets were so afraid of controversy that the writers weren't allowed to give gangsters Italian names. He had, as he puts it, a "reputation for being 'too dark.'" Says Larry Konner, an old friend who wrote three episodes of *The Sopranos* during the second and third seasons, as well as Chase's second feature, *The Many Saints of Newark*, "David's reputation inside the TV industry was, 'Good writer, but what's going on in his brain, we don't want to be part of.'" Chase understood. "I felt I was out of step," he says. "I remember seeing *Pretty Woman* on an airplane. Everybody was laughing their heads off. 'Ho-ho-ho!' It wasn't funny to me; it wasn't dramatic, it wasn't anything. I thought, 'Why don't I just open the door and jump out?'"

Still, with a home in Santa Monica Canyon, he was successful by every standard but his own. Explains Allen Coulter, whom showrunners relied on to helm their most important episodes—premieres and finales—"David was embedded in the belly of the beast, but his

mordant sensibility, his dark, caustic vision of the network world, his cynicism and bitterness, enabled him to resist the Kool-Aid, protected him from becoming a network guy. He knew TV could be better."

Growing up, "I didn't really watch much television until the first season of *Twin Peaks* in 1990," Chase recalls. "That was an eye-opener for me. There's mystery in everything David Lynch does, and I don't mean, 'Who killed Laura Palmer?' There's a whole other level of stuff going on, this sense of the poetic that you see in great painting, that you see in foreign films, that's way more than the sum of its parts. I didn't see that on television, which is an outgrowth of radio. Radio is just all yak-yak-yak-yak, and so is television. It's a prisoner of dialogue, film of people talking. Flashy words." When you watch an Aaron Sorkin show, in other words, you're listening to the radio. When you watch a David Chase show, you're looking at a movie.

By 1995, Chase was in a position to pick and choose his shows. His lawyer, Lloyd Braun, was now running, along with Brad Grey, Brillstein-Grey, the management-slash-production company behind *The Larry Sanders Show*, which Chase greatly admired. Braun had once said to him, "You know, we believe you have a great television series in you." Chase recalls, "It wasn't something I was really dying to hear, 'cause my response in my head was, I don't give a fuck—I hate television." He rolled his eyes, but was flattered: "I wasn't used to being talked to that way, and it had an impact on me."

Driving home that night, Chase thought about a feature idea that his agents had shot down a couple of years earlier. It was a comedy about a mobster who gets panic attacks rooted in his difficult relationship with his mother. He sees a therapist. Chase thought to himself, *I wonder if that would fly as a TV series? They like these things to have female appeal, and this would have his mother and his family.* He imagined a script that stitched together bits and pieces from of his own life.

"Network dramas have not been personal," Chase observes. "I don't know of very many writers who have been cops, doctors, judges, presidents—and, yet, that's what everybody writes about, institutions:

the courthouse, the schoolhouse, the precinct house, the White House." Even though it would be a mob show, *The Sopranos* would be based on members of his own family. "It's about as personal as you can get," he continues. "How many times has that ever happened in the world of TV, where you actually wind up making your show in the little town you came from? About the people you grew up with? It wouldn't have happened if HBO hadn't invested in the idea of the writer's voice."

The town Chase grew up in was Clifton, New Jersey. Very much under the thumb of his parents, he was raised in a U-shaped garden complex called Richfield Village. An only child, he had a lot of "issues," as they say, with those parents. His father, who owned a hardware store, "was a very angry guy," he recalls. "If he had a problem with me, I got the silent treatment. He wouldn't speak to me for a week, two weeks. He'd go around the house with this sort of Mussolini pout." Chase's wife, Denise, says his father "belittled David. I can re-member him making fun of David's physical appearance in front of me, at the time when we were engaged to be married. Why would you do that? I hated both his parents."

It was his mother, however, who really left her mark. She made a cottage industry out of belittling him. When Chase was about twelve, she threatened to put his eye out with a fork because he said he wanted a Hammond organ. He describes her as "a nervous woman who dominated every situation by being so needy. She was always on the verge of hysteria. You walked on eggshells." Like Tony's mother, Livia, so memorably played by Nancy Marchand, she was a drama queen, passive-aggressive, given to every sort of eccentricity. She wouldn't answer the telephone after dark, wouldn't drive in the rain.

David and Denise, high school sweethearts, married in 1968. She is credited by some with keeping his head above water. Says Konner, "She is his emotional rock, let's say. She is the one he turns to in times of trouble." Chase adds, "It's not that she is Rebecca of Sunnybrook Farm, she's not a Pollyanna," continuing, "but she's not subject to this endless dismal terror and negativity."

Denise supported him against his parents. Chase recalls, "When Denise's younger sister died of a brain aneurysm, we went back to

New Jersey for the funeral. My parents were like not speaking to me, because I was spending too much time with *her* family." When he told his mother how his sister-in-law had died, her response was, "You see, David, she was too smart." Chase goes on, "Instead of focusing on Denise, I was focused on my problems with my parents. They were in my head all the time. Denise said, 'The amount of influence your parents have over you is stupid.'"

With parents like these, it's not surprising that Chase was on intimate terms with depression. At Wake Forest, in Winston-Salem, North Carolina, where he went for two years of college, and detested it, "I slept eighteen hours a day," he recalls. Did he contemplate suicide? "Well, doesn't everybody?" He spent some time in therapy, but didn't stick with it. Later, he gave Livia the immortal line, "Psychiatry? That's just a racket for the Jews!"

Braun brought Chase to Brillstein-Grey and put him to work. Grey, who is often credited with launching *The Sopranos*, took one look at Chase and said, according to Kevin Reilly, then head of its TV division, "'Who's the old guy that's writing this script about the Italian?' In the formative stages, Grey had nothing, zero, absolutely zero to do with this. His support grew in direct proportion to David's success."

Chase was determined to write a script in which the material wasn't pre-chewed for viewers. "On network, everybody says exactly what they're thinking at all times," he explains. "I wanted my characters to be telling lies." Chase was also determined to avoid the tiresome uplift that is de rigueur on network where, as he puts it, "By the end of the show, there's been some sort of a breakthrough. One character understands another: 'I didn't realize that I was not giving you your space.'" He calls them "huggable moments." Above all, he wanted the pilot to be cinematic: "I didn't want it to be a TV show. I wanted to make a little movie every week."

The entire first season is about depression, cancer, and death, as befitted a writer who was chronically depressed and whose mother, as he puts it, "Talked about cancer, cancer, cancer all the time. I was

raised with this dread of cancer." The heart of the show is the casual violence, murder, and betrayal folded into the humdrum routines of family life—Tony and Carmela Soprano driving their kids to school, going shopping, attending weddings and funerals. They get sick, get better, just like we do. In other words, gangsters 'r' us. Scarface meets Ozzie and Harriet.

When the script was done, Brillstein-Grey steered Chase to the networks. "Because of *The Larry Sanders Show*, which, despite enormous critical acclaim, made no money, I really didn't want to do it at HBO," says one source. "Nobody went to cable, certainly not to pay cable."

Bob Greenblatt, who was head of primetime programming at Fox, had an overall deal with Chase. He too was bored by the heroic cops, miracle-working doctors, and clever lawyers who populated his shows. He wanted, in his words, "to see if we could put the bad guy, quote-unquote, in the driver's seat of the show, where the anti-hero was the protagonist, because it had never been done." Greenblatt loved Chase's script for the pilot, but, he explains, it "was dark, so we ultimately said, 'Are we ever going to be able to do the right version of this show on the broadcast TV network?' So we passed."

Broadcast television was a dead end. Chase recalls, it "has an unerring system for detecting whatever it is that gets you excited about a project, and telling you to get rid of it. 'Does Tony Soprano have to be seeing a psychiatrist?' That was, of course, what made the show different. They all looked at me like I was a poor fool, you know, 'You idiot.'"

Braun suggested taking it to HBO. Albrecht says he saw right into the heart of the show, and understood that the mob was a red herring: "I said to myself, This show is about a guy who's turning forty. He's inherited a business from his dad. He's trying to bring it into the modern age. He's got an overbearing mom that he's still trying to get out from under. Although he loves his wife, he's had an affair. And I thought, *The only difference between him and everybody I know is he's the don of New Jersey.* So, to me, the Mafia part was sort of the tickle

for why you watched. The reason you stayed was because of the resonance and the relatability of all that other stuff."

Chase rounded up the best un- and semi-known Italian actors in New York City. He knew that the pilot, and subsequent episodes, if there were any, would stand or fall on the actor who would play Tony Soprano. After seeing a tape of the scene from *True Romance*, the remarkable Tony Scott picture from a Quentin Tarantino script in which James Gandolfini opens Patricia Arquette's forehead with a corkscrew like it's a bottle of Chianti, he called Gandolfini.

Gandolfini thought, *I've never been the lead before. They're gonna hire somebody else.* "But," he says, "I knew I could do it. I have Mr. Soprano in me. I was thirty-five, a lunatic, a madman." Chase recalls, "What happens every time is that people come in and read, and they read and they read, and you start to think, *This is really badly written, the thing sucks*. And then the right person comes in, and it all works. It was pretty obvious that Jim had too much going on for this role to go with anyone else."

Edie Falco had studied at a conservatory, SUNY Purchase, "where doing TV was a no-no," she recalls. "If you were at all interested in it, you didn't say anything." She was already working on *Oz*, so she was no TV virgin. "But," she continues, "my actor friends kept telling me about this great script going around called *The Sopranos*." When she was called to read, she went: "I knew exactly who this character was, and that night or the next day, they called and said they wanted to cast me."

Little Steven Van Zandt read as well. He had played the guitar in Bruce Springsteen's E Street Band. "I'm not a Hollywood guy, so I didn't give a fuck about anything," he recalls. "I was just talking to David like a regular person. I said, 'This is really a good script. But I gotta tell you, the only thing that kinda bothered me a little—I'm an Italian-American and all my friends are Italian-Americans—I'm not sure people are gonna buy this whole thing with the mother. It's kinda outside anything I've ever experienced or heard.' He said, 'That's my mother.'" Little Steven was cast as Tony's consigliere, Silvio.

Chase shot the pilot in early fall, 1997, in New Jersey and at Silver-cup Studios in Queens. He handed it in and waited. And waited. Ten months passed. No one, not him, not Gandolfini, not Van Zandt, thought it would go to series; it just violated too many do's and don'ts, even for pay cable. Referring to *Sex and the City*, Gandolfini told writer Brett Martin, "It wasn't four pretty women in Manhattan. This was a bunch of fat guys from Jersey."

Although Potter says Albrecht had no fear, Reilly was in the room when he and his right hand, Carolyn Strauss, first saw the pilot. "Chris had his head in his hands and rubbed his forehead for what felt like an interminable amount of time," Reilly recalls. "That's not the reaction you're looking for. Finally, Chris went, 'It's good. It's good. It's really good.' I think he had to summon the fortitude to say it. A gangster with existential crises wading in the pool with ducks? Not the most obvious thing for HBO to make their big bet on."

The only show as daring as *The Sopranos* was *Oz*. But "*Oz* was different," Albrecht explains. "It was on later at night. *The Sopranos* was a primetime family drama. We were sticking our whole leg in the water with this show." More months went by, and still HBO couldn't make up its corporate mind about whether or not to go to series.

Bewkes recalls, "For us, it was a real stretch, just to pay for *The Sopranos*, because even in its first year, it was going to be the most expensive drama that I think anybody had ever made, $2.5 to $2.7 million per hour"—twice as much as an episode of *Sex and the City*. He continues, "If you were us, you were saying, 'Okay, so let's go spend $30 million for a series that on the surface looks like a gangster who's going to a shrink.' And later when we were casting Jimmy Gandolfini, we knew no network would put a guy with his bulk into the leading man role of a week-after-week series they were trying to make commercial. And when the networks come out with their new shows every year, one out of seven makes it into the vaunted syndication. So we're saying, 'If the show goes on and fails, we are completely wiped out.'"

Chase was so sure it would never see the light of day that he was having conversations with the *X-Files* folks. At the last minute, right

before the actors' contracts expired, Albrecht ordered thirteen episodes. He explains, "It was, If we're gonna get into the series business, this was the show that we had. It wasn't like we were looking at ten different pilots, and thinking which one we should put on the air." HBO had a reputation for being frugal, to put it tactfully, and Chase got their standard contract, probably something less than $100,000 to write the pilot, and then $50,000 or $60,000 an episode.

Writers Robin Green and Mitch Burgess had worked on *Northern Exposure* with Chase. The first time Green met him, in 1988, she was new to the business, and he was interviewing her at a restaurant in Studio City to write for *Almost Grown*, a CBS show. She remembers, "I saw this sourpuss coming towards me, and I thought, *Oh, my God. How am I going to do this?* He was solemn to the point of grayness. By the end of the lunch we were laughing so hard about our mothers, tears were streaming down my face. He's so funny. For a depressed guy."

Years later, when she and Burgess, whom she would later marry, were working on Fox's *Party of Five*, Chase called. *The Sopranos* was going to series, did they want to work on it? They thought, *Hallelujah, our lives are saved!* Green continues, "*Party of Five* didn't care if we left, because to them, HBO was not network. It was failure-land." They signed on anyway. For *Party of Five*, they were being paid $35,000 together for an episode of a twenty-four-episode season. Now they were downsizing to a show that paid them their episode fee, but for half as many episodes.

Albrecht, who would be upped to CEO of HBO when Bewkes became chairman of Time Warner's new Entertainments and Networks Group in 2002, and Strauss, now VP of entertainment in charge of series, invited Green and Burgess to lunch. "They were real humans," recalls Green. "There was no 'I know what I'm doing' barrier. They readily admitted they didn't know what they were doing."

Strauss, right out of Harvard, was whip-smart. She was Albrecht's stealth weapon, because she rarely revealed whether she liked a pitch or not. She unnerved creatives with her poker face: no smiles,

no nods, no yeses, no nos, no expression at all. When Allen Coulter and writer Howard Korder pitched her, "She sat there stone-faced so you never knew whether she liked something or didn't," Coulter recalls. "You just felt no support, or feedback. Howard finally said, 'Should I just go fuck myself?'" One writer who admired her nevertheless likened her absence of affect to the rhythmic thump of train wheels rolling over tracks: "'Uh-huh, uh-huh, uh-huh,' not even the errant 'Oh,' or an 'Ah,' just, 'Uh-huh.'"

Strauss always claimed shyness as the reason she was so remote, but it must have been more than that. Some of her colleagues suspected she had a touch of Asperger's. Strauss recalls, "People would get very anxious. Their voices would shake. I would see blood-red blotches appear." Says a friend who knew her well, "She didn't like meeting new people. Sometimes she kept them waiting for a half hour or more. Among other things, she is said to have clipped her fingernails during pitches. Powerful agents and managers felt disrespected." Strauss explains, "The percentage of shows that make it from pitch to screen are so tiny, I always was very conscious of leading people on with enthusiasm and breaking their hearts later. For me, that probably caused me to start with ice. I couldn't smile. I wish I could go back and do it all again."

According to some, her problem was that she didn't know how to say no nicely, so that the disappointed hopefuls would feel like they could come back with a different pitch. She gave bad news badly. Like almost everyone else at HBO, she was controversial. Says one former staffer, "She was one of the smartest people in the building, but she's a horrible, horrible person. She's very judgmental, and when she doesn't like you, she shows you. I don't think that's appropriate. It's not high school." On the other hand, Strauss would open her mouth and Harvard would come out. Says Reilly, "Carolyn would go, 'I'm not fully feeling the thematic resonance.' You'd have to kind of sort out what that meant. But I give her a lot of credit for consistently digging for deeper themes and complexity." And best of all, she championed many of HBO's most successful shows, among them *Six Feet Under*.

W hile HBO was twiddling its thumbs over *The Sopranos*, Alan Ball was flogging a script called *American Beauty*. Bored, he had left Fox in 1997 to become an indie producer with partner David Janollari, putting him in a better position to make the kinds of shows that interested him.

Ball was pestering Greenblatt and Janollari to read it. "We were thinking, Oh, here's another television writer who just longs to be a movie writer"—like Chase, Greenblatt recalls. "We're going to have to slog through a screenplay that'll never get made. Then he told us DreamWorks was going to option it. We were like, 'Yeah, right, DreamWorks is going to make your movie.' We read the script and we were absolutely blown away by his writing." Eventually, *American Beauty* scooped up five Oscars, including Best Picture and Best Original Screenplay.

It was after the Oscars in 1999 that Strauss called. She had read Jessica Mitford's *The American Way of Death* and wanted Ball to write a show about a funeral home. At the mention of funerals, Ball perked up. He had an intimate relationship with death. When he was thirteen years old, he was riding in the front seat of the family car next to his sister, Mary Ann, who was driving. She turned into a blind curve, hit an oncoming car, and died instantly. It was her twenty-second birthday. He was soaked in her blood.

Ball knew that a show about a funeral home was a nonstarter at the networks, unless they could unearth a mortuary that thought television was a good way to strike it rich unloading coffins and formaldehyde. He wrote the pilot for *Six Feet Under* on spec. He recalls, "I had just discovered *The Sopranos*, and I was amazed that like, 'Oh, TV can be like this?'"

Ball met with Strauss. "She said, 'Could you make it just a little more fucked-up? And not tie everything up in a nice little bow,' which is not a note that you get in Hollywood very often. I was like, 'Thank you God, thank you God.'" That was Strauss at her best. Says Greenblatt, "The version of Carolyn that we got was fantastic and unconditionally supportive and just a partner in crime with us."

Strauss kicked Ball's script up to Albrecht, who also loved it. Ball contrasted his experience at HBO with that at ABC, where "everybody felt like they had to give notes, just to justify their job." At one point, "people's assistants were coming up and giving me notes, like, 'I don't like the color of the wall on that set.'"

Six Feet Under included several major gay characters, most prominently one of the sons of the Fisher family that owned the funeral home, played by Michael C. Hall, and it featured as well what was perhaps the first interracial gay relationship on American TV, between his character and one played by Black actor Mathew St. Patrick. Greenblatt recalls, "HBO was just completely open to this. There was never one second of discussion about, 'Oh, can we get away with that? Or should it be a white guy instead of a Black guy?'"

In the same way that *The Sopranos* was marbled with characters and themes drawn from Chase's own life, "There was a lot of my own story in *Six Feet Under*," continues Ball. Like Chase, he had a difficult mother who was something of a religious nut. When he came out of the closet to her, she put her hands to her temples, and exclaimed, "Oh, God has dealt me some blows in my life." Once again, HBO was breaking new ground with personal television.

One of the writers on the show was Joey (then Jill) Soloway, who would go on to write and run the hit *Transparent* for Amazon Prime Video. "I had written a comedic piece called 'Courteney Cox's Asshole,' about being Courteney Cox's assistant, and my agent sent that writing sample to Alan Ball," Soloway recalls. Soloway was hired. "I was like, *Okay, I'm a real writer.* The writers' room was like a therapy group. Urged to draw on their own experiences, all sorts of things would come out. Someone would say, 'I went out with this guy last night.'

"'Tell us, tell us! Feed the machine, feed the machine!' the writers would chant, pounding the table.

"'OK, although I don't want this in the show,'" but as often as not, the machine was fed and it went on the show. "Alan was my first gay boss," Soloway goes on. "I had always had straight bosses, which

caused this confusion of 'Do they think I'm a good writer? Or is this just flirtation? What is this relationship?'" Alan Poul, Ball's executive producer, was gay, too. "I was in a gay world, so as a woman, I was free," adds Soloway. But not so free as it appeared.

Soloway begged Ball repeatedly, "'Can I direct an episode?' I was told 'No.' Over and over again." Being a woman was not going to help: "All the spots were being reserved for people who came out of Sundance and their buddies. A lot of gay men were saying, *Hey, we're making a revolution here, we're not hiring straight men*, but it was still just men. I really bought into it, thinking, *I'm just not ready. I must not know something*. There was a huge amount of—not open misogyny—but men admiring the work of other men, straight men for straight men, gay men for gay men. I watched Jason Reitman come up, [saw] the homosocial behavior of men where they really know how to mentor a rising star, but they didn't know how to do that with women. Opportunity hoarding. So we were just left to one side."

*T*he Sopranos premiered on January 10, 1999. To say it made a splash is an understatement. Recalls Albrecht, "Nobody had ever paid attention to us before. Now, *Saturday Night Live* was doing parodies of a first-season show. We were the focus of media attention, whether it was five o'clock news or *The Tonight Show* or *The New York Times*." Adds Konner, "David was a guy who, for twenty-five years, had been told, 'You can't do it,' but when he was given the chance, did it better than anybody else had ever done it, being his own dark, twisted self."

The excitement generated by *The Sopranos* was as intoxicating as it was contagious. Even the Teamsters were reading the scripts on the set, virtually unheard-of. The writers were flying high, so high that from the pinnacle of Mt. Soprano, other HBO shows, no matter how good, were pygmies. Somewhat embarrassed, Green tells stories on herself. They would run into the *Sex and the City* people and it was like high school. Green and Burgess were writing *The Sopranos*, and

they were just writing a dumb comedy. It was the same with *The Wire*. Green and Burgess felt they were writing meanly funny drama, while David Simon was writing corny melodramatic bullshit. She recalled Ball coming up to her a few years later during an HBO party at Spago, then the "in" Hollywood restaurant. Intending to compliment her, he told her that *The Sopranos* made it possible for him to write *Six Feet Under*. She thought, *You're equating* Six Feet Under *with what we did? You're speaking to me like we're equals? Oh my God, if I could die now I would be so happy that I achieved that for you! Go fuck yourself!*

Green wasn't alone. Gandolfini and company became instant celebrities. He recalls going to a fight at Madison Square Garden with some of the cast. "I walked in, there was a stampede," he says. "The whole crowd started chanting 'Toh-nee, Toh-nee!'" Executive producer Ilene Landress recalls, "We were like the Beatles."

Some fans were hard-pressed to distinguish the actors from their roles. "I was living in the meat market district on the far West Side, below Fourteenth Street," Gandolfini remembers. "I heard this banging on the outside door and screaming. It was late, like after midnight. So I opened the door, and the guy turns white. All of a sudden I realize, *Oh, fuck, he thinks I'm Tony.*"

Sometimes it seemed like everyone in America was watching the show. When Annabella Sciorra, who plays Gloria Trillo, hurled a steak at the back of Tony's head, a female fan came up to her on the street and said, "When you threw that steak at Tony, you threw that steak for all womankind!"

In the middle of the third season, after Ralphie beats his girlfriend to death, Joey Pants recalls, "I was getting stopped on Fifth Avenue by little old ladies who were like 'Oh my God, you were so bad to that woman,' feeling my arms. They were flirting with me, turned on that I was the guy who beat up this hooker. It was sick."

Chase says he was troubled by how much the "less yakking, more whacking" contingent of his fan base loved his mobbed-up characters, no matter how badly they behaved. The show is "about evil," he said. "I was surprised by how hard it was to get people to see that."

The fans might have loved the violence, but HBO, which prided itself on letting the showrunners run, drew the line at the fifth episode of the first season, called "College." Tony takes his daughter Meadow on a campus tour, where he stumbles across a fink in witness protection. He garrotes the "rat."

When Albrecht saw "College," he finally said, "No!" "That was a truly big flap," Chase remembers. "We'd gone four episodes, and I thought, 'If this guy really is a mobster, c'mon, he's gotta kill somebody.'" Albrecht told Chase, "You know, you've created one of the best characters in the past twenty years, and you're gonna destroy him in one fell swoop. The audience'll hate this guy. You can't do it."

At that point, Chase did not have the clout to prevail. He had to shoot a new scene in which the fink plans to kill Tony, which kosherizes Tony's behavior. Nevertheless, that put an end to the likability issue, a holdover from network. The *Sopranos* audience didn't seem to mind. Tony is a killer, pure and simple, although by his lights, he has his reasons. The black-and-white-ists in the audience demanded clear-cut heroes and villains, but Fontana, Chase, and the other cable pioneers refused to oblige. Their characters blended good and evil, making the good-bad guy, and occasionally gal, imperfect figures alternately sympathetic and repellent, and sometimes both at once.

Tony was in shouting distance of a real human being, and became a touchstone of the best small-screen shows, as Greenblatt had once hoped: from Vic Mackie in *The Shield* to the eponymous Ray Donovan, and Bobby Axelrod in *Billions* decades later, not to mention the good-bad girls: Nancy Botwin in *Weeds*, the entire cast of *Orange Is the New Black*, Jackie Peyton in *Nurse Jackie*, the eponymous Gentleman Jack, Deborah Vance in *Hacks*, and the castaways in *Yellowjackets*. Graham Yost, who wrote and ran *Justified* for FX, says, "I've got a picture of William Holden, Warren Oates, and Ben Johnson doing their walk in *The Wild Bunch*. They're bad guys, but they have a code. It took television a long time to catch up to features, and that's one of the reasons we would always look to them, 'Oh, features can do that shit and we're not allowed.' Once the fenders came off it was like, 'Dammit, yes, we're going to do an anti-hero.'"

Although often lumped together, the code is what separates good anti-heroes (the good-bad guys), who are vigilantes for justice, from the bad anti-heroes (the bad-bad guys), who are motivated solely by greed, ego, and revenge. They are vigilantes, too, but for personal, not civic, reasons.

Moreover, threaded throughout the mayhem and murder were serious themes. *The Sopranos* was actually about something. Green remembers, "Matt Groening said to me that *The Sopranos* was the only show, other than *The Simpsons*, that he felt really commented on contemporary America. Tony's always saying, 'Look at Enron. I'm small potatoes.'" Gandolfini adds, "Materialism and capitalism and the failure of America from when the immigrants came here—that, essentially, is the theme. David sees shopping as Satan." He pauses. "I think he thinks too much!"

Another difference between *The Sopranos* and network shows was that the latter were structured like daisy chains of stand-alone episodes because they were only aired once, and if viewers missed an episode, they wouldn't lose the thread, because there was no thread to lose. "The assumption in broadcast was always that since even your diehard fans are only going to watch one out of every three or four episodes, you had better make them self-contained," explains David Nevins, who was a senior programming executive at NBC in the *ER* and *West Wing* era, and Fox in the *24* era. That meant in, say, *The X-Files*, the Mulder and Scully you got in the first episode of Season 1 were the same Mulder and Scully you got in the last episode of the last season. Their quirks and foibles were familiar, dependable, and therefore comforting.

Even the episodes of early cable shows like HBO's *Sex and the City* were, as showrunner Michael Patrick King recalls, tied up with bows because audiences might not watch them sequentially. Shows like these were known as "closed." As cable evolved, its dramas, like *The Sopranos*, at least in part, were "serialized," and became known as "open."

Given the demands of the dense and complex scripts, the first season was shot on an insanely tight schedule, with each episode allotted only eight days. But long days, sometimes lasting up to sixteen hours,

created a pressure cooker for the crew and cast—especially Gandolfini, who was in almost every scene. The actor, like his character, veered from lovable to scary in a millisecond. He had alcohol and drug problems, and he often disappeared for days at a time, holding up production. Relations between him and Chase were often tense.

Allen Coulter directed Gandolfini in some twelve episodes. Coulter recalls, "In one scene, he had nothing more to do than walk back and forth in front of the camera." He asked the director, "Couldn't I just stand here?" Coulter remembers, "That was Jim's general approach, 'Can't I just stand here?' or sit for this scene. I had to say 'no.' You could never say to an actor—'Well, I agree, it doesn't make sense, but let's shoot it anyway'—because then it opens a discussion that could take all night."

Every once in a while, Gandolfini queried a line reading. Chase famously regarded every word in his scripts or those he had approved as sacred. If an actor wanted to make a change, it had to be cleared with him or his writer. Once, Gandolfini asked one of the writers, Terry Winter, "What's the difference if I call him 'a fuckin' cocksucker' or a 'cocksucking fucker'? Is that really gonna change anything?"

"Well, yeah, it sounds better the first way," Winter replied.

"I don't understand."

"You just have to trust me that, to my ear, it sounds better. I can't explain it."

The actors formed a close-knit group, and they often pranked one another. Gandolfini would moon Lorraine Bracco, who played his shrink, when no one was looking. In response, she took Anabella Sciorra's hair extensions, wadded them loosely in her pantyhose, and uncrossed her legs. Gandolfini went, "You're disgusting." She responded, "I learned everything from you."

Among the new subscribers the show attracted was, apparently, the mob. In one scene, Tony is at a cookout wearing shorts. Gandolfini's phone rang late at night. A voice said, "A don doesn't wear shorts," and hung up.

HBO would never reveal how much money *The Sopranos* generated, save for saying it was worth "tens of millions of dollars." In

2004, *The New York Times* estimated $100 million, which was the amount of damages for which HBO sued Gandolfini during a salary dispute.

Gandolfini's original deal paid him $5 million a season. Eventually, riding the show's phenomenal success, he demanded $20 million, still well under what network leads like Kelsey Grammer were pulling in, $35 million a season. Toward the end of Season 4, Gandolfini "got a phone call, and came back in the worst possible mood," Coulter recalls. "The reason was he had been holding out for a new deal, and he had been told that it had closed, and that he was going to get a huge amount of money for the next season." Coulter continues, "If you're filled with self-loathing, and find that you're going to make a ton of money you feel you don't deserve, it just adds fuel to the self-destructive fire. You get all fucked-up." As Chase puts it, "He didn't like who he was." Coulter goes on, "Unlike some actors who are just plain aggressive and hostile, dealing with Jim was closer to being in a room with someone who was beating himself up, and you'd catch an elbow in the eye." Gandolfini had settled for $13 million a season, and in this case, the elbow in the eye amounted to checks for $33,333 he distributed to other members of the cast in an unprecedented gesture of generosity.

Chase ridiculed the networks for making shows about institutions with which the showrunners had little firsthand knowledge. David Simon—fifteen years younger than Chase—also portrayed institutions, moving from the drug trade on "the corner" to the unions to city politics to Baltimore's public schools. But thanks to his lengthy run as a journalist for the *Baltimore Sun*, he actually knew something about them. And what he knew told him they didn't work; this is revealed in the striking difference between the way they are portrayed by the networks, and the way he would portray them. Unhappily, the history of America demonstrates that Simon was right.

Simon did ride-alongs with the Baltimore Police Department's drug and homicide squads, and immersed himself so thoroughly into the street culture that the dealers took his presence for granted.

Simon wanted to use nonactors drawn from among them and their customers. He teamed up with a former homicide detective named Ed Burns. They first met when Burns was preparing to indict a drug kingpin based on an investigation that involved an elaborate wire-tapping scheme; this would provide the framework for the first season of *The Wire*.

If the two of them knew anything, it was the mean streets of West Baltimore. In this sense, Simon's show, like *The Sopranos* and *Six Feet Under*, was personal. He turned his day job into a series. And unlike the network shows, the crimes *The Wire* dramatizes were rarely solved. They couldn't be, because they were systemic, and often the cures administered by the authorities were worse than the illness.

Simon firmly believed that the Times-Mirror Company, which eventually acquired his beloved *Baltimore Sun*, destroyed it. The Times-Mirror Company was to him what network television was to Chase. It fostered his cynicism about the "system," a term that meant to him, as it did to Chase, free-range capitalism or, in Simon's words, "raw, unencumbered capitalism" that devalues human beings in favor of profits. Every season of the show captures the devaluation of yet another group native to one of those institutions. A touch grandiosely, and perhaps prematurely, but not inaccurately, he describes *The Wire* as a story about the "decline of the American empire," emblemized by Ronald Reagan's so-called war on drugs. He regarded it as "perhaps the only storytelling on television that overtly suggests that our political and economic and social constructs are no longer viable, that our leadership has failed us relentlessly, and that no, we are not going to be all right."

As it turned out, even though he admired the police Simon started becoming less interested in the cops and more interested in the robbers. The result was that he started telling his stories from the point of view of the pushers and addicts instead, a slippery slope that led to his follow-up, *We Own This City*, years later in 2022, wherein the cops are the bad guys, lacking even the quasi-redemptive qualities that would make fans swallow the good-bad guys of *The Shield*.

In November 2001, after Season 2 of *The Sopranos*, Simon pitched *The Wire* as a cop show to Strauss. Neither she nor Albrecht was particularly receptive. Cop shows were what the broadcasters did, and Simon had to overcome HBO's not-the-networks bias. The two also worried that portraying a drug-addicted population of mostly Black folks would invite pushback from the sizable Black audience HBO had cultivated over the years, not only with *Oz* but with its diet of prizefights and shows like *Russell Simmons' Def Comedy Jam*. Hosted by Martin Lawrence, that show featured comics like Dave Chappelle, Kevin Hart, JB Smoove, and Chris Rock.

Simon cleverly argued that now that HBO had successfully mined subjects that the broadcast networks wouldn't touch, it was time to hit them where they lived, the genre that was their lifeblood. As Simon put it, the network cop shows were phony. Not only did they glamorize cops, they misrepresented the poor. "So much of what comes out of Hollywood is horseshit," he said. "How is it that there's nobody actually on a human scale from the other America? The reason is they've never met anybody from the other America. I mean, they could ask their gardener what it's like." He added, "The only time [these people] go downtown is to get their license renewed." By doing a cop series better, more realistically, more truthfully, underdog HBO had a golden opportunity to humiliate its top dog rivals.

Like *The Sopranos*, *The Wire* shunned the conventions of its genre. There are no shoot-outs, no hair-raising car chases. Instead, there was even more yakking than whacking, a lot of standing around in front of blackboards while the cops tracked beepers and burners used by the dealers.

Dan Attias, who came from network and went on to direct for shows like *The Americans*, *Homeland*, and *Billions*, did four episodes of the show. He says Simon is a "brilliant, brilliant writer. He thought the script was where all the value came from, [but] I'm not sure he understood what directors can bring to a project." Unlike Chase, "he wasn't really terribly interested in how you were going to do something."

Neither Albrecht nor Strauss liked Simon's pilot script, and they asked him to write two more. The story was loosely based on the saga

of Little Melvin Williams, who introduced heroin to Baltimore. His brainy number two took college classes in business and turned Little Melvin's street sales into a sprawling, money-minting enterprise. In the script, the two morphed into Avon Barksdale and Stringer Bell; the latter character launched Idris Elba's career.

The Wire cemented HBO's reputation for going beyond the networks' white-bread programming. It featured actor Michael K. Williams, who played Omar Little, a frightening, shotgun-toting killer who preys on street dealers while whistling "The Farmer in the Dell." And he's gay. "I'm a character actor, I always look for challenges," Williams said. "I look for things that are going to make me stand out. I'm a black dude from the projects of Brooklyn with some talent. It's like, 'Get in line.' I knew I needed to stand out from all of this motherfuckin' talent out here. When I read Omar, I didn't look at it and say, 'Why does he have to be gay?' I said, 'Oh, this is it. He's a homo. That's what I need.'" He added, "I went into *The Wire* like any newly budding actor: I was narcissistic. It was just about my career and how much screen time I had and blah, blah, blah, [but I saw it become] bigger than just a hood story. It was never about that. It was a social story told on an American tapestry. Just happened to be in the hood."

The Wire made its debut on June 2, 2002, as a cop show that wasn't just a cop show, but something more, as Williams puts it, three months before *The Sopranos* entered its fourth season.

Despite the long hours, the first-season shoot of *The Sopranos* had been expectation-free. Not so the second season, which was just the opposite. The pressure to do it again, and again, and better every season took its toll on Chase. Gandolfini's tantrums were mirrored by his own. "I have these same tendencies as he does, which is I'm very infantile about temper tantrums with inanimate objects," says Chase. In the grand tradition of producers Scott Rudin and, yes, Harvey Weinstein, he was a thrower of pens, phones, laptops—anything close at hand. "We're not allowed to have a temper anymore?"

exclaims Gandolfini. "There's something wrong with you, 'cause you raised your voice? When did that happen? To me, David is truthful, he's clear, he tells me when something's wrong. When actors came to me asking, 'Am I doing okay?' I'd say, 'Believe me, if you weren't doing okay, you would hear from David.' I appreciate that."

Anger is a great motivator. "What was driving the show, and driving David, is that he doesn't like the world as he finds it, and he certainly doesn't like the world of television," explains Konner. "He's taking out a lot of his frustrations by letting these characters act out, with no superego, with no sense of responsibility, because *he* wants to—and to some extent, we all do." Adds Coulter, "He has a flame of anger, almost violence, that burns just below the surface. People sense that, and it scares them."

Chase took no prisoners. As Tim Van Patten, who directed almost twice as many episodes of *The Sopranos* as anyone else, puts it, "If he finds your Achilles' heel, he will go for it, at war or play." Tony Sirico (aka Paulie Walnuts), who had done time for extortion, took a step backward whenever Chase approached him.

Cast, crew, and writers were afraid of Chase, especially the writers, who worked with him closely and with whom he had complicated relationships. He had little patience for those who were learning on the job. Either you got it or you didn't. He used to say, "I'm not running a writing school." After the first season, three writers were dropped; only Green and Burgess were left standing. Chase and Green were especially tight. "Every time David said something, he would look to me to see what I thought," she recalls wistfully. "I was like his consigliere for a very long time. I adored him, because he revealed himself as a human being. He would come into my office and throw himself down on the couch and was able to say, 'I'm so depressed.'"

Terry Winter, who joined the show in Season 2, had written, among other shows, a single episode of *Flipper: The New Adventures*, a tackier remake of a tacky 1960s series about a crime-solving dolphin, which Green would never let him forget. Winter grew up poor in Brooklyn. He went to a vocational high school and trained to be an auto mechanic. He made pocket money working as a security guard

at Lutheran Medical Center in a crummy neighborhood called Sunset Park, where he packed troubled people into an ambulance nicknamed the "Disoriented Express"—destination: Bellevue. Suffice to say, Martin Scorsese's *Taxi Driver* changed his life. "Until I saw *Taxi Driver*, I was a fan like every other kid. That was the movie that made me stop and think about movies for the first time as an art form. I probably saw it twenty-five times that summer."

According to Winter, it took Chase two years to warm up to him, the reason being he was prone to firing writers whom he thought didn't understand Tony, how he would behave, and why. Winter says he always kept his bag packed. "I don't think I hung any pictures up in my office the whole seven years I was there because I was afraid I might be fired. I'd never seen anybody fire people as quickly as David did. People would walk into his office and fifteen seconds later, the door would open again and they were leaving with their shit in a box." Winter would say, pointing at Chase, "Don't fuck with the boss. See David? That's the person whose ass you have to kiss."

Todd A. Kessler, now working on *The New Look* for Apple TV+, was then twenty-six and had a successful show on NBC called *Providence*, about the crime-riddled capital of Rhode Island. He recalls that Standards and Practices told him, "We do not accept the use of the word 'Mafia,' 'mob,' or 'mobbed up' on an NBC show that airs at eight o'clock on Fridays." He left to join the writing staff of *The Sopranos* for the second season in 2000.

A writer friend had warned that "I could learn a lot from David, but that the challenge would be to stay only so long as I was learning and to get out before David's personality, which was dark, permanently warped my personality." Kessler still jumped at the chance. "I was thrilled by the experience. I was on the set a lot and I sat in on editing. We were very close." Chase also introduced him to his wife, Denise, and included him in family dinners. Once, Chase asked him if he should fire Terry Winter, with whom Kessler shared an office, because he just didn't think that Terry was producing the stories that were really in keeping with the show. "I said, 'Well, why don't you talk to him?' He said, 'Oh yeah, I guess you're right, I should do that.'"

Kessler co-wrote that season's finale with Chase, called "Fun-house," in which Big Pussy joins the fishes, after Tony asks him, with characteristic delicacy, "Why are you making me do this, you fat, fucking, miserable piece of shit?" "Funhouse" was nominated for an Emmy on July 21, 2000. Afterward, according to Kessler, Chase called him into his office, and told him, "It was time to end our relationship, I had lost the voice of the show, even though the last thing we had written was that episode, and we were working on stories for Season 3. My heart sank and I started to sweat. When I asked him if he had been feeling this way, why didn't he tell me? He said, 'Oh, you're right, I probably should have told you sooner, but do you want another chance?' And I said, 'Yes, of course I want another chance.' I would've done anything to stay on the show. He said he would think about it."

Kessler went back to Manhattan—he was living in Soho—and sat down on the curb in front of his building, his head in his hands. His brother Glenn asked him what was wrong. "I just burst into tears and said that I think I was just fired. Then my cell phone rang. It was David calling to ask me for advice on the scene that he was writing for Tony, with no mention of what had just happened forty-five minutes earlier."

That sounds like the behavior of a sociopath but, explains Coulter, Chase was proprietary to a fault. "He guarded the keys to the kingdom assiduously. Success for him was a long time in coming, and this was the most important thing that had happened in his career. He was going to fight tooth and nail to defend it. Did he sometimes step on the credit due other people? Maybe. He just wanted to make damn sure that this was his vision, and that people knew it." Chase did give Kessler a second chance, but fired him for real a few months later.

The Sopranos happened, or at least an important part of it did, in the writers' room. Winter recalls, "Once in the third year we needed something really horrific to happen to [Tony's daughter] Meadow and her roommate." He continues, "I said, 'Once I was on the subway and I saw a homeless woman who had a skirt made out of a garbage bag. As she got up, the skirt fell off, and she had *The Daily News* stuffed

up the crack of her ass.' That image always stayed with me. I thought, 'Of course, we'll never use that.' David said, 'That's perfect.' I was like, 'Wow! There's no limits!'"

Chase had an FBI guy filling them in about the idiosyncrasies of mobsters. "He told us about fucking those girls with a broom," recalls Green. "We used a lot of that shit. He told us about the attitude of mob guys toward cunnilingus." Burgess explains, "There was one episode where Tony needed to get something on Uncle Junior [Dominic Chianese]. I said, 'What's the worst thing that can happen to him?' Well, shit. Tony finds out that Uncle Junior ate pussy."

The script meetings were grueling, from ten in the morning to seven, eight in the evening without much in the way of breaks. If, on a good day, the writers' room rang with laughter, on a bad day, it was a hellhole of competitiveness and backbiting. Chase could be the funniest guy in the room when he wanted to be, but he was no treat to work for when he was in a bad mood. He played favorites, pitting the writers against one another.

The writers felt free to argue with Chase—within limits. "David is a person with a lot of rules," says one source. "And, so, if you're not careful, he's gonna hate you." There was an issue of respect, a line they couldn't cross. No one could say, "David, that's the stupidest idea I ever heard, go back to film school." Green was supposed to be careful around him, not to say this, not to say that. But tact was not one of the arrows in her quiver, and for reasons best known to herself, she couldn't resist pushing his buttons. She would say things that she knew she shouldn't. Once, during a Writers Guild panel the discussion turned to the notorious "College" episode. Yes, it was based on Chase's college tour with his daughter. But where was the hook? Another writer, Frank Renzulli, was the one who suggested that Tony stumble on a rat in witness protection. Like a lot of great ideas, everybody thought it was theirs, and said so, including Chase. Green, however, contradicted him, saying it was Renzulli's. Later, Burgess asked her why she had goaded him, knowing it was going to piss him off. She replied that she said it because it was true. The moment passed but, as Burgess put it, "Nobody forgets where they buried the hatchet."

DEADWOOD AND ITS DISCONTENTS

HBO followed up *The Sopranos* with *Deadwood*, which was killed abruptly, creating such a storm that no one noticed Netflix, a start-up that was sending DVDs by snail mail.

David Milch walked into Chris Albrecht's office in 2002. At the age of fifty-seven (he was born in 1945, the same year as Chase), barrel-chested and bespectacled, of medium height with dark hair and an olive complexion, he hardly stood out in a crowd. But his reputation preceded him. Despite his decidedly monochromatic appearance, it would be difficult to come up with a more colorful character. He was blessed with an original mind, an elephant's memory, a gift for gab, and an uncommon facility with the written word.

These advantages had already made him a wealthy man. He was coming off an extremely successful network career that included writing for *Hill Street Blues* and, with Steve Bochco, creating *NYPD Blue*. According to *The Hollywood Reporter*, all told, he had made in the neighborhood of $100 million. Indeed, along with Tom Fontana, he was one of the threads that connected the late, great twentieth-century cop series to the shows of HBO's prime.

As a young man, Milch attended Yale. He was a precocious scholar, with a penchant for delivering oracular monologues filled with gnomic nonsense as if he were defending a nonexistent dissertation before a panel of imaginary senior faculty. Try this one, quoted by Mark Singer

in *The New Yorker*, in which he revealed an unexpected mystical-slash-spiritual bent: "We are all literally part of the mind of God and that our sense of ourselves as separate is an illusion. And therefore when we communicate with each other as a function of an exchange of energy, we understand not because of the inherent content of the words but because of how that energy flows." As Tim Olyphant, who plays *Deadwood*'s Sheriff Seth Bullock, once put it, "Quite honestly, I don't think I understand 50 percent of the stuff he's saying. But when he's done talking I think we might win a Nobel Prize." Strauss called him "David Genius."

On the other hand, it seems that not only was he given to bipolar episodes, he fell prey to enough addictions—alcohol, heroin, and gambling—to have earned him a fellowship to a twelve-step program of his choice. In a moment of lucidity, he once spoke of himself as "impersonating a human being." (Unfortunately, he is now stricken with Alzheimer's.)

During his tenure at *Hill Street Blues* and *NYPD Blue*, it seemed like he spent more time in Vegas gambling than he did in the writers' room. He was prone to infantile antics. He recalls, "At least one time I pissed in someone's pencil cup. If Steven [Bochco] drove me home, there was also a good chance I was going to stick my bare ass out of the car." Bochco was forgiving, because, Milch recalls, "He would never expect me to act with . . . integrity, that it would be like being mad at someone for the color of their eyes." Robin Green, who once worked for him on a short-lived ABC show called *Capital News*, recalled, "The guys at the network loved his line of bullshit. The bottom drawer of the desk was full of money. He pissed in the potted plant in the corner of his office. There wasn't anything offensive about it. He wasn't mean. But he wasn't fun. David Chase was fun."

In 2002, Milch pitched Albrecht and Strauss a cop show set in ancient Rome at a time when it was becoming Christianized. Hearing the word "Rome," Albrecht stopped him. "That's terrific, but we got one," he said, referring to an upcoming HBO series. Albrecht wondered whether the setting could be moved closer to home. The destruction of the Twin Towers on September 11, 2001, was still

fresh, and he felt the audience needed comfort food, so it might be time to revive the Western. Little did Albrecht know that turning to Milch for comfort food was like asking Dostoevsky for comedy.

Without missing a beat, Milch said, "Don't go anywhere, I got even a better idea." As he recalls, "I made up essentially the same show, except set in the Dakota Territory, and instead of it being about the cross, it was about gold." Rather than the Christianization of the Roman Empire, in other words, it would be about the gilding, read "civilizing," of the historic Deadwood. He further explained, "It's a Western in the same sense that *NYPD Blue* was a police drama." In his Television Academy Foundation interview, Milch explained, "Any show that is ambitious, is meant to transcend itself. Transcend its own conventions . . . there's always the feeling that something else and more is going on."

Just as Chase and Simon deglamorized the mob and the police, respectively, Milch would deglamorize America's march to the Pacific. Milch had given the perfect answer: Chase and Ball's "subtext," the holy grail of the cable revolution. Moreover, although *Deadwood* is miles removed from personal shows like *The Sopranos* and *Six Feet Under*, in many ways it was just as close to home. His forebears would have been comfortable in Deadwood. Milch's dad, a doctor, removed bullets from his gangster patients and introduced his son to booze, pain-killers, and, above all, the track at the tender age of five, turning him into "a degenerate gambler"—his father's words.

Deadwood turned into one of the best shows of HBO's golden age. Milch claims that Albrecht was scared to death of it. As Tom Fontana puts it, "Success breeds fear as much as failure does. And that's what happened at HBO. They became afraid that they weren't going to find the next *Sopranos*." Be that as it may, Albrecht greenlit the pilot and, as was his wont, left Milch alone. Milch felt, "I am very lucky that I have had any kind of employment at all—if they ever knew what's going on in my head, not only would I be unemployed, I would be institutionalized."

The series might have been based on a real town, but it was no ordinary town. Deadwood was an imperfectly civilized sprawl of

shacks and broken-down buildings that housed the prospectors and adjacent riff-raff who joined the fabled Black Hills gold rush of 1876. Its reputation for lawlessness was earned honestly. Illegal from the start, it was settled by squatters on land that had been granted to the Lakota people. Explains Milch, it was a "criminal enterprise, and it acknowledged itself as a criminal enterprise." There was at least one murder every day. There were two hundred men for every woman, hence bars and brothels were its Starbucks, one on every corner. At its height, Deadwood's five thousand souls included a who's who of western legends like Calamity Jane, Wyatt Earp, and Wild Bill Hickok, who had the bad luck to meet his maker there.

Deadwood's Deadwood is little more than a vast pigsty, where humans rut in the muck of their own making, a redolent soup of vomit, blood, piss, shit, and putrefying flesh. Its main products are gold and corpses, the latter conveniently disposed of by feeding them to ravenous pigs that carry a symbolic burden. The town is a Petri dish for disease and a magnet for every bottom feeder west of the Mississippi—and some from east of it as well. Traditional authority figures are either absent or compromised. There is no minister or place of worship, while the doctor is sick, racked by a tubercular cough, and the sheriff is an on-again, off-again lawman, mostly off-again. The closest Deadwood gets to a real authority figure is Al Swearengen, memorably played by Ian McShane. Swearengen is a killer and whoremonger by inclination and occupation, of whom someone says, "When he's not lying, he's the most honorable man I know." He runs the opium trade out of his establishment, the Gem Saloon, a full-service purveyor of booze and women.

To Milch, civilizing the frontier meant "how people improvised the structures of a society when there was no law to guide them." That was, after all, the core preoccupation of the genre, the best example of which, perhaps, is John Ford's *The Man Who Shot Liberty Valance*. The show's language was essentially the vernacular of the gutter marginally elevated by iambic pentameter, lending it a Shakespearean inflection. While, as Milch puts it, his sentences were "so soaked with obscenity as to bleach out the expectation that civility

could be expected," on the other hand, in lawless Deadwood, language itself became an instrument of civilization. "I wanted to show," Milch continues, "that people come to govern their own behavior as much through language as through law."

The scripts virtually rained expletives. Counting the number of times "fuck" was uttered became a parlor game, but it was a thankless task. The answer? An estimated 2,980 times over the course of three seasons, occurring at the rate of 1.73 times per minute. The profanity might have seemed spontaneous or improvised, but it wasn't. It was all on the page. "Put one fuck in the wrong place, and you're fucked," as McShane liked to put it.

Milch shot the pilot in October 2002. Production of the series proper began in August of the following year. Getting McShane on board was not easy. He lived in England and had never heard of Milch, but he was seduced by the profane poetry of the script. Olyphant recalls, "You would read something and just crack up because [of] how far it pushed the boundaries of what you thought was OK to do on television." Example: In one scene, Swearengen spends several graphic, jaw-dropping moments trying to get an adequate blow job, complaining bitterly to no one in particular that the "stupid fucking mutt . . . who sucks my prick" has changed her "entire fucking mouth pattern . . . Her technique's fucking awry," finally accusing her of altering "the level of your suction."

"Maybe if I got on my knees?"

"You're the cocksucker, change the fucking angle."

Paula Malcomson plays Trixie, Swearengen's favorite hooker. They proved to be a good team. "The first time I saw Ian giving a speech," she says, "I just thought, 'Oh my God . . . this is the bar.'" In one scene, Trixie gets roughed up by a customer and shoots him. McShane recalls, "I take her up to my room and I say, 'You can't do this, much as they abuse you.' We're rehearsing, and we're trying to figure out, 'What's Swearengen going to do to her?' Is he going to beat her up? He's a pimp, after all. David, who was watching, said out of the blue, 'You know Ian? I think you got to grab her cunt.' And Paula, who is game, said, 'Absolutely. Absolutely.'

"Of course, you couldn't say that now. They'd have an internal investigation. An intimacy expert would be hired. They'd ask, 'Did anybody get offended by that?' You'd say, 'Fuck no, man.' That sort of set the template for the entire show, that you could actually do anything, be anything, say anything, and you backed each other up."

In another outré scene, Trixie aims to exact a pound of flesh from George Hearst, father of William Randolph Hearst, who tries to borrow, buy, or steal all the gold strikes in and around Deadwood, and whose men have killed Trixie's friend. Gun in hand, she strides down the street, shirt boldly unbuttoned, bare breasts swaying in the breeze. It's a nervy scene for an actress to do, and today it plays into the red pill backlash against feminism evident in HBO's *The Idol*, but then it felt like taboo-busting, and Malcomson recalls, "Maybe some other actors might have said, 'Well, do I have to bare my breasts? Is that necessary?' But I thought, Trust the writing. And give it a whirl, to see if it works as opposed to sitting, going, 'Well, should I or shouldn't I?' You have to pull up your skirt and jump off whatever cliff you're being asked to jump off. You couldn't half-ass it with David. You had to really go for it. I feel like he made an actress out of me."

If Swearengen wasn't getting his urethra drilled to expel stones in his bladder, his finger was being chopped off. The scripts are chock full of casual violence, as well as racist, sexist, homophobic, anti-Semitic, anti-Asian slurs that, as McShane again observes, you could never get away with today. "Hair-curling" doesn't do them justice. "I won't fuck Chinese," says one local lowlife. "You can't deny it is off-puttin' how those Chinese girls' quiffers don't run quite plumb . . ." One character says to another, "You talk like you take it up the ass." A favorite epithet is "cunt-licker." The torrent of profanity was the verbal music that accompanied scenes of pain, savagery, and humor.

And of course, there was that arc, that allows cable characters to evolve season after season. One of the many reasons Swearengen was such a great role is that he is a complex character who changes. As McShane puts it, "You couldn't keep killing people and feeding them to the pigs. Civilization was going to come. Power and money

were going to win in the end, especially in a capitalist society. When Hearst came to town, Swearengen couldn't fight him. So he had to create his own victories within that system until the system could be changed, and that's what Milch was writing towards."

According to Logan Roy—oops, that's Brian Cox, who plays Jack Langrishe, an impresario, actor, and manager of a traveling theatrical troupe that enters the show in the third season, and was supposed to be integral to the fourth season, which never happened, "The thing about Al is, he starts off as someone who doesn't give a fuck for anybody. Then he begins to get this sense of Deadwood as being an entity in itself and being something quite extraordinary." And finally, Milch, "So even against his will, he comes to be a builder, and however grudgingly, he winds up holding meetings in his bar as they vote on creating civic institutions." Swearengen was another good-bad guy, like Tony Soprano or Stringer Bell.

The gold rush in the Dakota Territory provides a good metaphor for the streaming wars, although today's prospectors go by names like Netflix, Disney+, Max, and Amazon Prime Video, et al.

In 1995, while Albrecht was venturing into uncharted territory with HBO's scabrous series *Oz*, a rail-thin young man named Reed Hastings embarrassed himself by appearing in a photo on the front page of *USA Today* jauntily posed next to a flaming red Porsche—his own—having just sold his start-up, Pure Software, for $750 million. He was "venture capitalist catnip," according to Marc Randolph, who had a number of start-ups under his own belt and later partnered with Hastings. "He'd made a lot of people rich."

Hastings was born in Boston in 1960 to a well-connected and distinguished family of scientists and philanthropists. In 1985, he entered Stanford's storied Computer Science Department. "I really loved software," Hastings confessed. "I never loved anything so much," but "the big thing Stanford did for me was turn me on to the entrepreneurial model . . ." In other words, how to turn software into money.

According to Netflix co-founder Randolph, in his memoir, *That Will Never Work*, Hastings has the mind of a "supercomputer," and a way of brushing aside the ideas of his associates for being "totally unsupported by reason." The downside of having a mind like a computer is that he sometimes behaved like one as well. Gina Keating, a staff writer for Reuters and UPI, in her book, *Netflixed*, writes that some ex-Netflixers have described him as "unencumbered by emotion," and that he has an emotional IQ of zero. Maureen Dowd compared Hastings to Ayn Rand in *The New York Times*.

At the time, everyone knew that e-commerce was the next big thing. Randolph says that he and Hastings decided they wanted to create "the Amazon.com of something," they just didn't know what. Gourmet dog food? Personalized shampoo? Something. As fast as Randolph spritzed ideas, Hastings shot them down. Until he said, "Videotapes," and Hastings responded, "Maybe." Hastings and Randolph imagined a start-up boasting of two innovations that they hoped would give it an edge: DVDs, still a novelty, that were much easier to handle than bulky VHS cassettes; and the internet, which Netflix's customers could use to order their favorite movies from the comfort of their homes instead of negotiating traffic to reach the nearest brick-and-mortar video store.

Hastings initially financed the start-up himself, to the tune of $2 million, for which he received 70 percent of the shares. The infant dot-com giant was affectionately known as "Kibble," like the dog food—a placeholder. "Net" made sense, since customers would order their DVDs on the internet, but "flix" reminded everyone of "skin flicks." In the absence of an alternative, however, "Netflix" it became.

Every day, Hastings and Randolph made the half-hour drive together from Santa Cruz, where they lived, up Route 17 to Los Gatos, where Netflix set up shop in 1999. They had no idea how much traffic their maiden effort would attract. It turned out that there would be a lot—so much that fifteen minutes in, the servers crashed and the printers jammed, but at least they were up and running.

That same year, Hastings met Ted Sarandos, one of five children who grew up in Phoenix, Arizona. Sarandos dropped out of Arizona

State University in 1983 to sit behind the counter at Arizona Video Cassettes West. By the time Hastings met him, he was in charge of sales for one of the largest video distributors in the United States.

Despite their vastly different backgrounds, the two men hit it off. Among other things, both were liberal Democrats. In the year 2000, Hastings hired Sarandos with the title of chief content officer, thereby creating an improbable odd-couple marriage between Silicon Valley and sort-of Hollywood.

Right from the get-go, Netflix's computers vacuumed up data from the customers: where they lived, how many DVDs they ordered and how often, what titles, on which side they parted their hair if at all, and so on. The algorithm was able to predict which films users would enjoy based on their ratings of DVDs they had already rented. Heavy users were known as "pigs," light users as "birds." As Randolph put it, "Our hard drive knows almost everything." Everything, that is, except how to make money. Business might have boomed right out of the gate, but so did costs. They were losing money on every transaction. Hastings took one look at the numbers and told Randolph they didn't make sense. "It's like a taxi," he said, "driving all the way to another state just to pick up a four-dollar fare."

The two men were watching the riches-to-richer success story they'd dreamed about turn into an obituary. In September 1998, Hastings served Randolph a "shit sandwich." As Randolph recalled, his friend and partner began with a thick slice of twelve-grain praise, and then slipped in the shit by telling him that he had lost faith in his judgment. Hastings opened his laptop to reveal a screen on which his friend's performance was reduced to a list of pluses and minuses, with the latter more numerous than the former. Randolph was furious. "What the fuck, Reed," he exclaimed. "You're concerned about where we're going, and you're going to lay it out for me in fucking PowerPoint? This is bullshit. There is no way I'm sitting here while you pitch me on why I suck."

Up to that point, Hastings had been more of an absentee investor than a day-to-day presence. Randolph was the CEO, the man on the ground running the operation, and in his head he thought of himself

as the founder. Now Hastings was suggesting that he would replace Randolph as CEO, with Randolph demoted to president.

Hastings substituted the pay-per-DVD plan Netflix was using with a monthly subscription fee that entitled members to keep the DVDs as long as they wanted. By the year 2000, Netflix was shipping more than 800,000 discs a week to 300,000 subscribers. No sooner had Netflix begun to thrive, however, than the dot-com bubble burst.

A year and a half after the launch date, Netflix was again hemorrhaging money, to the tune of $45 million a year. They hadn't yet made it onto fuckedcompany.com, the site known as the "deadpool" of dot-com corpses, but they were entering its gravitational field. The big internet companies like Microsoft viewed Netflix as no more than a gnat buzzing about their ears. It was a content company hostage to the US Postal Service.

Randolph recalls trying to partner with or sell Netflix to Amazon, which at the time had an office filled with desks made of old doors sitting on sawhorses in a second-floor walk-up located in a seedy Seattle neighborhood squeezed between pawn and porn shops. Jeff Bezos, with a domed forehead and a too small body lost in a too large shirt, made Randolph think of a "turtle," but it was a turtle who lowballed them, while Blockbuster just laughed them out of its offices.

Netflix's empathy-challenged CEO cut the staff by nearly half, and then managed to halve that number again, which enabled it to reach its goal of one million subscribers by December 2001. The company went public in May 2002. The target was $70 million; Hastings raised $80 million. That same year, for the first time, it would break even. Netflix was back in business.

Meanwhile, Milch was busy spending HBO's money and trying to turn *Deadwood* into a hit. He had a bad back, and his preferred method of creation, says one colleague, was to "lie on the floor, [where] he's got writers writing down everything he dictates. It's all stream of consciousness, and it's very bizarre."

The *Deadwood* writers' room was at Gene Autry's Melody Ranch in Santa Clarita. "I can't stress enough the importance of being in one place, the ranch," says Malcomson. "It was really liberating for that kind of writing. Anything could change at any time because all our sets were available." Local cowboys tutored the cast on riding horses and other skills, like cursing. Robin Weigert, who plays Calamity Jane, recalls, "They were poetic and profane. David pulled turns of phrase from them. 'Tighter than a bull's ass in fly season,' came straight out of the mouth of one of the cowboys."

Milch loved actors and they, for the most part, loved him in return. The reason was simple: he invited them into his process. Says Malcomson, "He allowed us to have co-authorship of the show." He also wrote them the best roles they would ever have. McShane knew he would never get a better part than Swearengen, Malcomson knew she would never get a better part than Trixie. And the same goes for the rest of them. Says McShane, "David was the only showrunner I've worked with who is worthy of that name. It was a real trip every day, coming in knowing David would be there, knowing that you were also going to get maybe ten minutes of his opinions on Austrian economic theory in the thirties." Recalls Cox, "I always felt like I was about five years old when I was in his presence."

Actors are supposed to receive scripts at least a week before shooting, but awaiting inspiration, Milch claimed not to think about an episode until a few days before the camera was ready to roll. He was constantly churning out new pages, still warm from the printer, minutes before the actors had to go on camera. Some of them, like McShane, who had a photographic memory, could take the changes off the page in an hour. He explains, "Good dialogue ain't difficult to learn. It's only the crap, the flavorless expository bullshit, that's difficult to learn. This show didn't do . . . that thing where some character re-explains the entire plot for the fifth time to another character. [Besides] you were never just delivering a monologue. You were also getting a blow job or addressing a severed head in a box."

The other reason actors and crew loved Milch was that he was famous for his generosity. "Every Friday—'Good Luck Fridays'—we'd

have a raffle, and he would give away a minimum of $25,000 of his own money," McShane recalls. "Just for the crew. No actors." Milch even wrote a part for Cox's wife, Nicole Ansari, so that she could get a green card. Adds Weigert, "He's paid for people's kids' college educations or their court cases."

Money might have meant nothing to Milch, but it did mean something to HBO—a lot. The downside of Milch's gone-tomorrow, here-today improvisatory passion was that economy was never a consideration. He spent time the way he spent money—lavishly—but on a set, time *is* money. It was a habit that eventually would bite him in the ass.

Milch "was very clever about how he extended the schedule," Cox observes. "He made HBO dance to his tune. He would become obsessed by a theme, so I spent all my time at home just waiting on the call, maybe for two or three weeks—nothing. Then suddenly I was in, and he shot a lot of stuff, and then he would just throw it all away, and focus on something else." Says actor Jim Beaver, "*Deadwood* was the single greatest experience of my acting career." But, he says, "I remember seeing a call sheet one day that said, 'Day 19 out of 10.' We just shot until we got everything, which made for an expensive show, which ultimately was the cause of its demise."

Actors might have loved Milch, but directors not so much. Allen Coulter was known for his meticulous preparation and attention to detail, giving Chase those David Lynch moments he loved, the curtains flapping in a breeze coming through an open window, small but telling touches that planted wild plotting in the badly needed soil of "reality." Coulter valued his autonomy, and had an often prickly relationship with showrunners. He refused when Milch asked him to direct episodes of *Deadwood*. He explains, "David Milch was known as a lunatic who would rewrite things and show up with scraps of business written on little pieces of paper, who would direct the actors himself, and I wasn't interested in that."

If Chase was hard on directors by insisting on the integrity of the script, Milch's movable circus was tough on directors in the opposite way: often, there was no script at all. "Working with David Milch,

we never knew what he was gonna do and he never knew," recalls Adam Davidson, then a novice tasked with directing Episode 9 of Season 3. "He told me, 'All I ask is that you trust the process.' And I said, 'Of course.' I didn't know that that process meant when he wakes up in the morning, he doesn't know what he's gonna write that day. The very first day of shooting I had no script." He was given a page that said, "Title page," but there was no title. He turned to "Page 14, Scene 32," but there was nothing there. "I had no idea what Scene 32 was," he recalls.

Eventually, he got some more pages, and when he looked at the title page, he discovered that he was shooting "Amateur Night," which featured Cox and his traveling thespians. Davidson somehow improvised his way through it. Addressing Milch, he said, "David, I understand there aren't gonna be any pages. I'm fine with that. I just want to know what's the feeling you want behind the scene." Shouting, "Everybody stop what you're doing. Come over here," Milch brought the production to a halt, and proceeded to regale the cast and crew with a lengthy story about Theodora, the fifth-century beauty and former actress-slash-courtesan whom he referred to as the Whore of Constantinople. It was Milch unbound. The moral seemed to be the redemptive power of art, offering a glimpse into the heart of "Amateur Night," wherein the actors and crew were supposed to volunteer their assorted skills to raise money for the theater.

Milch went on: "Didn't I hear somebody can juggle?" He singled out one of the Teamster truck drivers who had a glass eye. "Let's get you in makeup and you're gonna take out your glass eye." It was thus that he cobbled together "Amateur Night." Says Cox, "I think the pages were blank because he would go, 'I want to show aspiration. I want to show the ability of people to transcend their concrete condition through self-expression,' even in lawless Deadwood where life is cheap. Rawness evolving into community. That's David, that's the artistry of David Milch. I admired Adam for just going with it."

Deadwood premiered in March 2004. The critical reaction was ecstatic. *The New York Times* called it as "addictive as *The Sopranos*."

In *The Washington Post*, Tom Shales wrote, "There are so many good actors having such good times that even at its most stubbornly twisted . . . there is something madly jubilant and robust in Milch's vision."

HBO was happy with the reviews, unhappy with the number of viewers, and unhappier still with the budgets. Beaver recalled, "Normally a 22-episode season of a [network] show will shoot from July to April. We were shooting from July to April on a 12-episode series!" Imagine how much time was eaten up entertaining cast and crew with the story of the Whore of Constantinople. Milch admitted to reshooting much of the third season. "The budget was astronomical," he said, estimated at $4.5 to $6 million per episode at a time when *The Sopranos'* budget was skyrocketing as well. Still, Milch always claimed he never got a note about cutting expenses. At the end of the shoot for Season 3, recalls McShane, "It was, 'See you next year,' whatever, but there was no next year." HBO pulled the plug.

Except to say that it was the occasion for simultaneous brain outages on the part of Albrecht and Strauss, why HBO traded its best show ever for its worst will never be satisfactorily explained except to say that it was a perfect storm of malign forces. The decision was, however, the first in a string of poor choices that would set the stage for HBO's gradual decline lasting (with the exception of a few blips like *True Blood*) until *Game of Thrones* five years later.

HBO's CEO claims the cancellation was more accidental than intentional, the result of poor communication with someone, and more or less blamed it on Milch. Albrecht was determined to produce the beyond-awful *John from Cincinnati*, another Milch show, so anxious that, according to Milch, he wanted to shoot it before embarking on a truncated Season 4 of *Deadwood*. Albrecht says he called Milch on a Friday and told him he wanted to do the fourth season, but suggested six episodes instead of thirteen, explaining that he was anxious to get to *John from Cincinnati*. But the showrunner, insulted, bridled and suggested no episodes at all, instead of six or thirteen.

Cox, quoting someone or other, attributed the demise of the series to "a Jewish pissing contest" between Milch and Albrecht. He says, "David took his ball away, said, 'Fuck it, I'm not doing it. That's it. No show.' We were all shocked, but also given David's fragility, shall we say, I wasn't surprised because he's a genuine artist working in a commercial industry and there's only so far you can push somebody like that." Looking back, Milch says, "That was one of the saddest days of my life."

Albrecht, citing *Deadwood* as his most expensive regular series, canceled the show in May 2006. It was as if HBO said, *We don't care about numbers, we want your show to make noise,* then turned around and said, *Your show makes noise, but it's not getting the numbers.* For all that HBO put quality at the top of its agenda, this was a reminder that it was in business to make money.

Were the actors ever given a reason? "Nothing," says McShane. "There was never a reason. It was like, 'Are you going to just throw the show away?' And they did." Worse, assured that there was going to be a fourth season, several of the actors—Olyphant, Malcomson, Weigert, et al.—had bought new homes, only to find the rug pulled out from under them.

Milch called everyone to give them the bad news. Weigert told him she had just written a check for a down payment on a condo. "I definitely felt out to sea without a paddle," she recalls. "There are very few times in an actor's life when they look good enough on paper to buy. What was a windfall instantly became an albatross. David's first reaction was, 'Do you want me to buy it from you?' I said, 'No, David. I'll figure it out.' That kind of generosity from him, you almost had to defend yourself against. He'd just offer you the world and God forbid you should say yes because it's way too much for anybody to give anybody."

Malcomson sums it all up: "*Deadwood* was lightning in a bottle. It all went to shit after that. But I'm okay with that. If Trixie is the highlight [of my career], I'm absolutely fine to be in that company and to have done that show."

Cutting *Deadwood* off at the knees, however, left a tangle of loose ends. Cox's plot, the arrival of the theater troupe, was meant to counterbalance the story of mining baron George Hearst, who was to consolidate his hold over Deadwood. His character, Langrishe, was a stand-in for Milch, who was supposed to illustrate the power of the artist over the power of the capitalist. If only.

As it turned out, money did play a starring role in the death of *Deadwood*. "Yes, David had an expensive process, but it wasn't about David's process," recalls Strauss. "It was more about the deal structure on it." At the time, says Greenblatt, "HBO would say, 'If you want to do it with us, we have to own it.' They were the first to do that, because they could." In this case, however, Paramount produced it and owned the international rights. "We had no back end on the show, Paramount did," Strauss continues. "It was one of those moments where a financial decision dictated the creative decision."

John from Cincinnati, on the other hand, was a wholly owned HBO show. It was written by Milch and Kem Nunn, whose novels were their own genre, "surfing noir." It was set in the underbelly of the surfing subculture of Imperial Beach, a derelict Southern California border town about five miles from Tijuana.

The eponymous John, variously a Jesus figure, an alien from outer space, or a half-wit—take your pick—has the ability to levitate himself at will, and appears to perform miracles. The script is packed with non-sequiturs and cryptic phrases. The nearly unanimous response to the show was confusion and consternation.

The eventual failure of *John* can at least be partly understood via a DVD extra showing Milch on the set vainly trying to explain a scene to a group of puzzled actors. Wearing one of his signature black T-shirts and dark glasses, he is standing in front of a motel, attempting to convey the motivation of one of the characters. Milch explains that there's "an echo of a poem by Stanley Kunitz, where the poet says, 'In times like these, the heart breaks and breaks and lives by breaking.' . . . In art, the reconstruction of experience, the reconstitution of experience does not have to be fetishized, it does not have

to be what they call spiritual materialism, it can simply be a healing." Hello? This wasn't Yale!

The pilot premiered on June 10, 2007, tacked on to the series finale of *The Sopranos*, a riddle upon a riddle. What was it about? It didn't seem to matter so long as Milch wrote it. He once explained, presumably with a straight face, ". . . if God were trying to reach out to us, and teach us something about the deepest nature of matter, he might use some drugged-out surfers." Enough said. *John* was so witless that every time Milch was interviewed, he was asked the same question: "Do you know what it's about?" In 2007, on *The Late Late Show with Craig Ferguson*, supremely self-possessed and unencumbered by embarrassment, he said, "The answer is no."

The good news was that although viewers had lost their beloved *Deadwood*, they had one more season of *The Sopranos* to look forward to, even though Mitch Burgess and Robin Green felt the show had been changing for the worse ever since Season 4, as reflected by the decline in numbers. The family element that had attracted them in the first place had lost out to the mob. "It became much more mobby with the Johnny Sack stuff," says Burgess. "Just having people shooting each other is easy. Writing family shit is hard."

Although the show was indeed leveling off, it was regularly lifted by a series of sick, kinky, or just plain nutty moments: In Season 3, Paulie paws through Adriana's underwear drawer, sniffing the crotches of her panties; Tony's sister, Janice, steals a prosthetic leg of Svetlana, one of his many mistresses; and in another scene, "Christofah" piously crosses himself as he drops Ralphie's severed head into a hole in the ground. Every time it seemed like there was no place to go, Chase and his writers found one.

Still, as the seasons rolled on, and the money continued to flow, production became harder, not easier. "As David became more secure, his temper tantrums got worse," says Green. "He demonized people. The objects of his hatred would change—the wardrobe person, the casting director, his secretary. And then he would

go back on his Prozac." Or, to put it more bluntly, says Burgess, "The more he got successful, the bigger asshole he became." Adds Coulter, "Once he was anointed a genius, instead of feeling, 'OK, I can relax,' his anxiety ballooned. 'How do I follow on the heels of this massive success? How do I be brilliant again?'" He also became more remote, coming to the set less often and delivering his edits by satellite from the chateau in the Dordogne that he had purchased. As *French Connection* director Billy Friedkin once observed, extraordinary success renders directors isolated and out of touch. "The day you take your first tennis lesson, your career is over," he said. "I don't play tennis," says Chase. There is a lot of golf in the show, but "He doesn't play golf," observes Larry Konner. "He doesn't play anything. He's not a happy-go-lucky guy. He wasn't a happy-go-lucky guy before, and he's not now. He's a troubled guy." Adds Little Steven Van Zandt, "He's not moody—he's always in a bad mood. Is getting a house in the middle of nowhere, in southern France, enjoying success? You tell me." Talk about anhedonia. Woody Allen had nothing on Chase.

As time went on, Chase seemed to experience the show less as a triumph and more of a burden, and it showed in his relationships with his collaborators. "We are all considered the enemies of the script," says Coulter. Chase would hover over his shoulder, watching his every move. He continues, "But you can't direct if you've got someone standing over you second-guessing you. Especially someone who is not a very good director. As a writer, David is blessed with a profound gift, but that's a different business. As he himself says, he's not really comfortable with the tools a director has to have—where to put the camera, how to use lenses or manage transitions between scenes or use shots to tell the story." Coulter carefully designed transitions between shots, and Chase would cut them.

For all Chase's talk about wanting episodes to look like movies (he had a photo of Fellini hung over the whiteboard in the writers' room), he was primarily interested in the story. Rumor was that he would cut with his eyes shut in sync with the actors' dialogue. "I would think, *Go fuck yourself*," Coulter continues. *"Hire somebody*

else or do it yourself. Give me my money, and I'll happily walk away. But he did apologize, which was very rare for David. He said, 'I know I was up your ass, but I couldn't help it, I was worried about the show.'" Coulter stayed, and remains one of Chase's staunchest admirers, saying, "He created one of the most important shows that's been on TV, ever."

For HBO, *The Sopranos* had become what *Pulp Fiction* had been for Miramax, a magnet for talent. Says Bewkes, "It was so respected by the creative community, that all kinds of people—writers, directors and actors—who previously had said, 'I only want to work in feature films,' wanted to work at HBO. We now had Tom Hanks and Steven Spielberg making the $129 million *Band of Brothers*, and coming back to make *John Adams*." The explosion of DVD sales demonstrated that series like *Sex and the City*, *The Sopranos*, and especially *Band of Brothers*, regarded as no more than subscriber bait, could be profit centers in themselves. Adds Albrecht, *"The Sopranos* was the hammer that broke the glass ceiling for us."

The only problems were good problems—those caused by success. Chase found himself in the catbird's seat, hence his posture toward HBO, which was essentially, *My way or the highway.* He borrowed a leaf from Gandolfini's playbook: if Albrecht tried to rein him in, he threatened to walk.

Although Albrecht wanted another season, Chase was getting restless. He worried about overstaying his welcome. "There's a point at which creative fatigue sets in," he explains. "There was something about the particular nature of the characters in the show that was limiting." He continues, "Not a lot happens to them every day. Mostly they socialize and collect envelopes. They were fairly provincial. Aside maybe rising up within the organization, from soldier to captain, from captain to boss, the male characters weren't really trying to achieve anything. Except to stay alive, and keep earning. They didn't solve a crime every week or perform an operation. And so it was hard to take them to new places without just repeating yourself." Still, he adds, "I had this great situation. Sometimes I began to think of it as the family business, my own farm, so why leave it? I was growing good tomatoes."

According to Burgess, when Matthew Weiner joined up, it changed the chemistry in the writers' room. "David stoked the tension between Robin and Matt competing for his affection—who was going to love him the most," he says. "It was pretty fucked-up." Paraphrasing a quip by Uncle Junior, Green says, "Matt was so far up David's asshole that he could taste the tooth decay," explaining that Chase was famously afraid of the dentist, and "his teeth were rotting in his head." Whereas Green was more than ready to argue with Chase, Weiner rarely contradicted him. "He was initially extremely quiet and deferential," Winter recalls. As Weiner himself put it, "I'd be like, You don't like that? OK. Well, I've got something else. No? I've got something else. Did you actually say 'Fuck you!' to me? Okay, you don't mean it."

Weiner was thrilled to be hired but unhappy to be there. He felt that he was no more than a pencil in his boss's hand, and didn't like it. He complained that Chase "would say 'No' to me about 300 times a day. And he, as far as I know, never took one of my ideas." Says Burgess, "He didn't take his ideas because Matt didn't really have any ideas."

True or false, Weiner nevertheless longed for his own show. He submitted his *Mad Men* script to HBO five times with Chase's imprimatur, but he complained that Strauss, who read it, didn't even have the courtesy to respond. Needless to say, he was angry.

The effort to answer the question of why Strauss passed on *Mad Men* became a cottage industry. The theories run from Weiner's personality—he could be very funny, but he also had a reputation for being abrasive and disputatious—to the fact that Weiner's future wife was Strauss's roommate at Harvard, and Strauss always dismissed him as a loser. Besides, Weiner's script was conspicuously lacking in those *Holy shit* and *What the fuck* moments with which Fontana, Chase, and Milch had so spoiled HBO. Instead, the script was talky and slow, and worse, it had knocked around for a while. HBO was too full of itself to pick through leftovers. Nor, finally, did Albrecht want to deprive Chase of one of his flavor-of-the-week writers while he was still going strong on *The Sopranos*.

In the course of the fifth season, in 2004, Albrecht had told Chase that he needed to begin to think about wrapping it up. As the cast of *The Sopranos* got bigger and the story lines more convoluted, the show became more and more expensive to produce. Eight-day shoots became twelve-day shoots, with some episodes reportedly taking nearly a month. The cost reached an estimated $10-plus million a pop, with Chase and Gandolfini pulling down eight-digit salaries, while the audience numbers were dwindling. But HBO was not about to clip the wings of its golden goose. Had Chase proposed to take the cast to the moon, HBO would have gone, "Well, those three-stage rockets are expensive, but I guess we can swing it."

After the season was over, Chase was exhausted. He said he didn't know if he had it in him to go on. Chase convened a meeting of the writers to sound them out. "We loved the show," says Green, not to mention that shutting it down was like "seeing a bag with a million dollars in it flying away from you. We'd have been idiots to get off that train." Chase decided to do one more season, a sixth, but one more turned into two parts of twelve and nine episodes each. Adds Green, "If I had had any integrity, I should have left. Instead, we made a deal with the devil."

Ever since Season 4, Green's relationship with Chase had been tense. She felt it got worse after Weiner arrived, turning into a boys' club, a lovefest between the two of them, and she couldn't stand it. She came to feel that Chase was shooting "hate-rays" at her. After the first half of Season 6, Chase fired her. She had been with the show from ground zero. In almost the same words he used when he fired Todd Kessler, Green says he told her, "We never got the voice of the mobsters." Says Kessler, "After six seasons of working on a show, you've lost it, that's absurd."

Green thought Chase's excuse was no more than a pretext. "'Cause really," she says, "he told me that he had a list of things that he'd hated about me for seventeen years. As a person. Like I'd be eating and if I had a fleck of food on my face, he'd point it out. I started to think I repelled him physically." She had noticed that in the writers' room he moved her chair so that he didn't have to look at her. "He didn't want

to straighten things out with me—he wanted to kill me. I was dead to him. He would give me the silent treatment. His father was the same way, a grudge-holding prick. When David fired me, he smiled. I loved him so much. I loved him for so long, it was just so hard to deal with the fact that he really hated me." She had seen it coming, but when it did finally come, she was devastated. Her face crumbled. She didn't want him to see her, and turned her back to him until he left the room.

One has to wonder whether firing Green, the only woman in the writers' room, was somehow related to Chase's widely publicized ambivalence toward women, most infamously expressed by Tony's aborted attempt to smother his mother.

Approximately 18 million of HBO's 29 million subscribers watched the final episode of *The Sopranos*, an unprecedented audience for cable, but many walked away dissatisfied because it was ambiguous and open-ended. Nobody who paid attention to what Chase was all about, however, should have been surprised. He had always refused to spoon-feed his audience. His anti-network instincts dictated restraint. He disliked the contrived drama of broadcast TV, the big climaxes, the dramatic go-to-commercial cliff-hangers, the overexplicitness lest viewers experience a moment of confusion. Network shows used music and camera movement to lead their lowest-common-denominator viewers by the nose, telling them who they should be listening to and what they should be looking at.

"I didn't want to punctuate what was important in the scene and what wasn't," he explained. "I hated that." According to Van Zandt, Chase was so anti-network that he hated anything he considered pretty. Everything was understated, from the cinematography, to the makeup, to the lighting. If the nets pursued closure like the holy grail—those huggable moments—he scattered loose ends galore, like the "Pine Barrens" episode, where the Russian gangster disappears in the woods. Fans wondered what happened to him and wanted Chase to resolve the issue, but he never did. Dr. Melfi never tells Tony who raped her, and consequently Tony never avenges her.

Chase didn't want to reward Tony because, as he always tried to show those of his audience who wanted more whackage, crime is wrong. He was always shocked by viewers' bottomless appetite for murder and mayhem. On the other hand, now he was also shocked by their insistence upon punishment. "They wanted to see him go face-down in linguini, you know?" he says, speaking of Tony. "And I just thought, 'God, you watched this guy for seven years and I know he's a criminal. But don't tell me you don't love him in some way, don't tell me you're not on his side in some way. And now you want to see him killed? You want justice done? *You're* a criminal after watching this shit for seven years.'"

Despite the title of the first post-*Sopranos* feature Chase directed, *Not Fade Away*, Tony Soprano did just that—faded away. Closure re-solves the narrative, makes viewers feel comfortable. Echoing Alan Ball, Winter observes, "We didn't want to make you feel okay."

The audience furor over the enigmatic ending annoyed Chase. He felt that the critics turned on him like a pack of wolves because Hollywood taught its audience to demand closure on everything, no matter how minor, leaving no place for mystery. Shunning closure, leaving loose ends, and refusing to wrap up seasons with the big red bows that Strauss discouraged in Ball is a kind of closure in itself, Chase's kind of closure.

By 2007, when it was all over, Albrecht recalls, "People went, 'What's next? Where's the next *Sopranos*?'" Answering his own question, he says, "There was no next *Sopranos*." Indeed, there wasn't. The show was sui generis. There would never be another show like it. When asked about his legacy, Chase said *The Sopranos* has no legacy. Perhaps he was defaulting to his curdled view of life, but we're familiar enough with him to know there's a robust ego lurking behind his façade of modesty, and so many gifted showrunners who followed in his wake have tipped their hats to him that we know that's nonsense. All roads lead back to David Chase.

HBO'S ANNUS HORRIBILIS

With no more *Sopranos* nor *Deadwood,* Albrecht
was busted for attempting to throttle his fiancée.
The party was over—until *The Song of Ice and Fire*
knocked on the door.

Under cloudy skies early on a cool Sunday morning—cool at least by
Las Vegas standards—Chris Albrecht, fifty-four, then chairman and
CEO of HBO, architect of its golden age, and at the time arguably the
most influential figure in television—network or cable—was arrested
at 3:00 a.m. in the valet parking area of the MGM Grand Hotel for
assaulting his fiancée, thirty-seven-year-old Karla Jensen, a corre-
spondent for HBO and Telemundo.

It was May 5, 2007. HBO had just aired the championship fight
between Floyd Mayweather Jr. and Oscar De La Hoya for the light
middleweight title. With both hands wrapped around her neck,
Albrecht was dragging Jensen across the lot when a security guard
intervened. Albrecht's grip was so tight that the guard had to pry
his fingers away, leaving a necklace of angry red welts around her
throat. Reportedly, Albrecht reeked of booze and was having trouble
standing up. Slurring his words, he explained that Jensen "had
pissed [him] off."

According to the Las Vegas Metropolitan Police Department, an
officer placed him in a "submission hold," forcing him to the ground.
Albrecht was charged with domestic assault and battery, apparently

no more than a misdemeanor in Nevada. Despite Jensen's refusal to press charges, Albrecht spent twelve hours at the Clark County Detention Center, after which he agreed to undergo domestic abuse counseling, was fined $1,000, and sent back to New York. A slap, in other words, on the wrist. For his company, however, it was a catastrophe.

Initially, Albrecht claimed he was not drunk, but thinking clearly. "The idea came up that I would say that I had been drinking and was drunk and fell off the wagon," he explained later. The idea seemed to be that a "heroic struggle against alcohol addiction" narrative would make him more sympathetic, transform him from a victimizer into a victim—of alcohol abuse. Albrecht later explained, "Jeff [Bewkes] said to me that it would soften everything and would help him to keep me."

Albrecht had indeed joined AA but had started drinking again around 2002, the same year he got divorced from his wife Annie and was upped to CEO. According to *Adweek*, HBO colleagues confirmed that drinking was an issue, and compared him to a "ticking time bomb." Nevertheless, Albrecht continued, "It didn't occur to me that I would lose my job."

Albrecht tried to hang on, but *The Los Angeles Times* disclosed that a similar incident had occurred in 1991 when he allegedly assaulted a woman in his division, someone with whom he had been having an extramarital affair. In 2022, a new book on HBO by Felix Gillette and John Koblin resurrected this story with some new details. According to this account, attributed to an anonymous source, "In an apparent fit of jealous rage, Albrecht had attacked [her], charging at her from across the room, grabbing her by the neck, knocking over her executive chair, and strangling her down to the floor. Before she could lose consciousness, he let go."

Albrecht denied the entire incident, but by the time it resurfaced, he was president of Legendary Television, which put him on leave, which became permanent. Albrecht's lawyer denounced the accounts, calling them "false, inflammatory and destructive depictions of Mr. Albrecht based upon fictionalized accounts."

Back in 1991, the press alleged that two, perhaps three similar episodes had occurred with other women. "He couldn't keep it in his pants," says a source at HBO. "It was like an addiction for him." The staff used to joke that the reason Albrecht and Carolyn Strauss made such an effective team was because she was gay.

Says Fuchs, "He was protected by the boys' network. You know how easy it is to destroy an actress's career like Harvey did with Mira Sorvino? You just tell the studio head, 'I got to tell you. This is the most difficult woman I've ever worked with. I mean, she's a terrific actress, but I wouldn't work with her again in a hundred years.' Boom, it's done."

The Jensen assault, however, was too public to stay in Vegas, and eventually the collateral damage threatened Bewkes himself. He was in line to succeed Richard Parsons as CEO of Time Warner, and he had a shareholders meeting coming up on May 18. Reportedly he wanted the mess behind him. He pressured Albrecht to step down for behavior unbecoming—anyone. On May 9, 2007, a year or so after Albrecht closed the Gem Saloon, he himself was deadwooded.

In 2010, Albrecht still saw himself as the victim. "Violence against anybody is wrong," he said. "I did a dumb thing in Vegas, it lasted three seconds, and the price I paid for it personally, professionally, and financially was enormous."

It's easy to understand why Bewkes was reluctant to part with Albrecht. In 2006, the year before he was ousted, HBO was swelling Time Warner coffers to the tune of $1.2 billion in profits on revenues of $3.4 billion, nothing to scoff at. And HBO still had plenty of room to grow. It had penetrated no more than a third of American homes, and its subscriber base was expanding at a rate of a million a year.

Albrecht had not only grown the bottom line, but he had made good on HBO's promise to furnish quality programming. It was *The Sopranos* for which he was best known. David Chase credits him with saving him from the "pissy little dolts and small-minded, fear-induced decision-making" network execs who were eating his soul. "I washed up on the beach of this place HBO," he goes on, "and I would have drowned if I hadn't."

Albrecht's abrupt departure could not have happened at a worse time. By 2007, HBO was staring into the post-*Sopranos* abyss. The cabler had scored with the behind-the-scenes Hollywood comedy *Entourage*, as well as *Big Love*, a charming, inventive, and well-reviewed dramedy set in polygamous Mormon country, but their numbers were nothing like those of *The Sopranos*. The premiere of the final season of *Big Love* was beaten by *Worst Cooks in America* on the Food Channel. Beyond those, other new shows failed to ignite. *Carnivale*, a depressing series set in the Depression, was slated for six seasons, but dropped after two. Ditto *Rome*. *Lucky Louis* only lasted one season, and same for the torpid *Tell Me You Love Me*. The aptly named *Bored to Death* somehow hung on for three seasons; *How to Make It in America* bombed, while *In Treatment* was a well-written but only a mildly interesting talk-a-thon largely confined to the four walls of a shrink's office. *Hung, Tremé*, and *Newsroom* all hovered in the limbo between success and failure. *True Blood* and *Boardwalk Empire* were in development, but still question marks.

HBO thought it would get a bump from Steven Spielberg and Tom Hanks's sequel to *Band of Brothers*, called *The Pacific*. Hanks in particular was hands-on. "If there was a showrunner on *Band of Brothers* and *The Pacific*, it was absolutely, one hundred percent Tom Hanks," says a source involved with the production. "He got all the scripts, he read them, he gave us notes. He hired the directors."

Kary Antholis, the executive in charge of miniseries, remembers, "The first cuts were coming in, and it was hard to make sense of what they were about, what the drama was, and who the characters were, and how it all fit together. It wasn't working." Antholis claims he figured out a way to salvage it. Still, if HBO expected it to replicate the success of *Band of Brothers*, it was going to be sorely disappointed. The costs spiraled upward to an estimated $21 million an episode for a total of $200 to $225 million, about $100 million more than its predecessor. A chunk of that price tag would have been defrayed by the DVD sales that had made *Band of Brothers* such a gold mine in 2001, but they never materialized. By 2010, when *The Pacific* premiered, DVD sales had slid 22 percent.

Then there was *John from Cincinnati*, the poison pill Albrecht had left behind. By the time the surfer and his board were scraped off the sand, the TV landscape had changed. HBO's slogan "It's not TV, It's HBO," was sounding increasingly hollow in view of the premium cabler's raft of subpremium shows. Sophisticated viewers could do a lot better with lowly basic cable networks, like FX and AMC, that were quickly recasting themselves in its image, albeit with ads.

Formerly adoring TV critics, who had licked HBO's face, started to growl. *The New York Times*' influential media columnist David Carr wrote that HBO was confronting a midlife crisis with a great deal of thickness around the middle while in the same pages, Bill Carter wondered if HBO had "finally tumbled from its pedestal of prestige." The answer was yes, and the tumble was taking its toll. It was no longer gaining subscribers at the rate to which it had become accustomed. By 2009, it had 29.3 million, only 600,000 more than it had in 2006.

Bewkes moved quickly to repair the damage, although his solution was inelegant, to say the least. He promoted a colorless, ex-military bean-counter, former COO Bill Nelson, to the top CEO slot. Beneath him, confusion reigned. There were three co-presidents, none of whom particularly liked or respected one another: Eric Kessler from the marketing side, Hal Akselrad, general counsel, and Richard Plepler from corporate communications who was rewarded with the plum programming slot. Problem solved, except for one thing: none of the top four, including Plepler, had any experience programming, while the two executives who did—Carolyn Strauss and Colin Callender— were passed over for the top jobs. Strauss was too cold, Callender too hot. His portfolio was the made-for-TV-movie division called HBO Showcase. He was another controversial character, a *monstre sacré*, as someone called him. A Brit, he was admired for his impeccable taste—his triumph was *Angels in America*—but feared and disliked for his terrible temper. The story, possibly apocryphal, was that he was thrown out of an anger management group because he was too angry.

Bewkes handed programming to Plepler despite his inexperience—he had neither a financial, a legal, nor a creative background. "Jeff didn't know the industry," says Fuchs. "You had a company that didn't have anyone at that upper level, after Chris left, that knew who to hire."

On the other hand, according to Glenn Whitehead, president of business affairs and production at HBO and HBO Max, "Richard was creative adjacent. He had been very close to Michael Fuchs. He was very, very close to Chris Albrecht. He had his nose in lots and lots of programming activities for many, many years. He had a keen understanding of how original programming in particular was critical to the HBO brand and how it could be deployed to support that brand."

Plepler was smart and preternaturally articulate, a protégé of the fabled spin doctor John Scanlon, who represented a spectrum of high-profile clients, including *60 Minutes*. Fuchs had met Plepler and Scanlon through Democratic Party circles, and hired Plepler to do PR in 1992. Smooth, unflappable, and strategic, he was the perfect counterweight to the combustible Fuchs, a master at fashioning the HBO narrative at a time when few would give it the time of day. He nurtured a coterie of New York City and Washington, DC, influencers, including the editors of *Vanity Fair*, *The New Yorker*, and *New York*, plus respected writers like Frank Rich. A political junkie, he was a member of the Council on Foreign Relations, and dined regularly at the Lambs Club, a watering hole for the who's who in theater and film. He would entertain at his Upper East Side townhouse with elaborate dinners, where the élite mixed with the élitest.

Plepler rose so quickly through the cabler's executive ranks that he collected more than his share of enemies along the way. As one source put it, "While he excelled at guarding the brand, the brand he was best at protecting was himself." And another, "Nobody enjoyed being Richard Plepler more than Richard Plepler." He basked in the limelight, the Emmys, the Globes, and so on.

Plepler seemed almost genetically engineered to extricate HBO from the perfect storm that was buffeting it, and well able to replace

Albrecht. Says yet another source, "Richard was adept at making you believe that you were in a sacred zone of closeness and friendship. It's easy to discount it or to minimize it, but whether it's a skill or an illness, awesome or sickening, it served him well." Fuchs, who originally hired Plepler, is particularly bitter. He says, "He did it to me. Richard's gimmick was, he was able to deal very well with men older than him. He became like their loyal son." Says another highly placed executive, "He became consigliere to Michael, to Chris, and then to Jeff Bewkes, never missing a beat."

By several accounts, Plepler managed upward better than he would manage downward. According to one, "When Fuchs blew himself up in his quest for the crown, Dick Parsons warned Bewkes, 'Plepler's Michael's guy. You can't trust him. You got to get rid of him.' Bewkes talked to Richard, said, 'Listen, if you want to continue with me, I can't have you maintaining your relationship with Michael.'" Plepler broke the bad news to Fuchs, telling him something like, "'I'm young in my career. I'm not getting a big payout the way you are.' Michael apparently understood."

As it turned out, Fuchs didn't understand. Eventually, the source speculates, "Michael got resentful, worried about his legacy. Because HBO was starting to do stories about Bewkes, building up Plepler and Albrecht, and Michael would think, *What about me?*" According to Fuchs, "Richard is all about Richard. He's a dog, he'll follow whoever feeds him. Richard had his head up Bewkes's ass so fast that he probably was wearing a diving bell. He should never have been a CEO."

Plepler declined to comment on Fuchs's characterization of him, and would say only, "Michael Fuchs brought me to HBO, for which I'm eternally grateful. He deserves all the credit in the world for focusing on original programming when it wasn't obvious. For that, he deserves a standing ovation."

There was even said to be such a thing as a "Plepler show," one bathed in an aura of prestige that was not crude and vulgar. But he was smart enough not to be limited by his limitations. He is said to

have disliked Danny McBride's comedies, which were all crude and vulgar, but he greenlit them anyway.

Plepler delegated programming operations that involved millions of dollars to Mike Lombardo. The head of business affairs on the West Coast, Lombardo was a lawyer and dealmaker who had good relationships with the talent agencies that sent projects his way. HBO's HR department said, "If he doesn't get this he's going to walk, taking his contacts with him, and you don't want to lose him." All the program divisions—documentaries, miniseries, sports, specials, and series, both drama and comedy—reported to him. (Lombardo declined to be quoted for attribution.)

As it turned out, the stone in HBO's shoe seemed to be Lombardo himself. First off, says HBO communications head Quentin Schaffer, "With Mike, Richard was gracious, supportive, and inclusive, and had said they were partners. Mike was under the delusion that 'partners' meant 'equals,' but Richard was the one fully in charge of running the company." Second, according to Whitehead, "Mike refused to be the head of programming operations. He insisted that he be the head of programming, period. He said, 'No, no, no, no. I want to be creative.' Making Plepler the person to whom programming would report was no mistake, but letting Mike be the head creative as opposed to head programming operations, I think in retrospect, was challenging." (Translated from HBO-speak into English, this means that *it was* a mistake.)

Lombardo was indeed a controversial figure. He seemed to want to be liked, but as someone put it, "Wanting to be a nice guy and being a nice guy are two different things." Some HBO-ers remember him as a know-it-all who didn't know it all. According to Schaffer, "Whether intentional or not, Mike operated through fear. Everyone was scared of him." And another source: "He would leave people crying. More people hated him than any other executive who has come through HBO."

Adds Whitehead, tactfully, "Mike is in many respects, an exceptional human being. But as he got elevated and got more and more power, he did not always wield that power graciously as he might

have earlier in his career. Mike intimidated many of the people that worked for him."

On the other hand, Lombardo had his fans. Says David Levine, who spent a decade at HBO starting in 2009, and became executive VP and co-head of drama in 2016, "I really loved working for Mike. He seized on fear. I never showed him any fear, and he respected me."

The net result of the executive shuffling was that Bewkes hired four people to replace one—Albrecht. As the number of executives metastasized, so did the bureaucracy. Previously, Strauss had simply reported to Albrecht, whereas now she reported to Lombardo, who reported to Plepler, who reported to Nelson. HBO was becoming an executive-heavy, network-style organization that Fuchs would never have recognized.

Reports of HBO's demise were premature, to say the least. Although Albrecht's exit was a body blow, the glass-half-fullers could point to shows incubated by Albrecht and Strauss, like *True Blood*, that would premiere the year following his exit and turn out to be the first real hit since *The Sopranos*. *True Blood* was not a "Plepler show," Ball explains, it was a genre show, and "it didn't feel like '*HBO important*.' By that time, they really liked the mantle of being important." Again, Plepler greenlit it anyway.

All but forgotten in the anxiety and bad press surrounding the black hole that threatened to swallow programming were the two nobodies who had waltzed into the HBO offices and pitched an implausible sword-and-sorcery epic to Strauss the previous March, 2006. The series, of course, was *Game of Thrones,* the very definition of a not-Plepler show.

David Benioff and Dan Weiss were novelists trying their hands at movies. Benioff had written a more than respectable thriller, *25th Hour*, which Spike Lee turned into a movie. Weiss had done little more than keep Eagles frontman Glenn Frey's bathroom stocked with toilet paper when working for him as his personal assistant. In 2006, George R. R. Martin's agent sent Benioff four volumes of *A*

Song of Ice and Fire. Fantasy had always been a déclassé genre target-ing kids and nerds. Benioff had read a lot of it when he was a boy but, he explains, "[When] I hit puberty, and realized that my *Dungeons and Dragons* game was never gonna get me laid, I just went cold tur-key on fantasy, I still didn't get laid."

Benioff groaned every time his gaze fell on the stack of Martin's books on the floor, approximately 4,200 pages' worth of sword fights, damsels in distress, and airborne, fire-breathing creatures of various shapes and sizes. He picked up the first book, *A Game of Thrones*, and was only a few hundred pages into it when, gobsmacked, he called Weiss and said, "You have got to buy this book, 'cause it's given me the most fun I've had reading anything in a long, long time." They became converts, more than converts, zealots in their devotion to the saga. They were desperate to put Martin's series on the air. When asked about their project, they described it as *"The Sopranos* meets Middle-earth."

Cut to the Palm Restaurant in Hollywood, in 2006, where the two were meeting Martin for the first time. Acutely aware that they had zero TV experience, and that Martin had turned down every single suitor who had approached him, they were more than a little nervous. As Weiss puts it, "For us, it was a once-in-a-lifetime opportunity. When you want something really, really badly, it can be terrifying to meet somebody who has the sole power to say yes or no."

Martin is a squat, elf-like man with an abundant beard, and a head of untamed but thinning white hair trapped under a trademark Greek fisherman's cap. He looks like one of his own creations. To Benioff and Weiss, and later the cast and crew of *Game of Thrones*, he became a figure of veneration.

Born in Bayonne, New Jersey, Martin was the son of a longshore-man. "We had no money, we lived in the projects, we didn't own a car," he recalls. "I lived on First Street, I went to school on Fifth Street. My world was confined to five blocks." His imagination, on the other hand, was free ranging, his lifeline. When he was a child, his teachers would catch him reading Robert Heinlein or Isaac Asimov. They grabbed the books, admonishing him: "Read a real book."

Real or not, Martin loved "reading a book and not knowing what's going to happen. And being in suspense." He explains, "When the hero is scared, I want to be scared," continuing, "A lot of this gets interfered with by the conventions of entertainment. The hero is surrounded by 150 Nazis, but if he's Harrison Ford, we know nothing really bad is going to happen to [him] . . . The moment the reader begins to believe that a character is protected by the magical cloak of authorial immunity, tension goes out the window."

For him, the game changer was Alfred Hitchcock's *Psycho*. After stopping for the night at a motel, Janet Leigh is knifed to death in the shower. Martin exclaims, "We're only twenty minutes into the movie. She can't be knifed—she's Janet Leigh! It's so powerful when it comes at you like that. I loved it. And I try to replicate that. The sense that anything can happen. If the jeopardy is real, it's much more exciting if and when they do succeed."

Martin ended up in the Hollywood trenches, where he spent ten years or so, from 1985 to 1995. By that time, he was dissatisfied with his two preoccupations, history and fantasy, the former because the readers already know how the story is going to turn out, and the latter, mostly set in the Middle Ages, because in his view they were getting it all wrong. He likes to says it was a "Disneyland middle ages," replete with castles, princes, and princesses, not to mention a class system featuring those without crowns and silk garments at the bottom. He came up with the formula that would make his work unique: "What I'd like to do is write an epic fantasy that had the imagination and the sense of wonder that you get in the best fantasy, but the gritty realism of the best historical fiction."

Needless to say, Martin was also frustrated with network TV, which, he discovered, was all about budgets. He likes to tell the story about an episode he wrote for *The Twilight Zone* featuring Sir Lancelot riding a horse into Stonehenge, which required building a costly set. He recalls, "The producer came to me and said, 'You can have horses or you can have Stonehenge, but you cannot have horses *and* Stonehenge.' I was heartbroken"—so much so that he returned to writing books, starting *A Game of Thrones* in 1991. It's

been described as "like J. R. R. Tolkien with a lot fewer elves and more sex."

The lunch dishes were cleared, but Martin was garrulous and Benioff and Weiss spellbound. After the success of Peter Jackson's *The Fellowship of the Ring*, which adapted the first of Tolkien's trilogy, Martin explains, "The studios said, 'That thing with dragons and elves is a hit, we better have something with dragons and elves.'" It had a familiar ring. They were all over him, but *The Song of Ice and Fire* was almost impossible to produce. They'd say, "We can't have these seventeen subplots and casts of thirty. We'll pick one character and get rid of everything else."

Benioff recalls, "He wanted to write a series where he could have both the horses and Stonehenge and fuck all these limitations and fuck length and everything else that they're holding you back with." Martin wanted it all—or nothing. He realized that it could only be done for television—not ABC or CBS or NBC or Fox because there was way too much sex and violence—but a cable service like HBO where sex and violence were the coin of the realm. When Benioff and Weiss proposed just that, he jumped.

Still, to this day, they remain thunderstruck by their good luck. When Martin asked for their qualifications Benioff admitted they didn't have any. "We don't know why he trusted us with his life's work." Nevertheless, with Martin's blessing in hand, the two novices brought it to HBO. They knew that convincing the cabler that had produced *The Sopranos* to go for dragons and ice zombies was extremely unlikely. Not only had HBO never done anything like this, but it was a "tweener," a mash-up of genres—neither fish nor fowl, fairy tale nor horror, fantasy nor swashbuckler—and could easily fall in the cracks between them. Then there was the stubborn fact that *Game of Thrones* was a budget buster, a period piece set in exotic locations and stuffed with funny character names that sounded alike—Tywin, Tyrion, Tyrell—made-up languages, and so on, which rendered it a challenge to follow. But they also knew "if HBO wasn't going to go for it, there was just nobody else who had the resources to do it right," explains Weiss. "Either they did it or we didn't do it at all. There was only one chance."

When Benioff ended up across the desk from the redoubtable Strauss, he had the unenviable task of persuading her to take an unserious genre seriously. He was, needless to say, petrified. They heard she was a hitman, that she wasn't going to smile at them, just stare as if they were idiots. They later described it as the scariest pitch they'd ever done.

The writers, who knew that they had little chance of being picked up, found to their surprise a passionate advocate in Strauss. She took them to Albrecht, who couldn't be bothered to read more than ten pages of the book. He sent Strauss to Plepler, in New York.

Plepler says, "It was an easy green light for us." But according to Strauss, "That was not an easy green light at all." Plepler's attitude was, *We've already got vampires,* referring to *True Blood. Now this? What are we, the Syfy service?* For starters, *Games of Thrones* was totally off-brand. Benioff reassured him that they intended to downplay the fantasy elements, both because they were expensive and because they wanted a broader audience, not just sword-and-sorcery geeks. They wanted mothers, NFL players—in other words, everyone—to watch the show. And, as they had also told Plepler, they would save money by keeping the sprawling, bank-busting battle scenes off-camera. "It's not a story with a million orcs charging across the plains," said Weiss. (They later admitted they were lying.) Weiss also felt that "with the fantasy genre on television, tonally it's very easy [to go too] campy. Every scene, you change two lines and it's *Monty Python and the Holy Grail.*"

Benioff, however, had done his homework, and played to Plepler's passions. "Knowing that I am a political junkie, he said that the show is about power," Plepler recalls. He says Benioff convinced him that "within the first fifteen minutes you'll forget where you are. You could be in fifteenth-century England or you could be in tenth-century France." Later, the two writers described the pitch meeting as "a con job." They knew they had considerable latitude in describing the project because they were confident that none of the HBO executives could possibly have read Martin's four-thousand-page opus, and therefore they had no idea what they were saying yes to.

Pitching only the pilot, the writers were vague about the rest of the series. Weiss confessed, "We knew that it was gonna turn into exactly what we promised HBO it wasn't." However they did it, it worked. Plepler was convinced. He is reputed to have thought, *Power and pussy. Who's not going to love that?* Plepler was working with a constrained $1 billion production budget when he became co-president in 2007 and only marginally more three years later when he became CEO. Nevertheless, in November 2008, Plepler gave Benioff and Weiss about $10 million to shoot their pilot. The following year, they went to work.

For seventeen years Albrecht was Strauss's powerful mentor and had given her a lot of latitude. When he left, she found herself with a target on her back. Lombardo remained her only shield. The tone of the office had been set by Mr. Hetero, as Albrecht was called by HBO's gay employees, and Lombardo and Strauss were two openly queer employees in the company. They became the closest of friends. They adopted kids at the same time. She sat with him in Cedars-Sinai in LA while his partner died of AIDS.

Strauss was loved and valued in the LA office. But in the New York office, they were just hearing the bad stuff, and Plepler is said to have begun pressuring Lombardo to get rid of her. Says Whitehead, "The firing of Carolyn Strauss who, along with Casey Bloys, was probably one of the greatest programming executives to ever walk the surface of the earth, remains an enduring mystery." It's possible that Plepler was punishing her for passing on *Mad Men*, the previous year. He was angry about it. He said, "This is the biggest mistake ever that we didn't make this show." Says Strauss, "I think that was something that bothered Richard. One of the reasons that they wanted me gone is because my development list was small. It takes a lot of time to do this stuff. It worked out much better for me to produce a few things really well than manage a huge slate of projects, which definitely is not my strong suit."

There was that other reason as well. "The feeling was that HBO had a 'Beware of Dog' sign up and now we wanted to roll out the welcome mat," says Schaffer.

The gossip reached Albrecht, who told Strauss that she was going to be fired. Strauss asked Lombardo outright if this were true. He confirmed that Nelson and Plepler said, "We think it's time for her to go." She was not the crying kind but she broke down and sobbed, stormed out of the building, and never returned. She was not officially fired, nor did she officially resign, but it became "a self-fulfilling prophecy," as one HBO-er put it. She didn't want to work at a place where she wasn't wanted, especially a place, as she puts it, "where I poured my heart and soul for a long time. It sucked." She left in 2008, a year after Albrecht was fired.

Plepler and Lombardo quickly moved to replace her with Sue Naegle, a top agent at United Talent Agency who had brought them Alan Ball's *Six Feet Under* and *True Blood*. Naegle's colleagues at the agency told her she was crazy to go to HBO, because it was still wallowing in its post-Albrecht doldrums. They warned her, "Do you want to go to work at HBO now? It's circling the drain."

Naegle ignored them and took the job as president of HBO Entertainment, responsible for comedy and drama series, each of which had its own head. Naegle knew writers, but as one executive explains, as an agent, "It's very different to sell television than it is to make it." Another notes, "Now you've got three people in the chain of command"—Plepler, Lombardo, and Naegle—"who do not have day-to-day experience in being creative executives."

Naegle and Lombardo would ironically become victims of HBO's success. Like kids in a candy store, they could get anything they wanted, and anything turned into everything. As David Nevins put it, "HBO was very focused on what was politely called star fucking." Lombardo's only compass seemed to be properties lionized by others, and therefore he was chasing Emmy, Oscar, Globe, Tony, and National Book Award winners. Says Reilly, "What people who don't have creative instincts tend to do is make shiny big deals

because they think that's the way to go." Nothing came of most of these deals.

HBO went on a buying spree, showering money on anyone who could press a key on her or his new Macbook Air. Well, not exactly anyone. It signed up Karen Russell (*Swamplandia*), Jeffrey Eugenides (*Middlesex*), and Gary Shteyngart (*The Russian Debutante's Handbook*), as well as Margaret Atwood, Jonathan Safran Foer, Dave Eggers, and Carl Hiassen. Naegle even convinced Mary Karr to turn her three memoirs into a script. She hired Noah Baumbach to direct Jonathan Franzen's National Book Award winner *The Corrections*, set to star Ewan McGregor, Dianne Wiest, and Maggie Gyllenhaal. "It was the kind of show that most people would do for two cents and we were spending what *Game of Thrones* spends," Baumbach said at the time, and "we didn't have dragons." Indeed, the list was so long that Ayelet Waldman, working with her husband Michael Chabon on *Hobgoblin*, joked that HBO was "like the Works Progress Administration for writers."

The deciding factor in all these deals might have been "schmuck insurance." When HBO signed a development deal with a writer, she or he was locked up. When you had as many of these deals as HBO had, they added up to millions of dollars a year, but if the alternative was being ambushed by an up-and-coming basic cable channel like AMC with *Mad Men*, making them look like schmucks, it was worth it.

In a not so thinly veiled criticism of Plepler and Lombardo, Naegle observes, "You can't just pick a name television creator and expect that his show is going to be a hit, especially when big feature names start to come into the television space. That's not something you understand when your background is PR or business affairs. The problem is that when you're focused on big names, you're forgetting that David Chase came from *I'll Fly Away*, or Matt Weiner started as a comedy writer, or Lena Dunham—nobody even knew who she was."

HBO gained a reputation for going through pilots like Kleenex, putting dozens of shows into development—there were reportedly 160 at one time. Lombardo insisted on sitting in on Naegle's pitch

meetings, undermining her authority. He enjoyed a reputation for saying yes. As one source put it, "He was a bully on the inside of the company, but he wanted to be liked on the outside." Says one HBO source, "I don't blame Sue for buying like a drunken sailor, because I think she knew that Mike wouldn't necessarily support her if she said no to things."

According to Mike White, of *White Lotus* fame, "They had all of these deals with all of these fancy people, and they were just notorious for never letting things go or coming to a decision. They're so much about artist relationships, but it ended up being—and I felt this—you want to keep me on the hook but you don't actually want to make my shit. Like, leave me alone. Stop calling me! This is not working. I have other places to go and do things."

Perhaps the crowning glory of Lombardo and the others' reign of error was, ironically, the one occasion when Lombardo said no. HBO rejected Taylor Sheridan's *Yellowstone*. Sheridan, a former actor and alumnus of *Sons of Anarchy* turned screenwriter (*Sicario, Hell or High Water*), recalls Lombardo telling him the only way HBO would produce it was if it were to star Robert Redford. When Sheridan got Redford to commit, Lombardo turned him down again, telling him that he said "an actor *like* Redford," possibly because Redford was too expensive for the tight-fisted cabler. Given that the show became 2022's biggest series, it would be fair to say that Lombardo was yellowstoned.

Plepler was well aware that they were signing up too many projects. "We were under tremendous pressure to deliver more and more money to an earnings-based corporation that prevented us from expanding our programming, and that was just the reality of being part of Time Warner." He continues, "I think it's fair criticism to say that we overbought in the early aughts. The intent wasn't to keep talent off the market," but rather to keep the creatives thinking HBO.

There were other reasons for it, besides corporate greed and schmuck insurance. Rupert Murdoch had already attempted a hostile takeover of Bewkes's company in 2014, and had HBO poured more money into production, it would have affected its bottom line,

knocked the stock price down, and made HBO once again a tempting takeover target.

This was also one of the reasons that as early as 2006, when executives from the West Coast office presented a plan to buy Netflix, the three blind mice Bewkes had elevated to the top—Nelson, Kessler, and Harold Akselrad—cut them off at the knees. (Only Plepler dissented.) They feared that the big MSO's like Comcast and Cox that distributed and marketed HBO, as well as the affiliates, would have, in Whitehead's words, "punished us for essentially going around them to create a business that was focused directly on consumers. And that would've cost us billions of dollars." He continues "The stock would have cratered, and Jeff did not want to make himself [yet again] bait for a hostile takeover."

Bewkes may have also been gun-shy of internet flash-in-the-pans like AOL, after the fiasco of the Time Warner–AOL merger. He liked to say that AOL was worth almost three-quarters of a billion dollars one minute, and the next minute, nothing.

Like almost every other executive, Bewkes walked the walk dictated by conservative economist Milton Friedman, who convinced corporate America that its sole purpose was to deliver profits to shareholders measured by the value of its stock every quarter. Poor quarterly earnings calls to Wall Street became the financial equivalent of DEFCON 1. HBO, in other words, was at the mercy of the Street.

Friedman's gospel discouraged the kind of long-term thinking that might have encouraged HBO to buy Netflix when it had the opportunity. Or, as Fuchs puts it, more colorfully, Bewkes "would say that he wanted to produce shareholder value. If I hear one more time that shareholder value means more than anything else, I'll go to Chicago and piss on Milton Friedman's grave because that fucking sentence has destroyed American capitalism."

Still, it wasn't all Friedman. There was more than a little arrogance involved. Says one agent, it was, "We're HBO. They're the minor leagues." Bewkes was, after all, the man who in 2010, referring to Netflix, famously quipped, "It's a little bit like—'Is the Albanian army going to take over the world?'" concluding, "I don't think so."

Hastings, of course, treated Bewkes's barb as a badge of honor. During one retreat, cocky Netflix executives wore Albanian army berets, Hastings recalled. "For the next year, I wore an Albanian Army dog tag around my neck." The crowning irony, however, was that years later, Hastings asked a former HBO-er how much it would have been prepared to pay to buy Netflix. The answer was $2 billion. Hastings said he would have accepted.

Every once in a while Naegle tried to put on the brakes. Recalls drama head Levine, "They would stop for a week and then something great would come in and they'd say, 'We have to buy that.' They couldn't help themselves. Michael spent way too much money on way too many things."

One hit that did make it on the air that Naegle developed was Lena Dunham's *Girls*, produced with Jenni Konner. Given the male-centric shows of HBO's golden age, it was like throwing open a window and letting in a cool breeze. Dunham was just twenty-three at the time. Says Naegle, "It was just difficult to get shows made with female creators. When I came into television there were no women running shows without a male counterpart, period. I was committed to the idea that there was nothing about television writing or producing that precluded an all-female team."

Girls was one of the first, if only, shows made solely by female producers. Initially, there was some skepticism on the part of the cabler. "Lena was quite young and there was a feeling that people who were the age of the characters didn't even get HBO, because they couldn't afford it," Naegle recalls. "But I knew that older women would love the show, and she had a proof of concept in [Dunham's feature] *Tiny Furniture*, which was very much her voice and made on a shoestring."

Comparing it to *Sex and the City*, which had been criticized for objectifying women and featuring characters who had to be "the right kind of girl," Joey Soloway praises Dunham for playing a young woman who is "the worst kind of girl, somebody who walks around naked, saying 'Here I am, here's my body,' and doesn't care how I look, and has sex with the worst men. It was all about, 'I'm the subject,

men are the object.' Dunham's character, Hannah Horvath, was really an anti-heroine," a good-bad girl.

The first season of *Girls* collected nineteen Emmy nominations with two wins. *The New York Times* quoted Jemima Kirke, one of the actresses, saying, "It's not *Sex and the City*. That's four gay men sitting around talking."

At the time, Dunham was the target of criticism for the show's lack of diversity and "hipster racism." Ta-Nahisi Coates, for one, blamed HBO more than Dunham. "My question is not 'Why are there no black women on *Girls*,' but 'How many black show-runners are employed by HBO?' This is about systemic change, not individual attacks," he wrote. "It is not so wrong to craft an exclusively white world—certainly a significant portion of America lives in one. What is wrong is for power-brokers to pretend that no other worlds exist."

Issa Rae, who a year later would make *Insecure* a hit on the cabler, agreed. "There could be more diversity, but I think that's the fault of the network, HBO, rather than Lena's."

HBO was not only all white, it was all, or mostly, male. Naegle complained that she had a hard time getting women promoted. She wanted to promote Gina Balian, who had been mentored by Strauss, to head of drama, and was a staunch supporter of *Game of Thrones*, but HBO blocked her, and instead hired Michael Ellenberg in 2011, who had a movie background but zero experience in programming TV. Says Strauss, "It was a boys' club," although Dunham insists that Plepler was very supportive.

With Lombardo, Naegle, Levine, Balian, and now Ellenberg in the mix, programming was divided into factions. Whitehead describes it as a "circular firing squad." Says one executive, "Lombardo and Ellenberg would always tell the artists, 'I don't like this part. You need to write it this way.' They both gave too many notes. That's not how great development happens."

Eventually the backbiting rose to a fever pitch. Another executive, who does not wish to be named, says, "It was not a pleasant place to work. There wasn't time to just be creative, because you literally were fighting for your life. People felt like you couldn't be smarter than

they were. I would have preferred feeling like I was working *on* the shows, instead of *in* the shows. I hated my colleagues. At one point I said to one of them, 'I wish you'd stop trying to kill me. I wish you'd focus more on killing Showtime and Netflix.'" With regard to Naegle, Lombardo confessed, "I was always thinking, 'You're not Carolyn.' It was still like dating a woman you aren't in love with."

Finally Lombardo ousted Naegle. She told him, "You have to get out of my backyard. If you just are saying that you want to do my job, then that's what you should do." He responded, "I think I do," giving her no choice but to resign. She exited with a production deal, in 2013.

In September 2012 Nelson retired, and Plepler succeeded him as CEO of HBO. The reaction was mixed, to say the least. "I think that if anybody had said that Richard Plepler was one day going to be the CEO, people would have said, 'You're crazy! No, no. Not going to happen,' but it happened," says a source who had a bird's-eye view of the maneuvering." Adds Fuchs, "I invented Plepler, who should never have been a CEO."

With Plepler at the top, Lombardo's power was enhanced, but as he asserted himself, his relationship with his boss or partner—take your pick—deteriorated. The infighting that tore apart programming seemed to be built into the company's DNA. Nothing was ever enough; from the beginning, everyone coveted, or was suspected of coveting, everyone else's job. Fuchs had wanted Levin's job, Plepler wanted Nelson's job, while believing that Kary Antholis wanted his, and Lombardo wanted and took Naegle's job. Says Kevin Reilly, "They had their own little sort of *Game of Thrones* over there."

After three *Sopranos*-starved years, HBO wanted its gangsters back. Terry Winter was one of the lead writers on Chase's show. He was a walking and talking Emmy. He had eight Primetime Emmy nominations, with three wins. Strauss gave him a book, a history of Prohibition-era Atlantic City called *Boardwalk Empire: The Birth, High Times, and Corruption of Atlantic City* by Nelson Johnson, published in 2002, and said, "See if there's a series in there." He was

halfway out the door, when she added, almost as an afterthought, "Oh, by the way, Martin Scorsese's attached." Winter stopped dead in his tracks and said, "I don't need to read the book. Yes, there's a TV series in this, and I'm going to find it.'" Recall that *Taxi Driver* was the movie that turned him into a screenwriter. To work with Scorsese, Winter would have pulled a gangster series out of *Mister Rogers' Neighborhood*.

Johnson's history of Atlantic City was rich with characters and events. World War I had just ended, Prohibition had arrived, and the twenties were getting ready to roar. The show would zero in on the career of Enoch "Nucky" Johnson, aka Thompson in the series, Atlantic City's Republican boss from 1911 to 1941, who ran its illicit trade in sex, drugs, and booze. Atlantic City was Deadwood-on-the-sea, a natural port of entry for bootlegged liquor, the sale of which created a high tide of money that washed over the town and floated its motley collection of clubs, speakeasies, and brothels. Says Winter, "I was kind of disheartened because I started to really get interested in doing this and I thought there's no way we can afford to do this. I mean we—on a television budget we cannot afford a boardwalk or an empire."

Back in 2007, Mark Wahlberg, who was a producer on *Entourage*, convinced Scorsese (they had done *The Departed* together) to join him on the project, and who better to get HBO its gangsters back than the director of *Mean Streets, Goodfellas*, and *Casino*?

Winter recalls, "HBO told me, 'You're going to have dinner at Martin Scorsese's house to talk about it.' I felt like a girl going to the prom. What should I wear? I got to his apartment twenty minutes early because I didn't want to be late, and walked around the block until nine o'clock."

Winter pitched the book. He explains, "Prohibition was the single event that made organized crime possible—it made millionaires out of criminals overnight." In his view, it bookended *The Sopranos*. Winter remembers that "Scorsese was excited, saying, 'Wow, that's the one era of gangster history I've not worked in. That's fantastic. I think I'd like to direct this.' I almost fell out of my chair. Originally,

Marty was only supposed to produce the show. He said, 'How do we make this happen?' I said, 'Well, there's this guy named Richard Plepler at HBO.' I said, 'If you call him and tell him what you just told me, I'm pretty sure it's going to happen pretty quickly.' Within ten minutes, Richard texted me, all exclamation points. We were off to the races." Winter liked Plepler. "A lot of times you get people hiring people they admire and then the very things they admire about them are the things they don't want them to do. Plepler hired smart people and got out of the way."

With Scorsese on board, the spigot opened. Scorsese told Winter, "Now you should go write the pilot."

"And I did," Winter says.

Strauss, who had not yet departed, told him with urgency in her voice, "This is important to us."

"Yeah, yeah, I know."

"No, look at me. This is really important." Because they had passed on so many shows the shelves were empty.

Winter was officially the showrunner, used to telling everyone what to do, but, he says, "I knew this was Marty's set. I was just there to watch." During the first day of the shoot, he saw actor Michael Pitt walk through a roomful of women wearing a cap, a grievous affront to period manners. Winter wanted to alert Scorsese, but the first AD told him, "No one's ever given Marty a note before." Full of trepidation, Winter made his way over to the Great Man, calling it "the longest walk of my life," and said, "It's 1920. The cap." Scorsese replied, "Oh my God, you're right. He's got to take his hat off. Look, anything you see at all, just come and tell me. Don't be shy."

Winter was surprised to find his idol so ignorant of TV. He hadn't even seen *The Sopranos*. After Scorsese read some of Winter's scripts, he said, "This is great. You get to see what happens to the characters after the movie is over." For him, the pilot was the movie, and everything that followed was TV.

Like most period pieces, *Boardwalk Empire* was indeed expensive to produce, but given the array of starry behind-the-camera names, and the expectation that it would be the next *Sopranos,* HBO was not

about to pinch pennies, while Scorsese, at that point in this career, was not about to spare them. The network was hungry for certified auteurs, but these same auteurs were hungry for the largesse they expected in return. As *The Wire*'s David Simon was quoted in *The Hollywood Reporter,* "A lot of feature people have thought, 'It's HBO. The world is my oyster,'" and tossed budgets to the wind. Michael K. Williams, who plays Chalky White, recalls, "We shot *The Wire* for scraps. They threw a shitload of money at *Boardwalk*. They had to." Adds producer Bob Greenblatt, HBO "started to buy these massive productions from Scorsese and other big auteurs and then just let them sort of run wild with budgets."

Jumping from writer and co-this and co-that to showrunner was impressive enough, but Winter's career was really taking off. Scorsese liked his writing so much that he asked him to do the script for his next feature, *The Wolf of Wall Street.* Winter wrote it while he was writing the pilot of *Boardwalk.* During the same period, Scorsese and Winter, along with Mick Jagger, pitched HBO with *Vinyl,* a show set in the music business, circa 1973. Winter was to be head writer and showrunner on that series as well.

Despite being a worthy follow-up to *The Sopranos, Boardwalk* struggled to attract viewers. It premiered in 2010 to an audience of 4.8 million, the biggest opening in six years, about equal to the numbers for *True Blood,* but half the size of the *Sopranos* audience. In 2014, after five seasons, Lombardo pulled the plug. The viewership had plummeted by about 50 percent. Still riding the numbers of *True Blood,* then in its final season, and with Dustin Hoffman signed on to Milch's *Luck, Boardwalk* seemed expendable.

Winter admired Albrecht for "pushing the envelope," and felt the show was a victim of the aftermath of his departure. "There was such a huge transition in terms of the attitude," he recalls. "Everything was being questioned and debated. By the end, it seemed like anything I did or I tried to do was met with pushback. The notes we were getting were risk-averse, not wanting to offend people. I think Lombardo hated the show."

BACK TO BASICS

FX FLIPS OFF HBO

When FX premiered *The Shield* in 2002, and followed it with a torrent of quality shows, it proved that basic TV could play in the premium sandbox.

When HBO launched *The Sopranos* in 1999, basic cable was little more than landfill piled high with old network series and second-, third-, or fourth-run Hollywood movies. It depended largely on local provider fees and the little advertising it managed to scrape together. FX and AMC realized that HBO had changed the rules of the game, and that they had better do something lest they shrivel up and die. But it was one thing to want to become the new HBO, and another to actually do it.

FX, owned by Fox, for lack of "It's Not TV, It's HBO" tagline, latched on to "TV Made Fresh Daily." This belied its actual programming, which was reruns of *Cops* and *The X-Files*, peppered with NASCAR races at night. The few originals it did have were pale copies of the male-bait shows HBO aired in its adolescence: an ineffably dumb game program called *Bobcat's Big Ass Show*, and a babes-in-bikinis parody of *Baywatch* called *Son of the Beach*, executive-produced by none other than Howard Stern.

In 1998, News Corp COO Peter Chernin hired Peter Liguori, who had been VP of consumer marketing at HBO in the Michael Fuchs era. He told him, "I have good news and bad news. The good news is that I'm giving you a network to run. The bad news is, it's FX,

it's total garbage, you're probably going to fail, and I'm going to have to fire you." Liguori was part of the HBO diaspora that spread its DNA across the cable spectrum. In addition to the *Six Feet Under* gang, Albrecht was at Starz, Tina Balian went to FX, and Matthew Weiner to AMC. No fool, Liguori killed *Bobcat's Big Ass Show* and *Son of a Beach*, and over the following two years increased the cabler's penetration of the market from 35 million homes to 53 million homes.

Two years later, Liguori, who was pushing FX for better shows along the lines of HBO's, hired Kevin Reilly from Brillstein-Grey as president of entertainment. FX was the other side of the tracks. Reilly, who took a big cut in pay, recalls, "I came from a place with museum-quality art, to a place where there was a giant stain on my carpet and a hole in the wall. I asked the office manager if I could have two chairs that matched. She said, 'No, I'm sorry. We can't do that for you.'"

Liguori and Reilly's mantra was, "Let's do HBO for basic cable," and they did. Reilly's first stab at becoming the new HBO was *The Shield*, a long, long shot. Shawn Ryan, a large man with a polished dome who resembles an inflated version of *Shield* star Michael Chiklis, submitted it as a writing sample.

After Ryan arrived in Hollywood, a rube from Burlington, Vermont, he ended up writing for *Nash Bridges*, a police procedural created by Carlton Cuse that was picked up by CBS and ran for six seasons starting in 1996. He'd gone on ride-alongs with cops, where he saw things that CBS would never air. He wondered what would a cop show look like on HBO. He wrote and submitted a spec script to FX. David Madden was president of Fox TV Studios at the time. He liked Ryan's pilot, despite the fact that the lead was a dirty cop. Says Madden, "We would have loved the show to go to HBO, but the impression was, unless you had big, fancy elements attached, a gigantic star or a star director attached to your project, you had very little chance of it getting made." Reilly liked it, too, and told Ryan, "We want to make this."

"What do you mean? Like, this actual show?"

"Yeah."

"Where a dirty cop shoots another dirty cop through the eye at the end?"

"Yeah, we want to make that."

Reilly recalls, "He couldn't believe it. This was not a time when network executives did scripts where the lead guy's a murderer." Besides, the dirty cops of *The Shield* would go on the air less than a year after 9/11, when the police were national heroes for rescuing people from the World Trade Center. If "*Nash Bridges* was all rules, there were no rules on *The Shield*," says Ryan. "My earliest memory working on *The Shield* was feeling like we were getting away with something criminal."

The Shield was based on a scandal that consumed the Los Angeles Police Department in the 1990s. Its elite CRASH unit was created to go after gangs, and the cops who comprised it were in effect granted license to kill. One CRASH squad worked out of the heavily Hispanic, crack-ridden Rampart district in East LA. Inevitably, it caused more than its share of collateral damage, wreaking havoc on the community it was supposed to protect. Seventy-odd officers were nailed for a laundry list of offenses, from murder to bank robbery. The Rampart scandal "got me thinking a lot about the balance of safety and civil liberties," Ryan explains. He wondered how much of the latter people were willing to give up for the former.

Chiklis, then best known for playing the chubby lead in *The Commish*, lost weight and gained muscle for his role as Detective Vic Mackey, a dirty cop with a fuck-you sneer and the anger issues to go with it. A poster child for so-called toxic masculinity, he busted heads, trolled cop groupies (referred to as "badge suckers"), and developed a bevy of sleazy CIs he used to snitch on bad guys little better than himself. In one scene, he barges into a holding cell to interrogate a suspected pedophile after a good cop had gotten nowhere. The prisoner sneers, "Your turn to play bad cop?" Mackey responds, "Nah, the good cop and bad cop left for the day. I'm a different kind of cop." He means that in *The Shield*, there are only bad cops and worse cops. Mackey beats the suspect until he divulges the whereabouts of a missing eight-year-old. Says Ryan, "He's not a television cop whom we feel good about at the

end of each episode. He doesn't cuddle puppies." Somebody or other observed that Mackey made "the Jack Bauers and Dirty Harrys . . . seem like hospital gift shop volunteers."

Mackey's CRASH unit, aka the Strike Team, spends as much energy committing crimes as solving them. In one scene, he gives a whole new meaning to the term "grilling." He takes a suspect who has apparently raped a seven-year-old girl and presses his face, cheek down, onto the red-hot coil of an electric stove so long you can almost smell the burning flesh. There's even a millisecond shot of the spiral seared into the sizzling skin. It's a scene that might have been routine on *The Sopranos,* but not something anyone had ever seen on basic cable.

On the other hand, Mackey is yet another good-bad guy. The glimmers of "good" include a sense of humor, a family, and a code, as well as the fact that those he's brutalizing are a lot worse than he is. As Black detective Claudette Wyms (CCH Pounder) explains, Mackey is a hero to most of the law-abiding citizens of East LA because "what people want these days is to make it to their cars without getting mugged, come home from work, see their stereo's still there . . . If having all those things means some cop roughs up some n-gger or some spic in the ghetto, hell, as far as most people are concerned, it's Don't ask, don't tell."

Damon Lindelof, of *Lost* and *Leftovers* fame, recalled reading Ryan's pilot and waiting for Mackey to reveal his heart of gold, but when he got to the end, he realized that Mackey didn't have a heart of gold. He thought, *Shawn Ryan will never get this . . . on the air.* But basic cable was about to change, and Ryan's show was the one that changed it.

Casting was a problem because Reilly didn't have much money to spend, and worse, no one wanted to be on an FX original. "I think there was an assumption that this was going to be cheesy," Ryan recalls. "I heard many stories about agents discouraging [actors] from pursuing it." He adds, "We were just trying to look for diamonds in the rough." Chiklis was one, and Walton Goggins, who plays Mackey's best friend and number two, Shane Vendrell, was another.

Goggins was a young kid who grew up in Georgia, had been unable to get work, and was hanging on to *The Shield* by his fingertips. Liguori and Reilly both said, "'We don't fucking like that guy,'" recalls Goggins. "They wanted to fire me. I didn't really have a face to launch a thousand network ships. Shawn said, 'Why? I like him.'" Goggins adds, "I only had four fucking lines in the pilot." But he did have enough screen time for the beyond-shocking finale in which he first shoots a Strike Team pal in the eye because he thinks he's a fink, then buys a rose and a toy police car that he gives to his pregnant wife and little boy, respectively, before he kills them, laying their bodies out neatly on a bed with the boy clutching the toy. Then he blows his head off, creating a pool of blood and gore. It's *The Shield*'s version of a happy ending, not quite the stuff that dreams are made of.

FX greenlit the pilot on August 30, 2001. It was originally called *The Barn*, the cops' name for their headquarters, but that made it sound like a farm show, so it was changed to *The Shield*. "No one knew what we could do and what we couldn't do," says Goggins. "FX took a risk. We were waiting for the censors to say, 'No, you can't do that.' But we didn't ask their permission. We just kinda did it."

FX executives knew what they had in *The Shield*: an HBO-killer. As veteran publicist John Solberg put it, excitedly, "We're gonna shove it up HBO's ass!" *The Shield* premiered on March 12, 2002, the same year as *The Wire*, to a phenomenal 4.83 million viewers.

Basic cable ran commercials, and a show like *The Shield* could be counted on to make advertisers run for the hills, but it didn't matter. "FX had shit advertising, so it's not like we were jeopardizing any great advertising base—Mike's Hard Lemonade was it," Reilly explains. He recalls that at the conclusion of the screening for advertisers, "They all looked at their feet and kind of shuffled out the back really quick, muttering, 'I gotta go, late for a meeting.'" He goes on, "Cable operators furnished its income to the tune of twenty-five cents a subscriber, so keeping the cost down, we had nothing to lose."

At the time, cable shows couldn't get A-list actors for their shows. "Their business model," recalls Alex Gansa, who was writing for the

Fox show *24*, "was to find actors and actresses who were regarded as past their prime looking to resurrect their careers on television."

FX pulled off a coup in luring Glenn Close, an A-lister for the likes of *Fatal Attraction* and *The Big Chill*, to play the Barn's captain in Season 4. Initially, she turned it down. "Everybody was telling me, 'Don't do TV, it will ruin your career,'" Close recalled years later. She ignored their warnings and never looked back. "It's such BS. It really is BS."

What finally hooked her was the opportunity to play a powerhouse woman in a man's world. "I was offered *Dune* right after *The World According to Garp*," she says. "I turned it down [because] there was this scene where they were running away from the big worm . . . and the woman fell down, and everyone had to come back to get her." She continues, "I don't want to be the woman who falls down. I want to be the woman who's running just as fast as everyone else."

In Season 5, Ryan hired Forest Whitaker to play an Internal Affairs investigator targeting Mackey. "Somehow, the audience was very much against him and for Vic," Ryan remembers. He continues, "What I realized as the seasons passed, it almost didn't matter what we had Vic do, people had just decided that they liked him and wanted to see what he could get away with." Chiklis reported that people on the street asked him, "How are you going to kill [Whitaker]?"

Finally turning the tables on the cartoon characterizations demanded by Standards and Practices was of course to be applauded, but what it revealed was disturbing. The "less yakking, more whacking" contingent that hounded David Chase was again unleashing its inner Charlie Manson. For them, the only trouble with TV's good-bad guys was they weren't bad enough. Still, in *The Shield*, the bad guys are ultimately punished. Policing may not pay, but neither does crime.

The show was a product of the era in which it was made. Explains Ryan, "When I look back, the vision of policing represented . . . was very much inspired by Bush's 'My country, right or wrong' doctrine." Waterboarding was next to godliness, and the ends justified the means, no matter how many ethical eggs were broken to achieve them.

The Shield lost money—it cost about $1.3 million an episode—but Chiklis won an Emmy for Outstanding Actor the first time out of the box, and the show broke basic cable ratings records. As *Nash Bridges* showrunner Carlton Cuse put it, "*The Shield* not only put FX on the map, it created the map. It created a model for how cable channels could create brand identities. And it started an era that you didn't have to make a show that appealed to everyone."

Ryan was generous in crediting his predecessors. "I never think of *The Shield* as patient zero because to me, without *Hill Street Blues* and *Oz* and *The Sopranos*, *The Shield* would have never existed." But like Fontana, he felt unfairly overshadowed by Chase's series. He confesses, "We felt like our show was comparable to [*The Sopranos*, but] we got about a fifth of the attention and about a 20th of the awards."

Ryan does, however, rightly claim credit for paving the way for the flowering of FX, which followed with shows like ratings hits *Nip/Tuck*, *Rescue Me*, and *Sons of Anarchy*, three good-bad guy series in quick succession, all testosterone cocktails of misogyny that flaunted their political incorrectness. They were all sons of *The Shield*.

The same way Chris Albrecht worried that he'd never find a follow-up to *The Sopranos*, Reilly worried that he'd never find a follow-up to *The Shield*. Eventually, he ran across a short, swishy former journalist from Indiana named Ryan Murphy. "All the guys in power were straight white men," Murphy remembers. "J. J. Abrams and I came up at the same time, but I never got those calls—because you mentor people who act like you and talk like you, and share your points of reference." No one, it seems, acted, spoke, or shared points of reference with Murphy.

"Ryan pitched this thing about plastic surgery," Reilly recalls. "These doctors are in the business of keeping everyone beautiful, but inside a lot of things are not beautiful." *Nip/Tuck* features two sleazy plastic surgeons, one of whom is described as "a man wound

tighter than a hummingbird's asshole." It opens with a graphic shot of an "ass-implant" procedure, and goes on to set women on the path of "designer vaginas." In one *Nip/Tuck* episode, a yogi asked for a penis reduction because his was so long he couldn't resist sucking it.

Reilly was impressed by Murphy: "He had visualized the whole thing. I thought, 'If he gets half of this on the page, we got another one.'" Ryan turned in the script, and it was perfect. But he had a reputation for being difficult. "I would give him notes, and he'd be like, 'Well, I think that compromises everything we're going for. And I don't even know if I could write this, and I don't even know if I want to be on the show anymore.' He would quit and wouldn't talk to me. I'd have to go meet him at the Chateau Marmont. He'd show up with his scarf around his neck and sunglasses on and kind of sulk, and I'd have to apologize. By the end we were hugging goodbye. He is a true artist. I love him."

Tasteless as *Nip/Tuck* was, it would get stiff competition from the next show up, *Rescue Me*. It begins with a veteran firefighter dressing down ranks of mostly white cadets like a drill sergeant roaring, "You want to know how big my balls are? My balls are bigger than two of your heads duct-taped together," and later the recruits work out their issues by comparing penis size, even arguing over where to measure: from "under the ball sac out to the tip" or, as Chief "Reilly" prefers, "from the pubic bone to the tip, 'cause that's all that enters the vagina."

Executive Reilly shuttled between the networks and the cablers, and returned to NBC in 2003. John Landgraf, who shuttled the other way, left NBC, where he supervised the development of *The West Wing*, *Friends*, and *ER*, and landed at FX in 2004 by way of Danny DeVito's Jersey Television. His title was president of entertainment, in charge of originals. The son of a pastor, his parents sang backup for evangelist Mel Dibble, who was part of the Billy Graham Crusade, which made his childhood sound like an episode out of the future HBO comedy *The Righteous Gemstones*.

Writer Stephen Tolkin remembers being sixty words into a pitch when Landgraf's phone rang. He said, "'I have to take this.' I'm,

'What?!' Then John put his hand over the receiver, looked at me and said, 'We're buying it,' meaning my pitch. He knew what he wanted. He didn't need a treatment. Who fucking does that?"

Landgraf left NBC because, he says, "I was just very frustrated at that time with the state of broadcast television. I felt like the business process was conspiring to dull down the vision of the artist." He arrived at FX in time for the second season of *Nip/Tuck*, the first season of *Rescue Me*, and Season 3 of *The Shield*. "I was really blown away by the uncompromising, aggressive originality of those shows," he remembers. "They didn't seem to care what you thought of them. They were made to be what they are and you can love it or you can hate it, but it didn't feel like it was a product that had been focus-grouped to death."

Realizing that good as they were, *The Shield*, *Nip/Tuck*, and *Rescue Me* all featured white male anti-heroes, Landgraf knew he had to vary his fare, but his attempt to diversify led him to what he calls "both the biggest mistake I ever made as a programmer, and maybe the best decision I ever made as a programmer." He bought *Breaking Bad*, but then, stricken with a case of buyer's remorse, let it go in favor of *Damages*. "*Breaking Bad* turned out to be maybe the greatest white, male anti-hero show ever made," he continues. "I wished I had it, but on the other hand, I didn't want to put a fourth white, male anti-hero show on the air. *Damages* . . . was trying to take the anti-hero genre in a different direction." Or he may have been pressured by parent company Fox, which was hesitant to air a show about a meth dealer.

Written by Daniel Zelman and the Kessler brothers, Glenn and Todd A., of fired-by-David Chase fame, each season of *Damages* was based on a ripped-from-the-headlines case, like Enron and Bernie Madoff. The cable shows, however, were still having trouble getting A-list talent. Thus, once again, it was Glenn Close to the rescue, for the role of a scheming lawyer, Patty Hewes, mentoring Rose Byrne.

With Close attached, the show was able to attract a starry cast that would have been the envy of HBO: Ted Danson, William Hurt, Lily Tomlin, John Goodman, and others. "I poured a lot of David Chase

into Glenn Close's character," Todd Kessler recalls. "It's fundamentally about my experiences coming up in the entertainment industry, working for talented people who are also ruthless, paranoid, egomaniacal." Like himself, the naif played by Byrne is warned about working for Hewes, who lies, bribes, blackmails, and fumbles murder. He continues, "Oftentimes the person who extends their hand in friendship the first day at work is the person you realize will be the first one to stab you in the back."

FX's shows differed in quality, but however offensive or inoffensive they were, Landgraf built a formidable network, proving that basic cable could produce shows that were head and shoulders above the networks and, perhaps more important, HBO.

Landgraf's lineup was so strong that "Free HBO" became a slogan FX could use without embarrassment. "We want you to feel when you're watching our shows that you don't know what's going to happen and that you're not in a safe place that is governed by guardrails that are going to keep you from going off," he explains. "I think there's a place in this world for safety. That's not the experience that we provide."

*D*amages was followed by *Sons of Anarchy*, and then *Justified*, which opens with US Marshal Raylan Givens, played by Tim Olyphant, seated across the table at a swanky poolside restaurant on the rooftop of a Miami hotel overlooking the bay, staring down a thug who looks every inch like the mob hit man he is. Givens has granted him twenty-four hours to get out of town or be killed, but the man just stares back, daring him to make good on his threat. Surrounded by languid sunbathers stretched out on deck chairs, Raylan begins the countdown on the thirty seconds the man has left, trying to provoke him into pulling his gun, which is poorly hidden in his lap under the fold of a starched blue tablecloth. Short of fuse, he can't resist, a big mistake, because of course the marshal is way faster on the draw. Before the thug can get off a shot, Raylan gets in three to the chest at point-blank range. Blood blossoms across the

mobster's pink shirt like a dark rose. It's a bravura entrée to as fine a specimen of cracker noir as you're likely to see anywhere, much less on basic cable.

The show was produced by Sony TV, whose heads, Zack Van Amburg and Jamie Erlicht, hired Graham Yost, who cut his teeth at HBO on *Band of Brothers*, to write the pilot. Yost is credited as creator and executive producer.

Yost is a Canadian who eventually made the pilgrimage to Hollywood. He was hired by ABC's *Full House* because "They said they needed someone on the show with some edge," he recalls, "but it was quickly apparent they didn't want edge. It was awful." He quit, joining the ever-expanding ranks of the unexclusive "never network" club. Coming off *Speed*, a movie he wrote on spec that became a hit in 1994, he dropped in on the *Full House* writers' room. His old friends, still there, were awed like ballplayers stuck in the minors greeting one of their own who has made it to the majors. "They asked, 'What's it like writing features?' That was everyone's dream," Yost recalls. "The flip side of that is now, over the last fifteen years, feature writers say to me, 'God, it must be great writing for TV.'" The worm, as they say, has turned.

Despite *The Shield*, FX was still basic cable, in those days eliciting a "What's that?" reaction from the average viewer, but Yost had nothing going when Sony sent him Elmore Leonard's *Fire in the Hole*, which featured a character named Raylan Givens. Yost recalls, "I was a big fan of Leonard's and when I read the novella I thought, 'I can see this Raylan Givens, being the coolest character on television.'" But he felt, as he puts it, "If you were going to do Elmore Leonard, you had to let Elmore be Elmore. The reason he's so wonderful is not because of his plots, it's the character and the dialogue," which was pithy and spare. Yost was shrewd enough to use as much of Leonard's dialogue as he could. "I would be wondering what Raylan was going to say next," he recalls. "Let's see what Elmore has Raylan say next, and use a version of that. Elmore read the pilot, and he said he really liked it, and I said, 'Of course you did, Elmore, 80 percent of it is you.'"

Indeed, the pilot is thoroughly Elmore-ized, so filled with cutting repartee spit out and gone before the laughs have a chance to come and the blood to spill. Yost would even have blue rubber bracelets made that were emblazoned with the letters "WWED"—"What would Elmore do?"—reminding everyone to strip-mine Leonard's work.

Meanwhile, back in *Justified*, it seems that US marshals aren't supposed to shoot people in the chest at point-blank range during dinner at swanky Miami hotel restaurants, no matter how depraved they are. As a punishment, the Marshals Service sends Raylan back from whence he came, to the hills and hollers of Harlan County, Kentucky, a crime-ridden backwater in coal country renowned for its poverty and violence. There, he comes up against his heavily checkered past that includes Ava (Joelle Carter), a former girlfriend, an estranged wife, Winona (Natalie Zea), a by-the-book boss, a larcenous father, and last but not least, Boyd Crowder, his childhood best friend with whom he once dug coal and who is now on the other side of the law. It's an explosive mixture, and it doesn't take long to combust.

Yost pitched it to HBO, and they bought it before he left for the elevator. But the cabler, its pipeline clogged with projects, had a daunting pilot-to-series ratio, thanks to Lombardo et al., and he knew he'd have better luck with FX. But despite the Leonard imprimatur, *Justified* was far from a sure thing. It was just what Landgraf said he didn't want, yet another male-driven show, featuring yet another good-bad guy. Besides, Yost joked that the show didn't fit the FX brand; it wasn't dark enough. Raylan wasn't a pederast with a nineteen-year-old boy chained to a wall in his basement. Nevertheless, Landgraf corrected the mistake he had made when he let *Breaking Bad* slip through his fingers, and snapped it up.

Yost doesn't like to think of Raylan as a good-bad guy, but as a genuine hero who just does things his own way. He admits, however, that he "did kill a lot of people. We were going to do a virtual Zoom panel about *Justified* for the Austin Television Festival in 2020," he recalls, "and we decided to cancel it because it was right after George Floyd was killed. The guy who was going to moderate it asked, 'Would you

do a show about a law enforcement officer who takes the law into his own hands, now? What would be different?' We just decided it'd be better not to do the panel because there was just no answer we could give, except to say, 'Fuck no, we wouldn't do it the same way.'"

If any of the characters heralded the coming of Donald Trump, it was Boyd Crowder, says Yost, in that "he was a liar who lied to himself, lied to everyone around him, but had a certain charm and could behave badly without ever losing the audience." He is played by Walton Goggins, aka Shane Vendrell in *The Shield*.

Boyd is Raylan's white whale to whom, despite being on the wrong side of the law, he is still drawn by bonds that neither can entirely fathom. He is a cunning con artist with a florid manner of speaking. If Givens is a man of few words, Crowder is a man of many. As one character describes him, he uses "forty words where four will do." He matches Raylan's charm with his own brand of shifty villainy.

"I turned down *Justified* twice," Goggins says, because having grown up in rural Georgia, he was uncomfortable with the way Crowder was written. He explains, "If you're from New York and Italian, chances are you're going to play a mafia guy. And if your heritage is Middle Eastern, you're going to probably play a terrorist. And if you're from the South, you're going to play a racist redneck. I didn't want to participate in perpetuating that stereotype."

Needless to say, Goggins preferred to think of his character as the smartest guy in the room. "I said, 'Look, I'll say the things you want me to say in the pilot, because this is Elmore Leonard's world. But in order for me to do this, I need Raylan Givens to acknowledge that Boyd does not believe a word he's saying.' Because you add that factor, and suddenly, he becomes a much more interesting, more complex character. And God bless them, they gave me autonomy over Boyd." He continues, "The hardest thing was how similar Boyd was to me in the sense that I'm a poor kid from the South. I felt there was a glass ceiling, and I could only get so far. I had a chip on my shoulder for not having the opportunity to spend four years in college, contemplating the meaning of life. My education began reading books while sitting in a valet chair, waiting to park cars outside of a restaurant."

Justified moves from the gangs of LA featured in *The Shield* to "shitkicker-on-shitkicker crime," as Givens puts it, of Harlan County, but the elements remain the same: stabbings, torture (by chainsaw), and of course shootings, albeit accessorized with leaky tattoos, sawblade haircuts, hillbilly accents, and lots of bourbon.

Where *The Shield* troubles itself over social issues, however, pitting security against civil liberties, *Justified* is less about ethics than aesthetics. There is no shortage of themes to chew on—race, class, family, crime as a species of capitalism, and, most important, changing times and those they leave behind—but they all seem to resolve themselves into issues of grace. Style is everything. As Olyphant puts it, "In the world of Elmore Leonard, people are defined not by good and bad but by whether you're a jerk or not." Raylan is a killer, but we overlook that not only because he wears a badge but, as Yost understood, because he's cool—smart and funny—smarter and funnier than the Harlan County bottom-feeders he dispatches to the afterlife.

Olyphant made Givens into a career-defining role, and was as cool as Yost could hope, but he was not the most popular actor on the set. Says one of his colleagues who disliked him, "He's deeply insecure, not that talented, and a bully. An asshole." By the end of the shoot, adds Goggins, "We weren't talking. We weren't friends. Maybe it was a case where he became Raylan Givens and I was Boyd Crowder."

Justified premiered on March 16, 2010, to the biggest numbers any FX show had scored since the opening night of *The Shield*, 4.16 million viewers. The first season won a Peabody.

Leonard died in 2013, the occasion for weeping and wailing on the *Justified* set. The director's chair with his name on it was treated like a shrine. No one was allowed to sit in it, but after a frustrating take where he couldn't get a scene to work, Goggins thought to himself, *Fuck it, I'm just going to sit down in your chair, Elmore.* He found it "very special, comforting," and continued, "When it's all said and done, we will be a small piece of thread in Elmore's coattail."

By the time *Justified* was approaching its last season, Peak TV was in full flower, with approximately 349 original scripted series.

Especially in the later seasons of the show, there were so many series on cable that it was almost impossible to be original. A writer would suggest a riff, and someone would say, "They just did that on *Breaking Bad*." A plot dictated that Ava had to spend some time in jail, and they worried that *Orange Is the New Black*, built around an entire prison full of women, had been there, done that. "In a good Elmore scene," says Yost, "someone's going to get fucked or someone's going to get fucked," meaning, "there was always the possibility that something could be going along funny, and then just take a hard turn into some shocking violence. We were always looking for those surprises. The problem becomes, when you do a show for six seasons, is that surprises stop being surprising and that was one of the reasons why we felt that six years was enough," avoiding the trap of series like Showtime's *Dexter*, or zombie shows that kept lurching along well after their shelf dates expired. Adds Yost, "Sony TV would have loved it if we'd been able to do a seventh season, but we were afraid of running out of story."

Yost didn't actually watch any of the other shows, but he was intensely competitive. "It's only a half joke but I'd say in the writers' room, 'I am a small, petty man.' Whenever everyone was raving about *Mad Men* I wasn't going to watch because everyone was raving about it. What about our show?" In the end, they just pretended the other shows didn't exist. Everything came back, as always, to "Does it feel like Elmore?"

Post-*Justified*, Olyphant had to look forward to unemployment, Goggins to playing transgendered Venus Van Dam on *Sons of Anarchy*. Yost, going from hit to hit, was already working on *The Americans*, also on FX.

Ever since co-creator Joseph Weisberg had read John le Carré's *The Spy Who Came in from the Cold* when he was eleven, he wanted to be a CIA agent. "That le Carré world was so appealing to me, and it was so connected to my personality—everything hidden, kept inside, while I'm secretly planning and plotting"—that he actually joined

the CIA's directorate of operations in 1990. He stayed for three and a half years, even though he was quickly disillusioned. As soon as he joined the agency, he began living a double life. In his words, "I was just lying constantly all day. The weird thing was how quickly I acclimated to it. After three weeks, it was like a switch flipped and I never thought about it again. It just became easy." Part of his training involved reviewing past cases, an assignment he called "read yourself to death."

Like other new recruits, Weisberg was given a polygraph test. "You're in this little box of a room, you're strapped up to this thing, it's intimidating. So they go through fifty questions, every one of which is pretty easy. And then, at the very end, the last question was, 'Are you joining the CIA in order to write about it?' My heart starts beating, my brain goes bananas. It was a very relevant question to me. I was not joining the CIA for that reason, but I'd been a writer since I was a kid, and I was serious about it. As soon as they said it, I thought, 'That's a good idea!'"

Eventually, it also occurred to him that continuing to work for the CIA wasn't such a good idea. "I saw that my job was going to entail recruiting people who didn't provide much valuable intelligence, and yet they had to put their lives at great risk, and I don't think I felt good about pursuing that."

After Weisberg left the CIA, he wrote a spy novel and one episode of *Damages*. CAA agent Joe Cohen called him. "I literally didn't know what CAA was. That's how little I had to do with Hollywood. He said, 'Have you ever thought about writing for television?'"

Cohen hooked him up with Yost, who hired him to write for a DreamWorks show, *Falling Skies*. Then, in 2010, the FBI rolled up ten members of a ring of Soviet "illegals," moles run by its secret "Directorate S," who were part of sleeper cells passing themselves off as ordinary Americans with ordinary jobs and ordinary children. One couple had started a successful diaper business. They were traded back for Americans held by the Soviets. One of them, Anna Chapman, was an attractive redhead, who reportedly nearly honeypotted a member of Obama's cabinet. Displaying her photo, Jay Leno

asked then vice president Joe Biden, "Do we have any spies that hot?" Biden quipped, "Let me be clear. It wasn't my idea to send her back. I thought maybe they'd take Rush Limbaugh or something." (See, he does have a sense of humor!)

The story caught the eye of executives at DreamWorks, who called Weisberg. "They said, 'What about making a show about this?' I thought to myself, 'I don't know if that's really a good idea, but you don't say no when those guys ask you to write a script.' So I said, 'Sure.' I started thinking and thinking, and I had two insights that made me imagine it could be a great show. One was that the Soviet agents should be the protagonists rather than the FBI. And the other was, *Nobody cares about this right now, you've got to put it back in the Cold War*, and as soon as you pictured Ronald Reagan yelling about the Evil Empire you understood the stakes of the show in a new way. Philip and Elizabeth Jennings become characters who were driven by ideology."

Weisberg pitched it to six or seven places. They all turned it down. "They never tell you why," he says. "Nobody but Landgraf was interested," he continues. He "was the one guy—FX was the one network—that got that doing a show where the heroes were KGB agents was a good idea, an exciting idea, rather than something scary." He continues, "Scary turned him on. Instead of rushing from it, he rushed towards it." Asking audiences to embrace KGB agents rather than the FBI wasn't going to be easy, but the root-for-them-anyway premise was on brand for FX. Even more so.

There was no Elmore Leonard to lead them by the hand, but Landgraf not only hired Yost as executive producer, he added Joel Fields as Weisberg's co-showrunner. Fields was a veteran writer who had executive produced and written for shows like *Ugly Betty*, *Rizzoli & Isles*, and later *Fosse/Verdon*. Landgraf steered them away from making an action-oriented series like *24*. "Maybe our desire not to do that was just the knowledge that we couldn't, or couldn't do it as well as they did on *24*," says Fields.

Whatever the reason, they minimized action and maximized character, the relationship between Philip and Elizabeth. "John

would have incredible ideas," Weisberg recalls. "In one meeting he said, 'Suppose Philip loved Elizabeth more than she loved him?' As soon as he said it, everybody in the room was like, 'Wow, that's really interesting and powerful and could really add a lot of depth to it, and it's not something we see all the time.'" It became a show about a marriage. Weisberg and Fields went so far as to "unwrite" scenes that struck them as over the top.

In effect, Weisberg and Fields embraced Alfred Hitchcock's "bomb theory," privileging suspense (the bomb that never explodes) over surprise (the bomb that does). Example: Nosey and oversharing neighbor Stan Beeman (Noah Emmerich), an FBI agent, is the bomb that the undersharing Jenningses fear, but the fact that he doesn't go off until the series finale builds the suspense.

"Most of the stuff that seems the most ridiculous . . . is real," continues Weisberg. He used the tradecraft he learned in the CIA in the show—bugs, dead drops, disguises, and how to follow someone without being detected. Stolen from the headlines was, for example, the so-called Bulgarian umbrella with a pneumatic tip that propelled ricin into the dissident Bulgarian writer Georgi Markov on London's Waterloo Bridge in 1978.

Like the Russian illegals, the Jennings family were engaged in kompromat, identifying vulnerable targets in and around policy circles while gathering information with which to blackmail them. In one of the most painful story lines in the series Philip, who is already not what he seems, pretends to be someone else and marries Marsha, an assistant in the DC office of the FBI. It "is absolutely based on reality," says Weisberg. "The real-life stories are horrible and tragic. A woman was called into a police station and told that her husband was a Soviet spy who had married her because she worked in such-and-such department, and she jumped out the window and killed herself." On the other hand, he confesses that it didn't matter whether the tradecraft is real or not: "Le Carré admitted that it's deeply unrealistic in his novels. It just feels authentic."

Weisberg's script for the pilot was a how-to in terms of scene setting and establishing almost all the show's themes in one brief hour. Says

Yost, "I don't believe he'd ever written a script before, and I read his first draft of his pilot, and I went, 'You motherfucker. This is brilliant. Out of the box. You're a better writer than I am. I hate you.'"

Casting the Jenningses was tricky, because the actors had to be ruthless KGB agents yet caring parents. Landgraf suggested Keri Russell, a *Mickey Mouse Club* alum and star of *Felicity*. He thought the contrast between her image, which Weisberg describes as "little Miss America, a wide-eyed, romantic, super sweet American girl," and the role she had to play on the show was provocative. Russell was convinced she was wrong for the part. She was too thin, scrawny, even. She recalls, "I was like, 'Me? What are you talking about?'" The script called for several honeypot scenes in which she had to seduce her targets to get information. "People don't cast me for my voluptuous body," she said, laughing. "'We're looking for a woman with a 13-year-old boy's body? Who can we get? Keri Russell?'"

More serious, Steven Spielberg, whose company was one of the producers, thought Matthew Rhys was miscast. Spielberg was adamant, and demanded a meeting with Landgraf. According to a source, Spielberg said something like, "'I'm Steven Spielberg, I know something about casting actors, and Matthew Rhys is wrong for the show. If you cast him, I will take my name off the show,' assuming that that threat would terrify anyone. Landgraf apparently just kept calm, and said, 'Okay.' Spielberg took his name off. Most other people would have never defied Steven Spielberg. That was considered a Hollywood heresy."

The Americans premiered on January 30, 2013. The opening scene of the pilot is set in Washington, DC, and is devoted to a protracted, violent knife fight with a Soviet defector set to the pounding beat of Fleetwood Mac's "Tusk," followed by a flashback to Elizabeth Jennings being raped by her instructor as she's being trained in martial arts back in the USSR. It then jumps forward to the present, where she and Philip (Matthew Rhys) stash a Soviet defector in the trunk of their car, park it snugly in the garage of their suburban home in Falls Church, Virginia, and open a door to the interior of the house to reveal a kitchen where their two young children, oblivious to the

Sturm und Drang around them, spoon their cold cereal. As Russell noted, one minute she's "making a bologna sandwich for her kids and then blowing a guy in a hotel for intelligence the next." The ho-hum routines of domestic life are juxtaposed with their real jobs. It's *The Sopranos* all over again, this time with spies, not gangsters.

Landgraf reminded the "J's," as Weisberg and Fields were called, that since they were writing a series for cable, they could indulge themselves with season-long, even series-long, story arcs. "That changed everything," says Weisberg, "because instead of having to pack a whole spy plot into every episode, we could put as much or as little of the spy thread as we wanted, and that allowed the personal stories to breathe. Suddenly they blossomed and took over the show."

As a basic cable channel with some commercials, FX wasn't as loosey-goosey as HBO. There were limits. Violence was okay, but it couldn't be too bloody. "They had limitations on nudity, naked from behind, that was fine," Yost recalls, speaking of *Justified*, but "we couldn't show breasts. We could say 'shit' as much as we want, but they did not let us say 'fuck.' That was 2009. By 2012, on *The Americans* they started to use 'fuck,' but it was, 'Well you get one a season, or you get two a season.' That was the beginning of the whole streaming thing. By the end they didn't care how much the characters on *The Americans* swore, or if there was nudity, because the secondary market was no longer syndication on stations in local markets, but Netflix or Amazon."

Endings are hard to do. You have to wrap up story lines, dole out rewards and punishments that make story sense and satisfy the audience, as well as include an unexpected jolt or two—unless you're David Chase. The surprising, bittersweet end of *The Americans*, along with that of *The Shield*, boasts one of the best, if not the best, at least until *Homeland* finally made it to its last episode in 2020. Their cover blown, the Jenningses have to flee to the Motherland. "When we started breaking season six, we looked very carefully at all the choices," says Weisberg. "If *The Americans* had been a network show, agent Stan would have arrested all of them. Where we were at that time in television, it seemed that people would expect them to die, but that didn't feel good to us." On the other hand, "Landgraf said

that Philip and Elizabeth couldn't just waltz away. They had to pay a karmic price for what they'd done," Weisberg continues. The question was, how?

The solution was a harrowing ten-minute confrontation in a parking garage that draws its power from an outstanding performance by Emmerich as Stan, who discovers them making their getaway. Virtually vibrating with rage, but one second away from tears, and holding them at gunpoint, he goes from saying to Philip, "You fucking piece of shit" to "You were my best friend. I would have done anything for you," and letting them escape through Canada. "We had some anxiety that people would feel that the ending wasn't big enough, that it didn't have the explosions, nobody shot anybody," said Weisberg. But it wasn't necessary. True to the heart of the show, the real explosion is emotional, not actual.

The Jenningses take daughter, Paige, with them to Canada, leaving their son behind. As their train stops at a station just before it reaches the border, Paige steps off onto the platform, seemingly for a breath of air, but she remains there as the train pulls away, appearing to have chosen the US over the USSR. Whatever her reasons, it seems that the family that spies together cannot stay together.

The Americans at its darkest portrays the cat-and-mouse game between the two superpowers, the two ideologies, as a lose-lose proposition, a zero-sum game with no winners and no exit. Yes, doing the wrong thing is punished, but so is doing the right thing.

In the last, melancholy shot of the series finale that aired on May 30, 2018, Philip and Elizabeth have made it back to the USSR, a country and a way of life to which they've dedicated their lives and sacrificed those of many others. As they emerge from their car on a deserted strip of mountain road, they look down at the twinkling lights of Moscow in the distance, a sight that is at once familiar and alien. They face a homecoming that promises to be as unsettling as their pretend lives in America.

AMC CHASES CHASE

AMC got its *Sopranos* in *Mad Men*, followed by *Breaking Bad* and *The Walking Dead*. Meanwhile, Netflix traded its red envelopes for streaming, with dramatic results.

Matthew Weiner was at his wit's end. With no response to his *Mad Men* script from HBO, a pass from Showtime, and a "Turn it into a half-hour show" from FX's Kevin Reilly, he had no choice but to fall back on AMC, aka American Movie Classics, which had not yet responded: no "yes," no "no"—nothing.

AMC was a division of AMC Networks, which would eventually include BBC America and SundanceTV. If not at the bottom of the barrel, it was close. Rob Sorcher, who was executive VP of original programming, described it as a "lesser TCM," recycling "a collection of shit-ass movies." Still, shit-ass movies cost shit-ass licensing fees, and in 70 million homes, AMC was making money, but not a lot. It didn't have to, because it was owned by Charles Dolan's Rainbow Media, part of his Cablevision company out of Bethpage, Long Island, aka "Deathpage" to cynical AMC employees. This was the same Charles Dolan who had started Sterling Manhattan Cable years before and stood by watching as it molted into HBO. His son, James, ran AMC, the same James who is infamous for his failure to get the family-owned New York Knicks into contention.

Cablevision, like other MSOs (multi-system operators), was treated by the government like a utility. "It was like making TV for Con Edison," says Vlad Wolynetz, who joined the company in 1995 and subsequently became VP of production, series, and movies. He adds, "We were showing movies to stick more wires into people's homes." It was a place, he is fond of saying, where "hope came to die and mediocrity came to thrive."

Senior management was headed by Rainbow's president, Josh Sapan, a tall, slender man with a long, narrow face. The senior executives under Sapan all came out of marketing or the affiliates. Says Wolynetz, "Asking sales people to do creative is a little like asking a basketball player to go into a boxing ring." Sapan's number two was COO Ed Carroll, who came from public relations at Bravo. He was said to be the humorless drone who never got the joke. Charlie Collier was general manager, by several accounts a glad-handing backslapper with a broad smile. His previous experience was selling ads for Court TV. He rubbed the creative executives the wrong way, especially since, as Laura Michalchyshin, who ran SundanceTV, says, "Charlie was an opportunist and if he saw an opportunity to take over, he pushed out [those above him]. He was a climber."

Not everyone shares their low opinion of the AMC executives. Says Mark Johnson, who produced *Breaking Bad, Halt and Catch Fire*, and *Better Call Saul*, all for AMC, "Charlie and Ed and Josh were this triumvirate that I still have great respect for and truly consider them friends."

Sapan was no dope, and he could see the storm clouds gathering on the horizon. Cablevision didn't have the clout to force the cable carriers to offer AMC, and those that did were dropping it. The service was looking at a loss of 30 million homes.

One day, Sapan came to his creative executives and said, "Bring me *The Sopranos*." Sorcher, who had been wondering what he was doing at AMC, thought, *How is that going to work? He's saying compete with HBO, which does the most expensive programming in the business.*

This was Sapan's Hail Mary, and Sorcher took the leap into original programming, adding screenwriter Christina Wayne to the creative mix. "I thought AMC was a movie theater chain," she recalls. "A bunch of basic cable channels were starting to do original programming because of HBO. They knew that if they didn't have must-see TV to bring to the table, they were going to be just one of a long list of other cable channels offering the same crappy movies that everybody had seen five hundred times." Although she was skeptical, when Sorcher told her she would be senior VP of scripted series, she signed on.

Wayne stumbled across *Mad Men* at the bottom of a slush pile of submissions. As she turned the pages, she thought, *This is one of the best scripts I've ever read.* Wayne contacted Weiner's agents, who were less than tickled about getting a call from AMC, which was regarded as the luckless Knicks of cable services. The universal response was, "Who the fuck is AMC?" Weiner's friends discouraged him from accepting an offer. "Don't go," he recalls. "It's really low status, no money, and even if they'd do it, they've never made a show before, and you don't want to be their first one." But he was realistic. It was AMC or the shredder. Neither Weiner nor AMC could afford the luxury of being picky. They made the deal. According to Wolynetz, "Albrecht laughed at us for doing *Mad Men*."

Set in New York City, Weiner's script was about a Madison Avenue advertising company on the cusp of the 1960s, those transitional years hammocked between the end of the sleepy Eisenhower era and the drugs, sex, and rock 'n' roll revolution heralded by JFK. But an ad agency?

With the rest of the world in ruins while the US was untouched, the American religion of the postwar era was consumerism, and its high priests were ad executives. "Admen were the rock stars of that era, creative, cocky, anti-authority," Weiner says, explaining that they provided ". . . a great way to talk about the image we have of ourselves, versus who we really are." He applied the lessons he learned at Chase's knee to *Mad Men*. He set out to tell a story about one thing that is really about something else. It looks like a workplace drama.

"But what it really is," he explains, "is 'I look in the mirror and I don't like what I see. And that's because I've created this false self.' That's the kind of thing that would have never occurred to me before I was on *The Sopranos*."

His Don Draper was yet another good-bad-guy anti-hero, a man whose foremost product is himself, a lockbox of unsavory secrets fashionably gift-wrapped in cover-boy paper. He is the not-so-hidden persuader whose subliminal messages penetrate every nook and cranny of American life, and earn him the title of creative director of Sterling Cooper, the agency with which we would spend almost a decade.

Weiner cast Jon Hamm as his lead. Hamm is handsome in a dark, square-jawed kind of way, the James Bond of Madison Avenue. It was indeed perfect casting, explained Alan Taylor, a *Sopranos* director who helmed the *Mad Men* pilot, because "what we were doing was basically deconstructing that."

The pilot was shot in two weeks at Silvercup Studios with *The Sopranos*' crew during that show's downtime. It cost $3.3 million, which was a lot of money for AMC at that point. With the pilot in hand, AMC lined up Lionsgate to produce it. Remembers Lionsgate's Kevin Beggs, "Rob Sorcher called, and said, 'Nobody will take our phone calls, no one thinks we're serious.' To put a show on a network known for reruns that had never done an original, with not a single name actor that was promotable was a huge risk." Still he says, Lionsgate "loved the conscious choice of casting nonstars and really letting the audience believe in the verisimilitude of those people really existing in the 1960s as opposed to the traditional broadcast marketing where you put a star in the nineteenth version of a comedy with the same star."

AMC covered all but $750,000, which was kicked in by Lionsgate, which ended up owning the show as well. Says Wayne, "It was probably one of the stupidest deals AMC ever made, but they didn't want to take on the liability for production or distribution, because none of the people who worked there had ever launched a show before. They didn't know what the hell they were doing."

Sorcher, Wolynetz, and Wayne protected Weiner as best they could from the AMC executives they all hated. "They were morons, absolute morons," says Wayne. As for Weiner, Wolynetz compares him to "the little kid who got bullied. He always had his dukes up. And sometimes he was absolutely right." Having graduated from Chase Academy, Weiner was unembarrassed to proclaim, "I do not feel any guilt about saying that the show comes from my mind and that I'm a control freak . . ." And as *Mad Men* seemed like it was improbably catching on, he exercised that control with an iron fist. When an enterprising ad salesman made a product placement deal with Jack Daniel's without consulting him, he went ballistic, screaming, "Nobody in my show drinks Jack Daniel's. It's rotgut. If you want me to work this thing into the show, I'm going to have it sterilizing equipment in the back alley of an abortionist clinic."

Nor was Weiner popular with those who worked on the show. Marti Noxon, a consulting producer and writer on *Mad Men*, had a long history of doing the same for a blur of hits, including *Buffy the Vampire Slayer*, *Grey's Anatomy*, and, later, HBO's *Sharp Objects*, which she created. "Maybe in retrospect Matt would express satisfaction with you, but when I handed in my pages, he said, 'I'm not angry at you; I'm just terrified,' the implication being that I had handed him hair balls. I certainly had no confidence in my own voice on that show because his initial reaction to every script was what a disaster it was."

Weiner told *The New York Times*, "No one cried in my room," but Noxon remembers, "You don't play to win with guys like him, you just play to survive. You'd walk into that room and be like, *Is someone going to be in tears by the end of the day? And will it be me?*" She continues, "Then there was a weird ritual of bringing people in that he admired, particularly men, like [screenwriter] Frank Pierson, and then telling them that their scripts were bad." Noxon goes on: "I think that he really enjoyed getting some of his heroes in there and then saying that he could write the show better than they could. Every day just felt like a pageant to his low self-esteem."

Although Weiner complained about Chase rewriting his scripts, when he was in Chase's seat, he did the same. It was as if he was daring writer wannabes to write something that he didn't have to do over. When he wasn't satisfied, which was often, he behaved as if he had been personally affronted. According to writer Chris Provenzano, "It was like a parent. Like you had taken a shit on the rug, and he was like, 'What did you do? Bad! Bad!'" Adds Noxon, "Rewriting some or a lot of the show is not uncommon, but he did it on almost every episode." Weiner claimed writing credit on 73 of *Mad Men*'s 92 episodes. Compare this to other shows with approximately the same number of episodes: David Chase took writing credit on 24 out of 86 episodes of *The Sopranos*, Shawn Ryan took credit on only 17 out of 80 episodes of *The Shield*, and Graham Yost took writing credit on 9 out of 78 episodes of *Justified*.

Writing credit is not just about ego; it's also about careers and money. The protocol is that if it's a given writer's turn in the rotation to do a script, that person gets credit for it, even if some scenes are farmed out to other writers. Explains Todd Kessler, "There are showrunners who put their names on everything and there are others who say, 'Look, I hired this person to write a script. My job is to rewrite it and get it to be what I want it to be. Do I have to put my name on it and take half of the money away from them for their writing?'" Adds Noxon, "I think he thought it was big of him to give other people credit at all."

Mad Men premiered on July 19, 2007, approximately two months after Albrecht resigned, five weeks after *The Sopranos* ended and *John from Cincinnati* made its debut—in other words, when HBO entered the twilight zone.

Sapan had asked for his *Sopranos*, and in *Mad Men* he got it and then some. Weiner's show turned out to be an instant success, and more, a phenomenon, a cultural touchstone. He recalled, "When I found out that a guy I know named his dog 'Don Draper,' I said to myself, 'I think we've arrived.'" After its first season, it won

a Peabody Award, and it would become the first basic cable show to win an Emmy for best drama. The show rippled through every aspect of American life, not only water coolers but dolls, nail polish, and men's suits. Even *Sesame Street* found a way to accessorize *Mad Men* for its toddler audience.

Despite its success, or maybe because of it, AMC was a snake pit of writhing egos. Eventually, the entire original programming staff either resigned or were forced out. Sorcher left in 2008, to be replaced by Joel Stillerman. David Madden, who spent two decades at Fox and would become president of entertainment overseeing all of the studio's shows, says he admired Stillerman, with whom he later developed *The Killing* for AMC. Wayne, however, says she was promised Sorcher's job, but it never happened. She recalls, "Women in my generation who were EVPs or SVPs rose to a certain point and then [crashed against] this glass ceiling. I was like, 'Fuck this shit, 'cause now the whole world knows that I just put all this programming on, and I have made them $400 million in profit in the four years that I was there.' I went back to my office, and there's an HR guy and Joel fucking Stillerman telling me I'm fired and offering me a producer deal. It was the most devastating thing that had ever happened to me. It was disgusting. And may they rot in hell, is all I can say." She left in 2009.

Wolynetz adds, "Christina was the most brilliant development executive I'd ever seen. I would sit in a meeting with her, and she would say something really smart, and everyone would ignore it, and I would repeat it twenty minutes later, and they all told me how brilliant I was. 'Cause I was a guy. That's how much of a male culture it was." Says Michalchyshin, "It was a boys' club. It still is. Look at where they came from. Long Island. The Dolans." Madden adds, "Christina was the smart one of that group. *Mad Men* was her child."

Weiner, too, hated the AMC executives so much that he wrote versions of them into the show. Back-slapping Collier became Duck Phillips, who takes over Sterling Cooper. Recalls Wolynetz, "There are whole phrases that come out of Duck Phillips's mouth that I had just heard Charlie say, because the tape was always on with Matt."

Says Noxon, "It definitely felt like Matt was getting back at all the people who hadn't believed in him or hadn't respected or lauded him."

At the premiere of the final season, they held a black-tie event, where Weiner, according to Wayne, announced to everybody in hearing distance, "You people are fucking assholes for doing what you did to Christina, you're all male chauvinist pigs. You just didn't want her there because your penises are too small."

It was difficult for the craziness at Sterling Cooper to keep up with the craziness at AMC, but Weiner did his best, and *Mad Men* deserved its collection of Emmys. There is no question that when the show was good, it was hard to find one that was better. Through a fog of cigarette smoke, Weiner's agency slowly comes into focus, revealing a withering picture of cultural manipulation executed by entitled white males—WASPs on the wing, as it were—indulging in casual racism, sexism, anti-Semitism, and homophobia that had infected so many of the characters for so long they never even noticed. Asked if the agency has ever hired a Jew when one is thought to be needed to service a Jewish client, Don answers, "Not on my watch. You want me to run down to the deli and grab somebody?" If your gender was male and your color was white, you could sell lies and be handsomely rewarded for it.

The problem was that *Mad Men* wasn't always good. Indeed, it was wildly uneven, with beautifully realized episodes cheek by jowl with clunky ones. Moreover, Draper is burdened by an overwrought backstory so lurid that it's almost comical, and it drags down the office drama. It turned out that our glib, slick Don was the illegitimate son of a hooker and grew up in a brothel. His father got kicked in the head by a horse and died, leaving him at the mercy of his holy roller stepmother, who also became a hooker. One or another hooker—it's hard to keep track—raped him. Enough? Not quite. He has stolen someone else's identity, a fellow GI killed in the Korean War, and "Don Draper" isn't even his real name.

Still, however badly Don behaves, he's more sinned against than sinning. "I don't think [Don is] a bad guy. I don't want you to ever

think that," said Weiner. "This is a story about how hard it is for him." But Weiner succeeded so well in creating a vivid picture of men behaving badly that what begins as critique turns into a male wet dream, full of nostalgia for a time before women, Blacks, gays, and Jews were invited into the corner office. He demystifies Don's world, in other words, only to remystify it. Using the example of Joan Holloway, the overendowed office manager at Sterling Cooper, Daniel Mendelsohn acutely observes in the *New York Review of Books* that the show at once critiques and exploits the era's sexism. It is "simultaneously contemptuous and pandering . . . As the camera glides over Joan's gigantic bust and hourglass hips . . . it keeps eroticizing what it's showing us." Moreover, it's only a short step from male wet dream to male weepy. The undertone of sympathy for Don gives him dimension, but works against the critique.

Art director George Lois, who was one of the rock stars of advertising in the 1960s, said, "The more I think and write about *Mad Men*, the more I take the show as a personal insult. So fuck you, *Mad Men*, you phoney [*sic*] grey-flannel-suit, male-chauvinist, no-talent, Wasp, white-shirted, racist, anti-semitic Republican SOBs!"

Given that Weiner assumed responsibility for every aspect of the show, and given the power accorded white male showrunners, it's not too much of a stretch to say that the same was true of him and his fictional alter ego: "Don Draper, c'est moi." Says writer Marti Noxon, "There was often drinking and getting high after five or six, and I really felt like he was recapitulating the atmosphere of the show. He wanted to be Don Draper, and he's not. The women just fell into Don Draper's arms, but with Matt it was manipulation and power, targeting people about their bodies and their sexuality day in, day out, and an assumption that you have to play to his good side. He was just hitting on a lot of different people. It was pretty relentless. There was a lot of reason to believe that you were only being kept around because he thought you were good to look at. Matt came on to me as well. One time I hit him with a newspaper, like a bad dog. But I felt like I could say no and it wouldn't end my career."

Kater Gordon, a former staff writer, one of several writers-in-training who were referred to as "babies," and worked with him in the same room, nine hours a day for six months on the second season, came forward in November 2017 and accused him of telling her, while they were writing the finale for which they would jointly win Emmys in 2009, that "she owed it to him to see her naked." Gordon added, "Matthew's abuse of workplace power dynamics was rampant, and the comments he made should not be viewed as an isolated occurrence."

Noxon backed up Gordon, tweeting, "I believe Kater Gordon." She went on to explain, "I was at work with her the day after what she described transpired. I remember clearly how shaken and subdued Kater was—and continued to be from that day on." Noxon added that while Weiner is "devilishly clever and witty," he is also, quoting a colleague, "an 'emotional terrorist' who will badger, seduce and even tantrum in an attempt to get his needs met."

With her long and distinguished track record, Noxon was financially secure. She explained the cost of blowing the whistle on a showrunner of a huge show like *Mad Men*, or any showrunner, for that matter: "Taking that action is one thing . . . if you have money in the bank and family to fall back on, but quite another . . . without a safety net." Still, "Kater and I were shocked that no one else would stand up with us," says Noxon.

After Gordon's accusations, Noxon recalls, "There was such a culture of fear. If he let people go or people quit, he would bad-mouth them to us and to other people outside of the show, and tell everybody how untalented they were. It felt like he could ruin our careers. I was still scared a little bit, like, 'What's he going to say about me?' But I felt like I could withstand his shit talk. One of the women he was having something with to this day is like, 'I thought he was in love with me.' I was like, 'Dude, if he was in love with you, he was in love with all these other women at the same time.' I've had so many experiences like that throughout my career it's not even funny."

Weiner initially denied Gordon's charges. He said, "I never felt that way and I never acted that way towards Kater." He told Jenji

Kohan, a close friend, that Gordon's charges were baseless, but he later conceded, "It's not impossible that I said that, but I really don't remember saying it."

On the other hand, according to a good friend, "Do I think he's a difficult person? Absolutely. Do I think he doesn't like the spotlight on anyone else and will punish anyone else who gets the spotlight because he's an egomaniac? Absolutely, but do I think he did something that made him worthy of being fired? No."

Speaking of the spotlight, when Gordon and Weiner collected their Emmys for their script, called "Meditations in an Emergency," in 2009, Noxon recalls, "He was giving his acceptance speech, and she took the statuette from his hand, and said something, and I thought to myself, 'She's dead.'" Adds Wolynetz, "My recollection is that he fired her because she'd gotten up to start talking at the Emmys after he'd told everyone that only he was going to give a speech." Noxon continues, "He apparently turned on her, went from saying how important and valuable she was to being talentless, and he was just carrying her. It was ugly." Gordon left the show right after the Emmys. It was the end of her career.

Noxon, with Gordon, wrote a guest column for *The Hollywood Reporter* recalling his behavior and attributing it in part to Hollywood's love of the "difficult genius," which excuses bad boys with phrases like 'Everyone hates it, but they're so talented.'"

Weiner seems to have mixed feelings about his tenure as showrunner on *Mad Men*, alternately defending himself and admitting he treated his writers badly. He said, "I'm sad that I might have caused people anguish in the job, or made people unhappy. Might have? I did."

The cloud over Weiner persists to this day. He had a project in development at FX in 2020. According to *The Hollywood Reporter*, "FX quickly came under fire for working with Weiner after word of the development deal went public." In February 2022, John Landgraf confirmed that Weiner's project was not going forward.

B ack in 2002, when Weiner was laboring in sitcom hell, and AMC
was airing old movies and looking for its *Sopranos*, *The X-Files*
was spawning some of the talent that would go on to create Peak
TV. Among them was Vince Gilligan, who was ending his stint as
a regular writer and then producer. Gilligan was a screenwriting
prodigy, discovered in Virginia by producer Mark Johnson, who re-
called, "I just felt I'd never read a voice so original." He produced
two scripts Gilligan had written right out of NYU film school, *Home
Fries* and *Wilder Napalm*.

Gilligan was casting about for his next gig when a friend who
also worked on *X-Files* mentioned that he had read about a guy
who made meth in his RV. Gilligan promptly wrote a script about a
guy who made meth in his RV. His guy is a brilliant, self-sabotaging
chemist who fumbled a chance to make billions and finds himself
juggling test tubes in front of glassy-eyed, pimply high school kids
in Albuquerque. He's so poorly paid that he has to moonlight at a
car wash to support his pregnant wife and son afflicted with ce-
rebral palsy. Going from bad to worse to worst, a routine checkup
turns into his death sentence: a diagnosis of Stage 4 lung cancer.
Untreatable.

Wouldn't that turn you on to making meth if you could? It did
Walter White in *Breaking Bad*. Bitter and depressed, with nothing
left to lose, he does what he does best, employing his considerable
skills to cooking the purest crystal meth the world has ever seen,
dubbed "Blue Sky," after its trademark color. He figures that selling
it will earn him the money to pay for his treatment and leave a little
nest egg for his family when he's gone. Living in the shadow of the
grim reaper as he does, we feel for him. Maybe we can even root for
him. As Gilligan puts it, "You say 'I don't like what he's doing, but I
understand, and I'll go with it for as far as it goes.'"

Like Shawn Ryan, like Weisberg and Fields, like Murphy, Gilligan's
ambition was to take advantage of the series format to portray some-
one who changes. As he was fond of saying, he wanted to take Walter
White from Mr. Chips to Scarface.

Johnson arranged a meeting with Sony TV, where he had a deal. Gilligan had a meal with executives Zack Van Amburg and Jamie Erlicht. He might have been desperate, but so were they because, according to Wolynetz, "Sony was going to shut the division down."

Sony TV agreed to produce *Breaking Bad*, but found it next to impossible to find a cable company to air it. Gilligan quipped to his agent, "Why don't you send it to the Food Network? It is a show about cooking, after all." Despite its troubles, HBO often remained the first port of call for unconventional scripts, especially if you were desperate. Gilligan met with Carolyn Strauss. "I couldn't tell whether she was loving it or hating it or even listening," Gilligan recalls. Echoing Weiner, he complained she wouldn't even give him a no. He continued, "They were basically like, 'Just get out of the office, please.'"

With HBO off the list, Sony found it a home at FX, until Landgraf dropped it in favor of *Damages*. It was back to square one, namely AMC. Recalls Gilligan, "*Breaking Bad* was dead by the time AMC came into the picture. I was emotionally moving on to other things, thinking, *Well, we fought the good fight, but this show was just too damn crazy.*"

Gilligan's agent hit AMC in the wake of *Mad Men* madness. Wayne read it and was ecstatic, but Sony wasn't convinced that AMC was actually in the series business, nor was AMC, despite *Mad Men*. It didn't fit the brand, whatever that was. The naysayers felt, "We could be licensing more John Wayne movies and exploiting the blue chip advertisers that *Mad Men* had leveraged. We don't need to do two shows." But Sorcher's gang argued, "Are you nuts? You'll have the two biggest shows on TV, you'll look brilliant." The are-you-nutsers? won, and AMC did look brilliant.

Gilligan turned to *X-Files* for his cast. He remembered directing Brian Cranston in a hard-to-play episode wherein the actor somehow made an anti-Semitic redneck sympathetic, much like the effect Gilligan was striving for with bad boy Walt. When Gilligan's agent sent Cranston the script for the pilot, the actor told him, "Actors are going to want to lift their leg on this. It's like, 'I want to mark it. I want to spray it with my scent.'"

Cranston was born in Southern California to a broken, downwardly mobile, lower-middle-class family. He got his start doing commercials for Preparation H, Shield Deodorant, and Coffee-Mate. He did standup and became known for dumb, off-color patter. Example: Giving free advice to car dealers afflicted with falling sales, he liked to quip, "All you have to do is name the cars after female body parts. Like, 'The perky little Ford Nipple.'" Or, "You'll feel the difference once you climb inside a 'Vulva.'" Occasionally he got bit parts, characters who even had a line or two, until he nailed *Malcolm in the Middle*, which made him if not a star then at least star-adjacent.

Anna Gunn, Sheriff Tim Olyphant's wife in *Deadwood*, was now Walt's wife, Skyler. Bob Odenkirk, who had a small role in *The Larry Sanders Show*, plays a sleazy lawyer named Saul Goodman. He prepared by listening to a CD of Paramount head, producer Robert Evans, a charming sociopath who produced *Rosemary's Baby*, *The Godfather*, and *Chinatown*, reading his memoir, *The Kid Stays in the Picture*. Aaron Paul plays his partner, Jesse Pinkman.

Gilligan delivered a letter-perfect pilot. He screened it for AMC at the IFC Center in New York City's Greenwich Village. Executive Ed Carroll greenlit it on the spot. The AMC folks went to a bar around the corner on University Place to celebrate, until Carroll announced, "When I said that you have a green light, I apparently don't have the power to do that!" The celebration turned into a wake. Sorcher and Collier, et al., had to drive out to Deathpage to screen the pilot for Tom Rutledge, one of Cablevision's senior executives. When it was over, Rutledge said, "That was very interesting. Have you heard about our new cable set-top box technology?" Then he got up and left. Sorcher screamed, "Wait a minute! What about our fucking show!?" Sorcher and Collier chased his car down the Long Island Expressway and caught him at a helipad where he was about to take a chopper to the city. Collier jumped in with him, and by the time they landed, he had talked him into it.

That was it for Sorcher. "When I realized that the company could see something like that but didn't have—that I was going to have to go through what I just went through on *Mad Men* again to get it done, I realized that it was just too difficult to work that way."

Gilligan's new series premiered three months after *Mad Men*'s first season wrapped, on January 20, 2008, and just shy of two months before *The Wire* ended. It was indeed controversial. Cranston quipped, "This is *Breaking Bad*, not *Breaking Good*. So the likelihood of things staying good is bad."

Walt started as your typical good-bad guy, but as one season followed another and he wades up to his waist in blood money, it became harder to remember the good. After furnishing him with an inciting incident we can understand, Gilligan kicks the crutch out from under him. Walt goes into remission, yet he's still cooking up a storm, which puts him in uncharted moral territory. Can we still root for him?

The lead character, formerly known as the "hero," was a colorless milquetoast, depressed, passive, and, worst of all, the lowest of the low, someone who destroys the lives of others for his own gain. Even Tony Soprano drew the line at drugs.

Walt chokes a man with a bicycle lock. He crosses the line that protects children, in this case by poisoning a little boy. In one particularly damning scene, he watches Jesse's girlfriend choke on her own vomit, without lifting a finger to help her. By one count, Walt is responsible for nearly two hundred deaths. Said Gilligan, "I've lost sympathy for Walter White, personally." He explained, "We want to make people question who they're pulling for, and why." Good luck!

Gilligan tried and failed to make Walt impossible to root for. Like the fans of Vic Mackey, Raylan Givens, Tony Soprano, Al Swearengen, and the Jenningses, Walt's fans didn't care how bad he broke; they refused to break with him. According to Robin Weigert, "Anna Gunn got a lot of hate mail from viewers who wanted her character to be a more supportive wife."

Breaking Bad didn't become the instant cultural phenomenon that was *Mad Men*, but the reviews were raves. Stephen King rated it better than *Mad Men*, writing, "Your uncle Stevie may not care much for *Mad Men*, but he has never seen anything like *Breaking Bad*." Comparing it to *The Shield* and *The Sopranos*, he added, "Thank God

for basic cable, if it can produce programming as strange and compelling as this."

Still, by the summer of 2010, AMC was ready to call it quits, telling Gilligan that Season 3 would be its last. Sony quickly found several services that offered to back two more seasons, and AMC reversed itself. Then something happened. The first half of Season 5 premiered in 2012 to 2.6 million, but the finale of the second half of Season 5 aired on September 29, 2013, and jumped to a remarkable 10.28 million viewers, despite going head to head with *Sunday Night Football*, *Homeland, Boardwalk Empire*, and premieres of the scripted network shows. That episode ranked third in the history of cable finales, behind *The Sopranos* and *Sex and the City*.

What happened? Netflix happened!

All in all, party crashers like FX and AMC were doing HBO's job better than HBO was. Moreover, halfway into the first decade of the new century, the purveyors of DVDs—not only Blockbuster, but Walmart, and Amazon—were trying to impersonate Netflix by developing algorithms of their own to predict users' viewing habits, but they were notoriously prone to error. A red-faced Walmart had to disable its proprietary algorithm when it pointed customers looking for content related to Black History Month to *Planet of the Apes*. Netflix had a brush with death when Viacom invested a billion dollars in Blockbuster. Hastings thought, *Uh-oh, we're dead. They're going to take over streaming and kill us.* Instead, they used the money to open new stores! The CEO quit, sold his stock, and invested in Netflix.

Hastings faced a daunting task. He had to build a library that took legacy studios decades to create, while at the same time producing a steady stream of originals. He also wanted to free his algorithm, Cinematch, from the crude ratings system by which customers made their preferences known. He was so obsessed by the viewing habits of those customers that one Christmas he sequestered himself in his Park City chalet with his algorithm during a skiing vacation, ignoring his children and deaf to his wife's complaints.

Netflix found that individual film selection was a less reliable predictor of future purchases than groups of films selected, that is, "taste clusters." Whatever they shared in common was what customers wanted. By 2005, Hastings had so refined its algorithms that he claimed they could predict within "a 10% range whether a movie will be a hit with a subscriber." Tossing William Goldman's old adage—"Nobody knows anything"—out the window, he replaced it with "Our algorithms know everything."

Just as important, if not more so, than rating viewers' tastes was coming up with the most effective way to deliver the films. Apple's iTunes had been streaming music practically from Y2K, and Hastings had had streaming in his sights almost from the start, but was waiting for the moment when, as Ted Sarandos put it, "Streaming economics made more sense than the postal economics," which is say, it was cheaper to stream than to mail. That moment came in 2007—the same year HBO said goodbye to *The Sopranos* and Albrecht, AMC premiered *Mad Men,* and about 50 percent of American households had broadband access. Netflix membership ballooned to 31 million. Hastings boasted to Ken Auletta in *The New Yorker,* "We are to cable networks as cable networks were to broadcast networks." To him, they were horse and buggies.

The pipeline was ready, but there was precious little to push through it. Netflix started its streaming service offering subscribers no more than a paltry six thousand titles. Initially, the old-line studios refused to license their wares to Netflix, invoking the specter of digital piracy. As they were at the dawn of TV in the 1950s, they were wary that the new technology would enable their golden goose to lay its eggs in baskets other than their own. Moreover, the premium cablers had already locked up the best of the new titles in long-term deals. Hastings found himself at the end of a lengthy queue.

The content dam finally broke in 2008 when Netflix paid Starz $25 million in licensing fees for 2,500 movies and series over four years that included Sony and Disney shows. One financial analyst called it one of the "dumbest deals ever." In 2010, Netflix signed a

deal with Epix, and then again in early 2011 with CBS and ABC, to stream TV hits like *Lost*, *Grey's Anatomy*, and *Desperate House-wives*.

The Netflix formula was simple: spend its way to profit. As summarized by Sarandos, it was, "More shows, more watching; more watching, more subs; more subs, more revenue; more revenue, more content."

Netflix's business model had always seemed wonky, so much so that many players, not just Bewkes, expected the company to collapse under its own weight. It borrowed $16 billion in fewer than ten years to create its content library. Says Soderbergh, "Netflix may end up being the Theranos of the entertainment industry." *Vulture*'s Josef Adalian, a dedicated Netflix watcher, quoted one analyst saying, "A wise investor once remarked to us, 'If Jesus were a stock, he'd be Netflix. You either believe or you don't.'"

Meanwhile, Albrecht, now at Starz, was convinced that he would be slitting his own throat by allowing Netflix members to see Starz's shows without paying for a Starz subscription. He was one of the few who realized early on that Netflix was more likely to be an enemy than a friend. As that deal neared its end in 2011, Netflix upped its offer to renew. Albrecht, calling the previous deal "awful," not only demanded ten times as much from the service, but also required that Netflix subscribers pay an add-on over and above the $8 per month subscription fee. Netflix refused, and the deal lapsed in 2012. As Bewkes predicted, the Albanian army didn't have the resources to pony up $250 million to Starz, so in 2013 about 1,800 titles disappeared from the Netflix library.

The Starz debacle, however, wasn't the end of the story. Hastings was not about to accept defeat and went directly to the source, striking a licensing deal with Disney in 2016 that included access to that company's vast library, as well as Disney Animation, Marvel, and Pixar, worth $300 million plus, annually. It cemented Netflix's dominance over potential challengers like Hulu and what was then called Amazon Instant Video, not to mention the cable channels. In

another expression of confidence, Netflix, which had been expanding internationally at a rate of one or two countries at a time, jumped into 130 countries at once.

David Zaslav, CEO of Discovery and eventually of Warner Bros. Discovery, says, "Studio executives [thought Netflix] was never going to really interfere with the core ecosystem. And it ended up eating the core ecosystem. They fed Netflix when Netflix looked like a harmless animal. And then they were stuck having to continue to feed it, when it was clear that Netflix was a beast."

Wall Street was in love with Netflix. Rather than valuing its stock according to quarterly profits, as it did every other company, it was blinded by its explosive growth and power to attract new subscribers. As Bob Greenblatt puts it, "Everyone was scratching their heads about the debt thing for years, but Wall Street is Wall Street."

Netflix was responsible, as we have seen, for the success of *Breaking Bad*. The first three seasons went viral on Netflix, one of the first manifestations of the so-called "Netflix effect." By the time the first half of Season 5 premiered in July 2012, all four seasons were available. Ultimately more people viewed the show on Netflix than on AMC. Netflix paid dearly for the privilege of airing *Breaking Bad*—an estimated $800,000 an episode for streaming rights to those first three seasons and eventually more for the remaining two seasons, to the tune of $78 million total. Streaming opened up a new revenue source for network and cable shows that had previously made most of their money in syndication. The exposure provided by Netflix led *Variety* to wonder whether AMC should have been paying Netflix, rather than the reverse.

Gilligan acknowledged, "[Netflix had] saved our bacon."

In May 2010, after the fourth season of *Mad Men*, Weiner's deal ran out, and AMC and Lionsgate, as the show's owners, had to renegotiate it. At the start, he was making about $60,000 an episode, or approximately $600,000 a year. With the hottest show on TV, and having won three Best Drama Emmys in a row, he demanded more.

It was a three-way negotiation between Weiner, AMC, and Lionsgate. The network, however, was on the hook for most of whatever increase Weiner was to get, and it played hardball. "AMC was making a shitload of money, but it would not share the profits," says Christina Wayne. "The way these companies are run is there's three people at the top who make all the money. Everybody else gets shafted. And when the business doesn't do well, those guys at the top don't take pay cuts, they hang on to their $20 million-a-year paychecks by laying off people. So with Matt, it was, 'How dare he ask for more? We launched him, we made him what he is, a household name.'"

According to Wolynetz, in 2010, Collier asked him, "'Do you think we should close the deal with Matt now, or hold off till after the Emmys, because there's no way he's gonna win a fourth time in a row, so we'll have more leverage because the show will be seen as on the decline.' I said, 'Close the deal now.'" Collier ignored his advice. One industry veteran observed at the time, "AMC may have had too much success too soon, and they think they know how to do it. But showrunners like Matthew Weiner and Vince Gilligan are so rare—you can't replace people like that." In any event, Collier and Weiner were deadlocked.

Months later, after Wolynetz too had left AMC, he ran into Weiner, who complained, "Can you believe they haven't called me about my fucking deal yet?" The show then proceeded to win another Emmy, its fourth, in 2011, for the preceding season, something Collier was certain would never happen. "Meanwhile," continues Wolynetz, "AMC put out a leak explaining that the reason there was no *Mad Men* in 2011 was because Weiner was being difficult." The truth seemed to be that "nobody had picked up the phone to call him. So he went absolutely nuts. He said, 'Can you believe they did this to me? I'm done. The show's over. They lied to me. I would reconsider if there was some way I could hurt them.'" There was.

The Bloomberg press repeatedly referred to AMC as "the *Mad Men* company." But how could it be "the *Mad Men* company" without *Mad Men*? Undoubtedly based on a leak from Weiner's camp, *The Wall Street Journal* reported something like "Josh Sapan stands to make $20 million off the IPO which is in jeopardy if they don't pick up *Mad*

Men." Suddenly there was a marathon negotiation that lasted for eighteen hours. Weiner finally got his money, a three-year deal worth $30 million, with bonuses for every Emmy nomination and win. Still, he wasn't mollified. He made it part of his deal that he didn't have to talk to anyone from AMC. "He became this autonomous island, who often publicly criticized people at the network," Wolynetz continues. "Because he could. And they walked right into it."

The reason that Weiner was worth that much money was that thanks to *Mad Men*, AMC was able to extract higher fees from the carriers and jump-start ad sales. Instead of selling steak knives, *Mad Men* was suddenly selling BMWs. Still, AMC executives weren't happy. Privately, they were rooting for *Breaking Bad* over *Mad Men*, Gilligan over Weiner, during awards season.

Wolynetz liked and admired Weiner. "Every time I've been low in my life, he's been the first guy to show up. The problem with Ed, Joel, and Charlie was that they always wanted to outsmart Matt, but Matt was smarter than they were, at least about his show," Wolynetz goes on. "He understood exactly what *Mad Men* had done. It saved the entire company. One show did it. It was always easy to get Matt to do the right thing—just don't lie to him. That's not how Ed, Joel, and to a lesser extent Charlie played it. They wanted to role-play men of vision. But there were no Michael Corleones in this company, only Fredos."

7

SHOWTIME'S BAD-GOOD GIRLS

Showtime finally found its footing with *Weeds*, then hit big with *Homeland*, and bigger with the *Yellows-* (-*stone* and -*jackets*).

Putting premium cabler would-be Showtime up against HBO seemed like running a donkey against a fine racehorse. Showtime was a perennial straggler behind its cable cousins, both premium and basic. When HBO stumbled at the end of the 2000s, however, Showtime finally demonstrated proof of life.

Showtime was launched in July 1976 as leverage against HBO's domination of the movies-to-cable market. Its prehistory is way too complicated, not to say tedious, to go into here. Suffice to say that eventually it landed at Viacom, which morphed into ViacomCBS, then eventually rebranded as Paramount Global. The company also owns the Paramount Network, BET, Nickelodeon, among others, and several streamers, including Paramount+.

Showtime started in Southern California with a piddling ten thousand subscribers. The inaugural show was a concert special called Celebration, featuring Rod Stewart, Pink Floyd, and ABBA. Two years after launch, it hitched a ride on satellite and went national. In 1981, Showtime jumped to a twenty-four-hour schedule, a few months ahead of HBO, but from the start it languished in HBO's shadow. Michael Fuchs dismissed it as "sucking hind tit forever. They didn't seem to have the wherewithal to compete with us."

Showtime's first real hit was the taboo-shattering *Queer as Folk*, which ran for five seasons starting in 2000. The show offered the first glimpse of gay life on American television, and it was explicit to a fault, portraying mutual masturbation, anal sex, and rimming, although without quite as much graphic detail as the British series on which it was based.

Showtime hired Bob Greenblatt, who had been producing independently since leaving Fox in 1997. He accepted the offer from this nowheresville service against his better judgment. "I never really considered Showtime as a place for me to work," he says. "But the idea of remaking the company, that was a really exciting opportunity."

Greenblatt drew on his experience at HBO: "I wanted to model Showtime after our involvement with *Six Feet Under*. I wanted it to be a place where people who disliked the networks would come. It was never going to be easy to play HBO's game because they were so far ahead of us, but I just thought, *We've got to build it one series at a time*."

Greenblatt had learned a useful lesson when he developed *The X-Files* at Fox that he applied to his new job: "Science fiction back in the early '90s was really a niche genre," he recalls. "We were thrilled when it turned into this global phenomenon." In other words, the lesson he learned was that programming could be quirky and commercial at the same time.

When he arrived, Showtime had already begun to emerge from obscurity, airing *The L Word* in 2004, which did for lesbians what *Queer as Folk* did for gay men. At the time, Greenblatt explains, "Showtime had cultivated a gay and lesbian audience, which I felt we should just keep [doing] because they are there, and because that spoke to me personally." He continues, "I don't have a secret mission to forward the agenda of the LGBTQ community. I just think it's the world that we live in. It's certainly the world I live [in]. But all my friends aren't gay and so why don't shows reflect that kind of mix?" Trying to distinguish Showtime from HBO and its malecentric shows, he explains, "I also decided to develop shows with more female appeal."

Jenji Kohan came by her comedy genes honestly. Her father was a writer for *The Carol Burnett Show*. She grew up in LA and went to Beverly Hills High. A born contrarian, she gave a talk at Columbia University, her alma mater, in which she described taking an exam wherein she wrote jokes in place of the answers she didn't know. One that stood out: "Why should you feel sorry for atheists? They have nothing to say when they're getting a blow job." (She got an A–.)

Kohan once had a boyfriend who told her she had a better chance of getting elected to Congress than of writing for TV, dominated as it was by male writers and showrunners. She was determined to prove him wrong. As soon as she graduated in 1993, she returned to LA and started writing spec scripts. The father of her sister-in-law worked in a building where an agent had an office. He gave the agent a couple of her scripts in the elevator, and presto!—she found herself in the writers' room of *The Fresh Prince of Bel-Air*, a classic fish-out-of-water series wherein Will Smith, later of Slap fame, or shame, plays a street kid from Philadelphia who is sent to live with wealthy relatives in Los Angeles.

Kohan was the only white women in a room full of Black males, pranksters all, that included Smith's bodyguard and his cousin. It was a three-ring circus. One of them peed in a bottle of tequila that belonged to the head writer. After Louis Farrakhan came to town to exploit the South Central riots, she was fondly referred to as the "white devil Jew bitch." Kohan was doubtless flattered.

Defiantly herself, Kohan refused to disappear into the woodwork. Eventually she perfected her "look": Jewish punk. She had always been zaftig, and with a few too many teeth, she has a charmingly crooked smile. She collects and wears cat's-eye glasses. When her hair started to turn gray, she began adding dabs of color, but Crayola wasn't her style. She preferred globe thistle blues, phosphorescent greens of the kind flaunted by exotic fish at the ocean's bottom, and, most often, cotton-candy pink.

Kohan relishes breaking the rules. She hungers for controversy, and if none is available, she creates it herself. She is always ready to say the impolitic thing, to roil still waters by heaving a stone or two

into the pond. As she puts it, "I have this deep-rooted 'fuck you' nature."

As befits the queen of political incorrectness, Kohan is a fierce enemy of quotas, affirmative action, and conventional pieties of any kind, left or right. The #MeToo orthodoxy is no different. She's not interested in diversity in the writers' room, and believes a good writer can portray any color of any gender. "It's always about talent," she says. "If you can find talent with tits, terrific, [but] it's hard enough to find a good writer, so I don't care what's dangling." She adds, "I would never want anyone to tell me I couldn't write male characters because I have a vagina."

Far from hung up on likability, Kohan revels in the flaws of her characters. "I think likability is bullshit—I think people identify with deeply flawed characters because we all are; it's universal. So when you're able to identify with the fuck-ups and the messes I think you feel sympathy."

If Kohan is driven by an ur-impulse, it's trespassing, breaking boundaries, crossing over into alien territory, no-go zones where her characters are strangers in strange lands. "Belonging," aka tribalism, is her enemy. "I want to meet all sorts of people, not to live in my bubble," she says. "And, right now, the world is just 'Everyone back to their corners.'"

Kohan was writing for network shows like *Friends, Will & Grace,* and *Mad About You,* but she was watching *The Shield* and *The Sopranos.* Needless to say, she was frustrated. She knew that if there was a place for her in television, it was on cable. An outlaw herself, she says, "I wanted to do an outlaw show. From there I needed to find an outlaw and a crime." She picked pot because it was a hot topic with the passage of Proposition 215 in 1996, which decriminalized medical marijuana in California. "It was the perfect vehicle because while it's illegal, no one takes it that seriously," she explains. "It's the funny drug."

In 2004, Devon Shepard, who was one of the writers on *Fresh Prince,* was handed a script about a single soccer mom who deals weed. He had dealt weed on the side himself, and he recognized aspects of his own story in the plot. His agent asked him if he knew the writer, Jenji

Kohan. Shepard said, "Do I fucking know her? If your white ass don't put me in the room, I'm gonna choke the shit out of you."

Kohan submitted it to HBO. They turned it down.

After HBO passed on *Weeds*, Greenblatt grabbed it. Kohan wanted more money than Greenblatt offered, so he partnered with Lionsgate to produce it. Lionsgate's contribution sweetened her deal, but it diluted Showtime's. "I didn't have the luxury of insisting on owning our shows," says Greenblatt. "I just needed to get people in the door." Indeed, adds Lionsgate's TV head, Kevin Beggs, "Nobody would work at Showtime, including Paramount, which *owned* Showtime!" He continues, "My suspicion was that *Weeds* would work globally because it skewered the war on drugs. International viewers think we're bananas over drugs, when we don't care about guns."

Weeds's bad-good girl anti-hero, Nancy Botwin (Mary-Louise Parker), lives in Agrestic, a cookie-cutter gated community just over the hills from Hollywood, near the infamous Valley, a name rarely uttered without a sneer because it refers to tracts of sterile "little boxes," like the ones in the show's theme, mostly sung by Malvina Reynolds. Botwin begins to deal dope after her husband drops dead, struck down by the yuppie disease: jogging. *Weeds* is *Breaking Bad* lite, although it anticipated Vince Gilligan's show by three years. Walter White takes up cooking meth to pay for his cancer treatments—that is, to save his life—while Botwin sells dope to pay for her life*style*. Moreover, she's promiscuous, selfish, and leads her older son into a life of "crime" as well.

Not only is Botwin a bad mom, there are virtually no good moms in the show. Elizabeth Perkins, who plays nosy neighbor Celia, is a brittle PTA striver whose performance feels like a preview of Reese Witherspoon's astringent roles in *Big Little Lies* and *Little Fires Everywhere*. Concerned that her daughter's chocolate habit is making her too chubby to succeed in life, she adulterates it with laxatives. In the last line of the pilot, she pithily expresses her attitude toward her offspring: "I should've had an abortion."

Bad dads are rarely frowned on in movies and TV (see Bill Macy in Showtime's *Shameless*), but in American pop culture, motherhood is sacred, up there with puppies and kittens. Even *The Sopranos* reveres motherhood, trashing Livia for being a bad mom. Says Parker, with considerable understatement, "People generally don't take to mothers when they're not represented in an idealized way." Yet Kohan didn't care, and never really punishes Botwin for her sins.

None of the actors thought the pilot would be picked up. Still, by August 2005, *Weeds* was on the air, a half hour on Sunday nights. The reviews were ecstatic. According to *The New York Times*, "'Weeds' has grabbed the kind of critical attention that has eluded Showtime for most of the last decade." Although accurate numbers are hard to come by, in 2010 *The Wall Street Journal* reported that it was still attracting four million viewers per episode.

And no wonder. "Inappropriate" is not in Kohan's vocabulary. Predictably, the dialogue throughout the eight seasons is raw and raunchy, more funny than offensive as in, say, Nancy to Celia: "I don't give a flying fuck if you do have cancer. Put your tits away in front of my kid." When Botwin's stoner accountant introduces her to the world of medical marijuana, he compares it to Amsterdam, "Only you don't have to visit Anne Frank's house." Or this sicko from Botwin's brother-in-law Andy (Justin Kirk) to his nephew-in-law on the virtues of sex with women with disabilities: "I once went out with this girl with a baby arm, insane in the sack, plus when she grabbed my dick with her little hand it looked gigantic." Of the erotic content of her shows, she once said, "I want more fucking, everywhere," explaining that "It expresses everything. It's comfort, it's release, it's brutality, it's companionship. It's so many things. We're all doing it. We're all thinking about it. We don't see it enough."

Kohan's relationship with Showtime was fraught. Premium cable or not, it had its limits, and she chafed under them. Reminiscent of the network rule that allowed characters to utter "Jesus" and "Christ," but not together, "We could show the dildo and we could show the lube," she recalled, "but we couldn't show her applying the lube to the dildo." Kohan complains, "Executives, especially Bob Greenblatt,"

were unhappy with the warp and woof of her characters, especially the warp, and sent Kohan countless script notes. She recalls, "I'd write back note by note for pages. Finally, he wrote back a terse email that said, 'Fine, do what you want.'"

Kohan and Parker were like oil and water. They rarely spoke to each other directly, but communicated through a "talent whisperer." In an exchange Kohan might have written herself, Parker, having thrown a script at her, screamed, "My mother can't watch this!" Kohan responded, "I don't write for your mother." In one scene that caused an uproar, Parker is taking a bath. She was quoted saying, "I didn't think I needed to be naked, and I fought with the director about it, and now I'm bitter. I knew it was going to be on the Internet: 'Mary-Louise shows off her big nipples.' I wish I hadn't done that. I was goaded into it." Their relationship was so acrimonious that Greenblatt cc'd Kohan, probably by mistake, on an email saying he was going to have to fire her. Her response was characteristic: "Good luck with that," and as the show grew and grew, all was forgotten.

Unlike Chase and later Vince Gilligan, she didn't aspire to make her show look like a movie. She wasn't interested in 360-degree pans, or shots of leaves blowing in the breeze. All she cared about was mouths speaking her words. "This isn't a director's medium!" she said. "I'm the auteur in television."

Weeds unleashed a gusher of female-driven, bad-good girl shows, including *Secret Diary of a Call Girl* in 2007. At a screening, Matt Blank, Showtime CEO, made a joke at the expense of his erstwhile rival Albrecht, who was in the audience with Karla Jensen, the woman whose neck he troubled in Las Vegas: "I know it sounds like the secret diary of Chris Albrecht. But it isn't!" Albrecht had no choice but to laugh. *Call Girl* was followed by *United States of Tara*, in which Toni Collette is afflicted with multiple personalities; *Nurse Jackie*, in which Edie Falco is afflicted with addiction; and *The Big C*, in which Laura Linney is afflicted with cancer.

In 2006, Greenblatt had aired *Dexter*, where Michael C. Hall—whom he featured in *Six Feet Under*—played yet another good-bad guy. He is a blood splatter analyst for the Miami PD by day and a serial killer by night. Unfulfilled by counting crimson stains on walls and windows, he kills killers who slip through the gaps in the loosely woven net cast by the criminal justice system. It turned into a hit.

Greenblatt's accomplishments did not go unnoticed. NBC hired him away in 2010, and he was succeeded by David Nevins, late of NBC and Fox, and then Imagine Television, where he supervised *Arrested Development*, *Friday Night Lights*, and *24*. Every new chief executive likes to put his or her (mostly his) stamp on the programming, and Nevins was no different. Greenblatt was known for shows that featured females with failings or, as Nevins put it, "psychological oddities." Greenblatt says, "David wanted to take the programming into more of a male-appeal direction."

Nevertheless, Nevins knew a good thing when he saw it, and when he inherited *Weeds*, which was then in its fifth season, he left Kohan alone, which made him, she says, "my favorite kind of executive." Still, good as it was, there's only so much dope you can sell in the Valley. Nevins pulled the plug after eight seasons in 2012.

HBO, meanwhile, was still stalled in a post-Albrecht midlife crisis. Almost lost amid its bloated development slate was an American version of the hit British show called *Shameless*, created by Paul Abbott and based on his own appalling childhood growing up poor (and bipolar) in Burnley, a town north of Manchester. When he became famous, he says a relative tried to sell his medical records to the press.

John Wells, a megaproducer (*ER*, *West Wing*), took it to HBO, but even he got ground up by their ponderous process, and Greenblatt remembers him complaining, "I've had a very slow and frustrating development experience with this at HBO, and I'd love you to consider doing it." Greenblatt snapped it up, and Nevins aired it in 2011.

Shameless is set in a seedy neighborhood in Chicago's famously seedy South Side. It offers an all-you-can-eat buffet of social issues, not only same-sex relationships, but addiction, to both alcohol and drugs; poverty; broken homes; gentrification; racism; sexism; crime;

you name it, all within the confines of a family, however dysfunctional, whose members actually care for one another. It features Emmy Rossum as Fiona, the moral center of the family, the eldest who raises a brood of kids in the absence of their feckless father, Frank Gallagher (Bill Macy), a drunken bum who uses the gutter as a bed.

Like *Weeds*, *Shameless* waged relentless war on middle-class proprieties. It telegraphed its bad attitude with its outrageous title sequence, set in the Gallagher bathroom that serves seven people. As "The Luck You Got" blares on the soundtrack, each Gallagher does his and her thing in turn: Frank is passed out in front of the toilet bowl and has to be dragged away by Fiona so that she can shimmy off her black panties, pee, and exit, to be replaced by Ian, who jerks off to porn, then makes way for toddler Liam to dip his toothbrush into the toilet before brushing. Next, somebody or other pees in the sink, and then another somebody or other pulls down his pants and fornicates with Fiona on said sink, which we observe from our ringside rearview shot. Nothing, in other words, is too, er, shameful to find a home on *Shameless*.

In *The Atlantic*, John Hendel called it "white-trash porn." Indeed, poverty serves as a springboard for the clever scams the Gallaghers employ to stick it to the Man. Just as 007 has a license to kill, the Gallaghers have a license to steal, lie, and sucker the professionals and institutions of the bourgeois world—the cops, courts, doctors, hospitals, social workers, schools—that have been the traditional subjects of network veneration and to a lesser extent cable. In that sense the show breaks ground. It is anarchic and subversive, but the stakes aren't real. When Frank needs a new liver and can't afford it, he doesn't die; his nurse falls in love with him, and he gets a new one. Poverty is portrayed as freedom, and freedom is fun. Although the characters are sometimes shown working at real jobs, they're hardly the working poor. They are, to underline the obvious, the playing poor. Although unavoidable, given the premise, it's poverty as entertainment.

Despite its faults, *Shameless* more than worked. Over the course of eleven seasons, according to one estimate, across all platforms, it averaged 6.14 million viewers per episode.

The first show Nevins greenlit when he succeeded Greenblatt at Showtime in 2011 was *Homeland*, the American incarnation of an Israeli series called *Hatufim*, aka *Prisoners of War*, a twisty, intricately wrought show about the Israeli-Palestinian conflict. Agent Rick Rosen, representing the Israeli production company Keshet, saw that *Prisoners of War* had potential for American audiences.

When Rosen got back to LA he called Howard Gordon, who co-wrote and executive-produced *24* and whom Nevins had supervised when he was at Imagine and Fox. *24* was just winding up. Rosen said, "I have your next show." Gordon had hired Alex Gansa to work on the last two seasons of *24* and he recruited Gansa for the new show.

"There were a number of things about *Hatufim* that were appealing to us," Gansa recalls. "*24* was a fantasy show born in the wake of 9/11. And here we were, ten years later, with a completely different perspective about how America had responded to the towers coming down. There was no show on television about what was happening in Afghanistan or what was happening in Iraq. There was no show about returning soldiers, about the cost of those wars."

24 was huge, and they were huge with it, but even they knew that if they submitted it to HBO, they would be competing for attention with the likes of Martin Scorsese, David Fincher, Aaron Sorkin, Steven Soderbergh, et al. There was only so much love to go around.

"We just felt that our chances were going to be better at a place that was going to look at the material for what it was, rather than who was bringing the project," explains Gansa. "I had been developing at HBO for a couple of years, and I knew the mountain that you had to climb there, the people that you were competing against, and frankly the star-fucking that goes on." In other words, times had changed. The not-TV cabler was experiencing the aftershocks from the landmines it had planted beneath itself during its "schmuck insurance" days: angry writers who saw their projects languishing, and while they collected development fees, their take-home was nowhere near as much as it would have been had their scripts actually been produced.

Moreover, HBO didn't play well with studios. "It used to be," says HBO's Quentin Schaffer, "we could get shows even if we didn't offer

the most money." Now, agents like Rosen bypassed HBO. Not even getting a chance to bid on *Homeland* was a slap in the face. Plepler and Lombardo were pissed and puzzled. According to Schaffer, they asked Rosen, "Why didn't you offer this to us? We loved *24*." Rosen responded, "You guys have this reputation of always wanting to own everything. And I'm in business with a studio, Fox, and they're producing this, so you're not going to own it, and I know Showtime doesn't care." Moreover, Gordon had a big, expensive long-term deal with Fox. He hadn't come up with a show since *24*, and as one insider puts it, it was like the gloves were off: "Dude, make a fucking show!"

Nevins was in his first week at Showtime. "Rick Rosen called me up and said, 'Hey, you know that show that Alex and Howard are working on? I think it could be good for Showtime,'" except that it was dark, troubling, and hard to watch—exactly what Nevins was looking for. Plus, he had developed *24* with Gordon at Imagine Television. He grabbed it. Despite his reputation and track record, he spent the first year and a half hearing unflattering comparisons between himself and his revered predecessor, Greenblatt.

"Twentieth wasn't jumping up and down to be in business with Showtime because Showtime was notorious for spending as little money as possible," says Nevins. He cleverly turned that to his advantage. "We didn't have enough money to stockpile shows," he explains, "so I always said, 'We are hard to sell to, but once you sell to us, you've got a good chance of getting it made.'" He told Gordon and Gansa, "If you give me this show, I'll order it to pilot right now," something no cabler and certainly no network ever did.

It seemed that *Homeland* was falling into place. But there were two big problems. Americans were getting tired of the "forever war" in Afghanistan, while Bush's adventure in Iraq had been a fiasco. And with Dick Cheney gone, CIA agents were no longer getting their jollies from waterboarding and other forms of "enhanced interrogation," a signature sport of *24*. Like Weisberg, Fields, and Yost on *The

Americans, explains Nevins, "Howard and Alex were very interested in differentiating from Jack Bauer." The most obvious step was turning Jack Bauer into a woman, Carrie Mathison. The second was that they gave her a bipolar disorder. "We didn't want to make Carrie a totally reliable narrator," explains Nevins. "You don't necessarily believe her, and she doesn't necessarily trust herself. It turned out to be a very powerful idea for a thriller. Compared to *24, Homeland* was on another level of psychological complexity."

Carrie's manic depression was an implausible conceit, but one that at least made metaphorical sense, reflecting "how the United States was of two minds about everything," Gansa explains. "Our view of the counterterrorism endeavor was just much, much, much more critical than *24*'s, which was just wish fulfillment. If Jack Bauer was a superhero, then Carrie Mathison was an anti-hero."

The second problem was that Gordon and Gansa had their hearts set on Claire Danes, so much so that when they wrote the first draft of the first episode of the pilot, the name of the character was Claire. Danes was uniquely suited to rendering a condition like bipolarity. Unlike a lot of pert-nosed Barbies who starred in most shows, her features aren't fixed in plaster of paris. Emotions flicker across her face like the sun darting in and out of clouds. She is especially adept at rendering anguish, as she did in her breakthrough series, *My So-Called Life,* and would do again in the extraordinary seventh episode of the FX/Hulu series *Fleishman Is in Trouble.* But some commentators made fun of it—Fiona Sturges wrote in *The Guardian* that it "retains the stricken look of a woman who has 10 seconds to get to a bathroom." Worse, Nevins didn't want her.

"We're doing this with Claire Danes," retorted Gordon and Gansa, and that was that. Ben Salkin, president of the Fox 21 production company, didn't want Damien Lewis, and said, "Never mention his name again." But Lewis, too, was hired, proving what—lots of executives know nothing?

It was evident that unless they really screwed up, the pilot would go to series. *Homeland* premiered on October 2, 2011, attracting 2.8 million viewers, a record for Showtime. The show swept the 2012

Emmys, with an award for Best Drama, as well as trophies for Danes, Lewis, Gansa, and Gordon.

The writers were aided and abetted by "spy camp," a periodic confab between them and fifty-odd CIA officers and journalists. The *Homeland* folks asked, "What keeps you up at night?" Gansa remembers, "The first thing we got was a litany of everything we got wrong: 'We don't talk on our cell phones. We don't operate on American soil. Carrie would have to take blood tests, so the medication would come up.'"

The meetings were surreal. Recalls Gansa, "We had [Bush's CIA head] George Tenet coming up one stair, and Dana Priest, who wrote a bunch of books critical of the intelligence community, going down the other stair because you couldn't have them meet since they just were at such odds with each other. Once Trump was elected president, those two camps were suddenly on the same side."

In one such meeting, at the exclusive City Tavern Club in Georgetown, another Pulitzer-winning journalist, Bart Gellman, said he was bringing a guest. He opened his laptop, dialed a number, and there on the screen was Edward Snowden, hitherto on the run, chattering away from Moscow. Former deputy director of the CIA's clandestine division, John McGaffin, who had no love for Snowden, prompted Gansa to say, "'There's a senior intelligence officer here, and he thinks he knows what's going to happen to you.' Snowden is all, 'What do you mean?'" Recalls McGaffin, "I made Alex say, 'Sooner or later, when they've gotten everything out of you, Putin is going to have you killed and make it look like the Americans did it.' I hope[d] he didn't sleep for weeks."

As the seasons fled by, *Homeland* became a fat target for both the left and the right. The left attacked it, of course, for demonizing Pakistanis, Afghanis, and Muslims in general, all portrayed as al-Qaeda dupes. The cleverest and most widely reported sally came from German graffiti artists hired to make a fictional Syrian refugee camp look more authentic. In Season 5, Episode 2, they tagged walls with Arabic slogans that said, *"Homeland* is racist," among other things. Of course, none of the *Homeland* gang could read them.

Gansa, who by this time had begun to believe that *Homeland* was indeed racist, was delighted. He recalls, "That is the greatest thing that could have happened. We always imagined that *Homeland* was a subversive show. I mean, the whole first season was all about putting an audience on the side of an American Muslim and justifying his terrorist acts. I was thrilled. I said, 'This is going to get us front-page news everywhere.'"

Homeland lasted for eight seasons. Gordon and Gansa knew that saying goodbye could be hard to do, but they managed an electric finale that even eclipsed that of *The Americans*. It's shocking to see the increasingly disillusioned Carrie at the end of the last season in the same state as Lewis's Brody in the first season, apparently defecting to the other side.

In one scene, having lived in Russia for two years, Carrie is pictured comfortably seated next to her lover, Soviet agent Gromov, at a Moscow jazz concert in Stalin Hall, even though hints of their mutual attraction had been sprinkled about like bread crumbs throughout the previous episodes. Afterward, perhaps the happy couple will hook up with Marsha and the Jenningses, not to mention Snowden, passing the time watching bootleg copies of *The Americans* and *Homeland* while collecting their residuals in rubles. She has even written what appears to be an exposé of American espionage—*Tyranny of Secrets: Why I Had to Betray My Country*. But then Carrie is off to the post office to send Saul (Mandy Patinkin), her CIA handler, a copy of her not-quite tell-all, with a little Easter egg hidden in the binding—and we know she's playing the long game, acting out an elaborate double switch. So far as endings go, we'd have to wait for *Succession* to beat it.

With *Homeland*, Showtime had found its groove. Recalls Nevins, "*Homeland* was the 'It' show. It really was the end of Showtime's inferiority complex with regard to HBO, which I hated."

Satisfying though it might have been to beat HBO at its own game, and outstanding as *Homeland* was, by 2011 Showtime was still playing catch-up with AMC, that lowly basic cable channel with

its down-market hit, *The Walking Dead*. Both services passed on it with their noses in the air, but both must have been pleased to watch AMC entangled in a high-profile and expensive bunch of lawsuits with the creatives who made the show.

Veteran writer Frank Darabont (*The Shawshank Redemption*) developed *The Walking Dead*, based on a popular graphic novel by Robert Kirkman, for NBC. Darabont got nowhere with the networks. But when he took it to the usual suspects, only AMC bit and premiered it on Halloween, 2010. Right out of the gate, it was a hit. The first episode drew 5.3 million viewers, and it was off and running from there. Five years later, it was averaging 15.8 million viewers an episode, making it one of the highest-rated scripted shows on television.

Despite its startling success, however, it appeared that AMC was cheapening out on it. For the second season, it insisted that Darabont double the number of episodes—from six to twelve—for three-quarters of the first season's budget. At one point the cabler suggested, for example, that the zombies be heard, not seen, kept off-camera so it could save money on makeup.

Darabont was abruptly fired at the end of July 2011, midway into the production of the second season. The cast and crew were dazed and confused. Said one, "Even when you have a hit, they can still destroy you." Reportedly, AMC was "terrorizing" the cast to discourage bad press. "They're scared," said an insider, speaking of the actors. "They're on a zombie show. They are all really easy to kill off."

Darabont was in the habit of promiscuously sending vituperative emails to everyone in whose work he was disappointed. He claimed their behavior had given him heart trouble. "Fuck you all for giving me chest pains because of the staggering fucking incompetence, blindness . . . and beyond-arrogant lack of regard for what is written." In this vein, he continued, "I deserve better than a heart attack because people are too stupid to read a script and understand the words."

Darabont targeted two writers, Chic Eglee, a veteran of *The Shield* and *Dexter*, and Jack LoGiudice for delivering what he considered inferior scripts, and he told an AMC executive he should have "hunted

down and fucking killed them with a brick, then gone and burned down their homes." Would that his own scripts were as colorful as his emails.

In December 2013, Darabont filed a suit for $280 million in damages, accusing AMC of self-dealing with its vertically integrated production arm, AMC Studios, which allegedly gifted the cable arm, AMC Networks, with abnormally low licensing fees, thereby minimizing the payouts to profit participants like himself. In 2021, Darabont (and talent agency CAA) won a payout of $200 million from AMC. With that in mind, in November 2022, producers Robert Kirkman, Chic Eglee, Glen Mazzara, and Gale Anne Hurd filed a new suit against AMC.

As things turned out, it seemed that AMC walked with the dead for too long: eleven seasons and innumerable spin-offs. It paid the price of becoming a monoshow network, putting all its bodies in the same grave. The problem seemed to be that no one who remained at the network after the exit of the Wolynetz-Sorcher-Wayne gang was any good developing new shows. "AMC was always in the habit of lining up behind one idea and beating it to death," says Wolynetz. "Their greatest successes were not developed there. Each arrived as a complete pilot script." *Better Call Saul* was a spin-off from the same team that produced *Breaking Bad*, and *Killing Eve* was developed by the BBC. Says one source, "They had nothing to do with it other than airing it."

By this time, the Dolans' company, which owns not only the Knicks and the Rangers but Madison Square Garden, Radio City Music Hall, and the Beacon Theater, was being run by Charles Dolan's son, James. "Jim was born on third base, part of that generation that thinks they're entrepreneurial titans, like Trump," continues Wolynetz. "But it's a company that started at an office park on Long Island. They got to a very, very high altitude through no fault of their own, but at the end of the day, they're still at an office park in Long Island." A veritable parade of executives followed the *Mad Men* gang out the door, including Stillerman, Collier, and Collins.

Sapan's job was to be a "Jimmy whisperer," as one source put it. In April 2021, Sapan gave an upbeat interview about AMC's glowing

prospects to *The Hollywood Reporter*, and then left three months later. Says the source, "They haven't been able to hang on to a CEO since Josh left." Finally AMC gave up and made James Dolan interim CEO.

The primary role of the CEO had been "to insulate everyone else from the whims of Jimmy Dolan," says Wolynetz. "What you're seeing is what happens when you have Jimmy untethered. He's petulant. Look at all the people he's banned from Madison Square Garden because they said something bad in public about his management of the Knicks." *The New York Times* reports that he is using facial recognition technology not only to bar lawyers representing companies that are suing him from the venues he owns, but all lawyers working for these companies. On Thanksgiving weekend in 2022, Radio City Music Hall, another of his venues, refused admission to a lawyer shepherding her daughter's Girl Scout troop to a Rockettes concert.

As Wolynetz explains, "Jimmy's not stupid. He has a command of what his business is—cable—but his business doesn't exist anymore. It had tremendous value as an acquisitions target a few years ago, but they missed their window. And Jimmy's reaction to anything that's complicated is to make cuts." AMC has been unordering episodes and shows that have completed shooting.

AMC has become a poster child for the ills that are besetting the cable industry. Since it has already licensed its most valuable asset, the endless zombie saga, to Netflix, chances are it will be picked over and sold for parts, like Sundance Now Channel or Shudder. As LightShed Partners' Rich Greenfield, a highly respected industry analyst, put it, "AMC Networks is the walking dead."

P ost-*Homeland*, Showtime went from hit to hit: *Ray Donovan*, *Billions*, *The Chi*, and *Yellowjackets*, plus some very fine limited series like *The Loudest Voice* and *Your Honor*.

If *Dexter: New Blood* was the most popular show in Showtime's history, *Yellowjackets* is second. HBO, as usual, turned it down—what with its hit, *Euphoria*, it apparently had had enough of teenagers.

Part teenage female bonding, part horror, *Yellowjackets* makes *Lost* look like a Disney series. The showrunners, Ashley Lyle and Bart Nickerson, faced skepticism that girls—schooled in social skills—could devolve into the required savagery. One man said, "What are they going to do? Collaborate to death?" But they proved good Donner partiers. *Yellowjackets* is best known for its casual cannibalism, as a plane carrying a New Jersey girls' soccer team crashes in the snowy wilderness of Ontario's mountains, stranding them for nineteen months. Instead of lobbing snowballs at one another and building snowwomen, the girls turn feral, indulging in demonic rituals, knifings, poisonings, dismemberments, and finally cannibalism.

The captain of the team, the pretty prom queen in most shows, freezes to death at the end of Season 1. As Season 2 begins, contemplating her frozen corpse on an empty stomach in an episode whimsically named "Edible Complex," her best friend gives it a shove, and an ear falls off. She tries to put it back on, but as anyone who has attempted to reattach a frozen ear knows, it doesn't take, and she ends up eating it. After the first bite, the rest of the gang barbecue the body, which smells like sirloin, and digs in.

Ironies abound. Said one of the actors, Jasmin Savoy Brown, "It's kinda funny to do COVID tests and then also be like, 'Hey now everyone just lick and bite this thing!' We exchanged all germs possible, but couldn't ride in the same van!"

Meanwhile, David Nevins lost a power struggle at Paramount Global, which owns both Showtime and the Paramount Network, and resigned.

Along came *Yellowstone*. After it was rejected by HBO, Taylor Sheridan reportedly told Viacom, also in the Paramount Global ownership mix (it's complicated), "You will have no part in any of this—except for footing the bill. I will write and direct all the episodes of the show. There will be no writers' room. There will be no notes from studio executives. No one will see an outline." Sheridan then proceeded to write a blizzard of prequels and entirely new shows, all of them hits to one degree or another. He's a one-man streamer,

Sheridan+. *Yellowstone*, which ended up starring Kevin Costner, not Redford in the lead, concluded after the fifth, 2023 season, as a result, rumor had it, of Costner's sundry dissatisfactions with his employer. He is also preoccupied writing his own multi-movie western series. If a former nobody-actor like Sheridan can write, why not a somebody-actor Costner?

Critics have called *Yellowstone* a "white grievance" show because it chronicles the saga of rancher John Dutton clinging to his land by fighting "progress" and change. When he's elected governor of Montana, he subordinates his gubernatorial responsibilities to the demands of Dutton-hood, and seemingly inherits the mantle of Barry Goldwater, the Republican cowboy candidate who lost the presidency to Lyndon Johnson in 1964.

Sheridan's work, however, presents a lesser-of-two-evils world that has something for everyone, red staters as well as blue staters. Those who think *Yellowstone* and its prequels are red-state shows are contradicted by the gut-wrenching portrayal of homicidal Catholic clergy remorselessly beating, torturing, and killing indigenous women in one of the prequels, *1923*. Sheridan, who has been known to wear a Liz Cheney T-shirt and once called Trump a "motherfucker," pushes back against the notion that *Yellowstone* is a red-state series. "They refer to it as 'the conservative show' or 'the Republican show' or 'the red-state *Game of Thrones*,'" he says. "And I just sit back laughing. I'm like, 'Really?' The show's talking about the displacement of Native Americans and the way Native American women were treated and about corporate greed and the gentrification of the West, and land-grabbing. That's a red-state show?"

If it is a white grievance show, it's a white grievance lite, easy for liberals and conservatives alike to swallow. As James Poniewozik puts it in *The New York Times*, John Dutton is "a Marlboro Man Tony Soprano."

OUT OF LUCK AND OFF-KEY, HBO GETS GAME

Mired in Milch, while Mick Jagger and Martin Scorsese fought over *Vinyl*, *Game of Thrones* came to the rescue, and *Insecure* added some color.

In 2011, HBO was on a knife edge of decline. It looked like the doomsayers were right. *True Blood* was still chalking up numbers, but *Big Love* had ended that year. *Girls* was still making noise, but it wasn't setting records. *Game of Thrones* first aired in 2011 but was suffering growing pains. There was still plenty of bad press. *The Washington Post* dismissed it as a "groggy slog." In 2008, *The Post* added, "They've struck out right and left—five years now. The last year or two was embarrassing, not just bad."

A case in point was David Milch's *Luck*, which HBO was just putting together. If ever a show was misnamed, it was that one, set in yet another seedy underbelly, the world of horse racing. Indeed, it was *John from Cincinnati* at the track, minus, thankfully, John from Cincinnati. Like the Gallaghers, no matter how dysfunctional, HBO still considered itself a family. No one benefitted more from this familial devotion than David Milch, who did something like five pilots for HBO. Had he not had his sinecure at HBO, he might well have become the Frank Gallagher of screenwriters, with his silver tongue and copious addictions. Indeed, in 2016, *The Hollywood Reporter* claimed that Milch had gambled away that $100 million fortune, owed the IRS $17 million, and was put on a $40-a-week leash by his wife.

Luck boasted not only a stellar cast headed by Dustin Hoffman, Nick Nolte, and Michael Gambon, but had added Michael Mann, a heavyweight Hollywood director and showrunner known for a slew of hits, including *Miami Vice, Heat,* and *The Insider.*

The HBO executive who hooked Milch up with Mann was none other than Mike Lombardo. He loved Milch's script and, as one source puts it, "was infatuated with Mann." He showed Mann the script and asked him if he would direct it. As Plepler recalls, "David [too] was very much in favor of Mann. You have talented artists hugging each other." As it turned out, oil and water doesn't begin to do justice to the chemistry of *Luck.* As a Hollywood director, Mann was used to running his own shows, and he did so with a vengeance, but since TV was a writer-driven medium, as the writer, Milch should have been the showrunner, and his creative process involved talking to the actors, going on the set, and even directing when he felt like it.

On the one hand, Milch and Mann were both volatile, both had huge egos, and both were used to getting their own way. On the other hand, they couldn't have been more different. As one source puts it, also speaking of Milch, "If you try to get a straight answer from him, you'll blow your brains out." No one, on the other hand, had any difficulty getting a straight answer from Mann, who was strong-willed and unafraid to make others afraid. Says director Dan Attias, who worked for Mann on *Miami Vice* and Milch on *Deadwood,* "I was surprised they were put together because you had two alpha males who were headstrong about how they wanted something done. It just seemed doomed."

The Sopranos producer Henry Bronchtein called Allen Coulter. He said, "Michael Mann wants to meet with you about *Luck.*" Coulter recalls that Mann was "a tough guy. Mr. Macho. He's got more testosterone than the whole town. He would just intimidate the HBO executives. He said to me once, 'Yeah, they're afraid of me.'"

Coulter knew that Milch was involved and understood that this was the kind of combustible situation for which the phrase "Don't try to mix these two chemicals at home" was invented. But Mann told Coulter, who had managed to avoid Milch throughout his career, that

he wouldn't have to worry: "We have a deal. I control the production, he controls the writers' room. He will not be bothering you." Coulter had never heard of an agreement like that and was skeptical. He remembers, "They each had people that were transcribing their meetings, one person from Michael and one person from David, in the same room at the same time, so they could each consult their notes and hold the other one to his word."

Nevertheless, Coulter went along with the arrangement, although he thought, "What am I supposed to say, 'Michael, I don't believe you'? From the get-go, the lines were blurred. Milch showed up at the first table read to which, as the writer, he was entitled, and Mann literally shoved him out the door and shut it on him. At which point Milch quit."

Milch eventually returned, but he was not a happy camper. Recalls Ian McShane, "I was seeing David at that time, and he was miserable because Michael Mann didn't let him be part of the process." Adds Brian Cox, "Of course, it ended up horribly because David being David, and Michael being Michael, it was very difficult for him to adhere to David's demands and his eccentricities. He's harsh, and I don't think David can work with anybody who's really going to challenge him."

Milch's response, according to one participant, was passive-aggression. It took a lot of pleading, threatening, and cajoling to get him to hand in his scripts, which would often be late. When Mann and Milch were in the same room together, Mann was oblivious to Milch, and Milch just shut down entirely.

Right off the bat, Mann and Milch were giving contradictory instructions to the actors. At one point, while Mann was directing the pilot, facing Hoffman and telling him what he wanted him to do, Milch was standing behind Mann shaking his head and waving his arms, "No, no, no, no, no."

"There was a day that David was going to kill Michael," recalls Nick Nolte, who played a trainer. "It's absolutely true. Michael hadn't turned the film in [for an episode] and David was livid. He said to John [Ortiz], who plays a trainer on the show, 'I'm going to go down

to the editing room and I'm going to kill Michael Mann.' The look on Milch's face was intense, and John was pretty upset and he says, 'David, you really don't want to do that. You don't have a gun, do you?' And Milch tells him, 'No, I don't have a gun, but I have a baseball bat and I'm going to kill him. If I'm not back in a few hours, get my lawyers on the phone.'" Recalls Coulter, "When he busted into the editing room with the bat, Mann didn't even look up, just kept on working. And Milch left." (Mann denied that he banned Milch from the set and the editing room.)

Against his better judgment Coulter became Milch's mole. "Milch is very, very nutty," he continues. "He's very intelligent, and very seductive the way alcoholics are, great at compliments, charming, but very untrustworthy. He'd take me to lunch, and when he saw my cut, he said, 'They can bury that one with me, I love it so much.'

"I went to his office a couple of times, and it looked to me like the inside of a madman's mind. Milch was just like a lunatic. You could tell he was just overwhelmed by his relationship with Mann, and he became lost in the writing—he just couldn't figure out how to tell the story, he was just confused." When it was later revealed that Milch suffered from dementia, it seemed to some that these were the early signs. Says a source close to the production, Milch "was zoning out. It was terrifying. And Michael was the wrong guy to fix it."

Then there was the cost. Milch had spent *Deadwood* off the air. "He was known to be indifferent to budget," Coulter continues. "But Michael Mann restraining Milch was like the fox guarding the henhouse. Michael never saw a budget he couldn't bust. They couldn't control Milch, and they couldn't control Mann." Instead of Mann restraining Milch, HBO had two Milches on its hands—or two Manns, whatever.

One HBO source explains, "Usually, the creative executive on the show appointed by HBO would have the primary relationship with a showrunner. That role was usurped by Lombardo. He wanted to be the director whisperer when we were in business with Martin Scorsese or when we were in business with David Milch or when we were in business with Michael Mann. The problem was his ego

interfered with what was best for the project. That was Mike's downfall."

Luck officially premiered on January 29, 2012. The most enthusiastic reaction came from HBO itself, which immediately renewed it for ten episodes, but its audience dwindled from roughly a million for its January premiere to less than 500,000 by the end of the season.

After two horses died during production, PETA (People for the Ethical Treatment of Animals) accused the show of using old, unfit, and drugged horses, which the cabler and everyone on the production denies. *The Guardian* wondered if the horses had died of boredom. Then a third horse died. HBO stunned the industry by canceling *Luck* on March 14, 2012, toward the end of the first season, when it was already in production for Season 2. Citing the deaths of the horses gave HBO the cover it needed to cancel the show.

Not everyone bought it. Says Coulter, "They were massively over budget. It was just killing them. Would they have forgiven it if it had been a hit? Yes. But it wasn't a hit." It was a sad conclusion to Milch's career. Of all the insanely talented writers who contributed to the era of Peak TV, Milch was perhaps the most gifted.

Luck had been a disaster, mostly of HBO's own making, and worse, an embarrassment. Nothing clicked until the first season of *True Detective* in 2014. Naegle and Lombardo hailed creator Nic Pizzolatto as a genius. That was the good news. The bad news was that he was widely disliked. "He had to be appreciated by everyone as the smartest guy in the room," says a source who worked closely with him on the show. "What was particularly galling to Nic, was that Cary Fukunaga got so much praise for what he felt was his work for the first season."

The worse news was that the second season of *True Detective*, which arrived in 2015, was disappointing. Nevertheless, Lombardo invited Pizzolatto to do yet another, saying, "I'd happily be in business with him for a long time," resulting in an indifferent Season 3. Season 4 is in the works, scheduled for late 2023 or early 2024, minus Pizzolatto.

The Leftovers became a critics' darling, and did much to repair HBO's reputation as a home for quality shows, but viewers were less impressed, and its numbers weren't great. It seemed like the business

model—two new originals in the fall and spring each—might not be enough to fend off the growing competition from basic cable and fetal streamers like Netflix and then Amazon Prime Video.

Just as discouraging as the shows HBO was airing were the shows it wasn't. It had passed on *Weeds, Mad Men, Breaking Bad, Sons of Anarchy, Shameless, The Walking Dead,* and failed to even get a shot at *Homeland.* The combination of internecine warfare, bad calls, and overdevelopment took its toll. Says one well-regarded rival executive who doesn't want his name used, "When production is run by an agent and a lawyer, I don't think that is the best scenario for creative excellence."

After Naegle's departure, the buying spree continued. Spreading the blame, one source points out: "It wasn't like Lombardo got to pick all these on his own." One source points a finger at Plepler as well. Echoing Fuchs and others, she argues that a lot of the projects Lombardo picked up were PR-driven, catering to the tastes of Plepler's dinner guests.

The team of Plepler and Lombardo presided over what would become the longest drought the cabler had known since it branded itself as "not TV." In April 2013, Lombardo signed Ryan Murphy, whose golden touch made *Nip/Tuck* and *American Horror Story* hits for FX, and whose *Normal Heart* would win an Emmy for HBO, to a straight-to-pilot deal for a sexuality series called *Open*—which never did, because he killed it in 2014.

Lombardo ordered a pilot from Jenji Kohan about the Salem witch trials called *The Devil You Know*, with Gus Van Zant (*Good Will Hunting*) directing. It was produced by Lionsgate, where Kohan had an overall deal. The pilot never aired and the project was never heard from again. *Lewis and Clark,* a six-part limited series, was slated to shoot in the summer of 2015 with Casey Affleck as Lewis and Matthias Schoenaerts as Clark. It never happened, either, and HBO blamed bad weather.

Although Lombardo had a reputation for saying yes to everything, after HBO had entered the valley of the shadow of death, he had become considerably more circumspect. Vlad Wolynetz was then at

the BBC trying to sell him shows. "We couldn't get anything moving," he recalls. "Half the problem there was that HBO used to be able to sit on things because 'We're HBO, they'll wait,' and they took full advantage of that. There's a wonderful word in Ukrainian that has no analog in English, *pidstrashena*, which means, 'quaking from the womb to the grave.' That was Lombardo to me, someone who was so terrified of making a mistake he wouldn't make any decisions at all. He had a firm view that we should hold a firm view. He was a mountain of nothing."

While Weiner was struggling with *Mad Men*, David Benioff and D. B. Weiss were shooting the pilot of *Game of Thrones*, entitled "Winter Is Coming." The show would prove beyond successful, and therefore has an air of inevitability about it. In the beginning, however, it was anything but. Every step of the way was fraught with the peril, the possibility, nay, the likelihood of failure.

It was directed by Tom McCarthy, who had helmed the well-regarded *Station Agent*, featuring Peter Dinklage. Production on the pilot began on October 24, 2009, three and a half years after HBO greenlit their pitch, and ended roughly a month later, on November 19, 2009. There was a pervasive confusion over the tone. Was it a drama bowing in the direction of fantasy? Or was it fantasy bowing in the direction of drama? Weiss explained that from preproduction to post were four of the "longest months of both of our lives—sitting there thinking every day that this thing that was a once-in-a-lifetime opportunity . . . and we fucked it up."

The two showrunners were writers, not directors, and they were in way over their heads. They made a lot of rookie mistakes. For example, in an early scene, a member of the Night's Watch talks about returning to the "wall," but the wall had neither been shown nor even mentioned, so viewers had no idea what he was referring to.

Hewing to the assurances the writers gave to Plepler, Benioff and Weiss had downplayed the spectacle and ditched the battle scenes, but as a result, the pilot, filmed in Northern Ireland and Morocco,

had no scope. Lombardo remembers someone saying, "We could have shot this in Burbank." Instead of *Lawrence of Arabia*, they got *In Treatment.*

Screening the pilot for HBO was painful. Benioff and Weiss recall seeing Lombardo sitting with his head in his hands as if he had a splitting headache. "I was just staring at Mike's face," Weiss recalls. "It was like a horror movie."

Weiss told *Variety*, "HBO was really on the fence about whether or not they were going to let this go to series." It was, after all, a project from the old Albrecht regime, but HBO had given Strauss a deal; she was attached to the project and fought for it. The writers recalled that while HBO "was mulling whether or not to green-light the pilot, we kept telling them the show would be a big hit. But we'd never made a TV show before so we didn't actually know what we were talking about. And we knew we didn't. We thought it was likelier than not that we were full of shit."

Plepler must have seen something in the pilot, because he gave Benioff and Weiss another $8 to $10 million to reshoot approximately 80 to 92 percent of it, depending on whom you ask.

Plepler called in his fixit team, comprised of HBO house director Tim Van Patten and cinematographer Alik Sakharov. Initially, Van Patten passed. "I got no more than fifty pages into the first book, and I said, 'I can't do it. I've got to have somebody I can grab and ask, What is this relationship again? Who is this? Where do they live?'" Eventually, he came 'round.

"We had to start from scratch because the original pilot was such a fiasco, with such a three-by-four TV-box mentality," recalls Sakharov. "We wanted to open it up. We didn't want to do something that would resemble small-screen TV, because that was not what was coming off the page. It was calling for a grander, more pictorial scope, more like a feature film."

Finally, Plepler allowed them to go to series. "That first year felt very probationary," Benioff said in 2015. "It was like, 'All right, these guys are probably not very good at this. Let's see what they can do. We've already sunk a lot of money into this pilot. Might as well get

one season out of it.'" A friend of theirs, writer Craig Mazin—who would go on to do *Chernobyl* and *The Last of Us* with Strauss—had seen and hated Pilot #1, then Pilot #2 at the premiere. "That is the biggest rescue in Hollywood history," he recalls telling Benioff and Weiss. "Because it wasn't just that you had saved something bad and turned it really good. You had saved a complete piece of shit, and turned it into something brilliant. That never happens." The $20 million or so pilot was one of the most expensive in the history of the business. Plepler gambled another estimated $50 million on the budget of first season.

Nothing could have been more different from the gamble on *Game of Thrones*, alien as it was to HBO's brand, and guided by its amateur-hour creators working in a déclassé genre, than the show up next, *Vinyl*. On its face it seemed a sure thing, another dark, warts-and-all drama boasting two gold-plated, pedigree producers, Martin Scorsese and Mick Jagger, working in their respective comfort zones where each was a megastar. It was as close to money in the bank as HBO could get. Except for one thing. If HBO, in the post-Albrecht, post-Strauss, Plepler-Lombardo era was notorious for its star-fucking, *Vinyl* would prove that it could just as easily be star-fucked instead. Who were the stars that fucked HBO, the platinum service that was too good to be TV?

Like everyone else, Lombardo was blinded by the glitter of the talent involved, not by the subject, in which he had, according to one HBO source, no interest. It was *Luck* all over again. If celebrity pairings like Milch and Mann had bitten HBO in its corporate ass, the cabler seemed to have learned nothing.

The Wolf of Wall Street, written by Terry Winter, had been Scorsese's biggest grosser, so the director called him in 2008 and asked if he'd be interested in helping him with *Vinyl*. As Winter remembers it, "I put the phone down and I was like, 'Holy shit. Marty Scorsese and Mick Jagger. Yeah, yeah, I think I'd be interested.'"

It took only one season for Winter's dream to turn to ashes. Fresh from *Boardwalk Empire,* he wrote the two-hour movie from a story by himself, journalist Rich Cohen, Jagger, and Scorsese. But the stock market crashed in 2008, and it was not the time for a $100 million Scorsese movie. Winter's wife suggested turning it into a series. Plepler and Naegle bought the pitch on the spot, but it appears that Lombardo was against it from the start. Says *The Wire*'s David Simon, "*Vinyl* was shoved up his ass because of who was doing it, how much heat there was behind it."

The show boasted a strong cast that included Bobby Cannavale, who had stolen Season 3 of *Boardwalk,* Ray Romano, Olivia Wilde, and Juno Temple. If Scorsese had spent $20 million on the pilot of *Boardwalk,* he outdid himself on the pilot for *Vinyl,* spending a reported $30 million. Says Coulter, who, along with Winter, was an executive producer, and directed three of the ten episodes, "Marty so exceeded the budget—by $6 million—that we started with a deficit. We were always behind the eight ball. That was the disadvantage of somebody like him. He's never going to scrimp.

"Neither Lombardo nor Jagger liked Terry's script," Coulter continues. They hired George Mastras, a *Breaking Bad* writer, to redo it based on HBO's and Mick's notes and made him the showrunner of the pilot. Scorsese hated the rewrite. He called Winter and said, "I don't even know what I'm reading. I can't shoot this. I don't know what this is." According to Coulter, Winter fired Mastras, and over a long weekend rewrote the script back to what it had been, with a few changes. Adds Winter, "Mike Lombardo found out about this and blew a gasket. 'How dare you. Who told you to do that?' I said, 'Michael, when I'm the executive producer of a show, and the director calls me up and says, "I don't know what to shoot," I'm sorry, but I didn't think I needed your permission to solve the problem. I would have expected a muffin basket instead of getting yelled at for this, but that's how you roll. George shit the bed here, and Marty hated what he did and I made Marty happy.'"

Adds Coulter, speaking of Winter's rewrite of Mastras's rewrite

and the dynamics at work, "No one can really tell Marty anything. He does what he does. And he has unlimited power. So already you had this schism built into the show. Basically Lombardo was never behind it. But it was late in the game, so that's the script they shot."

Winter defends the show to this day. Lombardo scheduled the premiere of what was basically their two-hour Scorsese movie for Valentine's Day, 2016, at 9:00 p.m. on a Sunday night. It was a choice spot, except for one thing. "That's head-to-head with the premiere of *The Walking Dead*, which is a cliffhanger coming off a cliffhanger from the last season," Winter told Lombardo. "Why are we going up against that?"

"Oh, it's a different audience," Lombardo replied, according to Winter.

"Michael, there is no other audience. Everybody's going to be watching *The Walking Dead*."

"No, no, no, no, it's fine. It's fine."

It seemed to Winter that hubris had overwhelmed HBO. They had a "fucking Martin Scorsese movie as their pilot, so they didn't [need to] tell anybody about it. But nobody watched the pilot. We got slaughtered. They were watching *The Walking Dead*. The headlines the next day said, '*Vinyl* is a disaster for HBO.' What people took away from that was, 'Oh, I heard that show's terrible,' but it was a ratings disaster, not a critical disaster." He says the show scored 74 percent on Rotten Tomatoes, "which is a hit." HBO was still so confident in the show that Lombardo announced that it was renewing *Vinyl* on February 18, 2016, less than a week after the Season 1 pilot aired.

"The whole thing was a bad marriage from the beginning," says Coulter. He points out, jokingly, "Jagger and Scorsese were two men who were essentially ego-less, and willing to listen to everyone." In fact, each was used to getting his own way, but on *Vinyl* they got in each other's way. A taste? Under the headline "Martin Scorsese: HBO's *Vinyl* Failed Because I Didn't Direct Everything," *The Hollywood Reporter* ran a story quoting him saying, "In order to make it right . . . I think I would have had to direct every episode and be there for the three to four years."

HBO was beloved by creatives for leaving them alone, but Winter et al. found themselves in receipt of a flood of notes. Coulter recalls, "Our reaction would be 'You stupid motherfuckers, you must have your heads up your asses.'"

Adds Winter, "If I expressed frustration about getting notes on *Boardwalk*, they were 100 percent worse on *Vinyl*. [They picked at] every little thing, every depiction of every character." The notes were bleeding with PC. He recalls, "'The women in the office need to be more empowered and they need to speak up for themselves.' But it was accurate to the period, 1973, and it was ugly, but we were trying to shine a light on this stuff."

It would have been easy for a showrunner of Winter's stature to just ignore notes like these, but these weren't just any notes; they also reflected the views of Jagger and Victoria Pearman, the head of his company and his eyes on the set. Says Winter, "I thought when I got into business with Mick, I was getting into business with a guy from 1972 who was the poster boy for sex, drugs, and rock 'n' roll. But Mick Jagger circa 2015 was now Sir Mick Jagger, who was a very conservative, proper British gentleman."

"Lombardo hated *Vinyl*, everything about it," Winter continues. "At the end of the year, he wanted me to fire my entire writing staff and make these huge changes in the show. And I said, 'No, I'm not doing it.'" Winter wondered, "What happened to the network that used to pride itself on being ballsy and taking creative risks? And now suddenly, I'm getting notes that I would expect from a network show."

What had happened to HBO? Winter says this "was during the Mike Lombardo era. As the head of the network and programming, the creative decisions were all filtered through his taste, and what he liked and what he didn't like."

As Winter sums it up, "It was really sad. We went from being part of the team that created the biggest show they ever did, and we had all their trust and all their support, to the point where they're questioning every decision we were making, and not only did they not like what we were doing, but they would rather we were really not there

at all—the level of disrespect was incredible—full circle in the span of ten years."

Winter wasn't the only one who had had it with HBO. The climate there had changed for Sheila Nevins as well. "I think that the first thirty years of my work life at HBO were manna from heaven," she recalls. "I gave my heart and soul to my work without anybody stepping on my toes. After Jeff Bewkes left it wasn't the HBO that I loved anymore. Richard wanted celebrity [documentaries]." She, on the other hand, was making docs on freaks like Robert Durst (she commissioned *The Jinx: The Life and Deaths of Robert Durst,* which aired in 2015). She ordered up Laura Poitras's award-winning *Citizenfour,* about Edward Snowden. According to one source, Plepler would say, "How old is she now?" As for Lombardo, she recalls, "He screamed at me. I couldn't even have a discussion with him. He hated me."

Nevins continues, "I was stupid. I really didn't get it. I would tell Richard that Mike was being brutal and nothing would happen. 'Oh, he doesn't mean it. Don't worry about it.' I didn't realize that there was a kind of collusion there."

Says one source, "Richard was really good at blowing smoke up her ass and behind her back saying, 'Oh, she said no to this or that documentary, I can't believe it.'"

Nevins continues, "It wasn't until I left that I realized that I was pushed out. I fought for my shows, but I didn't really fight for myself. I told Richard I was not going to stay after the end of my contract. He said, 'You are going to have the biggest party anyone ever had.' What he meant was *Thank God!* He wanted me to go. It was like cutting my heart out. I thought, 'I've got to get out of this place. It's rancid.' I actually couldn't breathe in the building. I cried myself to sleep too many nights."

Meanwhile, director David Fincher was virtually on fire coming off *Se7en, Fight Club,* and *Social Network.* He was not part of the hemorrhage of talent exiting studio features because they couldn't get work, or the work offered them was so dumb it gave them

migraines. On the contrary, he was one of the few Hollywood direc-
tors who had consistently been able to turn out high-quality movies
that were also commercial. He knew that TV needed him more than
he needed TV.

Fincher, in other words, was dealing from a strong hand. He had
his eye on *House of Cards*, which began life as a novel by Michael
Dobbs, Conservative Party chief of staff in the Thatcher govern-
ment, and was turned into a British TV show. It was about a ruthless,
conniving politician named Francis Urquhart. Fincher's producing
partners, Josh Donen and Eric Roth, brought it to his attention and
told him, "If you want to do something for television, and you're not
too lazy to sit down and watch TV for four hours, this is something
you should take a look at." Fincher did sit down for four hours, looked
and liked what he saw, but recognized right away it wasn't for the big
screen. "Francis Urquhart is not a character that you could build a
$50 million two-hour movie around," he explains. "I can't imagine
a studio that wouldn't be saying, 'Well, he's sort of untrustworthy.'"

Still, Fincher was so smitten with *House of Cards* that he was
willing to take the next step. He turned to Missouri-born Pack Beau-
regard "Beau" Willimon, then twenty-nine, fresh-faced with a shock
of unruly brown hair, and looking way too boyish for his résumé.
Fincher had read and liked his play, *Farragut North*, which George
Clooney had turned into the movie *The Ides of March* in 2011. When
Willimon himself was younger, he worked as a volunteer for several
Democratic politicians.

Fincher called him, and Willimon remembers, "I wasn't particu-
larly keen to write another story set in the political world or to work in
television, which I knew can take up all of one's life. But it was David
Fincher, so that was not a conversation I was going to turn down flip-
pantly. I watched the BBC version. Immediately the synapses started
firing, and I started seeing all sorts of ways to make it contemporary
and American. Between *The West Wing*"—Aaron Sorkin's fantasy
about what presidential politics might look like on another planet—
"and *House of Cards* was 9/11, two major wars in Iraq and Afghanistan,
and the George W. Bush presidency." Willimon continues, "We had a

president who was not just reckless but dangerous. It created this huge whiplash in people my age, and I think for a lot of others regardless of their demographic. The political consciousness that had got submerged after the '60s and early '70s came to the fore." He got on the phone with Fincher. "It turned out that we shared a lot of the same thoughts about what *House of Cards* could be. So we decided to team up."

Willimon disappeared for five or six months. When he resurfaced, he had a pilot and a "bible," an outline of the thirteen or so episodes that would comprise the first season. Fincher loved it. "I went, 'Phew! I can't wait to have my name on that.'" He decided that Willimon was the one to write and run *House of Cards* under his watchful eye.

The bible was sufficiently detailed so that Fincher felt he could approach actors. At the time, Kevin Spacey was set to leave his post as artistic director of London's Old Vic in 2015 and contemplating his future. Fincher had worked with him on *Se7en*, and was eager to work with him again. He recalls, "It was one of those things where you go, 'And who's second choice if Kevin doesn't pan out? Our second choice is not to be in the television business.'"

In the American version, Urquhart, now Frank Underwood, played by Spacey, would become the deeply duplicitous majority whip of the US House of Representatives, soon to be president of the United States. Willimon was happy, Spacey was happy, Fincher was happy.

While he was waiting for Spacey, Fincher plucked Robin Wright out of *The Girl with the Dragon Tattoo*, which he was directing, for what he calls the "Lady MacBeth role," Underwood's glacial wife. Likewise Kate Mara, who lends a feral ferocity to her role as an ambitious journalist.

Fincher hooked up with a production company, MRC, which owned the rights. He had never done TV before, but "I couldn't imagine working around commercial breaks," he says. "I didn't want to work with Standards and Practices. We knew there was going to be nudity. We knew that a congressman was going to eat out a reporter while she speaks on the phone with her dad. We didn't want to waste

our time on people telling us we couldn't do that." Consequently, MRC didn't even bother with the four networks, but went straight to HBO.

Greenlighting a series is expensive, often involving an outlay of many millions of dollars. As a consequence, when executives commit to a new show, unless it includes a conspicuously marketable commodity like, well, Martin Scorsese and Mick Jagger, they do it gingerly, even fearfully, as if tiptoeing through broken glass. So far as the networks went, in 2013 a script that went to pilot stood no more than a 2.1 percent chance of success.

As a consequence, when executives committed to a new show, they listened to the pitch, commissioned a script, and financed a pilot. If it passed muster, they reluctantly went to series, that is, a full season. And at the end of the first season, if the show had done well, maybe they would commit to a second season.

Landgraf explains the prevailing wisdom, which was sensible: "If we're going to go from a pitch to series, we're going to make a lot of mediocre stuff. I try not to commit so much capital at any given moment, because whether it turns out good or not so good, it's going on the air because you've committed so much money, and you've got to recoup as much of that investment however you can."

Even HBO operated with extreme caution. Despite the logjam there, and losing *Homeland* to Showtime, it still clung to its reputation as the Tiffany of cablers, and MRC went there first. Quentin Schaffer recalls, "MRC made a handshake deal with Plepler and Lombardo to shoot the pilot."

Fincher, nothing if not arrogant, figured he and the talent he had assembled had earned him the right to a bigger bite. "I'm asking Kevin and Robin to move to Maryland and give up twelve months of their lives," he explains. "Did I honestly feel that I could get their attention saying, 'Hey guys, you're going to be clay pigeons for somebody to judge and decide whether or not we are allowed to go ahead.' We wanted to live by the sword and die by the sword." He was not about to settle for a pilot, but demanded a commitment for an entire thirteen-episode season, a flagrant violation of the way things were

done. Adds Willimon, "We had a big ask, which was a hubristic thing to do when none of us had done TV before, but it was, 'Why not?' Why not say, 'This is the price of admission for us, otherwise we'd rather not make the show'?"

Despite Hastings's Napoleonic pronouncements, Netflix was still regarded as Blockbuster on speed or, as Bewkes put it, the Albanian army. Consequently, Fincher and MRC didn't go to it for financing, but just to see about a video window should they need one. Sarandos was flooded with scripts, but the cigarette burns, coffee stains, and well-thumbed pages indicated that they had made the rounds before ending up on his desk, so when Fincher knocked, he perked up. In their conversation with Sarandos, however, *Cards* producer Donen recalls, "We were bemoaning this whole notion of pilots, and they said, 'We don't really understand the whole pilot business either.'" Says Sarandos, "The idea of creating a piece of content that nobody would ever watch didn't make as much sense to me as building something that we could predict with a better level of accuracy than anybody else."

Netflix might not have understood the "whole pilot business," but it did understand the algorithm business. Given the fog of war—programming war, that is—imagine the excitement around the promise of a surefire measure of success. If the "taste clusters" they identified could guide the purchases of their subscribers, why couldn't they guide Netflix itself as it plunged into the treacherous waters of scripted originals? Sarandos applied his algorithms to the British *House of Cards*, a DC-based series like *West Wing*, Fincher's previous movies, and those featuring Spacey. The results all pointed to the same conclusion: *House of Cards* would be a winner.

In 2011, armed with his numbers, Sarandos made an unprecedented, off-the-charts offer: Forget the pilot, forget gambling on straight-to-series. Neftlix bet $100 million on two full seasons of Fincher's series. "I knew that everyone would give them a development deal, most people would give them a pilot deal, someone might give them a full-season order, but no one is going to go all the way out

to two seasons," he recalls. "That was the offer they couldn't refuse." Everyone told him he was crazy.

Endeavor agent Ari Emanuel went back to HBO to up its offer, but the cabler had been burned by committing to a full season of *John from Cincinnati,* so its attitude was "never again," and it held fast to its commitment to a pilot only. "MRC didn't honor the handshake," says Schaffer. *"House of Cards* was a show that we wanted to do, and thought we had it, and then Sarandos rather brilliantly snatched it away." According to an HBO source who was involved with the decision, it was "hubris, thinking that people would take less to be here, take a pilot at HBO over a multiseason commitment at Netflix. At HBO, the attitude was, 'Let them spend and piss away a lot of money. It's going to catch up with them. Fool's errand.' But they were playing by a different set of rules than we were at that point. Their stock price was soaring. They were spending aggressively, and HBO wasn't. Jeff was playing a quarter-to-quarter strategy with the Street, trying to move the stock price that wasn't moving, with an eye to selling the company."

Sarandos explains, "I'm building a team that's oriented as [*sic*] saying 'Yes' in a town that's built to say 'No.'" One of the reasons the streamer offered so much money up front was that it had something to prove. As Sarandos puts it, Netflix needed the credibility provided by a big-name director to establish itself as a serious producer of original programming. "After David Fincher directs a series for Netflix, no one else can say, 'Well, I'm not going to direct a series for the Internet.'"

The other reason, of course, was more hardheaded: $100 million represented a flat fee for a buyout of global rights. In other words, the international syndication window was slammed shut. Moreover, according to Cindy Holland, Netflix's VP of content, if Netflix was really going for scripted shows, this was the only kind of deal it could afford. It didn't have the budget to commission and develop dozens of pilots the way HBO did. Holland also recognized as early as 2010 that eventually, when streaming caught on, content providers would no longer be willing to license their shows to Netflix.

Needless to say, Netflix had its way. The *House of Cards* folks were stunned. Now they didn't have to worry about ratings, notes, and focus groups. They were free to do the work of developing complex characters and story lines over the length of a full season. Says Fincher, "When somebody offers you exactly what you're asking for, be smart enough to say 'yes.'"

Despite its algorithms, *House of Cards* was far from a sure thing. It premiered on February 1, 2013, five and a half months before James Gandolfini died. In the very first scene of the very first episode of the very first season, Underwood commits the cardinal sin: he kills a dog. Having heard the screech of tires outside his town house, followed by whimpering, he bursts through his front door, and hastily descends the steps to the sidewalk. It's pitch-dark, but he can see that a dog has been hit by a car. He crouches next to it, stares directly at the audience and explains, "Moments like this require someone who will act, who will do the unpleasant thing, the necessary thing." Then, lowering his eyes, his voice hushed and silky, he soothes the animal, purring, "That's OK"—and wrings its neck.

It's a brave but dangerous way to introduce the main character, a bad guy, but we don't know that yet, except that he kills the dog. When the *Sopranos* writers were trying to concoct something awful for Ralphie Cifaretto to do to his pregnant stripper girlfriend, Mitch Burgess suggested he kill her dog. Michael Imperioli ("Christofah") demurred. He recalled a previous episode in which, stoned on heroin, he sits on Adriana's tiny Maltese, crushing it, and got more fan abuse than he did for the sixteen people he killed in the course of the series. Robin Green piped up: "Can't kill [her] dog, people will go crazy. Let him kill the stripper!"

Undeterred, Willimon did it anyway, despite pushback from Netflix that had made a $100 million bet on this show, and now this? In the opening scene? He believed that it would be a litmus test. It was a "Holy fuck" moment. If it intrigued people, made them want to keep watching, then they were the right audience for this show. If not, not.

He discussed the issue with Fincher, saying, "Look, do you care if we lose half the audience at the beginning?"

"No, I don't give a shit."

"I don't either. So let's do it." Welcome to the world of Washington noir.

Of course, Washington noir was nothing new. In those days, there were a flood of shows that treated Washington like the Vienna of *The Third Man*, a city of intrigue. Says Fincher, "I don't think the show is cynical. I think it's realistic. A lot of people came up to me and said, 'How long have you spent in DC? Because you've got it exactly right.' I said, 'I don't spend any time in DC, but I spend a lot of time in Hollywood. If you're talking about hubris and venality, they're not that different.'"

Fincher was indeed new to TV production, and he was struck by the differences between it and movie production. One of his directors was the indispensable Allen Coulter, whom Fincher asked to bookend the first season, that is, direct the last two episodes after Fincher had directed the first two. He agreed with Fincher's view that so far as directing goes, features and series are apples and oranges. He recalls that HBO and Jagger would pressure Winter to hire feature directors for *Vinyl*, because "They didn't understand that feature directors often don't make good episodic directors."

Coulter liked Willimon. "Fincher is tough on everybody," he recalls. "He is very demanding, and did not take no for an answer. So here's Beau Willimon, he thinks he's the showrunner, and he's got a very powerful director telling him what to do. By the time I came in, and wanted changes in the script, Beau had been beaten up for a year by Fincher, so he did everything I wanted. How can you object to that?"

It turned out the last two episodes of the first season were the only ones Coulter directed, because, in his words, "Kevin Spacey was rude, disrespectful, condescending, insensitive, unprofessional, and arrogant, for no reason." He explains, "To him I was a nobody. I would give him direction, and he would look at me like, 'You gotta be fuckin' kidding.' It's the kind of thing you run into when you're

working with big stars. Their attitude is, *I am not only the actor, but I'm also the writer, and the producer and the creative force of the show. That's when I start looking for the door.* I kept thinking, *It's a shame I'm not sixteen. I could probably get him to do what I want him to do.*

The show was universally admired by reviewers and viewers alike. Its success seemed to prove that Netflix's reliance on data mining was paying off.

Not only did Fincher and *House of Cards* transform Netflix from a service recycling old movies into a company boasting its own original content, as Sarandos had hoped, but they helped Netflix turn the dream of direct-to-consumer services into a reality, successfully eliminating third-party middlemen, in this case the MSOs like Comcast or Charter Communications.

Premium cable and then recorders like TiVo had freed viewers from the tyranny of linear network and cable schedules, known as "appointment viewing"—thereby giving them complete control over when to see a given show. As Hastings put it, "The basic thing was watching on your schedule instead of the programmers' schedule." He predicted that "linear television . . . will be as much of a relic in 20 years as the fixed line telephone."

In the decade to come, Netflix would be less like the Albanian army and more like the nuclear-armed North Korean army.

ame of Thrones had premiered on April 17, 2011. Plepler's gamble paid off, and then some. It became the biggest show in HBO's history. It was strong stuff, even for the "not TV" cabler. Other HBO series had killed off major characters, but rarely in the first season, and they were all compromised to one degree or another. But in *Game of Thrones*, Ned Stark, the putative lead, was a pillar of virtue, which in George R. R. Martin's world is no armor against tragedy. His death, flamboyantly inflicted, flouts the conventions that are so deeply embedded in Western narrative that we don't even know they're there until they're violated. Indeed, goodness, trust, love are not only unrewarded, they're liabilities, and often

punished. As Richard Madden (Robb Stark) puts it, "No one is safe in *Game of Thrones.*"

Van Patten, speaking of the infamous "Red Wedding" sequence in Season 3, adds, "They killed three principal characters within the span of a minute and a half. I've killed a lot of principal characters in my career, but when I saw that go down, I said, 'Holy shit!' My jaw dropped. What the fuck! What balls! Could you have done that ten years ago? Before *The Sopranos*? I highly doubt it."

Game of Thrones is not, however, just blood, guts, and sex. It engages complex political and moral issues with considerable subtlety, distinguishing it from its generic siblings. George R. R. Martin was a conscientious objector during the Vietnam War, and he challenges Tolkien's notion of the good war that provoked an array of fantasy writers to pit brave young men against deformed tyrants swathed in black—good against evil, in other words—whereas in his view most wars are like World War I, wherein an entire generation of men was sacrificed for no better reason than to wipe out the Austro-Hungarian Empire. As the politics of power played out, it became clear that *Game of Thrones* was the anti–*Lord of the Rings*, Martin the anti-Tolkien.

Martin "wanted to explore with Jaime Lannister . . . the whole issue of redemption. When can we be redeemed? Is redemption even possible?" he says. "Woody Allen—is Woody Allen someone that we should laud, or someone that we should despise? Or Roman Polanski . . . When you're at war, do you do whatever it takes to win, or do you actually maintain your own moral standard and ideals?"

Politics is such an integral part of *Game of Thrones* that it couldn't help raising the consciousness of the actors. Says Emilia Clarke, who plays Daenerys, "You suddenly wake up to it and you go, 'Wait a fucking second, are you . . . treating me different because I've got a pair of tits? Is that actually happening?'" Initially, she complained about the "fucking ton of nudity" in the first season, but did it all. "I'd come fresh from drama school, and I approached [it] as a job—if it's in the script, then it's clearly needed." Eventually, however, she began to wonder if so much nudity was essential, and became less obliging.

She recalls, "I've had fights on the set before where I'm like, 'No, the sheet stays up,' and they're like, 'You don't wanna disappoint your *Game of Thrones* fans.' And I'm like, 'Fuck you.'"

Finally, the show strays from the straight and narrow by heroizing misfits, those who are customarily stigmatized as freaks or weirdos at the expense of heteronormative characters. Outsiders become insiders. Girls who behave like men, like Arya, who today we might call pre-trans, are ennobled, while femme men who behave like girls are advisors to heads of state. Drunks like Tyrion aren't dispatched to AA; they become the Hands (counsels) to kings. Some women may be mothers, but they are mothers of dragons, and warriors.

Between the premiere of *Game of Thrones* in 2011 and the finale in 2019, the per-episode cost rose from around $6 million to $15 million, while HBO's operating income rose by almost $500 million. Its domestic subscriber base grew a hefty 16 percent. All the hairline cracks and crevices in the edifice that was HBO were concealed by the veneer of the show's success until the controversial final season.

Meanwhile, Lombardo, despite the broken handshake, had continued to romance Fincher. He signed him up for two shows. One was *Videosyncracy*, a half-hour comedy set in the LA music scene of the '80s. A handful of episodes had been shot before HBO pulled the plug in 2015. The other was a fast-moving, intricate thriller called *Utopia*, based on a British series. The scripts were written by the red hot Gillian Flynn, whose novel *Gone Girl* Fincher had turned into a hit. *Utopia* already had a series order, and was reportedly a month into rehearsals when HBO pulled out, also in 2015.

Mocking the HBO programming executives, and probably referring to Lombardo, Fincher echoed Wolynetz, saying, "There are a lot of people in that position, deciding how they're going to spend tens of millions of dollars, who I describe as the Chihuahua inside a car with the windows rolled up on a hot summer's day. They are people who react to this situation with incessant trembling and dyspepsia."

Fincher avoided HBO, at least for the moment, and took Joe Penhall's serial-killer series, *Mindhunter*, to Netflix, where it became a hit.

With the entire drama division in disarray—drama head Michael Ellenberg was out by January 2016—Lombardo named Casey Bloys to replace him. How Bloys, a kid from Lehigh, Pennsylvania, had navigated HBO's venomous internal politics for so long is another story. The short version is that he "played his politics by being apolitical, which was brilliant, in a subtle way," says Schaffer. "By doing so, he never posed a threat to Lombardo. All he would hear from people was 'Casey's great,' and he was." First he developed HBO's series of hit comedies, then dramas. It didn't hurt that he was not a screamer. Moreover there was no superstar candidate inside the company, and HBO did not have much luck bringing in outsiders.

In April 2016, Lombardo confessed that he didn't have a clue as to what would replace *Game of Thrones*—not to mention *Vinyl*, which was winding up its first and, as it turned out, only season. After *Vinyl* imploded, Plepler invited Terry Winter to dinner. Winter recalls, "When we got through with the how's-the-family stuff, he said, 'I want you to very frankly walk me through what you see as the dysfunction of HBO.' And I said, 'Okay.'" Winter unloaded his *Vinyl* stories on Plepler. Plepler thanked him for his candor, and, as Winter tells it, "Literally ten days later Lombardo was fired."

Bloys was the last man standing. The first thing he did was address the insane number of projects HBO had accumulated. "There was a lot of development, a lot of buying, much more so than we ever would have been able to produce, hundreds of scripts," he says. "I tried to spin that all out. Basically, get the drama group together and say, 'What are you working on that you're just doing just because somebody bought it as a favor? What did you buy defensively?' Because if we passed on something, we would not allow the writer to take it to any of our competitors. Let's try to get real about what we're doing here and be honest with people and give scripts back and let them take them elsewhere. There's this old saying: 'The best answer is a yes. The second best answer is a fast no.' People just wanted to know

where they stood. That really helped our relationships in town when we stopped buying so much."

Bloys had no skin in *Vinyl*, which was still on the table. Killing it wasn't an easy call, given the starry names behind the camera, but the numbers were against it: the ratings were low, and $100 million was a lot of money, slightly less than half the budget for *The Pacific*, and in *Vinyl* there were no battles for Guadalcanal, Okinawa, Iwo Jima, and so on. Meanwhile, *Game of Thrones* was growing more and more expensive. The sixth season was shot in five different countries and cost somewhere in the neighborhood of $60 million to $80 million. In June 2016, Bloys said to Plepler, "Look, even if you get it right, couldn't the amount of money we're going to spend on Season 2 of *Vinyl* be better spent elsewhere?" The answer was yes. It wasn't a popular decision. As Bloys put it, "It did not resonate well in my building." Winter was out as of April 8, 2016.

The end of *Vinyl* was not the end of the world. Even Coulter admits, "Looking back, people in general did not like the show. They didn't like Bobby Cannavale's character. We couldn't see that, because we were inside it. In that sense, I guess Mike and Mick can say to themselves, 'We were right.' I don't know why it didn't work, except for this undercurrent of negativism [that] was coming from HBO and one of the creators of the show. It's not a great vibe to work in, but Terry was into the show, and we all did the best we could."

More important, it marked the end of HBO's relationship with a circle of talent that was largely responsible for much of its golden age. Justified or not, by putting *Vinyl* out of its misery, HBO slammed the door on the *Sopranos* era.

Winter had another year left on his deal, but he was bitter and exhausted. Bloys said, "Let's do another series." Winter replied, "I just spent years pushing this rock up the hill to give you a Marty Scorsese–Mick Jagger series, and I don't have another series in me right now."

Bloys was anxious to introduce more diversity into HBO Max's lily-white programming. Enter a raw, raunchy, and racy show called *Insecure*, a full-blown version of *The Misadventures of Awkward*

Black Girl, a series of 25 ten-minute internet episodes self-produced by Issa Rae for $56,000, much of which she raised on Kickstarter. It went viral, gaining an estimated 20 million views. It attracted just under two hundred thousand subscribers, enough to get the attention of Bloys and his comedy executive Amy Gravitt in 2013. They gave her a half-hour show to do more, much more, on a real budget. Rae co-produced (with Larry Wilmore), co-wrote (with Wilmore), show-ran (by herself), and starred.

Insecure is set in that netherland when young adults are not only insecure but unmoored, drifting between college and careers, flirtations and marriages, and boy or girl friends. In this case, there's the added burden of having to negotiate a world without color.

The first season wasn't easy. Rae recalls, "HBO was not feeling the latest draft and I was losing Larry. I was like, 'This isn't going to happen for me, and I just did all of this for nothing.'" She continues, "I'm going to put everything that I'm going through out on the table in this pilot. If they say no, at least I tried, and fuck it."

Easily recognizable for her red-ish, black-ish hair piled on top of her head at a dangerous angle, and a mouthful of dazzling white teeth that she displays in a signature cheek-to-cheek smile, Rae was born Jo-Issa Diop. She is one of five children of a Senegalese father and an American mother from Louisiana, who got together when they were both students in France and became a doctor and teacher, respectively. Rae calls herself "Halfrican."

Awkward had its roots in her childhood, when she was shuffled about by her itinerant parents from Senegal to Los Angeles to Potomac, Maryland, and back to South LA. A fish out of water in white Potomac, she was again odd girl out in Black LA, where she was considered too uncool-for-school, insufficiently dark by her teenage peers, lacking as she was in familiarity with their cultural totems. The nadir came, apparently, when rapper Tupac Shakur was shot to death in 1996. She had no idea who he was or even how to pronounce his name, and failed to register the shock it caused among her friends. Determined to catch up, she plunged into Black music and the few Black TV shows that were on the air, but the feeling that

she was Ms. In-Between left her uncomfortable in her own skin. She turned this to her advantage in *Awkward Black Girl* and then again in *Insecure*, where she's too Black for white people and too white for Black people.

Not to detract from its originality, which is considerable, *Insecure* is a verbally acrobatic high-wire act drawing on HBO comedies-so-white like *Sex and the City* and *Girls*, darkened by the lacerating humor of *Curb Your Enthusiasm*, all filtered through a Black lens. It bows in the direction of Queen Latifah, Nia Long, Sanaa Lathan, and series like *Moesha* and *Girlfriends*. With a stunning music track courtesy of Solange, it's safe to say that there has never been anything on cable quite like *Insecure* at its best.

The series focuses on Issa Dee (Rae) and her friends, a small group of twentysomething young Black women navigating life, love, and work in Los Angeles. It has some fun at the expense of well- and not-so-well-meaning white folks with their knee-jerk racism, to which they are, of course, all too oblivious. As Rae puts it, her character, Dee, spends a lot of her time "watching white people dictate what's best for black people," but mercifully not too much time, because it's a target that's just too easy to hit.

Rae's goal was "trying to convey that people of color are relatable," she says. "This is not a hood story. This is about regular people living life." Generally, Black roles have either been "focused on specific struggle stories, or we're just side characters, or we're just super-natural, and there was never any real in between," Rae explains. "White people get to have scenes with them just washing their hands and thinking. We don't get that shit."

The first few seasons are consumed by the ups and downs of the love lives of Dee and her friends, who couple and uncouple with reg-ularity. Despite its specificity, Rae succeeds in making this material irresistible to people bleached of color, partly because we come to care about the characters, but also because it's so damn funny. The highlight of Season 1 comes when a collection of young kids in a class Rae is running discover she has done a rap about her best friend Molly (Yvonne Orji), who constantly complains about her sex life.

It's called "Broken Pussy." They disrupt the class and embarrass her by chanting riffs: "Maybe it's really rough, Maybe it had enough . . . Broken pussy . . ."

Rae dissects relationships with surgical finesse, both female and male, the latter ranging from casual click-a-dick encounters to all-consuming ones. Her former boyfriend picks up some stuff he left at her house when he moved out. They have quick sex and he exits, leaving Issa confused. "What kind of fuck was it?" asks Molly. "Was it like a 'We back together' fuck, or a 'Fuck you fuck'?" Issa: "I don't know. It was a nebulous fuck."

Given the prickliness of her characters, relationships take up a lot of screen time. One of the things she does so well, however, is refuse to be trapped or limited by them, so effectively does she dramatize the 1960s slogan, "The personal is political." It can segue into feminism, race, and class issues in the blink of an eye, and she handles it all with potty-mouthed aplomb, sans preaching. In one scene, Molly and Issa complain about the lack of men in their lives:

MOLLY: "One day I looked over, my dick meter was all the way on E."

ISSA: "Join the club, bitch. Dick on E. Bank account on E. Life on E."

Politics lie just beneath the surface, and show up as if by accident, as when Issa pulls off a sweater over her head revealing, briefly, a T-shirt emblazoned with FBI KILLED FRED HAMPTON. In another scene, she walks a few blocks of her old, largely Black neighborhood, Inglewood, and sees her favorite stores boarded up to make way for gentrification. Alive as always to the absurdities and contradictions of her politics, she says, "I want the benefits of gentrification without the gents." She adds, "When I'm driving to work on Crenshaw seeing a Black woman" use the sidewalk for a bathroom "because she doesn't have a home, and she's not being cared for, and people just drive by—we can get used to stuff like this, and I want to do my part because I don't want to get used to it." She adds, "I want to be able

to expand my footprint outside of the industry; I want to make an impact, to combat gentrification, to help combat homelessness in the city."

Then, of course, there's the patriarchy, which is color blind, not in a good way. When Molly discovers that her law firm is paying her less than her white male colleagues who are at the same level she is, she asks for a raise. Instead, the smarmy white partners give her a ridiculous certificate of merit. She defects to a Black firm, only to face the same—sexism of another color.

Molly adopts a different strategy to even the scales. "I'm not one of these pay-me-half-as-much type bitches. That's why I make sure my white clients get less on their tax returns. It's reparations. I feel like Robin Hood. That's what I marched for . . . to do shit to white people."

Rae probably could have gone anywhere after *Insecure*, but she remains grateful to HBO for giving her a shot. "That first season, I was scared as hell," she recalls, explaining, "because the ratings on it were dry then, and they're very aware of being a subscription-based model." She continues, "[But] they've never pulled us to the side, 'Can you explain this first because the audience . . .' They don't care about your broad appeal, which is why I also wanted to make a home with them." She signed a five-year deal with Time Warner reportedly worth $40 million, and at one time has had fifteen new shows in development at HBO and HBO Max.

Rae is building a not-so-modest empire for herself—actually, not for herself so much as others. She wants Black performers and producers to put down roots in the entertainment business because she's seen them get hot and then go cold when everything is "ripped from under us because we don't have the control." She defines "roots" as permanence, longevity, "still being here. Alfre Woodard-ness. Denzel-ness, because he belongs to Black people and has never denied who he is and his roots. There's a legacy there, just realizing your worth. Also, seeing how little these white people care about asking for more than they're worth in many cases. You can't be polite, or tiptoe, or be modest about those things."

STREAM OR DIE

9

NETFLIX'S ALBANIAN ARMY

In 2013, using *House of Cards* as a wedge, Netflix disrupted linear TV with streaming, while Amazon dipped its big toe in the water.

Not satisfied with upending the cable applecart with its two-season buy, Netflix turned around and dropped the entire first season of *House of Cards* at once, all thirteen episodes, thereby further scandalizing both the networks and cablers by discarding the old watercooler model that drip, drip, dripped out shows one episode at a time. "With *House of Cards*, when we put up all thirteen, I had every TV executive in Hollywood tell me what a moronic thing I was doing," Sarandos recalls. "They insisted, 'You have to stretch it out, you have to keep them waiting for more, you have to keep them hungry.'"

Sarandos, however, remembered that way back when he worked in a video store, his customers swallowed whole seasons of *The Sopranos* on DVD. So-called binge-watching completed the transformation cable had started when it had made it possible for viewers not only to choose what they wished to watch, but when they wished to watch, and how much.

Watercooler conversations would go the way of watercoolers, to be supplanted by social media, with an eventual boost from the pandemic that forced fans to work remotely. Nevertheless, a spate of hysterical studies appeared likening binge-watching to drug addiction, and citing ancillary disorders like increased smoking, weight gain, muscle loss,

sleep deprivation, attention deficit, and dopamine flooding, accompanied by anxiety and a sense of loss when a series ends—everything, that is, short of suicide.

Bingeing was indeed addictive, or "immersive," the term its fans preferred. In words that would come back to haunt him, in 2017, when he was riding high, Hastings boasted that Netflix's most formidable enemy was sleep.

Sarandos and Hastings ignored the doomsayers and tried to normalize bingeing by comparing it to reading novels. "When you buy a book," said Hastings, "it's not remarkable that you're allowed to read three chapters one night, and five chapters the next night."

There's no question that bingeing changed the way stories were told for the better. Many of the shows of HBO's golden age, given the opportunity to exploit story arcs, didn't take it. They subordinated plot to character, which was another reason David Chase was so cavalier about loose ends. As we have seen, his attitude was that closure was for fairy tales and network TV, where everyone lives happily ever after. He didn't care about that. What he did care about, and what we remember, are the sharply etched characters: Tony, Carmela, Livia, Christopher, Uncle Junior, et al.

Streaming, and bingeing in particular, revived season-long and even series-long story arcs that allowed us to have story and character at the same time. Moreover, whereas network gospel dictated, "Don't confuse the viewer," eliminating the intervening week between episodes meant they could fracture their narratives. They used flashbacks, flashforwards, and even flashsideways to begin episodes without totally disorienting viewers.

The practice even spread to services that released episodes the old way, once a week. Fans, say, of Showtime's *Yellowjackets*, Apple TV+'s *Bad Sisters*, or Netflix's *Queen Charlotte* could hop between two alternating time frames, past and present. Netflix boasts that *Kaleidoscope* offers a non-linear streaming experience, wherein episodes are designated by colors, not numbers. Different viewers see them in different orders.

Yet another of Sarandos's data crunches revealed that hour-long shows devoted as much as 20 percent of their screen time to reminding viewers what had happened in previous episodes. "Exposition is the writer's enemy," says *Veep*'s co-executive producer Simon Blackwell. Sarandos converted this 20 percent creative advantage into revenue. "When you can give the filmmaker a much bigger canvas, they're going to make much better television, because," he explained in Netflix-speak, "they're worried about nothing but consumer engagement." It was, however, true.

Opportunities like this were red meat for writers who flocked to Netflix and the streamers that followed, bringing actors like Glenn Close, Meryl Streep, and Dustin Hoffman, who in turn attracted the finest directors and showrunners. Before you knew it, you had a revolution within the revolution. Reviewer A. O. Scott wrote, "A simple, linear story can look as quaint as a VCR or a landline phone. We prefer our plots twisted, nested, networked, layered or otherwise complicated."

Obviously, bingeing by itself is no guarantee of quality. After spending $100 million on two seasons of *House of Cards*, Sarandos turned around and dropped another $200 million on the instantly forgettable *Marco Polo* in 2014. But astonishing as the towering monuments of HBO's golden age were and are, there's little doubt that the bingeing model established a floor, if not a peak, of quality. In some ways, however, it was too good for its own good.

Writer-showrunners Robert and Michelle King, who wrote and ran *The Good Wife* and have worked for network, cable, and streaming, feel that streaming and especially bingeing have distended shows, eroding the narrative discipline of linear TV, making them slower and longer than they need to be. Robert King, in particular, feels that once liberated from the discipline of stand-alone episodes, the new, looser series format often feels too *too*—too many episodes, too many seasons—wearing out its welcome. For example, streaming bloat ruined the series finale of the otherwise entertaining *You*. An episode of the second half of Netflix's *Stranger Things* in 2022 ran

an hour and twenty-five minutes, while the finale ran two hours and twenty minutes. "Streaming is like most things," King says. "If you're given too many, you'll break them, and I think one of the things we've broken is the streaming experience, because this whole idea that a series is like an eight-hour movie—I would never sit through an eight-hour movie."

A nother unique thing about Netflix was its culture, fashioned with the help of Hastings's good friend Patty McCord, with whom he drove to work every day and socialized on weekends. He made her head of HR. Employees were paid top salaries, gifted with unlimited expense accounts and vacation time, and encouraged to candidly and publicly disagree with and/or criticize one another, including their bosses. There were no executive dining rooms; the highest of the high, including Hastings and Sarandos, and the lowest of the low sat tray to tray in the company's cafeterias, facilitating the goal of company-wide transparency.

Erik Barmack arrived in 2015 from Disney-owned ESPN to be VP of international content. He was involved with developing or acquiring shows like *The Witcher, Money Heist, Dark*, and so on. He explains, "With *Money Heist*, some network executive would have said, 'We can't have 80 percent of the show in a bank vault because people are going to get bored.'" As for *Squid Game*, which aired years later, "'We can't have the opening scene where half the cast gets gunned down by machine guns.'"

Barmack continues, "In the early years there was more of a tech company culture. It was less hierarchical than traditional media companies. There was a lot of autonomy in buying. Within my team, there were probably ten to fifteen people who could commission shows without really needing approvals." He reported to Sarandos. with whom he had weekly meetings, "but as we went from a couple shows to a hundred-plus projects, it wasn't like he was reviewing every show, or there was some kind of green light committee where

everything was costed out against a budget. It was more like he would say, 'Oh, okay, you're doing a romance in France.'"

Jenna Boyd moved from Nickelodeon to Netflix in 2017, where she was the executive in charge of original series in the children's division. She brought in *Avatar: The Last Airbender,* among other shows. Looking for a change, she didn't even consider Disney, because, she says, "We were getting all this research back about how kids were loving Netflix and YouTube and they were just leaving the linear world. It was done. At Nickelodeon, everything was a secret. At Netflix, every single company memo or strategy as well as financial information was available. You couldn't do anything at Netflix without somebody having an opinion about it that they shared with you and everyone else. The intention of the feedback was to have really incredible type A players not be assholes. It was really cool."

In exchange for freedom and autonomy, Netflix demanded only that employees put the good of the company ahead of their own personal needs. It expected them to behave like grown-ups who could be trusted to supervise themselves and refrain from abusing the goodies Netflix so freely dispensed. As McCord summed it up, "Hire, reward, and tolerate only fully formed adults."

The "Netflix Way" was brilliant but implacable. The company regarded itself as a "dream *team*," not a family, which is to say that hard work, loyalty, and friendships were subordinate to performance—and even performance, no matter how stellar, delivered no guarantee of continued employment unless accompanied by innovation, which Hastings prized above all things. In other words, Netflix treated its approximately 11,300 employees like male cicadas. Once they finish the job for which they are hired, they are fired, unless their performance was outstanding—and innovative.

By January 2019, Hastings and Sarandos had grown the company so fast that total chaos reigned. "The volume ambitions were massive," Boyd recalls. Volume was important, Sarandos explains, because it not only provides something for everyone but builds a library. And, Boyd continues, the rapid growth "spurred this incredible culture of

feeling like 'Oh, I work in the kids' division, but I could do this other kind of show because I found something fantastic.' So, 'Let's do it.' But it was incredibly confusing pitching multiple executives. There were no budgets. Every division was scaling up and there was a lot of overlap. There needed to be a come-to-Jesus moment recognizing everybody can't do everything. That's when a lot of reorganizing needed to happen." Eventually, Boyd was reorg-ed out of her job.

From a strictly ethical and rational point of view, it was laudable, but Hastings's attempt to inspire his employees to be their best selves sometimes brought out their worst selves. The aspirational slogans about candor, transparency, and so on turned out to have a dystopian side. Instead of doing their best because they should, they did it because they were afraid—afraid of being fired if they didn't. In one instance, a woman in tears, having just been terminated, was packing up her boxes, while the rest of her team ignored her because they were afraid that "helping her would put a target on their back," explained an employee. Some managers apparently felt driven to fire people lest they be regarded as soft and get fired themselves.

"Maxing up candor," in Netflix-speak, required getting rid of "normal polite human protocols" in favor of a Darwinian approach that favored the survival of the fittest. Erin Meyer, who helped Hastings write his book, *No Rules Rules*, compared the Netflix Way to *The Hunger Games*. Employees were subject to the "Keeper Test," which Hastings used not only to weed out hardworking but average performers, but also, in his words, "complainers and pessimists. Most of them would have to go."

The Keeper Test requires the managers of various divisions to ask themselves how hard would they fight to keep someone. If the answer is "not that hard," that employee is history. The culture of candor also demands that the blemishes and faults of newly departed employees be "sunshined" for the edification of their peers in company-wide assemblies.

Ironically the Netflix Way eventually claimed McCord herself, who was known as the "Queen of the Good Goodbye" for the exemplary way she had fired scores of employees over the course of her

fourteen years with the company. Hastings even fired mathematician Neil Hunt, who was at Netflix from the very start, a close friend and one of the brains behind the company's algorithms. Nevertheless, many employees valued their tenure at the company even after they were keepered out the door.

Despite Hastings's high-minded words about candor, he quickly lowered the flag, excusing himself from responsibility when Saudi Arabia pressured Netflix to withdraw an episode of a series called *Patriot Act* that included some not-so-nice things about Crown Prince Mohammed bin Salman, widely alleged to have ordered the dismemberment of dissident journalist Jamal Khashoggi. "We're not trying to do truth to power," he airily asserted. "We're trying to entertain." (Hastings did go on to point out that Netflix retained the offending episode on YouTube.)

On the other hand, one source praises the company for its dedication to diversity. "It's actually taking funds and putting them into Black-run space versus not just saying, 'We want diversity.' I sit in the creative leadership meetings for the animation department, and it's one of the most diverse rooms I've ever been in in my life." Netflix joined scores of CEOs denouncing the state of Georgia's voter suppression laws in 2021, and the following year over its anti-abortion laws. But as of 2023, Netflix is shooting *Back in Action, Collateral Data, Six Triple Eight, A Family Affair, The Electric State,* etc., etc.

When Sarandos decided to get Netflix into original programming, it didn't just get its toes wet. With characteristic bravado, it jumped in with both feet. *House of Cards* was a big bite for one year, but Netflix had a big stomach. Jenji Kohan had an overall deal with Lionsgate, and had written a number of scripts for Kevin Beggs. Among them was *Orange Is the New Black,* based on Piper Kerman's 2010 memoir, which Lionsgate optioned for her. Kerman was a blonde, WASPy Smith College graduate who did thirteen months of a fifteen-month sentence in Connecticut's Danbury Federal Correctional Institution for delivering a suitcase full of drug money for her

heroin-trafficking girlfriend on behalf of a colorful Nigerian drug lord.

Kerman might not have been among Smith's finest, but her book had Kohan's name written all over it, providing the showrunner with an aha moment. In it, she saw the opportunity for a female version of Fontana's *Oz*. She knew it would be catnip for an off-network service, constructed as it was around a favorite Hollywood trope: a fish out of water, in this case Kerman—her Trojan mare. "If you go to a network and say, 'I wanna do prison stories about Black women and Latino women and old women,' you're not gonna make a sale," she explains. "But, if you've got this blonde girl going to prison, you can get in there, and then you can tell all the stories. I just thought it was a terrific gateway drug into all the things I wanted to get into."

Still, *Orange* was not an easy sell. Kohan took it to her home, Showtime, which was airing *Weeds*, and expected a warm welcome. But the cabler, she recalls, "said 'No.' So fuck them!" Why? "When I first heard about it, it was very much about the upper-middle-class white woman going to jail," says David Nevins. "What ultimately made the show sing were all the other characters. And they were definitely not as evident in the initial pitch." Beyond that, he concludes, "Sometimes you just miss."

It was 2011, the trades were ballyhooing Fincher's deal with Netflix, and Kohan thought, "Why not?" She explains, "I had come through decades of the pilot system, which I always felt was stupid and inefficient. And here was this new thing saying, 'Let's shoot the whole season'—and with a respectable budget." Netflix excited her, she explained at the time, because "It's the Wild West. You can do what you want. What could be bad?"

Orange was different from *Weeds*. Instead of one good-bad girl, why not a prison full of them? It was also totally different from *House of Cards*, its opposite in theme and approach. There was no Netflix brand. Rather, it was a platform, and the more disparate its shows the better. Nobody says, "I love Netflix for its teenage romances, or its Mafia series." Netflix was all four networks plus cable rolled into one.

Sarandos credited Cindy Holland, VP of original content, with seeing the potential of Kohan's show. Netflix committed to the series instantly, in the room. "That was miraculous," she says. "That is every showrunner's dream, to just 'go to series.'"

At that time, Netflix didn't know what it was doing, knew it didn't know what it was doing, and for the most part did nothing. Kohan continued, "Their opening statement was: 'You've done TV before, we haven't. Show us.'" She praised Netflix executives for not "pissing in the corners." Netflix and Kohan were a match made in heaven. Disrupters in love.

Casting Piper, in Kohan's words, "was enormously challenging because I wanted that Americana ice queen . . . the cool WASP, privileged white girl. Usually, women in that package aren't funny, and Taylor [Schilling] is. She's actually a hot girl who can do comedy, which is like a unicorn."

After Schilling, in casting the other actors, Kohan was treated to an embarrassment of riches. "The pools of talent are so deep when you have a call for Latin women or Black women or a middle-aged woman because they never get their shot," she explains. Jen Euston, the casting director, adds that these were "character actors, women who weren't stick-thin, women who weren't 'beautiful.' The satisfaction in getting . . . actresses I've known for years cast into roles that weren't just 'Nurse No. 1'—roles that had names, history and arcs that became series regulars—I've never been asked to cast that before."

There were few if any transgender actors on TV when Laverne Cox, who had tried to commit suicide when she was eleven, got the role of Sophia, the Black trans hairdresser. Attacked by anti-gay protestors, Sarandos recalled seeing the GOD HATES FAGS signs they held aloft at an Oscar ceremony. Eventually Cox got her own sign: the cover of *Time* magazine.

Lea DeLaria, who plays the ultrabutch Big Boo, says, "I would have given my left nut to work with the creator of *Weeds*." She adds, "Lesbians on American television are usually pretty and feminine, or hard sexy girls. They are most often doing each other to the delight of the 16-to-24-year-old straight male audience for whom these

images are created." She looked around her set and said, "This set is like a dyke bar," adding "girls lick girls here." Indeed, the characters satisfied their sexual needs in a variety of novel and inventive ways. Whatever taboos Kohan had left standing in *Weeds*, she knocked down here. Nudity was ho-hum. There was fisting, squirting, dildos, and masturbation.

Kohan gave each and every one of her characters a humanizing backstory, even the Margaret Thatcher of the prison kitchen who feeds our girl Piper a used tampon sandwich to get even with her for something or other. The theme of the show, in Kohan's words, was: "You are not your crime."

No attempt was made to prettify the actors. Said Selenis Leyva, who played Gloria Mendoza, "We have no makeup on . . . They give you bigger pores, or highlight a pimple or bags under your eyes. We all look bad." Kohan's characters would have been less at home in the pages of *Vogue* than *National Geographic*.

With no censors or advertisers to worry about, Kohan took the show where none had gone before, exploring issues like sexual fluidity, gender bias, body shaming, punishment for profit, the criminalization of poverty, racism, you name it. It was all safely nested within the protective conventions of a prison drama that allowed—nay, demanded—all those goodies that audiences expected from that genre: violence, rape, beatings, stabbings, murder, and, last but not least, black humor. Female prisoners, no matter what they looked like, had permission to be funny.

For all Kohan's dismissal of political correctness, *Orange* is steeped in contemporary, real-world conflict. In 2016, two years after Eric Garner died in a choke hold and four years before the death of George Floyd, Kohan devoted Season 4 to Black Lives Matter. Fan favorite Poussey Washington (Samira Wiley), a tiny Black woman, is crushed to death by a large white male guard who places his knee on her back. Still, in Kohan's universe, character and the integrity of the story—that is, entertainment—come first, not issues. If the prisoners are more than their crimes, so are the most sadistic and racist guards.

Orange Is the New Black premiered on July 11, 2013, to rave reviews. Shonda Rhimes had just launched *Grey's Anatomy* when she met Kohan. She had been a *Weeds* fangirl, but when she heard about *Orange* she was "suspicious": "It seemed to be a show about a rich white woman's prison struggles, written by a white woman, when we know that white women are not the majority of people being victimized, forgotten, and destroyed by the prison system." But, she went on, "There are stories told on that show from the perspectives of women of color—and trans women and lesbians—that I don't think I'd ever seen before."

Kohan's show was the sleeper among Netflix's handful of new series, promoted with whatever scraps it had left over from its higher-profile originals, but it became the streamer's most watched series and one of the most original series ever to appear on the small screen. The first season of *Orange* was nominated for twelve Emmys and won three. Kohan, naturally, doesn't put much stock in awards. As she put it, "They can all fuck themselves."

For Netflix, *Orange* was the new green, driving up its stock price from under $60 a share in 2012 to over $400 a share in 2013. Of course, skyrocketing share prices had to be balanced against the cost of originals plus licensing fees for its movies, amounting to a $58 million negative cash flow in 2012. But Netflix was a company that, even when it was broke, never shied away from going for broker.

Just as important, *Orange* firmed up the streamer's reputation for providing a warm welcome for creatives. Says Holland, "There was some expectation that *House of Cards* would be good because of David Fincher—not because of us. There was a lot of chatter in the industry that you can get lucky once. *Orange* proved we weren't just a one-trick pony."

The Netflix frenzy, even then, had to be tempered by the wonky ways it measured success. In 2014, Netflix beat out HBO for *Bloodline*, from the Kessler brothers and Daniel Zelman, by offering a full season off a pitch; HBO, as usual, offered them only a pilot. *Bloodline* is a powerful but unaccountably neglected gem.

Recalls Todd Kessler, "At some point, Netflix told us that *Bloodline* had, and this was the quote, 'the highest intent-to-watch of any

series that they had had on their service.' We asked what does 'intent-to-watch' mean, and they said that it was in the most queues. As long as it stayed in their queues, then members wouldn't cancel their subscriptions. It was like, 'What world are we in right now? You don't even have to watch the show for it to be a success?'"

Moreover, *Bloodline* was not a great experience for the creatives. The humble *We don't know anything so show us* attitude that so impressed Kohan was nowhere to be seen. Says Kessler, "Netflix didn't really understand what the show was. And we got notes from them that it was moving too slow, so we speeded it up, and then they said it was moving too fast. It was just like a moving target all the way through." He adds bitterly, "This was in the first wave of Netflix canceling shows for no reason. They always needed new product." Indeed, canceling shows after two or three seasons became the Netflix Way.

When Hastings, myopically gazing at his own navel, once declared his only competition was sleep, he repeated the mistake made by Bewkes when he myopically declared that Netflix posed no more of a threat than the Albanian army. Sleep may have seemed to Hastings like his company's only threat, but solely because potential competitors had not yet awakened to the fact that streaming could grow their bottom line, even be a business of its own. Amazon was the first Big Tech company to take him on.

Amazon executive Roy Price was Hollywood royalty. One of his grandfathers, Roy Huggins, created TV hits like *Maverick* and *The Fugitive*, and hired David Chase to write for *The Rockford Files*. His father, Frank, headed up Columbia Pictures and then Universal Studios.

Price the Younger had a gilt-edged pedigree that included Phillips Andover Academy, Harvard, and USC law school, as well as a stint at McKinsey & Company and Disney Animation, impressing Princeton-educated Jeff Bezos so much that he hired him to create a new streaming division for Amazon—from scratch.

Price accessorized his pixie-ish good looks and brash manner with spiky hair, a black leather biker jacket worn over a white T-shirt, and a tattoo replicating the logo of the band Black Flag: four blocky parallel dark stripes. It worked to his advantage, distinguishing him from the studio suits on the one hand, and the Silicon Valley T-shirt-and-sandal crowd on the other. He might have had fun with his personal style, but the job with which he was tasked was no joke.

In 2010, under the rubric of what would become known as Amazon Studios, no one in Hollywood would take the newbie seriously. Indeed, its primary purpose was to lure consumers into Amazon's retail space, turning viewers into shoppers. Their membership was sweetened by a free month of Amazon Prime, in the hopes that they would convert to full Prime members at $79 per year. The thinking was, "Lock up their eyeballs, and their wallets will follow." As Bezos put it, "When we win a Golden Globe, it helps us sell more shoes." Price recalls, "It was as if Walmart had set up Walmart Studios." (Price thought he was joking, but in 2022, Walmart's shopping service bundled Paramount+ in its Walmart+ membership package.)

Amazon Studios borrowed space from IMDb, one of Bezos's numerous acquisitions. It was located far from the action in the Sherman Oaks Galleria, a shopping center in the Valley, mocked in *Weeds* for its "little boxes." Indeed, Amazon Studios was no HBO. As HBO's Bloys put it, "If we're talking about the golden age of television, why bother with Amazon Prime? That'll be a short chapter!"

Although Netflix had made no secret of its intention to destroy theatrical distribution, Price realized that the only chance he had of attracting talent was to go the other way. He added a feature film division and hired two highly regarded indie veterans, Ted Hope and Bob Berney, to run it. Price hoped they would reassure skeptical filmmakers that Amazon Prime Video was for real.

Price and Hope discussed how to create an Amazon brand that would distinguish it from the Netflix gusher. By way of contrast, Amazon would privilege quality over quantity. Explained Hope, "Roy's big thing for the first year was, 'We don't have to make things

for everybody. We just have to make things that are somebody's favorite shows.' And as long as people are deeply passionate about them, they would start to ripple outwards and resonate with wider audiences."

Like HBO and Netflix in their infancies, Amazon was network averse. "We hired no one from the broadcast networks," Price continues. "Game-changing shows are rule-breaking shows. If they're too safe, nobody's going to care. They had to be different. They had to be new. If there's no fear of failure, then you should not be ordering the show because it's going to be a down-the-middle series that would work on NBC." Says Hope, "Roy really wanted bold movies. What pulled me in was the promise of mid-budget films where excellence is the goal."

Leaning on quality instead of quantity, originality rather than the tried and true, might have sounded like a death wish, but it had worked for HBO, and the Amazon mothership up north was so flush with dollars—it would generate $321.8 billion in net sales in 2020—that it had a distinct advantage over Netflix. Its new streamer was a hobby, like stamp collecting, whereas streaming was the be-all and end-all for Netflix.

Hope observes, "Amazon was happy to have Roy come out as a punk rocker." It counteracted the company's tech image. He signed deals with all the usual suspects, gold-plated indie stalwarts like Todd Haynes, Richard Linklater, Jim Jarmusch, and Spike Lee. Amazon's movie division did have some striking successes, like *Manchester by the Sea*, which won two Oscars, making it the first streamer to do so, and later released much-awarded films like Asghar Farhadi's *The Salesman*, and moneymakers like *The Big Sick*, starring Kumail Nanjiani.

Still, Amazon couldn't decide on a strategy. "They'd move in one direction, change tactics, move in another direction, change tactics," Hope recalls. "It created a lot of distrust with our creative and business partners." Price made Jason Ropell, a money guy, head of Amazon Studios, in hopes of making the trains run on time. "Still," says an Amazon Studios executive, "you had factions and cabals."

Hope was desperate to make *Marriage Story*, which would be directed by Noah Baumbach, with Scarlett Johansson and Adam Driver attached. But Ropell looked at the numbers on Baumbach's previous films and said no. Hope argued that with Johansson and Driver, this would be his breakout film. Berney explains, "In a data-driven company, when you make an emotional, creative argument without the data to back it up, you're not going to win." To add insult to injury, Netflix made the film with the same cast. It was nominated for six Oscars, and Laura Dern won for Best Actress in a Supporting Role.

This was too much for Hope. He resigned. Berney followed, later explaining, "I felt like there wasn't a future for film at Amazon, and I wanted to escape the *Hunger Games*–style politics there. I could see that it was going to be much more corporate, much more about quantity. 'Let's make fifty films for streaming.'"

Like Netflix, Amazon was not about to depend on anyone's gut. "We have all these customers. We have all this data," says Price. "There had to be a way to use customer feedback to make our results better than those of a normal studio." Sifting through book sales yielded a pretty good idea of what buyers were interested in, and several of its successful series would be based on them, like Michael Connolly's Bosch saga, softened and sentimentalized as it was, as well as Philip K. Dick's *The Man in the High Castle*, Tom Clancy's Bosch-with-a-passport Jack Ryan series, and, later, Lee Child's Jack Reacher series, as well as *The Lord of the Rings*, which Amazon customers named their favorite book of 1999.

Drawing on books, however, was problematic. As Price discovered, the studios and agencies with years of experience were so adept at tracking them that by the time Amazon's sales figures came in, the hot books were already optioned.

Price deserves credit for starting a streaming service, as well as an animation and a live action movie division—ex nihilo— hiring talented executives to run them and (mostly) backing their choices, no matter how wild and crazy they appeared to be. One of these executives was Joe Lewis, whom he hired to run his comedy

division. Price was hands-off, still up in Seattle until August 2014, while Lewis was on the ground in Sherman Oaks Galleria for the first three years the service was up and running. One NDA-gagged former Amazon executive says, "Roy had little to do with series selection," and credited Lewis with choosing the shows. Tig Notaro, whose series, *One Mississippi,* premiered in 2016, says she only met Price "once or twice briefly." Lewis was the company's Cindy Holland.

Amazon quickly went to series with an extraordinary string of scripted originals, starting with *Mozart in the Jungle* in 2014, about the drama that roiled an unfamiliar milieu: a symphony orchestra. Who knew?

Meanwhile, Joey Soloway—or Jill, as they were then known—was coming off *Six Feet Under.* As a young, broke wannabe with two kids, Soloway was shocked to hear, "'Oh, Shonda wants Jill!' I was like, 'Holy shit, *Grey's Anatomy*. ABC. Twenty-four episodes a season. Wow.' Not really knowing anything or caring much about medical stuff, I probably shouldn't have taken it, but I just wanted that big network credit."

On *Six Feet Under,* "every word was kind of sacred," whereas on *Grey's Anatomy,* Soloway discovered, "the writers would write an outline, then it would get rewritten, then another outline, rewritten—a script could get written literally twenty times." Marti Noxon, who was a writer and executive producer on *Six Feet Under,* remembers being impressed by Soloway's fuck-you attitude. She recalls, "There are kids in school who if they were told to jump, they'd say, 'How high?' That was me. Then there were the kids who were like, 'School is dumb.' That was Jill. She realized quickly that *Grey's* wasn't the place for her." Soloway adds, "Shonda called me into her office and fired me—between the time we ordered lunch and the time the lunch came. I was thinking, *Should I leave now, which would be sad, or wait for my lunch, which might be sadder?*"

Over the course of a decade, Soloway had written about thirty-odd scripts. "I couldn't get my shows on the air. I was like, 'Where's my show?'" The deals were going to male directors whose films had

made a splash at Sundance. Then Soloway, too, made a splash at Sundance with *Afternoon Delight*, which won the Best Dramatic Director Award in 2013. But that still wasn't enough.

One day, Soloway goes on, "My dad phoned me and told me he was a woman named Carrie . . . I was overwhelmed by emotion, and I knew—this was my story. Being a woman meant being watched. I wanted to be a watcher." Jill became Joey, who wanted to write a show that allowed "women to feel like they're the subject in the story instead of the object . . . that's my vision as an artist."

The result was *Transparent*, as far as possible from a safe bet as you could get. Seemingly an innocuous half-hour comedy about the ups and downs of a spoiled Jewish family in LA, *Transparent* exploded gender conventions so thoroughly and cleverly that they would never be the same.

At HBO, Soloway met with Sue Naegle, whom they knew from the *Six Feet Under* days. Soloway recalls, "My agent got the word that 'Yes, of course they'll buy a pilot, but this is not a slam dunk to go to series.' The implication was that it's not necessarily Mike Lombardo's taste. [They] weren't looking for female gays."

Soloway pitched the script to seven other services, including Showtime and FX: "I went everywhere assuming that, honestly, everybody was going to want to make it, but you could not get a show on the air without a likable male protagonist at the center.'" It was pass, pass, pass.

Finally, they ended up at Amazon, the end of the line; few people even knew it existed. "I wasn't sure what it meant to have a show on Amazon," says Soloway. "My agent, Larry Salz, said, 'They're doing a great show about cooking.' I was like, 'So, when you watch the show, you buy the recipes? Buy the spices?'"

Amazon Prime Video had outgrown its offices at the Sherman Oaks Galleria and moved into the Water Garden in Santa Monica, a seventeen-acre office "campus" where visitors were screened as if they were potential terrorists by a computer-generated voice that announced "Enter now!" after their badges had been scanned. This reminded the talent Amazon was at heart a tech company with an

ethos very different from their own. As Soloway puts it, "It wasn't like going to CBS or NBC. It was this feeling that I was in a different industry."

After meeting with Lewis and his two assistants, Soloway was in a state of shock. "I was like, 'Oh, my God. These are college students I'm pitching to!' It felt humiliating." College students or not, it turned out that Lewis loved the script. Critical of the services that turned it down, he recalls, "The consensus view was, 'America's not ready.'" He thought, on the contrary, *America's totally ready*, which proved to be the case. Lewis flew up to Seattle, and pitched Price and Bezos. Like the leader of a cult, Bezos had distilled his success into fourteen Principles of Leadership, one of them being, "Bias for Action." He said, "I guess we have to pick up *Transparent*."

As the other deep-pocketed players watched Netflix explode in the aftermath of *House of Cards* and *Orange Is the New Black*, the question marks that surrounded the streamer evaporated. Albrecht was proved right. Netflix might have made hits out of shows like *Breaking Bad*, but it was an enemy, not a friend, and a dangerous one at that. As other players started their own streamers, they would begin bringing their shows back home, settling them safely in their own nests. NBCUniversal paid Netflix $500 million to regain the streaming rights to *The Office*, reputed to be the most watched show on the streamer, and Time Warner paid $425 million plus to do the same with *Friends*.

Flaunting its success, Netflix leased its new home in 2015, a fourteen-story Icon office tower on the corner of Sunset and Van Ness in the "media corridor," just west of the 101 freeway. Resembling ill-fitting slabs of cream and blue Legos, visitors didn't just enter a lobby so much as a nearly five-thousand-square foot "experience," featuring an eighty-by-twelve-foot LCD screen playing Netflix images spanning one wall that would put IMAX to shame; another wall was jammed with serried rows of plants, more than 3,500 of them, with their own irrigation system. Plus, a thirteen-story atrium.

Despite some evidence to the contrary, rivals claimed to be un-impressed by Netflix's algorithms, and the fact that it refused to release numbers muddied the waters. AMC's Josh Sapan called data mining a "goddamn disaster," useful for marketing and pro-motion but useless on the creative side. "You can't number your way to greenlighting a show and you can't get data that shows you how to fix a story."

Netflix executives downplayed the role of Big Data in their origi-nal programming, trying to sound human, lest all the chatter about algorithms was making them come off like quants, bots, or worse, "surveillance capitalists," off-putting to creatives. Nevertheless, says Reilly, "Netflix set the bar with a fire hose of new offerings that became the consumers' baseline expectation, that for fourteen bucks, they'd get a never-ending array of originals. It didn't do that because it just loved programming; its data told it the more originals it offered, the more certain cohorts would re-up every month. It was like a rat attacking a sugar cube." In 2016, Netflix announced that half its shows would be originals. The other streamers had to chase it or look like lesser values.

In its quest for world domination, Netflix tried to destroy theatri-cal exhibition, refusing to show its films in theaters, which provoked the Cannes Film Festival to ban them for several years. Prominent American filmmakers protested when Alfonso Cuarón's *Roma* was given the Motion Picture Academy seal of approval with an Oscar nomination in the Best Picture category in 2019. For some time, the biggest theater chains, AMC and Regal, declined to screen Netflix films even when available, because the streamer won't agree to tradi-tional windowing and financial terms.

Netflix found itself in an unenviable position, paying a heavy price for its success. Not only did it now have to spend astronomical sums for networks shows like *Seinfeld*, for which it forked over a reported $500 million, but it also had to sign celebrity showrunners to those rich overall deals it had always shunned. In early August 2017, it stole Shonda Rhimes away from Disney-owned ABC—which had been her home for fifteen years and for which she had created *Grey's Anatomy*

and *Scandal*—giving her a four-year overall deal said to be worth $100 million to $150 million. The Rhimes deal finally paid off when she hit the PBS viewers-likes-you button with *Bridgerton* in 2020, followed by the delightful prequel *Queen Charlotte* in 2023 that, with its head-snapping repartee, and focus on racial issues, is much superior to its predecessor. After ABC shelved an episode of *Black-ish* that contained a bedtime story its executives deemed too critical of then President Trump, Kenya Barris followed suit for a $100 million, multiyear deal.

Netflix also signed up Kohan, and two years after signing Rhimes, it made off with *Game of Thrones* creators David Benioff and D. B. Weiss, giving them an exclusive overall deal reportedly worth $250 million. Netflix spent $17 billion on original content in 2022, including a phenomenal $30 million per episode price tag for *Stranger Things 4*, and another several billion marketing its overall content.

Then there was Ryan Murphy. He had been a fixture at Fox ever since he made *Nip/Tuck* for FX, and then *Glee, American Horror Story, American Crime Story, Pose*, and *9-1-1*. Netflix lured him away from Fox after Disney bought it. His reaction? "I thought I would literally be buried on the Fox lot." Murphy asked Disney CEO Bob Iger, "Am I going to have to put Mickey Mouse in *American Horror Story*?" The answer was obvious, and when Netflix waved a check for $300 million in his face in 2018, he jumped.

FX's Landgraf, whose cabler was partly built on Murphy's shows, compared Netflix's predations to being shot in the face with a water cannon, except "it's money coming at you." Murphy, needless to say, was thrilled. He is the outsider who always wanted to become an insider, and he confessed, "My whole life has been in search of that brass ring, and now somebody actually thinks I'm worthy as opposed to being an aberration? People are astounded that I still want that. But everyone wants to be seen. Everyone wants to be loved."

Murphy's deal looked like money thrown away until he made *Dahmer—Monster: The Jeffrey Dahmer Story*, wherein the notorious gormandizer of human parts is played by Evan Peters of *American*

Horror Story fame. (Fans of Sarah Paulson's wonderfully creepy impersonation of Linda Tripp from *Impeachment* were disappointed that she didn't get the role.)

At the time, Netflix ranked *Dahmer* its third most watched show, after *Squid Game* and *Stranger Things*. It couldn't be franchised because, unfortunately for Netflix, the real-life eponymous anti-hero was bludgeoned to death in prison. Undaunted, Netflix morphed *Dahmer* into a monster-of-the month anthology series along the lines of *American Horror Story*, dramatizing the lives of John Wayne Gacy, Ted Bundy, and others. If AMC became the Living Dead Network, there was no reason why Netflix couldn't become the Serial Killer Network.

Holland oversaw most of those rich deals. but it's hard to imagine that she was allowed to dip into the honey pot on her own, without input from her bosses. As another source told *The Hollywood Reporter*, "The buck stops with Ted," but if they don't pay off, "I'm sure he will try to blame Cindy."

Most of these payouts, however, were not as costly as they looked. Netflix pioneered the so-called cost-plus front-end deals that were sweetened by the "plus," generally a 10 or 20 percent bonus. But the talent was excluded from the lucrative downstream profits that shows traditionally rack up in DVD sales and syndication—licensing and relicensing fees from other services—that could bring in income for years, because its streaming model eliminated such "long tail" opportunities. Residuals amounted to a fraction of the income creatives received under the old broadcast system.

These front-end deals have cost creatives an estimated $1.5 billion in lost income. Jeff Sagansky, a former top network executive, nailed the streamers for "backend theft," and "predatory behavior." He went on to say, "We are in a golden age of content production and the dark age of creative profit sharing." Sagansky's outrage is shared by the entire creative community, which feels, with ample justification, that it is working harder for less money.

"Without syndication, you can't monetize your monster hits and turn their success into cash," says Steven Soderbergh. "Netflix has

moved us, in economic terms, out of a Newtonian world and into a quantum world where it becomes very difficult to quantify whether or not it is quote, unquote worth making something."

In 2021, Netflix hit the 200-million-subscriber mark, which enabled it to announce that it no longer needed to borrow for "day-to-day operations." Although it reportedly was still $10 to $15 billion in debt, it was optimistic that it could pay off this debt without jeopardizing its content budget, and 2022 was the first year it was supposed to have a positive free cash flow. It aired seventy new movies in 2021, more than one a week, featuring the likes of Leonardo DiCaprio, Meryl Streep, and Idris Elba.

With an assist from Covid that accelerated home viewing, Netflix was humming, but as the entertainment newsletter *The Ankler* ominously reminds us, "No one has ever made money selling just content. Theater owners sell Milk Duds and Diet Coke for $4. Broadcast networks sell ad time . . . [But] Netflix only sells you content." Not quite true. It had merchandised *Stranger Things* with tie-in books aimed at children, teens, and adults, including sticker albums, coloring books, novels, graphic novels, Tarot cards, and comics. And, of course, video games, podcasts, theme park mazes, at least one dedicated store, and so on.

Netflix is also well on its way to capitalizing on the anti-capitalist *Squid Game* by selling trademark tracksuits, and has added a reality show called *Squid Game: The Challenge*, wherein 456 people will compete for an actual door prize of $456 million. Also, look for *Squid Game* sequels as well as an English-language version. Netflix also developed mobile games based on some of its other hits, like *The Queen's Gambit* and *Money Heist*—altogether thirty-five games and fifty-five more in development—while signing a contract with Mattel.

Jumping from popular shows to events, Netflix has launched "The Queen's Ball: A *Bridgerton* Experience," first staged at the Millennium Biltmore Hotel in LA, which targeted the underserved-no-more eighteen to forty-five female fan base. Eight hundred balls like it traveled around the country, hooped skirts and all, to cities like Atlanta, San Francisco, and Montreal, attracting more than

150,000 fans downing Whistledown & Dirty cocktails. No longer will a *Bridgerton* season, say, be a here-today, gone-tomorrow one-week binge indulgence, but an enveloping world of events and products. As someone put it, "It's Harry Potter for adults."

At the Grove shopping center in LA, Netflix has also erected a ten-thousand-square-foot pop-up store featuring Vecna from *Stranger Things,* as well as Queen Charlotte's throne from *Bridgerton,* touted as the "first-ever multi-title immersive shopping experience." It also held a so-called Poguelandia fest in Huntington Beach for the teenage demographic that lives and dies for shows like *Outer Banks* and *Wednesday.*

The arrogant attitude of Hastings and Sarandos has made "Netflix" a dirty word in the business. *The Ankler* shared a story about a producer who ran into the two men at an event and confronted them, saying, "You guys are being really difficult making a decent deal."

"Yeah! We know!"

"Why would you treat people like us, who are bringing you projects, like that?"

"You'll be back."

In other words, it wasn't because they were "pricks," it was about power. They were being difficult because they could. As another producer explained, "It used to be the town ran on fear and greed. [Now] it runs on, 'You'll be back.'" And another, "It used to be a handshake business, and sometimes contracts weren't signed until a show was delivered." Now, "everything has . . . [to go] through business affairs . . . Netflix and the streamers destroyed the relationship side of the business. There's no trust and no relationship anymore. It's now just commerce."

AMAZON'S WOMEN IN THE HIGH CASTLE

Amazon hit a roadblock called #MeToo, while Apple,
its bigger tech cousin, started its own streamer.

Ever since dad dropped the trans bomb, Joey Soloway had been mulling over a show in which "the father of three adult children transitions to mother, in this case, from Mort to Maura, Papa to Moppa. I was thinking about Lena Dunham in *Girls*, where the parents make it hard for Hannah to be Hannah. I wanted to take that idea and really bring in the family unit of *Six Feet Under*."

Soloway doesn't sentimentalize the characters in *Transparent* because they're nonbinary members of the transverse. Far from it. They're a rogue's gallery of self-absorbed, neglectful parents, heedless children, and faithless mates. Imagine your parents were Nancy Botwin and Walter White. They behave badly like everyone else, but Soloway makes them entertainingly politically incorrect, and indulges them, because they're human.

"Roy Price wasn't working creatively with me," says Soloway. "I feel very lucky that I met Joe [Lewis], that he could love these unlikable Jewish women. To get on TV, women could be just Jewish or unlikable, but they couldn't be both. It was the old 'Speak Yiddish, write British.' We want writers to be Jewish, but you don't want anybody who looks Jewish."

The pilot began conventionally enough with the credit sequence—a montage of Pfefferman family photographs picturing a boy at his bar mitzvah, prepubescent girls in period bathing suits, women cutting

PANDORA'S BOX | 217

cake—and then bang: naked women hungrily devouring one another, remarks like, "Why don't you clean up the barbecue sauce inside your vagina"; cunnilingus salted by self-pleasuring; intimations of inter-racial "sexercise," aka "twerkouts"; a tasteless riff Nazifying Jewish surnames into Marcy "Kristallnacht" or Barbara "Belsenberger"— funny if you have a certain, pre-Ye sense of humor. It was all topped off by the cherry on the sundae—the patriarch of the Pfefferman family appearing as a shapeless woman with long, stringy gray hair badly in need of volumizing, looking, from a conventional point of view, altogether grotesque. And that was the point. Calling it "blow-ing up the binary," Soloway tossed the genders in a blender and took them for a spin, and you never knew what was going to come out. But, the showrunner goes on, "I'm not saying destroy the category of male and female, or the category of straight and gay. I'm just saying that there is a third category. There is a place in between."

Soloway moved ahead, casting the members of the Pfefferman family with actors who shared in Soloway's vision, although one choice turned out to be ill-fated: Jeffrey Tambor, best known for *The Larry Sanders Show* and *Arrested Development*, to play the dad-to-mom. The trans community attacked him and the series for using a cis male in the role, comparing it to Black people watching a white actor in black-face—in this case, "transface"—even though Soloway made a real effort to hire trans talent and make them comfortable. All the restrooms on the set were gender neutral. Soloway established a "Transfirmative Action" program that pulled in trans people to work in various depart-ments even if they were underqualified. In meetings dubbed Trans 101, actors and crew were taught the differences between drag queens, female impersonators, cross-dressers, and so on.

The succeeding seasons continued in the same vein as the first, with Episode 9 of Season 2 creating mind-blowing scenes at a lesbian Woodstock comprised of all colors and shapes of women cavorting in a body-shameless space in various degrees of undress while the Indigo Girls sing a rousing song with lyrics like, "We're lesbians in the forest/nymphs, fairies, witches/not a cock in sight/'Cause sisters are doing themselves all night . . ."

On some level, *Transparent* was too good to be true, which is to say, the early episodes are pure pleasure, but they were hard acts to follow, although even the less than electrifying seasons that followed are strewn with hilarious nuggets and/or startling moments. In Season 4, there's a funny bit where Maura, who is pre-op, is stopped by security at the airport when the X-ray reveals a "groin anomaly," while flummoxed TSA officers try to figure out whether she should be patted down by a male or female agent.

One of Soloway's strengths is their instinct for puncturing the most overblown, sentimental scenes with deflationary low comedy. "That's one of the things I got from David Chase: the proximity of great tragedy and great food." Whether or not you go all the way with *Transparent*, with the Jewish thing, the trans thing, the thing thing, the influence of it is hard to deny.

Amazon dropped all ten episodes at once on September 26, 2014. The first season of the show scored an impressive 98 percent on Rotten Tomatoes. As a reviewer for *The Guardian* put it, it was "the reason Amazon needs to be taken seriously as more than just people who send you stuff in oversized packaging." In 2015, after its second season, it won five Emmys—including Outstanding Directing for a Comedy Series for Soloway—to Netflix's four. Although it didn't draw huge numbers, it made noise, lots of it, which was what Price was after, and it instantly transformed Amazon Prime Video into a real, if distant, competitor to Netflix. While accurate numbers are hard to come by, in 2017 the streaming service had about 45 million domestic subscribers. By 2020 that number had ballooned to 56 million plus.

Then the roof fell in.

Amazon wasn't the only company to compete with Netflix for Hastings's nighttime sleep. Apple TV+ was another, although it was hardly poised to give him nightmares. It got off to a slow start with indifferent programming and zero breakout hits, and few

took it seriously. In one significant way, however, it was and remains one of the most dangerous. When the streaming space became less a sandbox for Netflix and more like Jurassic Park, that meant the survival of the fittest, and in the streaming business, the fittest is the richest, and the richest is Apple. As of 2022, it was valued somewhere between $2 and $3 trillion, with approximately $195.57 billion petty cash in its piggy bank as of the previous year, and revenue of $366 billion in 2021. It's richer than Google, Amazon, and Meta combined. Apple spent an estimated $6 billion on content to start its streamer. There's apparently no ceiling on the price it will pay for scripted shows, but at the beginning, it was most interesting as examples of what money couldn't buy, which in Apple TV+'s case was apparently consistently good TV, although with the passage of time, its programming has blossomed.

Apple chief Tim Cook reportedly challenged Eddy Cue, senior VP of internet software and services, to spearhead the effort to start its new streamer. Unlike Cook, who looks like he stepped out of a Grant Wood painting, Cue was the walking embodiment of the clash between the tech companies and Hollywood. As an ambassador of Silicon Valley royalty, he had attitude to spare, embodied in a take-it-or-leave-it negotiating style that has been described as "We're Apple, and you're not." He reportedly raised hackles wherever he went.

Moreover, Apple is known for fetishizing secrecy. Brian Roberts, CEO of Comcast, the most extensive network of cable stations in the country, as well as NBCUniversal and eventually the streamer Peacock, complained that it "had had trouble getting Apple to share important details about a planned streaming-TV service." In further negotiations with Roberts, Apple refused to show him its user interface, saying only that it was "better than anything you've ever had."

Apple TV+ is one of the streaming services that don't release viewer figures. Here is a partial list of further security directives distributed to creatives:

1. Don't share or discuss any aspect of the project with anyone who is not NDA'd and does not have a "business related need-to-know."
2. Do not blog, tweet or post any social media regarding your work on this project or the project itself.
3. Your home office must be a fully enclosed private workspace with solid floors, ceilings, and floor-to-ceiling walls.
4. Any doors and windows must be closed and locked at any time when you are not in the space or when you have sensitive materials out in the open.
5. All windows must be obscured by frosting, tinting, or covered with closed blinds any time project information is visible.
6. All device screens must be oriented away from door and window openings (i.e., only the back of the device is visible from outside the room).
7. All pre-release materials and revelatory documentation such as scripts, etc. must be stored in a locking file cabinet, safe, or similar secure container when not actively in use.
8. Pre-release materials and revelatory documentation must be within your positive control (i.e., direct visual observation). At no time will pre-release materials or revelatory documentation be left unattended outside a secure, lockable container. This includes meal and bathroom breaks.
9. Undisclosed people (including family and friends) must not be allowed within your workspace any time revelatory information is exposed.
10. Janitorial, maintenance personnel, or family members must not be allowed in your workspace unless and only when all device screens are locked and all sensitive material is secured within lockable containers.
11. You must take responsibility for ensuring you do not dispose of materials in a way that exposes your work to the world. All documentation must be securely shredded using a crosscut paper shredder.

When it did approach other companies, Apple reportedly would make demands that were deemed unreasonable by their executives, who would say some version of, "Do you have any idea how this industry works?" For its part, Apple appeared not to care how the industry worked. It saw itself as a disrupter. In 2014, Cue was quoted as saying that the TV experience "sucked." This might explain why Apple decided to go it alone instead of buying, say, Netflix.

On June 16, 2017, Cue hired two veterans of Sony Pictures Television, Zack Van Amburg and Jamie Erlicht, to run the streaming service. The duo will forever be remembered for the shows they made for FX, and for greenlighting *Breaking Bad* when the smart money thought gambling on a nerdy chemistry teacher turned meth chef was a good way to go bankrupt.

Of course, Van Amburg and Erlicht had their detractors, as almost everyone in the entertainment business does. Says Vlad Wolynetz, formerly of AMC and the BBC, "Zack and Jamie are terrific widget factory guys. If you need someone to go to Bergdorf's and shop for you, they're your guys. Classic say-whatever-is-necessary-to-get-out-of-the-room guys, never take any responsibility, and always end up on the right side of things." Adds another source, a bit more gently, "Zack and Jamie have a good reputation as nice guys. I see them as political and careful. 'Oh, Jennifer Aniston? Of course, we're in.' I don't yet see them as visionary executives. They're suave preppies."

Erlicht and Van Amburg had a problem, however. They had successfully run a TV studio, but neither of them had ever run a streaming service, and there's a big difference. As Amazon Prime Video's Joe Lewis puts it, "Your job at a studio is to sell shows to networks. You're a schmoozy type of person, a salesman. Running a network is the exact opposite. You're a buyer, not a seller, and you're in a consumer-facing business, so you have to have a brand, a vision for what you want to buy." But what was the Apple brand?

Ah, the $64,000 question! Van Amburg told *Variety*, "The guiding word is 'humanity.' All of our shows have something to say about the relationships we have with each other and with the world." It's good to know that the guiding word is "humanity," and not, say, "citrus

fruits," but in October 2019, Erlicht couldn't help but admit that he and his partner were in over their heads. "Zack and I knew how to create a premium, high-quality, great show—that wasn't a problem," he said. "What we didn't know was how to create, from scratch, a premium service at Apple."

There was a reason Van Amburg and Erlicht returned from those meetings in Cupertino spouting inanities, and that had to do with the nature of their employers. Apple's first stab at programming was *Carpool Karaoke*, Season 5 of which aired in 2022. It's a bland spinoff from James Corden's *Late Late Show* segment that paired him with a celebrity and recorded them singing songs as they drove around LA. Days before the series was set to air, Cook is said to have personally delayed the first episode that featured then politic Corden with then wholesome Will Smith, until coarse language and references to "vaginal hygiene" were removed. Why? Initially, one idea was an app that would make Apple TV+ programming free to everyone who owned an iPhone or an iPad. But kids of all ages used those devices, and they couldn't be exposed to jokes about vaginal hygiene.

Apple was best known for its hardware, its sleekly engineered iPhones and MacBooks, and there lay the rub. Its brand is not to sully the brand, scuff the silky sheen of the devices designed by Jony Ive. As *The Ankler* put it, the attitude was, "Netflix is just soooo Android."

Apple's slogan used to be, "Think different." So far as its streamer went, its slogan seemed to be, "Think alike." Whereas Netflix told Jenji Kohan, according to her, "We don't know how to do it. Show us," Apple's attitude seemed to be, "We do know how to do it. We'll show you." According to press reports, Apple execs, including Tim Cook, were giving notes, the most common one being, "Don't be so mean." If Erlicht's and Van Amburg's reputations at Sony TV rest mainly on allowing Walter White to sell meth on AMC, at Apple he would be dispensing M&M's.

Cue categorically denies these reports. "There's never been one note passed from us on scripts," he said. "We leave the folks [alone] who know what they're doing."

Apple eventually dropped the idea of free shows for the owners of its devices, but it kept the wholesome family programming because that seemed to be Cook's personal inclination. "Apple isn't interested in the types of shows that become hits on HBO or Netflix, like *Game of Thrones*," he told *Bloomberg Businessweek*. "Instead of the nudity, raw language, and violence that have become staples of many TV shows on cable or streaming services, Apple wants comedies and emotional dramas with broad appeal, such as the NBC hit *This Is Us,* and family shows like *Amazing Stories*." (The original *Amazing Stories* flopped when it aired in 1985 but Apple revived it, so desperate was it for anything Spielberg.) Politics and religion were also off the table. Some of its executives started referring to their service as an "expensive NBC."

Much can be gleaned from whom Apple TV+ hired. It signed Kerry Anne Ehrin, who produced the ABC show *The Wonder Years* and was a producer-writer of NBC's *Friday Night Lights*, to a multiyear deal to produce original content. Apple also made deals with Jason Katims, *Friday Night Lights'* head writer; Katims's development chief, Michelle Lee; and writer-producer Monica Beletsky, who worked on, yes, *Friday Night Lights*. As the Ehrin-Katims-Lee-Beletsky axis suggests, *Friday Night Lights* became the go-to show for Apple TV+. When Cook named his two favorite series—guess what? *Friday Night Lights* was one of them.

Katims's *Friday Night Lights* was indeed an exceptional show, but did we need an entire streaming service devoted to replicating it? Poorly? Would *Friday Night Lights* kill Apple TV+?

Example: Not even Coach's wife Connie Britton with her hugs and cupcakes could save *Dear Edward*, an exercise in grief porn that aired on Apple TV+ in 2023. It starts with a plane crash, like ABC's long-running *Lost*, but instead of exposing the survivors to hair-raising adventures, the families of the dead find fulfillment support groups. Indeed, it turns *Lost* into *Found*, the most suitable title for this crash-happy drama. It was too much even for Apple, and was killed after one season.

For all Apple's attempts to cast Cook as "Coach," the company has its dark side. An outspoken gay rights activist, Cook has portrayed

Apple as a leader in the fight for digital privacy, and Apple+ shows have generally adopted a lofty moral stance. But in practice, when principles collide with business, as Hastings put it, the job of the CEO is not to speak truth to power, but to make money. For Apple, China is not only a honeypot of potential customers to the tune of $40 billion a year but a key element in its supply chain, manufacturing almost all its iPhones. Consequently, as *The New York Times* revealed, Apple "shares customer data with the Chinese government . . . proactively removes apps to placate Chinese officials . . . [and] banned apps from a Communist Party critic." Apple has denied and/or disputed some of these reports, but *Business Insider* reported that even though Apple knew one of its Chinese-based suppliers was using child labor, three years elapsed before it finally cut its ties.

Domestically, Apple's China is Texas. It is one of the state's largest employers, with seven thousand workers making MacBook Pros in Austin, but it failed to take a stand against Governor Greg Abbott's crusade against abortion. This has reportedly contributed to unprecedented "unrest" among its employees, who have also complained about "verbal abuse, sexual harassment, retaliation and discrimination at work." But Apple's fetish for secrecy prevents them from airing these issues with the company or even one another.

Meanwhile, back at Amazon Prime Video, 2017 proved to be what 2007 was for HBO. Breaking the rules seemed to have paid off, but it wasn't only Amazon Studios that broke the rules; for Roy Price, breaking rules might have become a way of life.

On October 12, 2017, a mere seven days after *The New York Times* outed Harvey Weinstein, Price was called to account by Kim Masters in *The Hollywood Reporter* for allegedly sexually harassing Isa Hackett, one of the executive producers of *The Man in the High Castle*, the Prime Video series based on a novel by her father, Philip K. Dick.

The Man in the High Castle had premiered three years earlier and ran for four seasons. It was Amazon's most popular show, a specimen of "What if" history. Dick's novel asks the question, "What would our

world have looked like had the Axis powers won World War II?" "I think that what's most chilling about *The Man in the High Castle* are the scenes that are normal, are every day, are really all-American, but you can see how it could happen here, too," explains Frank Spotnitz, the original showrunner.

Outside of the ubiquitous Nazi branding—imagine Times Square designed by Leni Riefenstahl or swastikas and Iron Crosses in place of stars on the American flag—it turns out that fascism is not so much imposed by hostile foreign powers as awakened by hostile foreign powers. The new fascist America isn't all that different from the old democratic America. Aryan pop culture still features Doris Day movies portraying the white-bread, ethnically cleansed version of this country that was peddled before the war by the studios without any help from the Nazis.

On July 10, 2015, at Comic-Con in San Diego, where the Amazon group was flakking the show, Hackett found herself in an Uber at 1:00 a.m. with Price, going to an after-party at the W Hotel. She told Masters that he persisted in saying, "You will love my dick," possibly a joking reference to Soloway's upcoming new show, *I Love Dick*, even though Hackett told him that she was gay, with a wife and children.

"I never said that," Price asserts. "And I never said anything similarly suggestive. Period. It was a five-minute ride with multiple people in the car."

Hackett also claimed that Price sidled up to her at the noisy party while she was conversing with others and shouted "Anal sex!" in her ear. Price recalls, "She came up to me and was jokingly trying to confirm that I'm gay. And I told her I wasn't gay. Maybe when we talked about the gay thing, there were some jokes about anal sex, I don't remember. I think she was uncomfortable. I apologized, and I recognize that she's in charge of her experience, and interpreting it. And I respect that."

After Hackett went public, Amazon hired an outside firm to investigate, the results of which are confidential. "In the end, if you're found guilty, you're fired," Price goes on. "I didn't get fired. They told

me, 'Don't go to *Man in the High Castle* events, and watch your joking.' So I surmised that I was [found] not guilty."

Two years after the encounter with Hackett took place, Price was at Campfire, Bezos's hush-hush retreat held that year at the Biltmore Hotel on the beach in Santa Barbara, when Amazon senior VP Jeff Blackburn called to tell him he "was suspended." The next day, his fiancée, Lila Feinberg, canceled their wedding.

Price was dumbstruck. "It's one thing if you're a bank robber and you've robbed thirty banks and they finally catch you, and you're like, 'Oh, well, the jig is up.' In my case, I [had] apologized. The details were already examined by experts. You build the whole studio in record time. You founded the network, Amazon Video. You're getting married in thirty days. All of those things are taken away. I felt, 'How can this happen?'" Lewis was tarred as well, and also let go.

Dana Calvo, the creator of a show called *Good Girls Revolt*, a series about women taking on the deeply entrenched male power structure at *Newsweek*, attacked Amazon for canceling it after one season for allegedly sexist reasons. Lynda Obst, who found the book on which the show was based, put it together at Sony TV, and was one of the executive producers, defends Price. "If Amazon was so sexist, why did they buy it so enthusiastically in the first place?" she wonders. "The show was canceled in part because they didn't have an acceptable second-season pitch. I think it's important that when women make mistakes, they don't blame people for being anti-female." As for Price, Obst says, "He never flirted with me or was disrespectful for a second. This was at that ugly moment when many people were destroyed left and right." Says Soloway, "He was only as sexist and misogynist as nearly every other culture maker. It was the same everywhere."

Price is quick to point out the irony involved in #MeToo-ing him. During his regime, Amazon ran way more female-made and woman-driven series than any other service, not only *Transparent, I Love Dick, Good Girls Revolt, One Mississippi*, but Phoebe Waller-Bridge's *Fleabag*, Amy Sherman-Palladino and Daniel Palladino's *The Marvelous Mrs. Maisel*, and several others.

If Price feels that the punishment didn't fit the crime, it's just as likely that the crime was an excuse to get rid of him. Something wasn't right at Amazon. *Sneaky Pete* was co-created by Brian Cranston and David Shore (*House*), but before it was premiered, Shore left and was replaced by Graham Yost, who left after two seasons. He recalls, "Your head's down, working on the show and you hear, 'Oh, so that guy we're reporting to is no longer there.'

"'Oh, now we're reporting to *this* guy.'

"'Oh, *he's* actually out now.' So there was a certain amount of that."

The Shield's Shawn Ryan, who made *Mad Dogs* for Amazon, complained about the notes, saying that "everything [was] in chaos," and the service wasn't "artist friendly." Frank Spotnitz quit halfway through the production of the second season of *The Man in the High Castle*.

As if this weren't bad enough, Amazon was virtually shut out at the Emmys in 2017. The best it could do was two nominations for the fourth season of *Transparent*.

Apple TV+'s opening lineup consisted of four shows that premiered on November 1, 2019, and boldly broke old ground—with the possible exception of *Dickinson*, an offbeat look at the reclusive poet from the perspective of *Gilmore Girls*. Its other offerings included its flagship, *The Morning Show*, starring Jennifer Aniston as Alex Levy and Reese Witherspoon as Bradley Jackson, the eponymous show's co-hosts, and Steve Carell as Mitch Kessler, a former co-host; *For All Mankind*, an alt-history of the space race; and *See*, an attempt at vision-impaired world-building, *Game of Thrones* style, that flopped on its face.

The less said about *See* the better. Rumored to cost in the neighborhood of $240 million for two seasons, it's remarkable only for its creator-slash-showrunner, Steven Knight, who raises the Milch question: How can someone who wrote one of the best shows of the golden age of streaming, *Peaky Blinders*, write one of the worst?

The show was only renewed because its "star," Jason Momoa, was a hit in *Aquaman. The Washington Post* called it "a puddle of mediocrity." It was finally put out of its misery at the end of its 2022 run.

Ronald D. Moore, responsible for the classic *Battlestar Galactica* and the marvelous *Outlander,* writes and runs *For All Mankind,* not as good as either but by no means terrible, and getting better every season with the help of smart casting choices like Joel Kinnaman and Sonya Walger.

The Morning Show never sank to the level of *See,* and if we choose to view the glass as half full, the first season deserves credit for showcasing the growing power of women in the industry. Not only does it feature two female stars, Witherspoon and Aniston, but women drove the production.

Reportedly, Cook objected to the spray of four-letter words in its first season, but given the competition, Apple couldn't help cracking the door for mild sex, violence, and salty language. More, the first season was saved, and much praised for its pivot toward #MeToo, where married Mitch Kessler is demonized as a sexual predator for targeting his network's Black female employees, among others, for not-so-consensual sex, culminating in the suicide of one of his rape victims, well played by Gugu Mbatha-Raw.

Season 2, on the other hand, takes back what Season 1 gave us. Having been summarily fired, Kessler licks his wounds in a to-die-for Italian villa, thoroughly whitewashed by virtue of contrition so profound he drives his car off a cliff, leaving us with the uncomfortable feeling that we're prompted to believe that the punishment exceeded the crime.

Aniston's Alex, heretofore portrayed as the bitchiest of bitches, is, like Mitch, humanized by dint of tearful and profuse apology to his wife for sleeping with her husband, delivered to get ahead of a tell-all book about the hanky-panky at the network. The network in turn seizes the opportunity to exploit Alex's new "I'm actually human" persona by putting her on the air in the final episode of Season 2 so she can deliver a soapy, self-pitying confession. So what if she had sex

with the oh-so-last-season's married Kessler, and besides, the tell-all author invaded her privacy. After rehabbing the bad players, we return to business as usual, as if Kessler's victim never committed suicide and he never, in effect, raped her.

What this muddle makes clear is that #MeToo politics of the first season, for which the showrunner, writers, and actors gladly accepted kudos, was no more than virtue signaling. When #MeToo lost steam, *The Morning Show* simply reversed gears and discarded it, leaving the impression that the show goes on, whatever and wherever the wind is blowing.

Save for *Dickinson*, Apple's first four originals had one thing in common: they cost truckloads of money. Outbidding Netflix and Showtime, *The Morning Show* cost an estimated $240 to $300 million for two seasons ten episodes long, each rumored to cost as much as $15 million a pop, with Aniston and Witherspoon said to be getting $2 million plus per episode per season.

Nevertheless, Van Amburg and Erlicht marched on with *Lisey's Story*, widely publicized as one from the heart from Stephen King, who is to bestsellers what Spielberg is to blockbusters. It yoked King with red hot producer J. J. Abrams, who doesn't come cheap and who proceeded to populate it with an expensive cast. The result, however, was an unintelligible mishmash that scored 45 percent with reviewers on Rotten Tomatoes, and only a bit better with viewers. *The Guardian* called it "a swollen snoozefest."

Likewise, Van Amburg and Erlicht had so much cash that they were lured into overambitious world-building shows like Isaac Asimov's *Foundation*, made by Apple TV+ for no better reason than it could, but the show buried itself in dollars. *The New York Times* described it as an "overstuffed epic . . . that gets lost in space." Another franchise squandered.

As of 2020, despite the millions, most likely billions, spent on programming, Apple TV+ had no more than an anemic 10 million subscribers. As one source put it, "It has a weak creative team." And another, "If it disappeared tomorrow, no one would notice."

Then, that same year, along came *Ted Lasso*, refreshingly low-key,

cleverly written, and inexpensive, compared to the streamer's blue-chip offerings. Indeed, the first season passed under the radar until it earned twenty Primetime Emmy nominations—whereupon it became a sensation, earning Jason Sudeikis and two other actors wins for their performances. One hit like that can change the narrative of a streamer, and this one transformed Apple TV+ from a loser to a winner.

In the first season of the series, Rebecca, a peeved British heiress (Hannah Waddington), hires a clueless college football coach from Kansas (Sudeikis) to manage a soccer team. Ted—excuse me if I call him by his first name, but he seems like an aw-shucks kinda guy—is a paragon of positive thinking who is unembarrassed to say things like "I believe in hope" and "I believe in believe." He has nice words for everyone and is not invested in winning so long as everyone has a good time. He tells one player to "woman up," and foregrounds qualities like empathy, forgiveness, and openness, so much so that he comes in for nice-shaming. He's like Coach in *Friday Night Lights*, hit in the head one too many times.

The show premiered in the dark days of the summer of 2020—August 14, to be precise, a day when a Yale epidemiologist predicted that the pandemic would make the coming autumn "gruesome," fires blazed out of control in California, and the Trump campaign was in full flower.

Against this unhappy backdrop, *Ted Lasso*'s Dairy Queen aesthetic was so welcome that it became a breakout show. Bill Lawrence, an executive producer on the show, called it "a sunshine enema." As Sudeikis put it, "If people could look at this show as maybe being *Friday Night Lights* with jokes, then we've done it correct [*sic*]." *The New Yorker* described it as "engineered by Pixar."

Apple TV+ confirmed its reputation as the happy streamer with a Best Picture Oscar for *CODA*, which *The New York Times* lead critics accurately described as a "pedestrian heart-tugger" and explained its win over *The Power of the Dog*, a much better picture, as "sentimentality triumphing over craft." Or, as *Vulture* put it, "In a time of crisis, the Academy was in need of a fuzzy blanket, and

CODA just so happened to be expertly knitted from baby-alpaca wool."

The two shows were yet another indication of the return of comfort viewing, which had never really gone away. Will we get a steady diet of more of the same? Apple TV+ scored in the feel-good wars by picking up the smarmy *Cha Cha Real Smooth* at the 2022 Sundance Festival, which most critics liked but whose young male lead and director was called "a slobbering puppy" by the one prominent reviewer. Even the Duffer brothers, auteurs of the very uncomfortable Netflix hit *Stranger Things*, cite comfort viewing as one of their goals, "where heart wins out over cynicism."

It's easy to see the appeal of comfort viewing in troubled times, lulling audiences into an early bedtime so they can sleep through pandemics, the Russian assault on Ukraine, the ever-present specter of nuclear war, the Supreme Court, the Big Lie, and climate change, etc. After all, one of the primary appeals of movies used to be escapism with its obligatory happy endings.

An irony too evident to ignore is that many of the most popular shows on Netflix, theoretically a disrupter, have always been network standards: *The Great British Baking Show*, not to mention *Friends* and *The Office*. Their appeal suggests the limits of innovation. Several reviewers compared the 2021 Emmy nominations—*Ted Lasso* and inoffensive comedies like the Netflix hit *Emily in Paris*, an insipidly charming fish-out-of-water trifle created by Darren Star of *Sex and the City* fame, long on scenic Paris, and short on skirts that *The LA Times* compared to "a giant bowl of mac and cheese."

Apple TV+ would never run a discomfort viewing show like *Dahmer*, no matter how big a hit it is on Netflix, but the good news is that the streamer is slowly moving beyond the shadow cast by *Friday Night Lights*. One of the smart things it did was to drill down into the conflict in the Middle East, airing either originals, as in the case of a little Palestinian gem called *Huda's Salon*, a feel-bad, no-way-out movie, or remaking large-scale Israeli series, a la Showtime's *Homeland*, in this case *Tehran*, as well as Keshet's *False Flag*, aka *Suspicion*, and Mark Boal's *Echo 3*, co-produced by Keshet and Apple.

Best of all is its crackling spy thriller, *Slow Horses*, about a clutch of deplorables guilty of crimes against their employer, MI5, that can't fire them but can't use them, either, and puts them out to pasture in Slough House, headed by Gary Oldman, as an older, even more curdled George Smiley, whom he played in John le Carré's *Tinker Tailor Soldier Spy* in 2011.

One hangover from the past that was too big to ignore was HBO's unfinished World War II trilogy, produced by Spielberg and Hanks. According to one source, at the 2010 Emmys where *The Pacific* cleaned up, "Plepler literally walked up to Tom and Steven, and said something like 'How quickly can you get me another one?'" Hanks, accompanied by Spielberg, came back to HBO with *Masters of the Air*, a saga of aerial combat over Europe, with an initial price tag in the $200 to $350 million range.

Masters of the Air tells the story of the "Mighty Eighth," the strategic bomber group comprised of B-17s and B-24s that carried out daring (and virtually suicidal) daylight raids over German-held territories in preparation for D-Day.

During the negotiations, however, AT&T bought HBO, and Plepler's yes became AT&T's no. Enter Apple, for which this was small change. At a meeting with Spielberg and Hanks, Apple TV+'s Van Amburg and Erlicht, as if unable to believe their good fortune, were so starstruck that reportedly they were nothing short of obsequious, saying yes to everything the producers asked for. Apple snapped it up, with Van Amburg or Erlicht quipping, "Do you take Apple Pay?"

What Hanks didn't know, says a source, was that Apple's process was totally different from HBO's. If Hanks was effectively the showrunner on *Band of Brothers* and *The Pacific*, there was no one on *Masters of the Air*, or rather, there were too many. The writers, Graham Yost and John Orloff, each understood he was going to be the showrunner. So, in a sense, did Morgan Wandell, late of Amazon and now Apple's head of international content development, who seemed to be calling the shots. One source close to the production called him "the worst executive I have ever met. He gave notes on every single

page of script, and didn't understand things unless they were spelled out in dialogue, over, and over, and over."

According to the source, Wandell brought in Cary Joji Fukunaga, with whom Apple had an overall deal, and treated him as if *he* were the showrunner. It became "a shit show," in the words of one participant. Wandell "decided that he wanted to make the Cary Fukunaga World War II show, not the Tom Hanks–Steven Spielberg World War II show."

Apple apparently considered Fukunaga a "BFD" ("big fucking deal") because he was credited with the success of the first season of *True Detective* and the most recent Bond movie, *No Time to Die*. But he had a reputation for being difficult. "I honestly thought he was one of the most arrogant A-holes I ever encountered in my career," says Kevin Reilly, who worked with him once. He added, "There's Ryan Murphy difficult and Fukunaga difficult. Guys like Fukunaga get on a pedestal and say, 'It can't be done like that. I'd be compromising my artistic integrity.' With Murphy, it's ultimately going to get done."

Fukunaga was already under a cloud for alleged inappropriate behavior toward several actresses. Raeden Greer says he tried to get her to appear topless in the first season of *True Detective* despite being assured that she would not have to appear nude. She refused, and was fired from the series.

According to a lengthy exposé in *Rolling Stone*, prior to *Masters of the Air*, "Nearly a dozen sources say the *No Time to Die* director repeatedly crossed professional lines, using his sets to openly pursue much younger female cast and crew members." Fukunaga denies these accounts.

In any event, according to one source, Fukunaga knew little about World War II, but began to rewrite the scripts anyway, introducing new characters and scenes, saying "I want this to be *Top Gun*," which was anathema to the writers.

Hanks, who did know World War II by virtue of producing *Band of Brothers* and *The Pacific*, appeared to wash his hands of the whole thing.

Hanks's absence created a black hole in the center of the series. Graham Yost was slated to write Episode 4. When Fukunaga asked, "Who's in charge here?" he replied, "That's a good question." Years later, Yost recalls, "That was part of the weird thing about *Masters*. It was always difficult to figure out who had the last say. Some days it was [Hanks's producing partner] Gary Goetzman, but then it's also people at Apple, but there's no real showrunner."

When Yost started writing Episode 4, Fukunaga began giving him notes and wanted to rewrite it entirely, says a source: "Cary wouldn't do anything Graham said, and in fact thought Graham worked for him." That episode "was very near and dear to my heart," Yost says. "I'll take notes from anyone, but I'm a showrunner, and I'm too old to be rewritten. Then I was rewritten, and I said, 'I'm out.'" He quit.

Most or all of the last six episodes were said to be run by Fukunaga. Production started in February 2021. He was still shooting inserts for Episode 1 in January 2022. According to one source, "This is going to be at least $35 million an episode. And they are only forty, forty-five minutes long." Moreover, there was pressure to divide the ninth and final episode in half to make ten episodes in total, to bring the average per-episode cost down. Otherwise, the actual cost was going to make the executives look bad, and it might encourage future Apple showrunners to demand the same budgets. Finally, many of those involved in the production threw up their hands and started calling the show, "Masters of Despair." The good news, however, is that the aerial sequences look spectacular.

As the folks at *The Ankler* point out, Apple seems less interested in franchises and tentpoles than in relationships with prestige A-list talent. The days when Netflix boasted about financing the highly touted "passion projects" of legendary filmmakers—like Martin Scorsese's *The Irishman*, which is said to have cost in the neighborhood of $175 million—are over, at least for Netflix, where they are now known as "vanity projects." Netflix sat on the sidelines while Apple TV+ paid Scorsese a salary in the neighborhood of $20 million to direct his latest love, *Killers of the Flower Moon*, for $200 million, which came in with a bloated runtime of three hours and twenty-six

minutes. Apple also bought Scorsese *Flower Moon* author David Grann's next book, *The Wager: A Tale of Shipwreck, Mutiny, and Murder*, with Plepler producing, to be followed by another Scorsese movie, this one on the Grateful Dead. It also dropped another $200 million on Brad Pitt's Formula 1 movie without a script or finalized deal details.

An inventory of the names in lights who have gotten first look and/or overall deals from Apple TV+ reads like Hollywood's Walk of Fame, starting with Scorsese, Adam McKay, Ron Howard and Brian Grazer, Idris Elba, Julia Louis-Dreyfus, Jon Stewart, Alfonso Cuarón, Ridley Scott, and on and on. Let's not forget Tom Hanks, whose Apple TV+ show *Greyhound* was a disappointment, but the franchise here is Hanks, not his movie, and Apple is gifting him with another shot—*Greyhound 2*.

It used to be said that strengthening Apple TV+ with the current team in place looked more problematic than buying a rival streamer with a deep library. Van Amburg and Erlicht may nevertheless manage what none have done before, emerge from Slough House to rejoin Regents Park. Its 2023 slate is impressive, not the least of which is its coup in signing Vince Gilligan, who still owed them for picking up *Breaking Bad*, for a two-season straight-to-series order, at somewhere around $13.5 to $15 million per episode.

Still, despite its starry deals, Apple TV+ only has about 30 million subscribers, less than half of Netflix's domestic number. It doesn't matter. Explains Steven Soderbergh, "Apple and Amazon are distorting the ecosystem because they don't need their streaming business to make money. They can make bad deals and just hold everybody's head underwater until they drown."

Having lost its key executives—Price and Lewis, as well as Hope and Berney—it seemed like things couldn't get any worse for Amazon Studios, but they did. No sooner had the fourth season of *Transparent* ended in September 2017 than star Jeffrey Tambor was accused of sexual harassment.

Tambor's accusers were two trans women: a former assistant, Van Barnes, and co-star Trace Lysette.

Lysette, who went on to star in the trans drama *Monica*, alleged that in a scene where she and Tambor were both wearing pajamas, "My back was against the wall in a corner as Jeffrey approached me. He came in close, put his bare feet on top of mine so I could not move, leaned his body against me and began quick, discreet thrusts back and forth against my body. I felt his penis on my hip through his thin pajamas, and I pushed him off of me."

Tambor denied that he had behaved inappropriately, asserting, "I have never been a predator—ever." He expected no more than a slap on the wrist, and was shocked when Amazon opened an investigation and Soloway fired him, proving, maybe, that you can't bring a cis male to a trans party. He was the lead character.

For Soloway, it was a disaster, the end of the show. A ruptured aortic aneurism resolved the plot problem, and *Transparent* bled out in 2019. What was supposed to have been the fifth season instead became a single two-hour musical aired on September 27, 2019.

The barrage of bad news coming from Amazon Studios created such a dark cloud of malaise that even creatives working for the studio wondered if it would ever be able to find anyone to replace Price. Amy Sherman-Palladino, coming off the first season of *The Marvelous Mrs. Maisel*, said, "It was almost like, 'Who on earth wants that horrible job?'"

Sherman-Palladino was wrong. Apparently determined to erase Amazon's reputation as a playground for abusive white males, it bowed in the direction of #MeToo and selected a woman—but gone were the days when she could have come from one of the successful indie companies. Instead, blond, fifty-five-year-old Jennifer Salke came from NBC Entertainment. She was the smart choice, if by smart Amazon meant a safe and conservative executive with a track record of hits like *Glee* at Fox, and *This Is Us*, *Modern Family*, and *The Good Place* at NBC. She accepted the post in February 2018. Sounding like Soloway and their producer, Andrea Sperling, Salke said all the right things: "Years ago, people would say that you need a white

male star, that women should be sexy," she observed. "We turned off generations of viewers; it didn't feel relevant to them." However, she also said, "We're not going for something small and niche." Says Ted Hope, "Salke's is the opposite of the approach that Roy had," continuing, "Roy was looking for things that would stand out as unique. And she's looking for the big shows and movies."

First on her list was bringing in the holy grail, that is, a *Game of Thrones*–killer. Hers was *The Rings of Power,* its source material being the appendices of *Lord of the Rings*, said to be a personal obsession of Bezos's. It was not as crazy as it sounded, because in them Tolkien laid out a prehistory of the *Rings* trilogy. The rights alone cost about $250 million, while the production costs of the first season have been estimated at $400 million. Adding on the marketing expenses, we arrive at an obscene number flirting with $1 billion for the first season.

The Rings of Power premiered in September of 2022. Amazon's claim of 25 million viewers defies independent verification, and eventually a cone of silence has descended over the figure, suggesting it was disappointing. It grabbed headlines despite multiple questions about how many minutes constitutes a "view," as Todd A. Kessler points out, but the other question was quality. As *The New York Times*' Jeremy Egner wrote of the George R. R. Martin series, "World-changing events erupt from recognizable human impulses and flaws . . . jealousy, lust, insecurity . . ." Amazon's *Rings of Power*, on the other hand, gave us a slow, talky, humorless clash of empty abstractions, as did *The Wheel of Time*, with its Dark One, the One Power, the True Source, etc., etc., its previous attempt at world-building.

The Rings of Power is at its best a showcase for special effects, particular the spectacular destruction of the Southlands in Episode 6, so shocking that it brings to mind uncomfortable comparisons to Russia's attack on Ukraine. Beyond that, dialogue—if you can call it that—is customarily delivered in ponderous speeches alternating with fortune cookie homilies.

Salke also bet $300 million–plus of Amazon's pots and pans on its six-episode spy thriller set in the *Citadel* universe, with segments

semi-independently produced in countries all over the world. It is so ambitious that the trades refer to it as a "global event . . . the second most expensive show ever produced," after *Rings of Power*. *Citadel* scored no more than 51 percent with reviewers, and *TV Guide* dismissed it as "offensively dull." Domestically, only 37 percent of those who started it persevered to the end. (Comparatively speaking, Netflix canceled *Resident Evil*, which had a 45 percent completion rate.) Never accused of not knowing a bad thing when she saw it, Amazon is in for another season. In other words, while Amazon may reserve its old "prestige lane" for quality product, to use Salke's metaphor, chances are that it will become no more than a footpath choked by a tangle of roots and weeds. Amazon signed one of those prestige talents, Phoebe Waller-Bridge, coming off Season 2 of *Fleabag* in 2019, to a $20 million a year three-year deal that came to nothing, but was renewed anyway.

The one thing *Rings of Power* had going for it was that it was rich in intellectual property (IP), in this case the preexisting audience for *The Lord of the Rings*. As the competition among the streamers heated up, IP became more and more important. Lionsgate's Kevin Beggs elaborates on the irresistible lure of the built-in audiences delivered by preexisting underlying material: "In a world of many platforms and five hundred shows, an original breaking through is incredibly hard, so finding some marketing edge, some previously recognized fan base, is hugely important. If you're a buyer, a graphic novel, sales figures for a bestseller, or a sensational podcast that you can put in front of upper management where you can say, 'Look at this thing!' makes it easier to rationalize the buy."

Moreover, IP is, of course, another version of comfort viewing, warm and fuzzy, continuing familiar story arcs with the same characters, plus new ones who are no more than variations on the old ones. Or, alternatively, aged (or de-aged) stars like Sly Stallone in *Tulsa King* who make older audiences feel right at home.

Movies and TV show festooned with IP include bestselling books like Warner's *Harry Potters*; Starz's *Outlander* or HBO's *My Brilliant Friend*, of course, as well as video games, like HBO's *The Last of Us*;

comics (DC and Marvel); a buffet of notorious crimes and scandals; as well as headline-grabbing true stories like HBO's *White House Plumbers*, and finally, live events and sports.

One easy way of extending IP is through sequels, prequels, and reboots—that is, franchises. In 2019, the last prepandemic year, Franchise Entertainment Research reported that franchises comprised 42 percent of new wide releases and 83 percent of global box office. Showtime gave us *Dexter: New Blood* in 2021 and *American Gigolo*, based on the 1980 film. Even FX is getting into IP business with a sequel of sorts to *Justified,* called *Justified: City Primeval*, with Tim Olyphant reprising Raylan Givens in Detroit; Vince Gilligan capitalized on *Breaking Bad* with *Better Call Saul*. Apple TV+ is prepping a *Prince of Tides* reboot, and there are many, many more in the works.

Amazon bought itself $8.45 billion worth of IP when it purchased MGM Studios for twice as much as it was valued in May 2021, acquiring its four-thousand-film library as well as the United Artists library that MGM owned. Bezos's stated aim was to exploit MGM's "vast, deep catalogue of much beloved intellectual property," and he planned to "reimagine and develop that IP for the 21st century."

Despite the hefty number, however, its library is not that deep, once we move beyond the handful of titles in lights, and many are encumbered. Its most valuable asset is the James Bond franchise, which Amazon has to share with the rival streamers that have licensed it, and cede creative control to Barbara Broccoli and Michael G. Wilson, with whom Amazon seems to have a cool relationship. Perhaps worst of all, those two were quick to turn Bond's license to kill into a license to kill the franchise with Fukunaga's *No Time to Die*, in which lovesick, sensitive soul Daniel Craig was so out of character with 007 that it made even the wokest of viewers long for the politically incorrect Sean Connery of old.

Amazon inherited MGM top execs Mike De Luca and Pam Abdy, who had revitalized the moribund studio by using a strategy that clashed with Bezos's goals. Sounding more like Price and Lewis than Bezos, De Luca said, "We thought there was a lane open for the

movies Hollywood used to make—bold provocative originals. Not everything has to be a tentpole or a franchise entry." A month after the deal closed, both De Luca and Abdy resigned and were replaced by Salke, whose portfolio was dramatically expanded to include a confusion of subdivisions that all seem to have identical mandates. MGM's streamer, Epix, was redubbed as—guess what?—MGM+.

Although none of Amazon's features has taken off, Salke seems determined to make a splash. She has a lot riding on its 2023 holiday season family-friendly action comedy *Red One* with Dwayne Johnson, aka the Rock, who alone will pocket $50 million. She also has an Eddie Murphy comedy coming up, and a Matt Damon/Ben Affleck–production *Unstoppable*, starring Jennifer Lopez and Jharrel Jerome, the latter playing a wrestler with one leg, following up on their *Air*.

On the plus side, Salke has a lot of money to spend, and has been spending it on talent, signing, among others, Donald Glover and Barry Jenkins. She also resurrected *Mrs. Maisel* from the Palladinos, Amy and Daniel. Soloway and company still have a deal with Amazon, but as one source connected with *Transparent* puts it, carefully picking a path through a thorny bramble of words, "We still want to push the boundaries of the form, but it's been a little bit harder for us than it would have been if Joe [Lewis] were still there because he was our artistic cheerleader." Could *Transparent* find a slot in today's Amazon's lineup? Producer Sperling wonders, "I would like to think it would, but it's hard to know." Adds another former member of the show's creative team, "Maybe not."

Nor has Salke, at least so far, been able to solve the branding problem: Just what kind of service is Amazon Prime Video, and what is its audience? Is it a curated, prestige service as originally intended by Price et al., a "gimme *Game of Thrones*" service as *The Rings of Power* and *No Time to Die* suggest, or some tincture of the two? Given the direction all the streamers are going in, the last option seems most likely.

One thing it has going for it is live sports. Thursday night NFL football, along with Sunday, is the nirvana of streaming. Streamers pay in the megabillions for the rights to air games from the National

Football League, Major League Baseball, National Basketball Association, Formula 1, and Major League Soccer. Amazon is in a good position to foot the bill. The fans of these shows are more interested in home runs, goals, baskets, and touchdowns than *The Rings of Power*'s IP.

In October of 2012, Jeff Bezos surprised everyone by praising Netflix for its hit *Squid Game*. "Reed Hastings and Ted Sarandos and the team at Netflix get it right so often," he tweeted. "Their internationalization strategy isn't easy, and they're making it work."

Some Prime Video tea-leaves readers interpreted that tweet as his passive-aggressive way of indirectly criticizing the job Salke and Co. were doing at Amazon. After rating it a money-losing fourth among the streamers, *The Ankler* asks: How long will mothership subsidize it? How many of its subscribers really buy more shoes?

At the 2021 Emmys, two of Price's shows, *The Boys* and *The Underground Railroad*, got a slew of nominations. But Amazon came away empty-handed, despite its $8 billion programming budget, whereas Netflix won about ten or so awards for *The Crown* and *The Queen's Gambit*, and HBO Max also scored about ten for *Hacks* and *Mare of Easttown*. As one industry veteran sums it up, "Amazon does not have an ethos of 'Let's put on something special.' It's a one size-fits-all, tube socks ethos."

DISNEY'S EMPIRE STRIKES BACK

Disney digested Marvel, Lucasfilm, Pixar, and Fox, while AT&T gagged on Time Warner and spit it out.

The Walt Disney Company has become the most successful studio in Hollywood, while boasting of extensive holdings in TV, parks, cruises, and a vigorous merchandising business. CEO Bob Iger cultivates the image of a good guy in an industry that values the ruthless and the brash. He is a casual dresser—Mr. Rogers style—of whom it was said, he "occupies a sofa well." Commented the sage of Berkshire Hathaway, Warren Buffett, "When he calls I don't spend time thinking, *How do I tell this guy no? It's, How do I tell this guy yes?*" He was a Democrat who considered running against Trump but ended up backing Hillary Clinton.

Iger always believed that content is king. Speaking of Apple and Amazon, he says, "We view them . . . as competitors, but we never worried that they were going to put us out of business or own Hollywood, [since] they can't make a *Star Wars* movie. They can't make a *Thor* movie."

Yet, when Iger sat down at the desk of his predecessor, Michael Eisner, on November 1, 2005, he faced daunting challenges. Content is a fickle mistress, given to dancing with any suitor flashing a fat wallet who walks through the door. And it wasn't the only factor he had to consider. Iger had to rejuvenate a weakened animation division that had been eclipsed by John Lasseter's Pixar with films like *Toy Story 1* and *2*. Lasseter had recently stalked out of talks intended

to shore up the foundering twelve-year partnership between the two companies. Adding injury to insult, Disney's share of the theatrical exhibition market was shrinking, and would fall to a mere 10 percent by 2008.

That wasn't all. The chatter Iger was hearing about cord cutting had become a deafening roar. In 2018, Bloomberg blared, "Netflix-Loving Kids Are Killing Cable TV." According to *Cord Cutters News*, the audience for Disney Channel dropped dramatically from 2 million viewers in 2014 to 534,000 viewers in 2019. Its enormously profitable sports cable network, ESPN, had lost 7 million subscribers in two years. He was, in his words, hearing "an alarm bell."

As far back as 2015, he decided, as he puts it, "You don't really have a choice if you want to stay in the business or grow the business, except to go in the streaming direction."

At the time, Disney was licensing Marvel movies to Netflix. "I woke up one day and thought, we're basically selling nuclear weapons technology to a Third World country, and now they're using it against us," he says. "So we decided at the time that we would stop licensing to Netflix and do it ourselves."

What Iger needed, in other words, was his own bright and shiny Disney-branded direct-to-consumer streaming service, aside from Hulu, of which Disney was only part owner. Before that, however, he had to make sure that he had enough content to push through this new streamer when it was ready. He needed to ramp up production dramatically if Disney were to compete with Netflix, given its mile-long head start. There was a one-word answer to Iger's problems: "Buy!" He went on a spending spree that transformed Disney from a cartoon factory into a goliath among the studios. No longer would Disney's offerings be confined to talking mice, quacking ducks, and slumbering princesses, the diet consumed by decades of tweens and teens and animation nerds. Instead of trying to negotiate with Pixar, he bought the company in a stock deal worth about $7.4 billion. (Eventually, Lasseter, under a cloud for unwanted hugging, left Pixar entirely.)

Barely digesting Pixar, in December 2009, Iger set out to charm the

irascible Ike Perlmutter, CEO of Marvel. Initially Perlmutter refused to meet with him. An Israeli army veteran, he disliked Hollywood and had a reputation for being pugnacious and litigious.

Inside Disney, executives scratched their heads. Acquiring Pixar made sense, but Marvel? Nevertheless, as one Disney source puts it, "The Pixar deal gave Iger the ability to say, 'This is what we should do.' What Bob wanted, Bob got." Iger bought Marvel for $4.24 billion, and with it corralled a royal flush of superheroes—Iron Man, Captain America, Thor, the Avengers, and so on—that he hoped would secure Disney's holdover boys, long a weak spot in its demographic. (Elon Musk, by the way, was an inspiration for *Iron Man*, and had a cameo in *Iron Man 2*.) Better yet, the movies would function as commercials for Marvel merchandise that, as of 2020, funneled about $41 billion into the company, more than the earnings of all its superhero pictures combined.

Iger, however, was just getting started. He talked Steven Spielberg into releasing DreamWorks pictures through Touchstone, a Disney division. In December 2012, he added Lucasfilm to his collection for $4.05 billion. That brought him the *Star Wars* franchise, which had been squandered by Rupert Murdoch's 20th Century Fox.

Not satisfied with acquiring content engines like these, Iger turned his attention to Fox itself, beating out Comcast in a bidding war with an offer of more than $71.3 billion, thereby hitting the delete key for one of Hollywood's storied studios while fattening Disney's library and supercharging its production. Save for Fox News, Disney hoovered up all its parts, including Fox Searchlight, its well-regarded indie division.

Disney also acquired Fox's movie studio that not only boasted *Avatar*, the biggest-grossing movie of all time, and its four sequels still in production, but errant Marvel series like *X-Men*, the *Fantastic Four, Daredevil*, and the new hit, *Deadpool*. (Disney also secured joint custody of the *Spider-Man* franchise fumbled by Sony Pictures.) All in all, that gave Disney nearly sole possession of the Marvel Cinematic Universe (MCU), a complex group of interconnected stories

boasting scores of characters. And last but not least, it picked up the Fox television studio, which was then producing thirty-six shows, including *This Is Us*, *Modern Family*, *Homeland*, and *The Simpsons*, the longest-running scripted series in the history of American TV.

Among the treats that Disney collected from the Fox feature library were classics like *The Sound of Music*, the *Home Alone* franchise, and the *Aliens* series. And wait! There's more. Disney also acquired control of Hulu, the streaming service that it had shared with Fox and NBC-Universal. Iger could have just as easily deep-sixed FX, Fox's linear cable service, but he recognized that it could be Disney's HBO, and under the Disney umbrella it would continue to build hits like FX-on-Hulu's *The Bear* and *Reservation Dogs,* as well as Donald Glover's *Atlanta, Under the Banner of Heaven, The Old Man*, and *Fleishman Is in Trouble*. Says Landgraf, whose stand-alone cabler otherwise faced death, "Thank God that Disney bought us."

Iger's purchases were so strategic that they amounted to winning the lottery, and he came to be regarded as a latter-day Walt. As someone or other told *The New York Times*' Maureen Dowd, "Nobody expected Bob Iger to be Bob Iger." And finally, with as much originality as he could muster, Iger would call his new streaming service Disney+.

Again, given that the pandemic made the numbers for 2020 and most of 2021 meaningless, we have to go back to the prepandemic year of 2019 to get a snapshot of the entire Disney operation. Its studio division, fattened by Fox, effectively controlled nearly 35 percent of domestic box office, tripling its market share in just nine years, leaving its nearest competitor, Warner Bros., with scraps, a mere 13.8 percent. Of the ten top grossing theatrical features that year, Disney released eight, including five $1 billion box office movies.

Disney's Dumbo-size chunk of the theatrical exhibition revenue, however, accounts for only 13 percent of its annual revenues of $70 billion. It's no more than an accelerant for its real business, led by broadcast and cable networks, as well as its twelve parks nesting within six resorts. California governor Gavin Newsom called it a "nation state."

n contrast to Iger's great adventure stands AT&T's great misadventure—its acquisition of Time Warner, renamed Warner-Media in 2018. AT&T's COO, John Stankey, had watched the frenzy of mergers and acquisitions that defined the era, as Comcast gobbled up NBCUniversal, CBS and Viacom merged into Paramount Global while its streamer, Paramount+ (formerly CBS All Access), was poised to swallow Showtime, and Disney gobbled up everything else in sight. To him, Time Warner seemed like a perfect fit, its product with his pipeline, described by that magic word "synergy," the marriage of hardware and software.

Could New York–based HBO with its Democrat-affiliated CEO Richard Plepler find happiness in bed with Dallas-based Stankey? Randall Stephenson, Stankey's boss, was hand in glove with Trump, who hated Time Warner's CNN for baiting Fox News, and was pressing Stephenson to get rid of its head, Jeff Zucker. (Stephenson claims he protected the integrity of CNN.) AT&T employees referred to Stephenson, the head of their top-down company, as "Mr. Chairman," while Time Warner employees referred to Bewkes as simply "Jeff." Bewkes, however, would hear no evil, saying the two companies "fit together very well culturally." What was he smoking?

When Plepler met with Stephenson at his favorite haunt, the Lambs Club, he too left reassured that AT&T would be hands-off, confident that Stephenson understood the necessity of "a Chinese wall between the creative process and everything else." But China had outgrown its wall, and HBO would find that it had more in common with Taiwan.

Bewkes had finally awakened to the streaming threat, only to discover that he had overslept, and it was too late. As he testified in 2018 when the Justice Department tried to block the merger, "We don't have the tech platform, don't have the engineers, don't have the infrastructure" to compete with the likes of Netflix and Amazon. Trump's "antitrust" division allowed the deal to go through. AT&T bought Time Warner, including its cash cow, HBO, for $85.4 billion.

When Stankey first planted his foot in Time Warner, he was like Gulliver among the Lilliputians. He seemed to have no idea of, or

else didn't care about, the damage he might do. On a steamy day in July of that same year, 150 or so HBO executives and staffers gathered in the theater atop its Bryant Park headquarters to hear what Stankey had in store for them. Plepler, with his perennial tan and casual, open-collared shirt looking like he'd just breezed in from St. Bart's, kicked off the now infamous town hall on a cordial note, introducing Stankey as "a superlative businessman," and "a gentleman [who] will be a tremendous boost to where we're going with this company." He went on to recall having dinner with Stankey months earlier in Dallas when, as he launched into HBO 101, Stankey interrupted him, saying, "Richard, you do not need to waste one more minute telling me about the superior quality of the HBO brand." Plepler thought, "This is one smart fucking guy!"

Plepler opened with a brief video featuring HBO stars like Emilia Clarke, Bill Hader, Sarah Jessica Parker, and Jeffrey Wright, which concluded with "Welcome to the HBO family" plastered across the screen in large type. It was so laudatory that Stankey asked for a copy to take home to his family. John Oliver refused to take part in the video, saying no good would come from the AT&T takeover. Oliver proved to be right. The audience applauded appreciatively as the six-foot-five Stankey lumbered onstage, but he opened his remarks with, "It's going to be a tough year." They had no idea just how tough it was going to be.

Instead of stroking his new, nervous employees, and providing answers to the bread-and-butter questions they wanted to hear, like, "Are our jobs secure?" Stankey aggressively reminded them that there was a new sheriff in town, warning that HBO was going to have to "alter and change direction." By that he meant it needed more "engagement" with its viewers. "It's not hours a week, and it's not hours a month," he went on. "We need hours a day. You are competing with devices that sit in people's hands that capture their attention every 15 minutes." Stankey continued, "Why are more hours of engagement important? Because you get more data and information about a customer that then allows you to do things like monetize through alternate models of advertising as well as subscriptions."

AT&T had promised to be hands-off its new bauble, but this didn't sound like it. Stankey had used his first appearance before staffers to lecture them about their business, about which he seemed to know next to nothing, since he apparently didn't watch much TV. When asked about his favorite shows, he was flummoxed. Tired of questions from HBO-ers, he yelled, "I'm sick of hearing this! I know more about television than any of you! Stop questioning me." He also gave the impression that Time Warner, which he renamed WarnerMedia, was no more than a perk for AT&T's new customers, like Amazon Prime Video was for Amazon's customers.

Predictably, this didn't go down well, especially when he thought it necessary to remind them, "We've got to make money at the end of the day, right?" But HBO had been making money, netting its no-longer-parent company, Time Warner, $6 billion a year. When Plepler broke in to say, "We do that," Stankey retorted, "Yes you do. Just not enough."

Even more discomfiting than Stankey's remarks was one by Randall Stephenson, his boss, suggesting that hour episodes don't play well on "direct-to-consumer platforms" like cell phones; *Game of Thrones*, then HBO's flagship show, might do better in a "mobile environment" if reduced to twenty-minute segments. Stories had become product, then content, then, as one AT&T executive referred to HBO's programming, "bits in pipes." Although Stankey denied it, it sounded very much like AT&T wanted to remake HBO in the image of Netflix.

Plepler, by that time a twenty-eight-year veteran of the company, tried to paste a smiley face on Stankey's presentation, saying, "AT&T understands that we have no interest in being Netflix," and more, it gave HBO the opportunity to become "a turbocharged version of ourselves." He couldn't have been more wrong.

f it were possible for an old-guard legacy studio to big-foot tech companies like Netflix, Amazon, and Apple at a time when research indicated most Americans subscribed to no more than two

streaming services, Disney was the one to do it. An old friend, Barry Diller, observed that Iger was "absolutely determined not to turn the world over to Netflix and Amazon." Indeed, many regarded Iger as the white knight who would slay the Hastings dragon, send the Albanian army back to Albania. Disney's deal with Netflix for its Marvel shows was said to be worth between $200 and $300 million in licensing fees, but when that agreement ended in 2019, Iger was happy to let it lapse and eat the loss so that it could gather those films under the studio's own roof and air them on Disney+.

It was one thing to be convinced that Disney needed a streaming service; it was another thing to figure out what kinds of shows it should air. It was not a decision to be taken lightly. Disney had so thoroughly colonized the imaginations not only of America's children but of children everywhere, that veteran animator Glen Keane observed, "The Disney version becomes the definitive version." He had animated *Pocahontas*, and he said the first likenesses of her that appear on Google Images are his. The answer seemed obvious: It was time for Disney to wake up its sleeping beauty, that is, its library of classic animation, and what a beauty it was. Not only would kids watch these shows over and over, but their appetites extended to endless knock-offs that allowed Disney to CRISPR franchises like *Beauty and the Beast* and *The Lion King*, turning them into gifts that never stopped giving.

There was, however, a problem. Most of Disney's classics were honeycombed with racism, sexism, and homophobia, all of which were axiomatic at the time they were made, so as to make them virtually invisible. Two decades into the twenty-first century, however, Critical Mouse Theory had made the racial and gender biases of the classics all too apparent—and Disney was kept busy scouring images and attitudes that were unacceptable in today's woke culture.

When *Toy Story 2* was released on DVD, Disney cut a casting couch joke that appeared after the tail credits wherein Kelsey Grammer's Stinky Pete comes on to a pair of Barbie dolls by promising them a part in *Toy Story 3*.

A snip here and a snip there were enough to sanitize most of these movies, but they weren't going to work when the bad stuff was baked into the plots themselves. In Disney's beloved *Dumbo*, it's hard to ignore the fact that the circus hands are exclusively voiced by Black actors, and in one scene where they are erecting circus tents, they are singing "Song of the Roustabouts" that contains the lyric, "Grab that rope, you hairy ape." The black crows whose leader is named Jim Crow and who speak in cadences lifted from blackface minstrel shows are missing from Tim Burton's 2019 remake. When it was impossible to excise racist, sexist, or homophobic elements, as in *Song of the South*, the movie was canceled entirely.

Then there's that vein of gold, the original *Lion King*, with its overriding theme: In the natural order of things, the strong rule the weak, the predators lord it over the herbivores. Extrapolating the power dynamics of one type of social organization that many critics derided as "fascist" to the animal world serves to naturalize it, normalize it, make it seem like "this is just the way things are."

Eventually, time caught up with the Mouse House. After the parade of Snow Whites, Cinderellas, Ariels, Auroras, etc., etc., Disney got around to a Black princess in its forty-ninth animated feature in 2009—Tiana in *The Princess and the Frog*.

Doc McStuffins, created by Chris Nee, known as the "Shonda Rhimes" of children's animation, featured a cartoon doctor who restores broken toys to health. Disney customarily cubbyholed its characters according to their ostensible appeal: It argued that boys wouldn't watch girls' shows, and girls wouldn't watch boys' shows. Nancy Kanter, then creative head of Disney Junior, the Disney pre-school channel, and eventually promoted to executive VP of content and creative strategy at Disney Channels Worldwide, suggested making the character a Black female all the way back in 2012. The Consumer Products division suffered a collective heart attack, in-sisting that white children wouldn't buy Black dolls. Nee recalls, "The prevailing wisdom was that that would hurt the chances of the series." Kanter insisted, and she proved that that was not the case.

On top of selling dolls, the show won a Peabody Award. Nee goes on, "It opened up opportunities for other series to be more diverse in a way that really broke what people thought about the product lines in the kids business." Diversity, in other words, wasn't just about doing the right thing; *Doc McStuffins* proved it was good for business. Disney's 2023 live-action *Little Mermaid* featured a Black actress, Halle Bailey, in the lead, and in its 2024 *Snow* not-so *White,* Latina Rachel Zegler plays the lead.

When Stephenson retired in 2020, Stankey became AT&T's new CEO. Merging two giant companies with different cultures is not for the faint of heart, especially when they were as disparate as AT&T and Time Warner, which included not only a storied film studio and HBO, but Turner Broadcasting—TBS, TNT, and CNN. While Casey Bloys ran programming for HBO, Turner had been run by Kevin Reilly since 2014. In June 2017, Stankey put him in charge of content strategy, finding a way to enter the streaming wars with its own version of Netflix. The problem was HBO, at once Stankey's rarest jewel and biggest headache because its reputation demanded that it be handled with kid gloves. "Quality," however, was not a word AT&T knew how to spell, and the company believed that branding as such rendered HBO too narrow. It wanted a streaming service with wider appeal, hence, HBO Max. It made its debut in 2020, airing Warner's *Friends* and the *Harry Potters* alongside *Game of Thrones*.

One of the reasons Bewkes chose AT&T as a buyer was that he thought Stankey's ignorance of the entertainment world would be to Time Warner's advantage, meaning that he would leave its team in place. That turned out to be an illusion. Too late, Bewkes regretted it, saying, "The level of malpractice is something I would never have believed possible," referring to AT&T. "The value destruction has been monumental."

Stankey's solution to his organizational problems was to hire more executives. He hired Bob Greenblatt in March 2018, over

Reilly, which struck many as a boneheaded move, since the two had almost identical résumés. A major problem, according to multiple sources, all NDA'd, was Stankey himself. Says Greenblatt, "No strategic thinker, he made decisions off the cuff. It was all just seat-of-the-pants, figure it out as you go."

On April Fools' Day, 2020, he announced that he'd made wunder-kind Jason Kilar, formerly of Hulu, CEO of WarnerMedia for a reported $52 million. Kilar wasted no time getting off on the wrong foot. In August 2020, he abruptly fired both Reilly and Greenblatt with no more than an hour's notice before news outlets broke the story. Says one executive who worked with both Reilly and Greenblatt, Kilar "took out a huge chunk of experienced, talent-friendly personnel, and that says a lot about the way AT&T viewed the company, as a commodity. They cut the heart out of the place."

Plepler is said to have been miffed that Stephenson never invited him for lunch, and felt that Stankey disrespected both him and the HBO brand. Stankey is said to have met with Bloys virtually behind his back, further angering him. He eventually resigned in February 2019, to be replaced by Bloys.

It's difficult to assess Plepler's tenure at HBO. There's a lot to praise, and a lot to not. As he himself says, "Executives get more credit than they deserve for things that work and more blame for things that don't."

In any event, with Reilly, Greenblatt, and Plepler gone from Warner-Media, the company was left with an open wound. Who, if anyone, was going to replace them? For a long time, AT&T had had a female problem. At a time when the entertainment business was trembling before the power of #MeToo, all the important posts at the company were held by men, and Stephenson was actually quoted saying, "I also have to protect this telco guy culture."

Back on March 6, 2019, before the bloodletting, the company held a town hall meeting in New York, a highly anticipated event that was beamed back to LA, where the division heads—including Reilly, Greenblatt, CNN's Jeff Zucker, Turner Broadcasting chief David Levy, Warner Bros.' Kevin Tsujihara, plus Stankey—faced an audience of

250 people. Speaking was Stankey. With his hulking size, he looked like "the ultimate white guy," as one source puts it, with a deep, booming voice, virtually a walking and talking commercial for toxic masculinity. Peppered with questions, his responses, according to a source, were "dismissive, borderline offensive," and tangled up in telecom jargon.

Tsujihara sat through the whole thing looking ashen, because he knew what was coming. *The Hollywood Reporter* was about to out him for having an affair with an actress. He was quickly #MeToo-ed off the lot. AT&T was virtually forced to hire a woman to replace him. Several experienced female executives turned it down. Three months later, the studio accepted Ann Sarnoff, almost by default.

Meanwhile, Kilar was watching theatrical exhibition struggle with the pandemic. Exhibition was in a bad way. Not only was there a shortage of customers, but there was a shortage of movies, as production ground to a halt. Many screens were sited in "zombie malls," according to one analyst, while Regal, the second biggest US theater business, with 542 multiplexes, declared bankruptcy, predicting that box office wouldn't re-up to prepandemic levels until 2025, and claimed the US was overscreened, to the tune of as many as twenty thousand theaters. The nation's biggest chain, AMC, was also struggling with a heavy debt. When the curtain fell on 2022, ticket sales were 35 percent under their 2019 prepandemic totals.

Watching exhibition in flames, in December 2020, Kilar added fuel to the fire with his so-called Project Popcorn, which broke the heretofore, more or less sacred theatrical window that gave exhibitors a seventy-five- to ninety-day lock on new releases before they went to DVD, cable, or affiliates. He announced that Warner's features would henceforth be streamed on HBO Max at the same time they were released in theaters, outraging not only exhibitors, but agents and talent whose back-end payouts depended on ticket and DVD sales, as well as syndication to secondary markets. Spielberg felt that filmmakers were being thrown "under the bus" by Warner Bros. One studio bigwig commented, "Without question, Kilar fucked things up so badly in terms of the general health of our industry that we're

going to be feeling those reverberations for a long time." The studio's highest-profile director, Christopher Nolan, left for Universal. Wags began calling it "Former Brothers."

The Disney classics—*Snow White, Sleeping Beauty, Pinocchio,* and so on—might have been the backbone of its new streaming service, but Disney still needed new product, especially shows to feed its new streamer, Disney+. The issue of what that was going to be like became a stumbling block that Disney never quite surmounted.

Disney gave creative oversight over Disney+ to Ricky Strauss, head of marketing. According to several sources, Strauss was good at stroking talent, but had no idea what, exactly, he wanted. Said one Disney veteran, "Ricky's expertise, outside of marketing feature films, was zero." In essence, however, Strauss said he didn't need creative experience. He told the press, "To be successful in making content, you need to have a marketing lens on everything you do— who are the people you are driving toward?"

Disney was structured hierarchically. "Everything had to bubble up to Ricky for a final approval," a source recalls. "You had to go through a whole lot of layers to get there." Strauss's responses to the material before him that were life-and-death matters to creatives were, they felt, at once too personal and too generic, too personal in the sense that he was fifty-one and single, and he would say, "'Would I want to watch this?' Well, maybe you wouldn't, but we're not actually making them for you. We're making them for six- to fourteen-year-old kids." And too generic in the sense that they seemed like he had spent too much time reading screenwriting gurus like Syd Fields or Bob McKee: "We need to understand more about this character's emotional journey," "We need to understand more about the backstory to this character." The notes read like a checklist: "Emotional journey," check; "Backstory," check.

None of this helped to solve the overall problem of what that Disney+ programming should be. On the one hand, there were pow-

erful executives like Gary Marsh, head of the Disney Channel, who had a very "conservative view of what content would work for kids," remembers a company veteran, "and much of it was, Let's do what we've done in the past. And that's rebooting the shows they had been making for fifteen years." For them, that meant lots of prequels and sequels.

On the other hand, there were dissenters who felt that sticking to the same stories over and over again was a losing formula. Explains Kanter, "Disney is filled with people who have dreamed of working there from the time they were six years old. They want to go to Disneyland and look up and see the light in Walt's office. Once when I was going through Customs, they asked me, 'Where do you work?' And I went, 'The Walt Disney Company.' They beamed and said, 'Oh my God, the happiest place on earth.'" But if Disney were going to develop the happiest streaming service on earth, she goes on, "You were going to have to bring in people other than just the ardent Disney fans, and that meant millennials, that meant single people, and people who wouldn't necessarily show up at a Disney movie."

Which was it going to be, the old way or the new? Backward or forward? Or just standing still, frozen like Anna's heart in the 2013 Disney hit *Frozen*?

The muddle at the top over the direction of Disney+ trickled down through the ranks and wreaked havoc with some of its biggest hits, most prominently *Lizzie McGuire*. The original *Lizzie McGuire* premiered in 2001. It starred fifteen-year-old Hilary Duff, who was so popular that *Vanity Fair* called her the "Tween Queen" and put her on the July 2003 cover with a handful of other junior stars. From 2001 to 2004, Duff's thirteen-year-old Lizzie negotiated the fraught journey from tween to teen—pimples, first dates, training bras, bf's and gf's, school, parents, and the pressure to be popular. Like other Disney productions, it is riddled with upbeat Life Lessons like "Be nice," "Tell the truth," "Obey your parents," "Treat everyone as equals." Perceived betrayals are not real betrayals, never motivated by real malice, but by misunderstandings, adolescent confusion, or miscommunication.

Terri Minsky wrote the pilot, as well as one other episode, and was given "created by" credit before Disney-owned ABC picked up another pilot of hers and she was taken off *Lizzie*, but nevertheless she had become synonymous with it. Minsky confesses, "I don't know shit about teenagers," but her script was nominated by the Writers Guild of America.

Lizzie McGuire was a cash cow, and spun off at least twelve books, published, naturally, by Disney Press; a soundtrack that went platinum, issued, naturally, by Disney's Buena Vista Music Group; and a feature film, produced and released, naturally, by Disney's movie division. The consumer products division marketed and licensed Lizzie dolls, sleeping bags, pencils, notebooks, and a clothing line. Disney milked it like Clarabelle, and the franchise raked in an estimated $100 million.

Lizzie McGuire was so successful that, looking for surefire hits without stepping outside of Disneyland, the company rebooted it for Disney+, picking up Lizzie seventeen years after the original had ended, when she was thirty years old. Minsky was again hired to write and run. The script for the pilot is a fizzy, light-as-air confection filled with witty banter that at its best is in shouting distance of the screwball comedies of the 1940s, but unfortunately for Minsky and the show, "screw" was the operative term. As an adult, Lizzie has adult problems that are different from pimples and training bras. She is living in New York City with a boyfriend who runs a hip restaurant in Brooklyn. She discovers, however, that he has someone on the side: her best friend.

The reboot had hit written all over it, but it wasn't family-friendly enough for Disney. When Lizzie's boyfriend cheats on her, it's a real betrayal, not a faux betrayal that can be explained away. Worse, Lizzie was to have a gay roommate, and sleep with her old high school boyfriend. Then there were the three naughty words in the script for the second episode, where characters sing a bar or two of "Dance: Ten, Looks: Three" from the musical *A Chorus Line*. Unfortunately, the three words they chose were "tits and ass." When the second episode was shot, those words were gone. In-

fidelity, promiscuity, off-color language, and homosexuality—it was all too much.

If there was a tug-of-war between the Disney Channel and Disney+, the Disney Channel was winning. Even though Lizzie was thirty, she was supposed to behave as if she were still thirteen. According to one person attached to the show, "There was never any discussion about having it be for a family audience. They knew about it, they approved it, they applauded it, they presented it." Adds actor Robert Carradine, who played Lizzie's dad, the cast did two read-throughs of the script, and "There were literally three rows of chairs and in each chair was . . . a Disney executive. I mean, there were 25 of them . . . and they were laughing their asses off."

Nonetheless, Disney cited the dread phrase "creative differences" and paused the show, even though, according to one account, no one in a position of authority at Disney+ had ever said, "We want this, we don't want that" at the development stage, but instead waited until the first season was in the can to lay down the law. Says the source, "You don't give notes on the completed show, you give notes on the script so that when you shoot the show you know what they want. That's how you do television." Disney fired Minsky and looked for another writer, but when Duff refused to do the reboot without Minsky, they killed it.

Iger put down Netflix, saying in 2019, "What Netflix is doing is making content to support a platform," whereas Disney is a brand. But one of the reasons Disney was so reluctant to let Lizzie be Lizzie, so to speak, is that it *is* a brand. It's no accident that theme parks and merchandising to one side, the most successful Disney's brand is the least Disney, the outlier Marvel.

Netflix has been quick to take advantage of the fact that many of Disney's creatives feel suffocated by the heavy hand of branding. A veritable parade of Disney producers has defected to Netflix—including Kanter, a twenty-year veteran. "I was ready to play outside the Disney sandbox," she says. "The kind of content they were looking for just became less and less interesting for me. 'Find the next Hannah Montana.' But you know what? We did Hannah Montana.

Why don't we try to do something else? What you won't find at Netflix are the remakes of remakes and spinoffs of spinoffs."

Perhaps the most high-profile defector was *Doc McStuffins'* Chris Nee. In 2018, she left for an overall deal at Netflix's animation division, which was becoming a refuge for disgruntled animators from Disney and Nickelodeon. She gained, in her words, "great creative freedom." At Disney, she says, "To get a same-sex family into an episode was a fight over multiple seasons. You are in a constant notes mode. They weren't looking to empower someone to create their own brand within the world of Disney. Over a period of almost ten years, I made two shows. Plus, they were very clear that two would be the cap. At Netflix, I have five different series in process right now. You get to kick down those barriers of 'This programming is for this age.' You can work in different age ranges. You can work across genres. I get fewer notes. I am left alone. They trust what I do and how I do it. It's like night and day."

Nee says that although she knew how to make hits like *Doc McStuffins*, Netflix told her, "'You don't have to make the huge hit here. You can make the smaller, more personal thing because we're trying to find specific programming for everyone.' The idea of 'You're not going to be penalized for making a niche show' appealed to me. For the creator it's catnip to hear that Netflix has no brand. It's one of their great selling points. How that will end up working overall for Netflix, that's the big question. Or with the number of different streaming platforms, do you need some kind of identity to help people know where to look for what? I don't know the answer to that."

Shonda Rhimes agrees. One of the reasons she left ABC for Netflix is that Netflix isn't branded. It "didn't require you to make a show that is an 'ABC show' or to make a show that had a certain budget or tone to it," she explains. "In network television, if you make a show, they just want you to make more of that show, and if you make a different kind of show, they're worried it's not going to work."

Says Nee, "For the most part I found the Netflix culture amazing. It really was meant to be this Shangri-la." But, she goes on, it was almost too much of a good thing. She recalls, "At some point, I started

saying, 'It's really hard working at a place where no one will say no about anything.' You actually can't tell that a yes is a yes. When the first of the animation projects got killed, there were a lot of people who felt relieved to know that there were walls in the room in which we were."

Netflix premiered three of her new shows in 2021—*We the People; Ada Twist, Scientist*; and *Ridley Jones,* "so it's 'so far so good,'" she said then. But "eyes wide open—all organizations change. Leaders change. The world changes. So I'll be very happy here until I'm not."

As the female flight from Disney indicates, all was not well at "the happiest place on earth." Disney has been charged by ten women with discriminating against female employees, which the company denies. According to one employee, a female producer was taken to lunch and advised to be more "ladylike." Adds another source, men were given more latitude than women in terms of behavior. "There was one creator there who had a restraining order against him for harassing younger female employees, who was not allowed on the lot. And yet they did not let him go. They created an entire system around him, bringing in another co-showrunner so that he could give the notes to that person who would interact with staff." Would a woman in the same position with, say, an abusive temper, be given the same consideration? Replies a former employee, "No. I would consider that a double standard." As one source put it, "Disney is not a nice company."

Worse, Abigail Disney, the granddaughter of Walt's brother Roy O., and long a thorn in her family's corporate side, offers a broader critique in a documentary she produced called *The American Dream and Other Fairy Tales.* Among other things, the doc attacked Disney's leadership for its shabby treatment of its approximately 223,000 employees during the pandemic when it closed its parks.

The magnitude of the layoffs caused her to take to Twitter and tweet, "WHAT THE ACTUAL F***???," calling Iger's 2018 salary of $65.6 million and 2019 salary of $47,525,560 "insane" and "a naked indecency." She asked, "What kind of a person feels comfortable with that?" especially at a time when Disney laid off nearly half its

workforce, eventually amounting to thirty-two thousand employees by April 2020. "Let's not pretend that [they] go somewhere and disappear," she wrote. "They lose their houses, they are homeless, and they have to steal things to eat." She quoted multiple park employees complaining that they had to "forage for food in other people's garbage."

I f Uncle Walt made a name for himself with *Steamboat Willie*, steampunk *Star Wars* generated one of Disney+'s first breakout hits of the Iger era, *The Mandalorian*. The Mandalorian himself is a bounty hunter played by Pedro Pascal, who then might have been familiar to *Game of Thrones* fans as Oberyn Martell, but we're not talking *Game of Thrones* here. The Lucasfilm show is all action, little character, and most of what passes for dialogue is just noise, no better than computer-generated gibberish—"Chain codes," "tracking fobs"—or worse: "Not so fast, Fennec!" or "Who's this guy?" It's all sound and fury, signifying money. Most of the characters look like the Stop the Stealers who descended on the US Capitol on January 6, 2021, horns and all. The droids, who don't have to pretend they're actors, turn in the best performances. They even ended up on postage stamps, suggesting that Iger had added the US Postal Service to Disney's holdings. Frozen in place, they look much more comfortable than they do when animated.

Despite *The Mandalorian*'s cachet, and Pascal's emergence as a genuine action star in HBO Max's *The Last of Us*, each *Star Wars* movie since *The Force Awakens* in 2015—*The Last Jedi*; *Solo: A Star Wars Story*; and *The Rise of Skywalker*—has done less business than the previous one, with *Solo* actually losing nearly $80 million.

According to one report, "agents" say, "Top filmmakers are dying to make a *Star Wars* movie—until they sign on and experience the micromanagement and plot-point-by-committee process." The next *Star Wars* picture, written by Steven Knight, who replaced *Lost*'s Damon Lindelof (let's hope it's more *Peaky Blinders* than *See*), isn't expected until 2025 at the earliest. Lucasfilm president Kathleen

Kennedy, who seems to be focusing exclusively on streaming, is taking the hit for neglecting the movie franchise, with *Puck*'s Matthew Belloni calling the lengthy gap between the last *Star Wars* movie and the next "borderline corporate negligence."

Meanwhile, it seems like Marvel is dropping new films and TV series every month. *WandaVision*, for example, generated an inordinate amount of press and won two Primetime Emmys, richly deserved. It's another one of those shows that are interesting as a "metafiction." On one level, it is about itself and its niche in the Disney firmament.

WandaVision begins as a proto-Disney, anti-Marvel show, an homage to everything Marvel isn't, that is, a small screen, black-and-white simulacrum of a '50s going on '60s sitcom like *I Love Lucy*, featuring two B-list Avengers in love, Wanda Maximoff, and Vision, an android-slash-synthezoid-slash-technosapien (see *After Yang*), neither of whom made so much as a ripple in their previous MCU outings. It is five years since the "Snap," wherein Thanos, the Big Bad of *Avengers: Endgame*, killed off half of all living things, including Vision (twice), with a click of his fingers.

The two live in connubial bliss in a hypernormal New Jersey suburb called Westview. All, however, is not what it seems. The sunny *WandaVision* is cleverly linked to the darker byways of the MCU by a slip of the tongue, whereupon Westview is revealed to be no more than an illusion, a spell called the Hex, cast by Wanda, who turns out to be the Scarlet Witch from the *Avengers* series. It's a wish-fulfillment dream born of her desire for a happily-ever-after life of domestic bliss with Vision, with whom she is in love and has revived, re-created, or otherwise reanimated.

In this idyll, Ted Lasso could well be their next-door neighbor, but the Marvel world from which she is trying to escape will not be denied, and her actual next-door neighbor, nosy Agnes, is no Ted. It turns out that Wanda is not the only witch in town, and the new one is a bitch. "Agnes" is really Agatha Harkness, accused of practicing black magic during the Salem witch trials. (She has been spun off into her own series, *Agatha: Coven of Chaos*.) When she reveals her

true nature, the two go full Marvel, flinging bolts of flaming energy at each other—to what end?

It seems that Wanda has to choose between family (Vision and her twin boys) encased in, say, *The Dick Van Dyke Show* that she has created with her spell, or doing the right thing by releasing the town from the Hex, which would entail Vision's death. Despite a hopeful sentiment expressed by someone or other—"Families are forever"— hers isn't. Revoking, nullifying, abrogating, or whatever it is you do to dispel a spell, she does it, returning the good citizens of Westview to their normal routines at the cost of her family. What started as an anti-Marvel show, in other words, pitting family-friendly Disney against family-unfriendly Marvel, ends up as an anti-Disney show, with Disney muscled by the mighty Marvel. The tail, in effect, is wagging the dog.

WandaVision is full of echoes, allusions, callbacks, and Easter eggs from old TV sitcoms and previous Marvel shows, creating a puzzle for superfans by entangling them in the increasingly intricate Marvel maze, all of which is fine. But when *Black Widow* was released, requiring *The Washington Post* to run a piece entitled, "The 7 Marvel Movies You Should See Before *Black Widow*," the danger is that those who merely want to watch, not research a PhD in MCU studies, are left out in the cold. Ditto *Doctor Strange in the Multiverse of Madness*. For those studying for their MCU exams, *The New York Times* recommended rewatching five films to fully understand it.

If the Lucasfilm franchise is too dumb for its own good, the Marvel franchise is too smart. On the other hand, the vacuum at Lucasfilm and the bottomless pit that is streaming may be stretching Marvel too thin. VFX artists complain of being "pixel-fucked" by the studio's demands. Still, better smart than dumb, which is Disney's problem.

Marvel, in other words, has done what Disney hasn't—extended its brand instead of repeating itself. It retired, more or less, its first-, second-, and third-generation superheroes like Iron Man, Thor, Captain America, and the Avengers—no matter how well they did at the box office—and replaced them with a batch of newbies comprised

partly of wannabes neglected in previous shows, like the Scarlet Witch, Loki, and Black Widow, plus unfamiliars like the Eternals, all lumped together in the post-*Avengers*, so-called Phase 4? 5? Something? of the MCU. They've even begun to experiment with new characters, strangers to the MCU, as in *Moon Knight*. *Ms. Marvel* features the franchise's first Muslim superhero, an Avengers-crazed Pakistani fangirl.

Still, if much of Disney's "product" leaves a lot to be desired, while Marvel's is ever evolving in interesting ways, there's a downside to this dynamic. If shows like *The Lion King* keep on giving, Marvel keeps on taking. Even when its movies are "good of their kind," Marvelizing the moviegoing experience sucks the life out of it. Jon Favreau started his career writing a more than promising indie film produced on a shoestring called *Swingers* in 1995. But ever since he ended up as Marvel's go-to director for its blockbusters, indie filmmakers who constitute the lifeblood of our movies have jumped from festivals to franchises, traveling through what *Washington Post* film reviewer Ann Hornaday has called the "Sundance to spandex pipeline."

So far as indie talent goes, Marvel's story is little different from that of *The Invasion of the Body Snatchers*. Like Favreau, many, many other promising indies filmmakers have been snatched by Marvel. Ryan Coogler went from *Fruitvale Station* to *Black Panther*. Cate Shortland traded in her debut indie, *Somersault*, which premiered at Cannes, for *Black Widow*. Chloé Zhao went from an Oscar for *Nomadland* to Marvel's *Eternals* without Thanos even having to snap his fingers. Elizabeth Olsen, aka Wanda Maximoff, started her career at Sundance in 2011 with *Silent House* and *Martha Marcy May Marlene*. Some of the films, like *Black Panther*, are better than others, of course, but as critics are starting to notice, most are not even aimed at fan service, but corporate service.

"Small is beautiful" is a thing of the past, yet another relic of the '60s. It's not a phrase you hear much in today's Hollywood. With its soup-to-nuts parks, worlds, uni- and multiverses, Disney has become our Homer, with tales of the Avengers and the X-Men our *Odyssey* and *Iliad*.

On February 25, 2020, Iger finally exited the C-suite, stepping down as CEO of Disney after fifteen years. As he explains it, with big helpings of humble pie for which he is famous, his thinking was, "Things had been quite good at the company in the period of time that I was CEO," adding, "Subconsciously, I felt like I was always right, or I knew it all. Bringing someone in with a fresh perspective is like opening the windows and letting fresh air blow in." The "fresh air" was named Bob Chapek, a twenty-seven-year veteran of the parks and cruise-ship division, and master of Mickey Mouse merchandising. Iger, at his farewell party, put himself next to Spielberg but put Chapek with the suits, a seating plan that did not bode well for the future.

Meanwhile, as is her wont, Abigail Disney wasted no time expressing her "disappointment" as soon as Bob Chapek was anointed. She called him "a person who never held a creative job in his life." As agent Rick Rosen notes, "Historically, it has been easier for CEOs who had creative backgrounds like Iger to learn the business, than executives with business backgrounds to learn creative."

While Iger was known as a visionary, Chapek is known for his inability to see beyond the profit-and-loss numbers on the screen in front of him, as well as his dedication to raising prices and reducing costs. The entry fee for two nights in 2021 at Chapek's Star Wars: Galactic Starcruiser "immersive adventure" (which includes a hotel and food component, role-playing that teaches vital skills like how to wield a lightsaber as well as a visit to the Star Wars complex at the studio) starts at $4,800 for two people—in the middle of a week in off-season. In 2022, food prices were up 12 percent. According to Len Testa, author of various "unofficial guides" to Walt Disney's Tragic Kingdom, the company has "essentially abandoned the middle class." Chapek's compensation, meanwhile, as of 2022, stood at $32.5 million.

Chapek never seemed to have been a student of the Life Lessons— fairness, tolerance, and so on—so freely dispensed by Disney films, and no sooner had he moved into the C-suite than he became embroiled in a fight with one of the biggest and most highly respected stars in Holly-

wood, Scarlett Johansson. She had played a supporting role as Black Widow in eight movies over eleven years, one of the few females among the Avengers, while she watched her male counterparts each star in multiple films, some of which grossed over $1 billion, before she was given one of her own—*Black Widow*. In July 2021, she sued Disney for breach of contract when the film, originally slated for a theatrical exhibition, was simultaneously aired on Disney+, sacrificing it, she argued, to build its streaming service. Naturally, it underperformed in theaters, negatively impacting her back-end deal, which included a cut of the box office.

During the ensuing war of words, Disney released a personal attack on Johansson, calling the suit "sad and distressing in its callous disregard for the horrific and prolonged global effects of the Covid-19 pandemic." The vitriol was virtually unprecedented. Despite the fact that males make up 63 percent of characters with speaking parts in movies with females at a mere 37 percent, Chapek picked the wrong woman to fool with, not to mention that it's bad business for film companies to go to war with talent, particularly someone of Johansson's stature. They later settled, but Disney-ologists felt that the blowup would never have happened under Iger.

The ball finally fell in January 2022, ending Iger's long goodbye. The two Bobs were reduced to one, with Iger destined to inherit Robert Redford's old handle, "Ordinary Bob." Or so it seemed.

Disney, with its parks, cruises, and hotels, was particularly vulnerable to the pandemic. Although Iger made way for Chapek in February 2020, he announced that he would not only mentor his successor but actively see Disney through the crisis. By some accounts, this infuriated Chapek, who hadn't asked for his help. Instead of consulting his storied predecessor, he froze him out of the decision-making process. Said one source, to Chapek, "It seemed like Iger wouldn't get out of the way."

CAN WBD'S KID STAY IN THE PICTURE?

With Netflix and Disney hogging the limelight, Warner Bros. Discovery fights for its shot.

Back at the unhappiest place on earth—AT&T's WarnerMedia—as one stumble followed another, it became clear even to Stankey that the marriage between the two companies was on the rocks. In May 2021, he turned around and spun off WarnerMedia into the arms of another AT&T property, the Discovery Channel, creating a new, stand-alone company rechristened Warner Bros. Discovery (WBD), and run by Discovery head David Zaslav, who enjoyed the distinction of being one of the highest-paid executives in Hollywood, taking home $246.6 million in 2021 thanks to a stock option grant. He took home $39.3 million in 2022. AT&T stockholders own 71 percent of WBD.

WBD was generally interpreted as an admission that AT&T's acquisition of Time Warner was a failure. According to Kara Swisher, the doyenne of tech, Stankey is "the worst media strategist in recent memory." Meanwhile, it left the Discovery Channel, the minnow that bought the whale, saddled with a $55 billion debt, leaving Zaslav to face the knotty conundrum that in one way or another now plagues the entire industry: spend too much, the debt runs up, gutting the price of the stock; spend too little, the debt goes down, gutting the product.

The abyss between WarnerMedia—with its twin jewels, HBO and Warner Bros.—and Discovery was almost as wide as the yawning chasm between AT&T and Time Warner. As Richard Rushfield described in *The Ankler*, it was like wedding Tiffany to Walmart.

Discovery had always been something of a joke, with dumb reality shows like *Sex Sent Me to the ER* and *Here Comes Honey Boo Boo*. Since then its streamer, Discovery+, has been spruced up with how-to-tie-your-shoelaces hits like *My Feet Are Killing Me* and *Dr. Pimple Popper: This Is Zit*, as well as a sprinkling of science-based documentaries.

High-octane Zaslav had come up through NBC and taken over Discovery in 2006. Joke though it may have been, under Zaslav, Discovery's profits were no laughing matter. He turned a $5 billion company into one valued at $22 billion in a matter of years.

Still, if HBO and to a lesser degree HBO Max are synonymous with quality, Discovery is synonymous with—well, whatever it is, it ain't quality. The audience for the former tends to be diverse, single, social media savvy, with few to no kids; the audience for the latter is predominantly comprised of empty nesters, grandparents, white widows and widowers, and strangers to social media. A headline in *Daily Beast* read, "Laid-Off HBO Max Execs Reveal Warner Bros. Discovery Is Killing Off Diversity and Courting 'Middle America.'"

Still, Discovery and WarnerMedia are not the worst match in the world. The fact that they are so different could work to their advantage. Together they could be a more formidable foe for the Big Three streamers than either was alone, poor as they are in live content. Netflix lacks sports, Disney+ lacks reality shows, and Amazon Prime Video doesn't do news, while WBD does all three.

Solidly built, athletic, with short, curly hair going on gray, Zaslav is no outlier; he's one of the new old guard, online in regular Zoom meetings soliciting advice from the giants of the recent past, like Iger, Bewkes, and music industry heavy Irving Azoff.

Zaslav bought and salvaged the legendary Beverly Hills home that belonged to Bob Evans. The house had seen its share of drugs, sex, and rock 'n' roll, had succumbed to weeds, rot, and decay, and become a fitting gravestone for the New Hollywood of the '70s. By paying $16 million for it, Zaslav laid claim to the legacy of Evans—a mixed blessing, to say the least (he was convicted of cocaine trafficking, and pleaded the Fifth in the so-called Cotton Club Murder)—which committed him to salvaging Warner Bros. as Evans had salvaged Paramount.

One cynical producer, applying a can opener to Zaslav's psyche, thinks he is still trying to pop the pimple of his legacy at Discovery. "I think Zaslav sees in [Evans] a direct connection to . . . an old school Hollywood mogul, [because] he thinks he won't be taken seriously as the Discovery guy. Also, he can't get credit for HBO because Casey Bloys is already doing a good job. But changing Warner lets him re-brand himself and get invited to the Met Ball and *Vanity Fair* party."

Like everyone else in the business, Zaslav has his detractors. "He's really, really tough. If he likes you, he loves you. And if he doesn't like you, he doesn't want to know that you exist," says one source. "He chews through people and they're scared of him."

Working for Zaslav is "a revolving door, and most people who went out that door had a very bad experience, because the one thing about him is he's a little bit of a ready-aim-fire guy," says another source. "He kind of just gets a notion in his head and doesn't let the facts get in the way."

Zaslav had no qualms about making a deal with Stankey. When the two first met, he recalls, "Right away I thought, 'This is someone that I could do a lot of business with.' We became friends, we played golf." Even though Zaslav's pal Bewkes would come to see Stankey as a buzzard, picking over the innards of his company, Zaslav was im-pressed that he had been an Eagle Scout, saying, "He was very honest, straightforward, and transparent about, 'I can do this, I can't do that, I'm willing to pay this, and if you could do that, I can do more.' He was quick to create a road map to what could get a deal done." In other words, it all boiled down to a headline in Reuters, "How a Golf Tournament Led to the Merger of Discovery, WarnerMedia."

Zaslav implies Bewkes was naïve in assuming that Stankey would be hands-off Time Warner. "You don't buy a company and have the existing people run it," he says. "You buy a company because you think you can make it better. Of course John got in there and made changes." (Bewkes declined to comment.) He continues, "I never consider who's selling it to me. It's not about Jeff Bewkes. It's not about John Stankey. It's, 'What are the assets?' What IP does Warner own—*Batman, Superman, Wonder Woman, Green Hornet, The Joker,*

Harry Potter, Looney Tunes, HBO with *Game of Thrones*—they have the greatest portfolio of IP anywhere. Together with Discovery's global reach, we are not just formidable, we could be the best entertainment company in the world."

If nothing else, Zaslav thinks big. "Netflix and Disney seem to be running the table, and everybody else is trying to figure out, 'Am I going to be able to catch them?'" he said to Stankey. "You got two wars going on. You got a war with Verizon and T-Mobile, and you have a war with Disney, Netflix, and Amazon. Wars are expensive, and you are highly leveraged. You need a lot of artillery and you need a strong stomach." Zaslav thought he could furnish the artillery and the stomach Stankey needed. Deal done.

Zaslav, a Democrat, was nevertheless mentored by John Malone, Discovery's biggest shareholder, a libertarian who donated $250,000 to Trump's inauguration, although he later repudiated him. Known as the "cable cowboy," although Al Gore once called him "Darth Vader" on the floor of the Senate, Malone advised Rupert Murdoch when he started Fox News. He is America's largest landowner—2,200,000 acres—putting John Dutton to shame. Malone is rumored to have also had a hand in the purge of the so-called CNN left, Fox News–baiters like Jeff Zucker, Brian (*Reliable Sources*) Stelter, and finally John Harwood, shutting them down under the cover of "both-siderism."

Says Fuchs, "If you were in Sun Valley, you'd see Zaslav following Malone around like a fucking puppy." According to *The New York Times*, Zaz, as he is familiarly called, reportedly asked him for permission to buy WarnerMedia. Malone reportedly gave him the go-ahead.

Zaslav is nothing if not unsentimental, and Ann Sarnoff was out before the ink had dried, added to the mass grave that was WarnerMedia. He replaced Sarnoff with former MGM-ers Mike De Luca and Pam Abdy. They fit into his strategy of abandoning expensive theatrical movies in favor of midbudget movies that can make money in both the theatrical and streaming markets.

Despite Zaslav's upbeat predictions and reputation for shrewdness, in a cards-on-the-table moment, he admitted, re: Warner, "You opened up the closet, things fell out. There were a lot of things that were worse

than we thought." J. K. Rowling had to be dragged screaming and kicking to revive the *Harry Potter*s, and the DC Extended Universe, which is the only hive of superheroes that could conceivably challenge the MCU, is no treat, either: see 2016's embarrassing *Batman v. Superman: Dawn of Boredom* (oops, that's *Justice*). Zaslav booted DC's boss and replaced him with James Gunn and Peter Safran of *Suicide Squad* fame. Straight-shooting Gunn wasted no time saying that DC was "fucked up," and that they were "giving away IP like they were party favors to any creators that smiled at them."

Fuchs thinks Zaslav is out of his depth. "Zaslav is like a joke," he says. "He comes in to run things that he knows nothing about. Two layers of management have been cut out"—Reilly and Greenblatt—"but Zaslav is having every division report to him, particularly when you're running assets you've never run before—scripted entertainment is a completely different culture than reality-based programming—it's impossible, unless you're Superman." (Zaslav has an estimated eighteen executives reporting directly to him.)

Whoever Zaslav thinks he is, he apparently knows he's not Superman. He brought back former Warner president Alan Horn, who is "credited," if that's the right word, with the tentpole strategy that "siloed" Warner in his day into powerful baronies called *Harry Potter*s, *Dark Knight*s, and *Hobbit*s. Horn successfully implemented that strategy when he moved to Disney, whose divisions (Marvel, Pixar, etc.) were ready-made for siloing. In other words, Zaslav wants him back, to silo Warner in the image of Disney that Horn had remade in the image of . . . Warner. And so it goes.

Zaslav has positioned WBD to be the antithesis of Netflix, insisting that WBD "will not overspend to drive subscriber growth," thereby rejecting the latter's romance with Wall Street based on viewer numbers at the expense of profits.

Unlike Kilar, who seemed to see the Warner Bros. movies as no more than finger food for the streamers and trampled on exhibition in favor of the small screen, Zaslav smartly sees theatrical as an asset, "'the top of the funnel' for drawing eyeballs to lucrative direct-to-consumer services." He nixed Kilar's plan to produce big-budget

movies for direct-to-Max consumption. They will play at theaters first.

The biggest hurdle WBD faces is money. With Wall Street downgrading its stock, chipping away at the $55 billion debt by dropping a show or axing an employee here and there won't do it. (There are well over one thousand employees.) Personnel-wise, according to a source, Zaz's approach boils down to "If they are old Discovery people they stay, if they're old Warner Bros. people they go."

Worse, a WBD career ad on the internet touts the company as "Home to the World's Best Storytellers," but the financial interests of the owners with their debt load and the creative interests of filmmakers are at odds, as illustrated by the *Batgirl* fiasco in 2022.

Batgirl was intended to be the latest iteration of the Batman franchise, Zaslav's best shot at mighty Marvel. It was slated for theatrical release and then streaming on HBO Max. Not only was it nearly finished, it brought back Michael Keaton, everyone's favorite Batman, it featured a Latina actress in the lead, a trans actress in a supporting role, and was written and produced by women and directed by two Muslim men (Adil El Arbi and Bilall Fallah), making it a showcase for diversity. Its $90 million cost, however, apparently led Zaslav to believe it was too big—that is, too expensive—for streaming, but too small for theatrical. In an unprecedented move he decapitated it, refusing to release or air it. Adding insult to injury, he said it was most valuable as a tax write-off. Pointing to the company's $55 billion debt, Rushfield wrote in *The Ankler*, "What did people expect? A ceiling on paperclips?"

The problem is that producing entertainment involves creatives, not paperclips, and managing WBD for Wall Street may seem prudent, but it has its downside, to say the least. The burial of *Batgirl* sent a message to the "best storytellers" they didn't like, earning Zaslav the sobriquet of "Zaslav the butcher," the anti-Evans. The careers of *Batgirl*'s co-directors were set back, if not destroyed. Said filmmaker Kevin (*Clerks*) Smith, "There was a time when the . . . worst thing a director had to worry about was that, Oh, maybe they don't take it theatrical, maybe it goes straight to video . . . Now [it's like] 'We may

not release it at all.'" Added John Oliver, one of Zaslav's employees courtesy of his HBO show *Last Week Tonight*, "Hi there, new business daddy," referring to his boss, "I get the vague sense that you're burning down my network for the insurance money."

Subsequently, the creatives that Zaslav wants to attract are beginning to depart for greener pastures. Legendary Entertainment, the producer of the *Dune* remake and *Godzilla vs. Kong*, fled WBD, while *Aquaman* producer James Wan followed Christopher Nolan to Universal after merging with Blumhouse, all bad news for Zaslav. *Aladdin* producer Dan Lin says that diversity will take the biggest hit. "A recession is coming, budgets are tightening and I'm really worried that diversity is going to be the first thing that goes," he said. The danger is summed up in the phrase, "go woke, go broke."

One of Zaslav's weaknesses, as someone put it, is that he "doesn't know what he doesn't know." (For the record, CAA head Bryan Lourd says the opposite: "He knows what he doesn't know.")

Zaslav seems like he's ready to go to any extreme to reduce his debt, save, in the words of *Puck's* Matthew Belloni, putting Evans's house "on Airbnb," including taking the ax to the heretofore untouchable HBO Max. He killed Plepler and Lombardo's high-profile and expensive tentpole *Westworld,* after the fourth season of what was supposed to be a five- or six-season run, after the numbers fell off dramatically at the end of Season 3. (Season 1 cost at least a no-figure-is-too-much $100 million.) To some degree, the show was a victim of superfans, aka "stans," who kept guessing and blogging about the plot twists, forcing the showrunners, Jonathan Nolan and Lisa Joy, to complicate the plots to the point that those very same fans complained the shows were incomprehensible.

Reportedly, Zaslav had nothing to do with these decisions, but they're certainly in line with the cost-cutting fervor that has seized WBD since he acquired it. Generally, HBO and other services like to give creators time to tie up the finales of their important series to avoid upsetting fans—the *Deadwood* backlash—whereas dropping them midstory reflects badly on the streamer.

Zaslav's protestations to the contrary, one jaded executive claimed, "This is going to be about finding a suitor [for WBD] and riding off into the sunset with even more multi-generational wealth than he already has."

M eanwhile, over at Disney, Chapek was finding Iger a hard act to follow. It seemed like every time he opened his mouth he put his foot in it, but when he kept it shut, he made things worse, a case in point being his initial reticence regarding the furor over Florida governor Ron DeSantis's so-called Don't Say Gay bill, which potentially criminalized discussion of sexual orientation and gender with children below the third grade and older if considered age-inappropriate, while empowering aggrieved parents to sue to enforce it. Iger seconded President Joe Biden, who called it a "hateful bill" because it was rightly interpreted as an attack on the LGBTQ community.

Chapek, on the other hand, said nothing, and is rumored to have worried that Disney could be perceived as too liberal, turning it into a "political football." He appointed several close advisors to George W. Bush to high-level posts in the company, and refused to join Amazon, Apple, and 148 other corporations in condemning the bill, and put his money where his mouth wasn't, donating to the war chest of every sponsor and co-sponsor of the bill to the tune of $250,000 or more. Still, the bill's supporters accused Disney of favoring "grooming."

In line with its public face as the "happiest place on earth," Disney had zero tolerance for controversy. But his silence with regard to De-Santisizing got Chapek in trouble with many of Disney's employees, especially Gen Z-ers who, prior to the growth of social media, would never have taken up arms against their bosses. A *Variety* headline blared, "Disney Censors Same-Sex Affection in Pixar Films, According to Letter from Employees," when the studio ditched a scene from *Lightyear* featuring two women kissing, then restored it after an uproar. Michael Paull, the current head of Disney streaming,

acknowledged his employees' discontent, and unhelpfully suggested they use Disney's Employee Assistance Program to find therapists!

Belatedly, Chapek commented, "We were opposed to the bill from the outset," but claimed it was more effective to pressure DeSantis quietly, behind the scenes. Eventually, Chapek actually apologized, saying, "I am sorry," and pledged $5 million to the Human Rights Campaign (HRC), which fights for LGBTQ rights groups. HRC turned it down.

DeSantis's response was to mock the company as "Woke Disney." And, as of this writing, seventeen members of Congress have indicated they will not support an extension of the copyright on the *Steamboat Willie* version of the company's Mickey Mouse trademark, which has earned it billions in licensing fees. It expires on January 1, 2024.

For its part, Disney has joined Netflix, Paramount, Sony Pictures, Apple, Amazon, and the SAG-AFTRA union in defraying costs for those of their employees who need to travel out of states like Georgia and Texas for abortions.

Meanwhile, the tension between Iger and Chapek escalated. Chapek seemed to endorse the idea that Disney should be a data-driven company. At a June 2021 retreat in Hawaii, Iger gave a talk rejecting the reliance on data as a driver of production decisions, popularized by Big Tech companies like Netflix. Data, he said, "should not be used to determine what stories are told." He likes to say that had Henry Ford been able to run the data on what people wanted in 1903, they would have said "a faster horse"; instead he gave them the Model A. He added, "If we had tried to mine all the data that we had at the time to determine whether we should make a superhero movie that was essentially about an Afro-futuristic world with a Black cast, the data probably would have said, 'Don't do that.' *Black Panther* never would have been made."

Iger's statement was interpreted by some as an admission that he regretted selecting Chapek, and a signal that Disney was moving in the wrong direction. One source feels that Iger misjudged his new, handpicked CEO, much like Jeff Bewkes misjudged Stankey.

Nevertheless, the Disney board of directors gave Chapek a three-year extension on his contract in 2022, despite a 60 percent decline

in Disney stock as of the summer of that year, and skepticism that he would be able to meet his projection of more than 230 to 260 million subscribers to Disney+ by 2024, given his failure to get the rights to Cricket League matches in India.

Then, on November 20, 2022, Bob 1.0 suddenly became 2.0. The board astonished the jaded industry by ousting Chapek and reinstalling Iger as CEO for two years, five months after it gave Chapek his extension. Contributing factors were a $1.5 billion loss in the July–September quarter on its streaming business, and a 41 percent dive in Disney stock as of November 22, 2022.

The dropped shoe was the earnings report in November 2022, in which Chapek threaded Disney's dismal financial picture with inappropriately happy talk about its success in selling "magical memories that last a lifetime," as if the board were comprised of theme park groupies. Several high-up Disney executives talked about resigning.

To some extent, the Chapek fiasco was of Iger's own making. Streaming-first was his baby, after all, and he groomed, then knifed two successors, Tom Staggs and Kevin Mayer, before selecting Chapek.

Some felt that Wall Street was punishing Chapek for his streaming strategy, which consisted of favoring general entertainment programming at Disney+ over traditional Disney content, thereby diluting the brand. First on Iger's agenda was reversing Chapek's reversal of Iger's decentralization strategy administered by Alan Horn, restoring budgetary powers to division heads. Disney would not be based on the top-down tech-based data-driven model that Chapek favored.

Disney execs welcomed Iger redux with enthusiasm. One tweeted, "Daddy's back!" Iger quickly reversed Chapek's punishing price gouging at the Disney parks. In May 2023, Iger killed Chapek's Star Wars: Galactic Starcruiser hotel, a ten-figure failure. That same month, Iger struck back at DeSantis, yanking a billion-dollar office complex planned for Orlando that would have created more than 2,000 jobs. Iger also proceeded to fire seven thousand employees in a cost-cutting measure, including Ike Perlmutter, who had hung in at Marvel in some capacity, proving that behind smiling Ordinary Bob

was another Iger with a long memory and a touch of Captain Hook. He then proceeded to sue DeSantis. The irony is that the Democratic left has always disparaged Disney's power over the state, and DeSantis is doing what they have longed to do for decades.

Reed Hastings expressed dismay at Iger's return. He wanted him to run for president, presumably so that he'd be preoccupied with climate change. But Iger's immediate problem is Disney, not Netflix. His new two-year term can go by quickly, and his last succession plan was not exactly a success. The question remains: What happens next? Can anyone restore the "magic," such as it was? Is there anyone who can replace Iger but Iger? Ted Lasso?

Back at WBD, Bloys developed originals of unequalled quality for HBO, including *Mare of Easttown, Euphoria, The White Lotus,* and *We Own This City,* all on Sundays, while expanding its footprint by occasionally stepping into Thursdays with *Hacks,* Fridays with *A Black Lady Sketch Show,* and Mondays with *My Brilliant Friend,* an impossibly artful adaptation of Elena Ferrante's *Neapolitan Quartet* for the small screen.

On the whole, this may augur the revitalization of a legacy cabler, but worriers worry that the marriage of Discovery+ to HBO, with the twin goals of cutting costs and broadening its appeal, will further dilute the latter. HBO is no longer *The Sopranos* channel, or *The Game of Thrones* channel; it's the *Flight Attendant* channel, and where you go to watch Batman spinoffs like *The Penguin, Pennyworth,* and *Arkham Asylum* (forthcoming), alongside a laundry bag of old Warner Bros. network shows that most HBO watchers have never heard of, like *Doom Patrol, Gossip Girl, The Sex Lives of College Girls,* and *Ten Year Old Tom.* It will enable the 130 million subscribers that Zaslav dreams of to watch Mike White's *The White Lotus* and *Battle Bots* on the same streamer.

HBO started a revolution, but one of the nasty habits of revolutions is that they often consume their own. The combined HBO-DISCOMAX+ was renamed simply, Max, a generic title like "+."

Indeed, why not go all the way and call it Max+. Whatever it's called, the name change symbolically marks the end of the prestige cable pioneer as a distinct, "stand-alone entity," and was interpreted as an attempt to turn away from HBO's perceived elitist, bicoastal audience, towards the pimple-starved heartland. HBO still lives on as a tile on the Max screen, which made its debut in May 2023. Meanwhile, shows like David E. Kelly's *Love & Death* are presented as "MAX originals," not "HBO originals." Says Fuchs, "This is a fifty-year-old company. I consider that it died at fifty. There's no longer an HBO. Max has made HBO become like Kleenex. It's fucking crazy." (By the way, while "Max" may recall the 2018/2019 twin crashes of Boeing 737 Max jets, on the other hand, in 2022, it enjoyed the distinction of being the most popular name for male dogs in America.)

Then, along came *Succession*. Writer-producer Jesse Armstrong had approached Bloys with an idea about a powerful media family. Bloys explains, "The thesis was, 'All families are somewhat dysfunctional, siblings fight or your brother's getting more of your father's attention, but when you add this other element, the obscene wealth and the power and the influence, their dysfunction affects the entire planet.' I thought that was a really interesting way to do a family show."

Bloys has a degree in economics, and he was also interested in the political angle. "Since the 1980s, we as a country have made decisions—tax cuts, deregulation—that have concentrated wealth in a smaller and smaller number of hands," he continues. "And there are consequences to that," namely, the creation of a new class of robber barons, comparable to those of the nineteenth century. When Bloys replaced Lombardo as HBO's president of programming, he was in a position to do something about Armstrong's pitch.

Succession had the added appeal of lacking stars, with the exception, perhaps, of Brian Cox. Taking the lessons of *Vinyl* to heart, Bloys was not about to put himself in the position of servicing talent. Like any number of his other shows, there would be no celebrity names behind and/or before the camera. *Succession* was the anti-*Vinyl*, a throwback to the kind of shows HBO was known for in the old days,

where the talent served the show, not the other way around. Nor did it come encumbered with massive, bestseller IP. Said Bloys, immodestly, "At HBO, we make our own stars."

The contemporary context is the entrance of Big Tech into the media space. "There's another . . . succession going on," explains Armstrong. He is referring to "the big news companies [that are] under massive strain [when] Netflix and Apple [come] knocking at their door." He continues, "We can see these media consolidations in response to that. [It's] hopefully in the DNA of the show."

Succession was marinated in the brine of the Trump era. "After taking a backseat for about fifty or sixty years, inherited wealth and nepotism seem to have come back with a vengeance," observes Adam McKay, the auteur of *The Big Short* and *Don't Look Up*, who executive-produced *Succession*.

With a touch of King Lear, at eighty and in poor health, Logan Roy pits his children against one another in the struggle to succeed him. Born to money, pampered, cossetted, and coddled to the point of curdling, with silver spoons lodged in every orifice, none of the Roy children seems to have the mettle needed to run the company, let alone determine its future. Meanwhile, Logan, frustrated by his inability to step down, targets each of them with his volcanic temper. Zaslav, anyone?

The sadistic apogee of the show is the infamous third episode of Season 2, called "Boar on the Floor," in which he humiliates his subordinates by making them crawl on all fours, oinking like pigs as they hunt for sausages like truffles.

Armstrong says casting Cox as the patriarch was practically a foregone conclusion, since he was on everyone's wish list. Cox, whom we last saw as the impresario in the aborted third season of *Deadwood* and who trails a mile-long list of theater and movie credits in his wake, says he can't resist TV because it "liberates" him from the three-act structure—beginning, middle, and end—of theatrical drama that he finds inhibiting. He goes on, "The beginning is inevitable, the end is inevitable, but the middle is not so inevitable, and television is about the middle."

Cox is perfect as Roy, accurately describing himself as an actor able to go "from a roar to whisper within the space of a single line of dialogue," although usually it's the other way around. He continues, "It's wonderful when you see an actor nail a phrase so completely that you think to yourself, 'Nobody will ever be able to say that again.'" In his case the line, for better or worse, is his furiously uttered "Fuck off!" or, better, "Fuck the fuck off," which he uses to such effect, with so many inflections, that it has become the mantra of the show.

Cox is somewhat dismissive of directors, whom he occasionally refers to as "pests," more interested in the lighting than the performances. On *Succession*, he says, even after multiple seasons, "The cast, as veteran a unit as you could find, are still getting notes from newcomer directors. One newbie said to Kieran Culkin, 'Do you always have to talk so fast?' Well, hang on. This is who his character is." He continues, "[Kieran] is an actor who's calibrated the patterns of his character's delivery over the course of three previous seasons . . . He's not going to suddenly slow down just because you've given him a note. But that's directors for you."

Cox describes *Succession* as "a writers' show," and calls Armstrong a "modern Jonathan Swift." He explains that "If I wanted to change a word, just a single word of Logan's dialogue, I know that I'd have a fight on my hands." When one character abusively calls another a "nancy," he recalls, "I thought 'faggot' was a much better word than 'nancy,' because I think 'faggot' is more American, and 'nancy's' very British. I won that one."

The superrich aren't like you and me, and consultants advised the actors on their habits. Example: the proper way to exit a helicopter. "You wouldn't duck," says Culkin. "Because we grew up getting out of helicopters, you just walk right the fuck out." Nor would he or any of his family wear overcoats, because it was door to door, from chopper to limo to mansion. Armstrong decided against including the pandemic in the third season, because he guessed that it would never impact the Roys, insulated as they are in their bubble of privilege.

The writers were initially concerned that audiences would have little interest in the ethereal world of the superrich and their high-

class problems. Culkin wondered, "Who gives a shit about these rich motherfuckers?" Luckily, that proved not to be the case, a tribute to dialogue so ribald and performances so sparkling that the Roys give familial dysfunction a good name. There are more than enough familiar types to whom viewers can relate. Indeed, the characters invite a peculiar combination of attraction and repulsion. Or, as Cox puts it, the show is so successful because it reflects the fact that "we live in this age of wealth and entitlement. Look at the Kushners and Ivankas of the world—a lot of them are behaving horribly. [It's] a bit of a cancer in our society."

Succession can boast dialogue that would be the envy of any show on small screen or large. The children and assorted hangers-on—the sycophants, schemers, and self-promoters, all barely afloat in the choppy Roy seas—often thrash about in a state of utter confusion, but are rarely at a loss for words. Often they would be better off saying nothing at all, but they can't keep their mouths shut, and give themselves away by constructing comical simulacra of everyday speech ridiculously conflating florid circumlocutions with gutter sniping, Julian Fellowes or Peter Morgan by way of David Mamet—because they're too frightened of their father to say what they mean. Here's Kendall Roy threatening a "friend" in one oft-quoted example of the show's inspired scatology: "I will come to you at night with a fucking razor blade and I will cut your"—the "friend" interrupts, finishing his sentence with—"dick off, and then push it up your cunt until poo-poo pops out of my nose hole."

The dialogue is so rapier sharp, so charged with zingers, that it becomes the verbal equivalent of the thrust and parry of swords in, say, the Battle of the Bastards. Indeed, the show has become the new *Game of Thrones*, with Roy a dinosaur instead of a dragon. *Succession* is about the twilight of a dying generation, that of the white patriarch. Says Cox, "White, essentially male, dinosaurs are in a death throes," although looking at the entertainment business that sounds like wishful thinking.

Showrunner Armstrong makes this literal by killing off Logan Roy in the third episode of the ten-episode-long fourth and final

season, a shock to Roy's children and the show's fans, for whom it was like killing off Tony Soprano in the middle of a crime spree.

Cox thinks Armstrong was burned out. The obligation of churning out the hottest show on television was draining. But, he says, "I think Armstrong slightly shot himself in the foot by making Logan's demise a couple of episodes too early. I think he may have underestimated how challenging it would be, writing-wise, to have the show sans Logan." It must have been odd for Cox to look down from the afterlife, the special heaven or hell his character occupied, at all the fun that followed upon his death. He said he felt "a little bit rejected [given] all the work I've done."

The parallels between the show's plotting and reality are eerie. In the final season, after the Roys' right-leaning TV news network ATN ignores a suspicious fire that burns 100,000 absentee ballots at a vote-counting center in Democrat-heavy Milwaukee, and calls a presidential election for the Nazi-dinged Republican candidate, Roman congratulates everyone, saying, "We just made a night of good TV"—while, in the real world, CNN head Chris Licht likewise congratulated himself after airing the widely derided Trump town hall in New Hampshire, saying, We "made news. Made a *lot* of news." (The Zaslav-appointed Licht was Zaslav-fired in mid-2023.) As Kurt Andersen writes, the show caught on because "a critical mass of Americans has come to understand that big business and the rich hijacked and corrupted our political economy."

Zaslav, on the other hand, is no dinosaur. If we persist in looking at some of these shows as metafictions, as shows about themselves, where is he in the *Where's Waldo?* maze of *Succession*? He styles himself the son of Bob Evans, but by some accounts, he's more the son of John Malone—which makes him who? Personality-wise, he resembles Logan Roy, of course, the ruthless entrepreneur with a volcanic temper who sullies all he touches. But, as the GoJo deal goes through, with the streamer acquiring Waystar, he has to be its owner, Lukas Mattson, who screws, figuratively speaking, his Roy ally Shiv when she threatens to eclipse him by overplaying her hand, which he realizes when he sees her cartooned in a *Vanity Fair*–like

magazine pulling his strings. He gives the reins of ATN to her docile husband Tom, because he's competent and won't make any waves, which makes the latter loosely analogous to Casey Bloys, who rose to the top of HBO by successfully navigated its poisonous politics.

Shows like these put moguls like Zaslav on the griddle, and some wonder if Zaslav will continue to mesh with Bloys. Zaslav is a type A, hard-charging, testosterone-driven, heterosexual man. Bloys is an introverted, openly gay man very focused on programming. If each stays in his own lane, all should be well. Reilly, who knows both men, says, "In my opinion, they're not likely to be chumming it up around the country club, but Zaslav will not mess with Casey's formula. It's working well, so as long as it does, it doesn't matter whether they're buddies or not."

That sounds right, but we've heard it before, when Bewkes said the same thing about Stankey, before the latter took a wrecking ball to Time Warner/HBO. Still, Zaz locked up Bloys with a five-year contract. In other words, there's blue sky, along with clouds on the horizon. HBO made $2 billion in 2019 but lost $3 billion in 2021, thanks to increased spending on content. But so far, he's letting Bloys be Bloys, to the extent of programming some weird but wonderful shows like *Landscapers*, *Somebody Somewhere*, *The Baby*, and *Rain Dogs* that nobody in their right mind would put on TV due to their outré premises and/or unconventional leads, except for him, hand in hand with Carolyn Strauss, who executive produced *The Baby* and *Somebody Somewhere*.

Let's hope Reilly is right, because under Bloys, HBO, or HBO Max, or Max—whatever it's called—stands so far above the competition that messing with it beyond what Zaslav has already done would be a cultural tragedy that defies description. For example, says Robin Thede, whose series *A Black Lady Sketch Show* HBO has aired since 2019, "HBO, if people haven't noticed, is Black woman central." Indeed, of all the streamers, with the exception of BET (Black Entertainment Television), it's the best place for watching while Black. Thede credits *Insecure* for opening the door for shows like Misha Green's *Lovecraft Country*, with Jurnee Smollett and Jonathan Majors. To that list we can add *Watchmen*, starring Regina King, which shoehorns

the infamous Tulsa race massacre of 1921 into the superhero genre. "I don't think there's any other place on television where Black women are telling their stories in such a high quality," Thede continues. "And that's no shade to anyone else. That's not an accident; that's being curated."

Like Rae, Thede never plays it safe. Episode 4 of Season 5 is titled, "Peek-a-Boob, Your Titty's Out." Episode 2 of that same season is called, "Baptism Runs on Dunkin," and features an insane imitation of an NBA slam-dunk contest called a "Dunk-a-Thon," wherein filthy-mouthed deacons compete to baptize the most babies by hurling infants through a basketball hoop.

Issa Rae herself followed up *Insecure* with a razor-sharp *Rap Sh!t* in 2022, similarly soaked in sex and politics, about two female Black rappers, Shawna and Mia, trying to hustle their way to fame and fortune. Shawna wants to rap about issues like predatory lending and the male gaze, but she's not getting much engagement. Mia says she's crazy and wants to rap about "fun bitch stuff," like money and fast cars, such as, "If he drives a Rolls-Royce, don't give it up until you see his license and registration!"

Bloys's slate also included *I May Destroy You*, written, co-directed, and featuring the multihyphenate Michaela Coel, about the unraveling and raveling of a young Black writer after she is raped.

Coel was born of Ghanian parents and grew up in a council estate intended for homeless people that was ironically nestled in the heart of London's financial district. Briefcases in hand, fat cats preoccupied with the stock market rushed past it every day with, as she put it, "no idea this council estate existed." She has more than her share of demons, including an absent father.

Without mincing words, she poured out an uncensored account of her personal history—the good, the bad, and the ugly—to a startled audience of industry professionals—mostly white and male—in a prestigious MacTaggart Lecture delivered in August 2018. "We were one of four black families there," she remembered. "Not something I thought anyone gave a damn about, until someone left a pile of shit on our doorstep."

Growing up, she was part of a brutal adolescent web culture, and was once called a "big lipped coconut" (Black on the outside, white on the inside) "who gave three blowjobs last week," insults she returned in kind.

Eventually Coel was admitted to a drama school, where she was called the N-word twice, once by a teacher, and described as the "elephant in the room" by the head of the school. She recalled "rummaging through a gift bag for my first big mainstream award. It contained dry shampoo, tanning lotion, and a foundation even Kim Kardashian was too dark for. A reminder: This isn't your house." Whatever she is—outsider, misfit—she's definitely an original.

Coel would never say she broke into the inner sanctum of the industry, because she knew that somebody like her couldn't, but after she breached the outer walls, she was unsurprised to discover that it, too, was rife with racism and sexism. She went on to describe an encounter she had at a film industry party. Approached by a producer, she said, "Oh yes, nice to meet you." He replied, "Do you know how much I want to fuck you right now?"

It was not Coel's style to blend into the woodwork, even if she could. The phrase "good trouble," while not invented by her, fits her perfectly. While making her 2015 breakthrough sitcom *Chewing Gum*, she discovered five actors of color crowded into one-third of a trailer, while a white actress, "looking like a privileged piggy," had one entirely to herself. She burst into the production office, yelling, "You know what that looks like, doncha? Like a fackin' slave ship." They bought more trailers.

Netflix twice refused to give her executive producer credit on *Chewing Gum*, and she had to fight off the streamer's attempt to create a writers' room. She later said, "[It is] important that the voices used to interruption get the experience of writing something without interference, at least once." Netflix subsequently offered her a million dollars for *I May Destroy You*, but Coel declined because it entailed losing control of her show. "The first thing I asked was: 'Why do you want to take all the copyright?'" she recalls. There was just silence on the other end of the phone. She asked for 5 percent, then 2

percent, then 0.5 percent. "And when the answer was 'That's just the way it is,' then I'm out because that doesn't sound like a good answer to me. It sounds cloudy. I don't trust that." Instead, she made a deal with the BBC, which did grant her ownership rights, and brought in HBO to co-produce. She was the sole writer on *I May Destroy You* (she wrote 191 drafts), directed nine of twelve episodes, and got executive producer credit.

I May Destroy You is a portrait of the artist as a young rape victim, a raw exploration of denial and consent, hurt and healing, sex and drugs—you name it—thrown or, better, knit together into one narrative. It was based on an experience of her own that occurred while she was working on *Chewing Gum*.

Coel's character, Arabella, is a writer whose publisher is excitedly awaiting the last chapter of her book, which is expected to be a bestseller. But she's too undisciplined, self-sabotaging, and blocked to sit down and finish. Instead, she goes bar hopping, is given spiked drinks by strangers, and wakes up the next day with a bleeding gash over her eye, and vague, dreamlike images of a white man plunging his member into her in a toilet stall. She soon realizes that it isn't a dream at all, but a fractured memory. The series is, among other things, a racial and feminist detective story presented as a tortured account of her search for the man who spiked her drink and violated her.

Buried within the narrative are spiky observations on race, gender, and class, with Arabella asking rhetorical questions like, "Why can't we have a White History month? What if we had a Straight Pride day? We get a day. You get a lifetime knowing that you are likely to walk free from rape. This is why I be hating straight white guys." Hashtag: IHSWG.

Accentuated by percussive editing and a cacophony of sounds and images hurtling at her and the viewers from every direction, it is also an anatomy of her attempts to understand the nature of rape and the multiple shapes it assumes, in order to recognize and come to terms with the aftermath of the particular variety she experienced.

Although it drags in places, *I May Destroy You* is one of the most unusual series HBO has ever aired, which is going some. *The New*

Yorker called it "mesmerizing." In 2021, Coel became the first Black woman to win a Primetime Emmy.

Aside from its World War II miniseries, to its credit, HBO was one of the last holdouts against franchising, IP, and spin-offs, the practices that ruined other streamers. When *The Sopranos* ended, it didn't reincarnate as *The Contraltos,* nor did HBO launch reboots, prequels, or follow-ups of its other hits: *Seven Feet Under, Truer Blood, Bigger Love*? (Not so fanciful. See Netflix's reboot of *Full House,* entitled *Fuller House.*) It liked to think that each of its offerings was a new and unique experience. Under the aegis of WBD, no longer.

HBO couldn't just walk away from *Game of Thrones* and leave it blowing in the wind. Despite its fiasco of a finale the question of sequel or prequel was a no-brainer. Prequel it was. George R. R. Martin assumed that the one he was writing, called *Dance of the Dragon,* was next in line, until he discovered there were three others in development. (HBO disputes his account, arguing that Martin is such an important asset that it would never commission another pilot without informing him.)

HBO spent just under $30 million on one of them, a prequel that was discarded by Greenblatt and Bloys. Asset or not, the one that was eventually selected was not Martin's, but *House of the Dragon,* written and run by Miguel Sapochnik, a veteran director of *Game of Thrones,* although Martin has been given creative and executive producer credit on it.

House of the Dragon seemed to sweep the board, with a server-crashing 10 million US viewers on the night of its premiere, and an another 10 million catching up later on HBO's other platforms. Moreover, HBO bettered Amazon in the bang-for-your-buck department, with *House of the Dragon* costing about $200 million to produce, against its near billion-dollar competitor.

In every respect the antithesis of Amazon's airy, kingdom-hopping entry into the fantasy genre, *House of the Dragon* nearly suffocates

in its relentless focus on the battle over the Targaryen succession centuries before Daenerys Targaryen incinerates King's Landing at the end of *Game of Thrones*. It opens with a painful delivery scene wherein the king must decide between the life of the queen (Sian Brooke) giving birth to his heir, in breech. Of course he chooses the heir, but in the course of the grisly C-section, both mother and infant die in a gusher of blood. The queen, of course, is never considered or consulted—"A father gets to choose," explains an elder.

Even though the scene was written and shot long before *Roe v. Wade* was overturned, the contemporary resonance is too obvious to ignore. "This woman [is] at the mercy of a man's decision," explains Brooke, adding, "You think you've made this huge leap forward, with women being able to make decisions about their own bodies . . . It's quite shocking, that, sadly, there is some similarity between that and centuries ago."

House of the Dragon was immediately renewed for another season, without Sapochnik, reportedly because of a row with HBO Max over the inclusion of his wife. That other season won't air until sometime in 2024. After this lapse of time, few will be able to remember who's who in the densely populated *Dragon* universe, their confusion compounded by characters with nearly identical names—Rhaenyra? Rhaena? Rhaenys?—who also look alike.

Reportedly, there are a minimum of seven new *Game of Thrones* series in development, including three animated prequels, plus a stage play, enough to make us wish that the White Walkers, with an assist from Daenerys, had destroyed every living thing in Westeros.

Game of Thrones seemed to have changed HBO's aversion to spin-offs (why wouldn't it, when its final season drew a estimated 46 million viewers per episode?), proving that what HBO could do best, it could also do worst, airing a sequel to *Sex and the City* called *And Just Like That . . .* , wherein three of the four women (Kim Cattrall wisely absented herself), apparently comatose for eighteen years, awakened to navigate the maze of today's wokeness. *The Los Angeles Times* greeted the show with the headline, "How Terrible Is the *Sex*

and the City Reboot?" and went on to call it a "franchise extinction event," which, in this case, is an understatement.

The best thing about the sequel is that the show's most entitled character, the preening Mr. Big, is the victim of his Peloton, dropping dead at the end of the first episode, his aorta clotted by self-regard. Bad as the series was, it was renewed for a second season. In other words, once bitten by the IP bug, and responding to the growing competition from new streamers as well as pressure from above to mind its money, even it will begin to feed on itself. *True Blood* is also slated for sequeldom, apparently at the behest of one of its stars, Alexander Skarsgård; *True Detective*, Season 4, is upcoming, minus Pizzolatto, plus Fukunaga.

For now, HBO's playing it safe, more frequently going back to the well. Its 2023 lineup is full of sequels to its hits and almost hits, including not only *House of the Dragon,* but *Euphoria, My Brilliant Friend, The Gilded Age,* and *The Last of Us.* Reportedly in the works is a spin-off of *Big Bang Theory* even though Max is already airing twelve seasons of the original.

Programming to one side, what's most intriguing is the prospect being bruited about that Comcast/NBCUniversal, run by Brian Roberts, who is probably still smarting from losing Fox to Disney, might eventually find happiness with Zaslandia. This scenario envisions Roberts, nearing sixty-five, retiring, succeeded by Mike Cavanagh as Comcast president, with Zaz presiding over the combined NBCU/WBD, creating an entertainment Godzilla ready and more than willing to take on not only Disney, but Netflix, as well as tech giants Apple and Amazon.

BACK TO THE FUTURE

CASH IS KING

With the streamers in crisis, will they spend more or less, choking quality with dollars or starving quality with pennies? Will we be winners or losers?

Nobody expects this golden age of television to last forever; some have already pronounced 2022 the peak of Peak TV. As FX's John Landgraf—who, we remember, coined the term—ominously puts it, "TV is analogous to some of the golden ages in cinema," because the golden ages of cinema didn't last that long. The most recent one, the explosion of independent filmmaking in the 1990s, was done and dusted by the middle of that decade when *Pulp Fiction* broke the $100 million ceiling for indies and Miramax, which produced it, became an attractive acquisitions target for Disney.

The era of Peak TV has already exceeded that flicker of creativity by decades, thanks to the streamers that dominate today's entertainment space, but their future is the subject of a raging debate: Will they succeed or fail?

To make things even more confusing, it has become increasingly difficult to know which way is up. Streamers have become studios, producing their own big-budget movies, and studios have created streamers, airing movies and series, even as traditional measures of success or failure have vanished.

Accurate numbers are hard to come by, but as of July 2022, according to Nielsen, streaming viewership exceeded network and

cable each for the first time. With the broadcast networks continuing to trend downward, some of them seem to have just given up. Instead of developing new scripted shows, they're resorting to "bubble shows"—that is, shows "on the bubble" that in more prosperous times would have been canceled.

As of this writing, NBC is even debating turning its primetime 10:00 p.m. slot, when it aired signature shows like *Law & Order* and *ER*, over to its affiliates to program. Its owner, Comcast, wants to cut $1 billion from its broadcast division to trim its debt. At the 2022 Upfronts, where the TV poobahs parade their wares before advertisers like Big Pharma, Big Auto, Big Pizza, Big Big, and so on, Jimmy Kimmel, providing the laughs, dismissed network as "a fax machine five years after they invented email."

Meanwhile, *The Los Angeles Times* pounded a nail in the lid of the network coffin in May 2022 by discontinuing its primetime grid of TV listings, explaining that "even the broadcast networks . . . have acknowledged that streaming is the future, and with it the option to watch most TV whenever and wherever one likes."

Still, despite this epitaph, the viewership picture is confusing. In the winter quarter of 2022, Netflix took a big hit. It predicted it would add two million users but in fact lost 200,000, the first time it shed subscribers since 2011. Its rainbow target of a billion subscribers was downgraded by some analysts to a mere 400 million. Moreover, it still had that $14.5 billion debt. Hastings, not known for pessimism, was quoted as saying, "It's a bitch."

Netflix was moving too fast and breaking too many toys. Its stock fell 35 percent, erasing $54 billion–plus of the company's value in one day, and then another 35 percent over the course of the following six months. When Maureen Dowd in a lengthy interview with Ted Sarandos, whose 2022 SEC filing revealed an income of $50.3 million, asked him whether he could pass the Keeper Test, he answered, plaintively, "I hope so." Paradise gained was turning into paradise

lost. The irony is that the risky business practices that made Netflix
Netflix looked like they might end up unmaking it.

As it turned out, however, Netflix projected that it would lose an-
other two million users in the spring quarter of 2022, but it lost only
half that, thanks to *Stranger Things 4*. Still, in mid-2023, its market
capitalization was down $150 billion from its high in November 2021.
Losses of this magnitude created a sky-is-falling hysteria among the
I-told-you-so's, who predicted, with some reason, that Netflix's Wall
Street honeymoon was over—in turn meaning that Netflix itself was
over, or at the very least it had become a takeover target.

There were several reasons for Netflix's downturn. For many
years, it had been the only streamer on the block, with zero compe-
tition. Thriving under Wall Street's umbrella, it was so successful
in convincing corporate America that streaming, evaluated by sub-
scriber growth, was the wave of the future that it seemed like every
company on the Big Board wanted part of the action. The streaming
landscape was suddenly littered with pluses, like Apple TV+, Disney+,
and Paramount+, as well as Hulu, Amazon Prime Video, Peacock,
and HBO Max. All of them took bites out of Hastings's universe of
subscribers while bulking up on content themselves. Upstart Para-
mount+ ordered 150 international originals through 2025. Wounded
by these upstart rivals, Sarandos's free-spending, high-volume
strategy suddenly seemed unsustainable.

Since Netflix invented streaming, it had become synonymous
with it, and when it sneezed, the other streamers went on ventila-
tors. For the moment, it looked like the whole sector might be in
trouble, with stocks down and streamers ridding themselves of
employees like fleas. Save for Netflix, the dilemma, especially for
young sprouts like Comcast-NBCU's Peacock, is that they have to
reach profitability before their own pay TV linear cable channels,
which are still throwing off profits that the infant streamers needed
to grow, are chewed up and spat out. They resemble the ouroboros,
a serpent eating on its own tail, but instead of a symbol of infinity,
it is a symbol of nullity.

Another factor is deglobalization, meaning instability in big markets like India, Russia, and China—although after four years, China lifted its ban on Marvel, allowing *Black Panther 2* and *Ant-Man 3* to play in its theaters.

Streaming, however, is a business that goes from gold to dross and back in the flick of an eye, and the clouds parted in the summer of that year, thanks to shows like *Wednesday, Dahmer, Bridgerton, Squid Game, Glass Onion, The Gray Man, Stranger Things 4, Red Notice,* and *The Diplomat.* Altogether, they added up a lot of new subscribers. Netflix boasted 232.5 million worldwide. (Most of these gains, however, came from Asia, not maturing markets like the United States.) Additionally, Netflix, which had fed on subscriber growth, tried to shift Wall Street's focus away from it to profits, claiming that its 2022 revenue was up 6 percent from the previous year and predicted an impressive $3 billion in free cash flow for 2023, while alleging that the other streamers combined lost $10 billion.

Almost obscured in the hullabaloo around the Netflix roller coaster was the entry of Big Tech into the fray. Size and consolidation have their advantages, but they are a mixed blessing, to say the least. When companies consolidate, they take on debt that translates into cost cutting. Moreover, when entertainment companies are owned by bigger companies that are in turn owned by even bigger companies, and over them towers Wall Street with its demands for increased quarterly earnings, salaries that depend on stock options stagnate, yet with more takeovers looming in the future, morale plunges, and creativity is crushed. The "business" becomes just a business, like any other. It's all about money.

If Netflix had been the big spender, it was a pauper compared to deep-pocketed Amazon and Apple, which flooded the streaming space with money. This should have been welcomed by consumers. On the one hand, money can enhance, if not guarantee, quality. It can finance more shows, which means more jobs and opportunity for everyone. It can pay to tie up the best writers, showrunners, and

actors in exclusive overall deals. It can provide lavish production values, including spectacular special effects, pay for saturation marketing campaigns, and help buy Emmys and Oscars that secure even more viewers, creating Sarandos's self-perpetuating loop of profit. What could go wrong? As things turned out, plenty.

Money, it turns out, is a double-edged sword. Run wild, among other things, it drives up costs. Look at the impact of Apple TV+'s deep pockets on the economy of streaming. HBO's *Big Little Lies* was supposed to be a one-off, and therefore it signed Reese Witherspoon and Nicole Kidman for a single season only, paying each somewhere in the neighborhood of $250,000 and $350,000 per episode. When HBO tried to sign them up for a second season, the notoriously tight-fisted cabler discovered that Apple TV+ was reportedly paying Witherspoon and Aniston between $1.25 and $2 million per episode for its flagship *Morning Show,* plus producing fees. Witherspoon used this to jack up her price for Season 2 of *Big Little Lies* to about $1 million per episode. Needless to say, her co-star Kidman expected the same, with the rest of the cast most likely getting substantial salary bumps as well.

As Bloys says, "It is true that, not just Apple, but Netflix, Amazon, and the rest are paying higher salaries. That's not just actors' salaries, that's across the board. The cost of doing business has gone up." Speaking of the impact of the so-called Apple Effect on the second season of *Big Little Lies*, HBO's VP of drama Francesca Orsi said, a bit less tactfully, "We've been . . . raped." Hastings reflected, "Some day *The Crown*"—the first season of which cost a hefty $13 million an episode—"will look like a bargain." One 2019 headline read, "Disney and Apple Are Pushing Us into the Era of the $25 Million TV Episode." Says David Nevins, "We're paying too much for the return on investment and what the market can sustain."

Not only doesn't money necessarily guarantee quality, it can even compromise it. Says Landgraf, "You don't make art just by throwing money at it. Will we cross from a golden age to a gilded age? I think there's a very big danger that's already happened, and if it hasn't happened, it will soon."

Meanwhile, whether we have or we haven't, the cash-poor (relatively speaking) streamers can't keep up. For them, the star system presents an almost insurmountable obstacle. On the one hand, they need stars; on the other, they can't afford them.

One way those streamers appear to be fighting salary inflation is by paradoxically packing their shows with talent. Norma Desmond famously said in *Sunset Boulevard*, "I am big . . . It's the movies that got small." But that was then and this is now, when it's the other way around: Actors have gotten small and the movies have gotten big, too big. *Spider-Man*: *No Way Home* used three A-list stars (Tom Holland, Andrew Garfield, and Tobey Maguire) to play one character—Spidey—plus Benedict Cumberbatch, Jon Favreau, Jamie Foxx, and Zendaya. Both Michael Keaton and Ben Affleck play Batman in Warner's *The Flash*. That seems like an indie production compared to *No Time to Die*, which boasts eight big names. Every time we wake up we see a familiar face—Daniel Craig, Ralph Fiennes, Ben Whishaw, Rami Malik, Jeffrey Wright, Rory Kinnear, Christoph Waltz, and Ana de Armas.

Stuffing them with stars like piñatas makes the shows more appealing, but it also undermines the power of individual actors to claim credit, and therefore demand a salary bump on the next one. It's also an admission that traditional stardom may be fading. *Succession* didn't seem to suffer unduly from the untimely death of Logan Roy, even though Brian Cox is the best thing about it. The gifted ensemble managed to carry his water.

Of course, actors and "matinee idols" are two different species, but Tom Cruise, talent-challenged though he may be, could indeed be the last "movie star." He's entering his sixties, and one survey determined that most of the stars that draw audiences to theaters are seniors—Tom Hanks, Brad Pitt, Denzel Washington, Julia Roberts, etc., averaging 57.5 years old. Few youngsters and women, no Zendayas, no Zoe Saldanas make the list.

The growing importance of IP and branding have also taken their toll. Audiences want to see Captain America, not Chris Evans, who is more or less indistinguishable from the other three Chrises—Pine,

Pratt, and Hemsworth—especially when they're hooded. The fact that nine different actors, including Adam West, have played Batman doesn't seem to have made a dent in the franchise. (Maybe these superheroes should throw in their lot with the anti-masking crowd.) And finally, the phenomenally successful animated *Spider-Man: Into the Spider-Verse* and *Spider-Man: Across the Spider-Verse* do away with actors entirely.

IP, superheroes, spectacle, money—they all degrade acting as a skill. We don't have actors anymore, we have empty supersuits. Many of the most popular shows, like *Tell Me Lies*, or the *Avatars*, have done fine without stars. The plight of human stars is such that several shows have been built around consumer brands like *Tetris*, *BlackBerry*, or Nike in *AIR*, where Matt Damon is barely recognizable in a fat suit. The best way to become a star these days is to get involved in a scandal picked up on social media, like Olivia Wilde in *Don't Worry Darling* or Ezra Miller in *The Flash*.

Then there's content. Over- or underspending on content fosters consolidation, uniformity, and, worse, allergy to risk, both narrative and aesthetic. With innovation the casualty of caution, many shows even build risk aversion into their narratives. The vast majority of Marvel's superheroes, for example, never die, that is, die for good, unless an actor wants out or the franchise itself is dying. Superheroes are valuable IPs, and with multiverses galore, if they die in one, they just pop up in another. They can't go to the store to buy a quart of milk without ending up in another universe. Marvel's so-called Phases 4, 5, and 6 are even known as the Multiverse Saga, which will extend through 2026, when presumably it exhausts the universe of universes.

The *Avatars* are multiverses under another name. Stephen Lang was too good in *Avatar* to leave for dead, so he's revived in *The Way of Water* as his avatar, that is, his personality in a Navi body. The apotheosis of this trend is the 2022 series *Doctor Strange in the Multiverse of Madness*. And, as *Rolling Stone* puts it, risk avoidance is another version of comfort viewing: "Multiple worlds are . . . a comforting thought as ours goes to hell."

George R. R. Martin well understood that opening the door to other universes slams it on ours, whether we like it or not. The absence of the realism that grounds fantasy in the best of these shows erodes the emotional bond between viewers and characters because we know that whatever jeopardy the latter may face is phony. This suggests that these series don't so much resemble novels, the template that defined much of the early Peak TV era, and that carries with it a certain gravitas with its commitment to behavioral authenticity in which actions have consequences—that they don't have in fairy tales, the difference, as we have seen, between *House of the Dragon* and *The Rings of Power* that reeks of Hans Christian Andersen.

Back in the day, the difference between the disrupters and the disrupted—HBO and Netflix, say, versus the staid old studios and networks—was dramatic. We recall that when HBO was breaking with the sponsor-driven model, it shunned anyone and everyone who was redolent with the stink of network. Bridget Potter, remember, was reluctant to hire Tom Fontana to write and run *Oz* because he had written for *St. Elsewhere*, and Amazon's Roy Price refused to hire network executives who were synonymous with down-the-middle shows. Never mind that Potter herself came from ABC, and David Chase had a network résumé as long as his arm, because if a cabler or a streamer wanted personnel with experience, there was little choice but to recruit from the despised networks or even the studios.

As companies consolidate and scale up, they are virtually forced to become cozier with their corporate cousins, because they need executives with the kind of experience and contacts that outsiders like Fuchs and Bewkes, Hastings and Sarandos, didn't have. At first, the cable companies hired renegades like Nevins, Reilly, and Greenblatt, who were impatient with the network and studio values and wanted to emulate HBO. But as the competition became more intense, and the cost of acquiring more subscribers increased, that too changed. First cablers and then streamers began hiring ex-

ecutives from networks and studios not despite but *because* they brought those values with them.

As we have seen, when Amazon was looking to replace Price as head of Amazon Prime Video, it turned to the networks, seizing on former NBC Entertainment head Jennifer Salke. Salke in turn hired the former chairman of Sony Pictures Television, Mike Hopkins, to supervise Amazon's video entertainment division and promoted Julie Rapaport, a survivor of the Weinstein Company, to co-head of movies. Rapaport was put in charge of a new division devoted to what Salke described euphemistically as "more widely engaging stories that audiences will connect with."

Forced to compete with a Big Tech rival for which money was no object, Hastings and Sarandos seemed to feel that they had no choice but to re-create Netflix as a studio. According to *New York* magazine, "The official word from Netflix insiders is that Sarandos . . . simply decided he wanted the company's TV operations to mirror the structure of its film business."

Hastings has tried to explain away his new romance with the studios and networks by saying that Netflix has a lot to learn from Hollywood, singling out the studios' skill in exploiting franchises like *Star Wars*. But franchises like *Star Wars*, as Disney+ has skilllessly shown, are often graveyards for creativity, and mastering the machinery necessary to manufacture them is the last thing Netflix needs to learn from Hollywood.

For Netflix, becoming a studio to make studio movies meant purging itself of veterans of its disruptive era, while recruiting oldschool studio warhorses, often doubling their studio salaries. In September 2020, Sarandos fired Cindy Holland, by that time an eighteen-year company veteran and his first hire when he moved to LA in 2002. Sundry Netflix insiders regarded her exit as an inflection point, when the company downgraded quality. From *House of Cards* to *The Queen's Gambit*, "That service was built on the back of Cindy Holland's taste," says one. "Ted is . . . not a picker." Another source referred to Holland's exit as "the beginning of the Walmart-ization" of Netflix. Holland was one more example of a Netflix pioneer who

became a victim of the "culture of candor," says still another insider: "She would call Ted out on his shit," and urged her team to speak up if they disagreed with his programming decisions. But, said another source, the reality is, "No one really likes that." One employee says the culture of candor "works well peer to peer," but compares Netflix to Orwell's *Animal Farm*, "where all animals are equal, but some animals are more equal than others."

The *Animal Farm* analogy fit more snugly when Hastings promoted Sarandos to co-CEO in 2020 and the latter reportedly became less interested in candor. A veteran Netflixer says, "It's not easy for Ted to admit if he's wrong, to hear other points of view, if he feels strongly about something."

Sarandos added Scott Stuber, vice chairman of Universal Pictures, where he produced franchises like the fabulously successful Jason Bourne series, as Netflix's head of global film. Netflix wanted Stuber to focus on big, nine-figure action films, which he did, supervising the liftoff of the blockbuster era at Netflix, paying unconscionable amounts of money for bankable stars and hot directors. He set his goal at sixty movies a year, way more than any studio.

As summed up by *The New York Times*, Netflix "is aiming straight for what the old-line studios do best: the PG-13, all-audience films that traditionally pack movie theaters, create a cultural moment and often transform into lucrative franchises."

In 2021, former Netflix enemy Steven Spielberg's Amblin signed a multiyear deal to make films for Netflix. Netflix also signed onto the fourth installment of Eddie Murphy's Beverly Hills Cop franchise, *Axel Foley*. Then there was *6 Underground*, a $150 million "Bayhem" express from schlockmeister Michael Bay that aired in 2019, starring Ryan Reynolds, who reportedly received, yes, $30 million for his efforts. The movie impressed no more than 36 percent of its reviewers, according to Rotten Tomatoes.

At the same time, several Netflix warhorses are either over, like *Ozark,* or are nearing their eternal resting places, like *The Crown* and *Stranger Things*. Netflix is leaning on a sequel to its biggest money-maker, *Squid Game*, that its creator isn't sure he wants to make.

One producer who had several shows at Netflix experienced pure chaos. When *Emily in Paris* was successful, they said, "Can you make it more like *Emily in Paris*?" Then another show got hot, and they wanted it to be more like that one. Despite lavish spending on some projects, on others there was constant pressure to lower the budget: cut, cut, cut. Says Stuber, "We were a business that was, for a long time, a volume business. And now we're being very specific about targeting."

One blight that has proved true for studios and streamers alike is that, as many have noted, the middle has dropped out. Everything is either niche or blockbuster. Is it *Tár* or *Avatar*? Both or neither? As Soderbergh puts it, "We have the gigantic movies on the one hand, and you have A24 on the other, and there's nothing in between. The starting number for a wide release movie in prints and ads is $30 million. I mean, you just can't get out of bed for less than that. The idea of *Erin Brockovich* making a hundred million dollars today, theatrically, is impossible." When Chris Nee left Disney for Netflix, she said that she'd be happy there "until I'm not," and "not" turned out to be at the end of 2022 when her deal ran out. Nee supervised a slate of three shows, and the last, *Dino Daycare*, said to be from an LGBTQ creator, was killed altogether.

In January 2023, Nee was looking for a new job. Says one Netflix source, "Nobody at Netflix is saying any more, 'Don't worry about making a big audience hit,'" which is what she was told when she first arrived. "In fact," the source continues, "what they're saying is quite the opposite." The watchword now is "creative excellence," "excellence" being a euphemism for reaching as big an audience as cheaply as possible rather than just a niche audience.

As if trying to find the sweet spot between blockbusters and niche series, which is hard enough, Netflix also says it needs "better" shows. Despite dominating Nielsen's 2022 Top Ten list, quality-wise, as reflected by the combined reviewer and audience ratings as measured by Rotten Tomatoes that same year, Netflix scored worst among the streamers. *Me Time* with Kevin Hart and Mark Wahlberg scored a critics' rating of 6 (six!).

As Soderbergh points out, however, quantity doesn't translate into quality: "You can make thirty movies, and five of them are going to be really good," he says, continuing, "and you can make seventy movies, and only about five of them are going to be good. There's just no algorithm that guarantees, 'Oh, if you have this much great art and you make ten times as much, you'll have ten times as much great art.'" More can be more, but so can less.

The most revealing indicator of Netflix's new turn in an old direction is that in the past, Sarandos was in the habit of traveling north to the Netflix mothership in Los Gatos two days a week. Now Hastings goes down to Hollywood for two days a week. At least he did. In January 2023, he stepped back, ceding the co-CEO slot to Greg Peters, formerly Netflix's COO.

Netflix mapped several escape routes from its looming death spiral, including fewer originals, while achieving surprising success by reviving obscure items from its vast library, like Mel Gibson's *Dragged Across Concrete*, which flopped in theaters in 2018. Meanwhile, its exhibition strategy is a mess, especially in view of the fact that exhibition began a modest bounce back over the 2022–2023 holiday season with *Black Panther: Wakanda Forever* and *Avatar: The Way of Water*, and later *The Super Mario Bros. Movie*.

Whereas Sarandos could easily have opened his expensive features or launched new franchises in theaters before moving them to Netflix, he continued to fight exhibition, ignoring Bloys, who said, "It's much better for us that movies have been launched theatrically and then come to HBO."

Struggling to open new product post-pandemic, three theater chains granted Netflix a six-day theatrical window for Rian Johnson's *Glass Onion: A Knives Out Mystery*, the first of two sequels to *Knives Out*, the rights for which Netflix bought for an astounding $450 million, give or take a few zeroes. Sources say that they were given the impression that this was a test to see whether exhibitors and Netflix could cooperate in the future. The former, however, were

furious when Sarandos, on the red carpet of the 2022 Venice Film Festival, announced, "Streaming first."

An angry theater executive groused, Netflix "couldn't care less about exhibition." Instead of the two thousand screens exhibitors anticipated, it played in 638. Given that it grossed $15 million in just one week, and could have made an estimated $50 million in wide release, "This is probably one of the biggest gaffes in modern film release history in terms of bungling what could have been made at the box office with *Glass Onion*," said Jeff Bock, a senior media analyst at Exhibitor Relations. "In my mind, they left hundreds of millions of dollars at the table."

Netflix is also experimenting with live programming and cracking down on password sharing, despite its 2017 slogan, "Love is sharing a password." And then there is bingeing, perhaps its signature innovation, but now a luxury it may no longer be able to afford. Whereas HBO, say, can ride shows like *House of the Dragon* and *The Last of Us* for weeks and weeks, Netflix has to come up with fresh shows week by week. As Bloys puts it, "Releasing a new season of a new show instead of a new episode every week—that's expensive." It's like stuffing a bag of rocks with millions of dollars and dropping it into the ocean. Worse, when subscribers have finished, they look for another multi-million-dollar series, and if Netflix doesn't have one ready for them, they may just click their remotes to take them elsewhere, which is called "churn"—a word that elicits dread and loathing from streaming executives.

Churn was never an issue for Netflix in its infancy because its network-hating, cord-cutting audience had no place to churn to. But as the fresh crop of streamers popped up, its new shows had to be able to attract viewers *and* retain them. "There's millions of people who don't watch Netflix, who do not pay for Netflix, because there is not enough content on the platform that is engaging to them," said former Netflix program manager B. Pagels-Minor.

Bloys convincingly argues that social media has taken the place of the water cooler conversation on a vastly bigger scale, and in this environment, the old strategy of drip, drip, dripping new episodes

makes more sense than drowning viewers in an entire season all at once. He explains, "There's an entire ecosystem of people who write about television, and want to talk about it, and get on social media and criticize it or praise it, or whatever. The effect of all of it together is to keep the show in the cultural conversation"—in other words, free publicity.

In the most dramatic divergence from its old ways, Netflix introduced an ad-supported tier for the ad-immune, charging $6.99 a month versus its ad-free price of $9.99 a month, on November 3, 2022. Although viewers say they hate commercials, their viewing habits suggest otherwise. They like them more than paying higher prices for ad-free subscriptions. Amazon has even experimented with its so-called FAST service, Freevee, a free ad-supported streamer to which it has moved *Bosch*, one of its most popular shows. Other streamers like Disney+, as well as what was formerly known as HBO Max, are following suit. Disney's streaming service lost money in 2022, but the company expects that its new ad-supported tier will restore it to health. Trends indicate, however, that streamers may never be as profitable as the networks of the past, and even if Netflix is successful in carving out the biggest piece of the pie, it will be a smaller pie.

Moreover, the overriding irony in all this is that the map Netflix has drawn to escape from the corner into which it has painted itself diverges, nay, negates everything that made Netflix Netflix. It has its executives doing somersaults, reading from different scripts, saying one thing and doing another. Just when it seems like Hastings is standing fast, defending binge-watching as an accelerant for engagement for shows like *Squid Game*, Netflix backs away from it by dividing new seasons of shows like *Stranger Things 4* into two chunks released weeks apart, proving that it's hard to teach a new dog old tricks.

When a streamer known for originals remakes itself in the image of a studio or a network, it is indeed on its way to becoming a studio or network, producing studio and network content: bland, bloated, and inoffensive. All in all, there are too many streamers making too

many shows, a lot of them of questionable quality, leaving consumers oversubscribed and underwhelmed.

Meanwhile, producers and writers feel shortchanged, watching their cost-plus deals shrink to cost-minus. Reflecting the cost of cost cutting, anemic advertising, and fear of a recession and a strike, scripted shows for adults are falling off. Predicting "a world of hurt," Bob Iger said in September 2022 of his industry, "[This is a time of] great anxiety, because this is an era of great transformation."

At a time when the studios and streamers are cutting back, the long-feared picket lines finally materialized on May 2, 2023, when 11,500 writers laid down their pencils as if say, "No wages, no pages," ending a decade and a half of relative tranquility between them and their employers. Said Tony Kushner (*Angels in America, The Fabelmans*) from the picket line of the so-called Netflix strike in New York, "These companies are absolutely destroying our industry." Craig Mazin thinks even the studios know they've "fucked up," as if they finally understood, "You've just blown out the foundation of your own house and now the whole thing's crumbling down around you."

The shrinkage of the networks' twenty-two-episode orders to the streamers' eight- to twelve-episode orders, in addition to the increasing prevalence of "mini rooms," where fewer writers work longer hours for shows that may never be produced, adds insult to injury, forcing many writers, unable to pay their mortgages, to supplement their incomes by, say, driving for Uber.

One strike sign read: "Don't piss on my leg and tell me, 'It's streaming.'" As writers picketed, David Zaslav was booed during his commencement address at Boston University ("Pay your writers!"), but if he really aspires to shrug off the pimple poppers of the world and become Bob Evans, he achieved it at the expense of poor optics in 2023 at Cannes, where he cohosted a one-hundredth anniversary for Warner Bros. at the Hotel du Cap, and rubbed shoulders with Scorsese, Robert De Niro, Leonardo DiCaprio, among others, as well as a puppy named "Maxi."

Financial transparency is also a fighting issue, since many streamers refuse to release numbers of views and/or viewers, making it difficult for writers to assess the few residuals they do get. "It's not right," says Graham Yost. "What they always say about streaming is, 'Hey, we don't even know if this works.' And it's like, 'Well, then don't do it.' Don't do it and put it on our backs. Don't suddenly change the deals with writers. People get hired for a certain number of episodes, but then they stretch them out over so many months and now we're getting peanuts compared to what writers used to get."

The studios, meanwhile, are pleading poverty, to which their across-the-boards cutbacks attest, but with those at the top like Sarandos pulling in his $50.3 million salary, that's a hard one for writers at the bottom to swallow.

The streamers and studios probably have enough shows banked to withstand a long strike, not to mention the ability of, say, Netflix to use new work from writers overseas, especially South Korea. A lengthy strike may knock out smaller companies, leaving only the behemoths intact. Some of them may even benefit from the strike, as ceasing production saves money that can go to reducing their debt. And, of course, they can always call on assists from AI, another target of the strikers, as if anyone would notice on movies like *Top Gun: Maverick*.

The real issue, however, isn't so much whether entertainment can survive in its new streaming guise—because it always has and always will—or who will win the streaming wars, but what the landscape will look like when the dust settles.

Historically, of course, the networks were straitjacketed by their sponsors. Cablers and streamers allowed creative freedom that the networks could not, putting the networks at a severe disadvantage. Says Greenblatt, "Every broadcaster is grappling with how to compete with the streaming experience when broadcast television with commercials is the last thing anybody wants to watch." While the

going is slow, some network shows have acknowledged that streaming presents an existential threat and have given creatives more room.

Like Robert and Michelle King, David E. Kelley has written for all three formats: network, cable, and streamers. The reviewers dismissed two of his streamer series as flat and flavorless. *The Los Angeles Times* scorned his Netflix show, *Anatomy of a Scandal*, saying we are given "familiar archetypes, paint-by-numbers plot elements, recognizable beats . . ." CNN's Brian Lowry dissed *The Undoing*, Kelley's HBO show, as "Big Little Lies Lite," while *Time* called it "blander and grayer and more predictable."

Paradoxically, however, *Time* praised his network show, *Big Sky* on ABC, for "boundary-pushing." Among other things, it features the first nonbinary actor—Jesse James Keitel—to play a gender-fluid role as a series regular on a primetime network. It's considerably more violent than your normal broadcast show, presenting several repellent torture scenes verging on outright S&M. It's also more loosely plotted than a network series. The point here is that Kelley's network shows may be more innovative than his streaming shows.

Big Sky is no anomaly. After producing seven seasons of *The Good Wife,* starring Julianna Margulies, for CBS, Robert and Michelle King produced *Evil* on the same network. The premise: A Black Catholic priest in training (Mike Colter) and a white forensic psychologist (Katja Herbers) investigate cases of ostensible diabolic possession. In one shocking episode, especially for network, parents kill their child because they think he/she is possessed by the devil. Michelle King said of the show, "We're sort of doing a streaming show on the network. Isn't that peculiar?"

When *Abbott Elementary* premiered on ABC, *The New Yorker* said it "feels fresher than a lot of the buzzy streaming comedies." Another network cop show, CBS's *East New York* was favorably compared to *NYPD Blue*, high praise indeed from CNN's Brian Lowry, and presents "cops and policing as flawed tools in need of rethinking," according to *Variety*. It acknowledges the chasm between the police and the policed, the way the wealthy are treated with kid gloves while the poor are shot or shackled. True, the shady cops are dismissed as a

few bad apples, and the show is a far cry from the acidic portrayal of police as an occupying army in *We Own This City* from HBO, but it's progress of a kind. Or was, because it was canceled after one season, probably because the network didn't own it.

Meanwhile, the streamers still offer talent a lot more freedom than network, but that may be changing. When Season 2 of *Evil* moved to a streamer (Paramount+), Robert King was delighted. "We had footage that was a little like, 'Oh fuck, we'll never get this past Standards and Practices,'" he says. "Creatively, it's a godsend . . . They can curse, give the devil his due, the sexual subtext can become text, and the Catholic Church can be put on the hot seat." Contemplating a scene in which a character throws a Bible, one of the writers asked, "Will we get canceled?" Robert King replied, "Not on streaming." Perhaps.

When the Kings spun off *The Good Fight* to the same streamer, Paramount+, Michelle explains that streaming gives her "freedom in terms of format," but found, however, that the freedom streaming confers is by no means unlimited, and is even diminishing. "I think [now] there might be a little bit closer oversight in terms of content that might be potentially offensive," she says, citing as an example a musical short included in *The Good Fight* attacking American entertainment companies for toadying to China for access to its market. CBS killed it.

Ed Burns, who wrote and produced HBO's *The Wire* with David Simon, says HBO's series are "not cutting new paths," adding that *The Wire* could never be made by HBO today, when everything has "to be disconnected from stepping on anybody's toes." And we recall what Terry Winter said about the notes he received on *Vinyl*.

Poker Face on Peacock has been praised for refusing the advantages of streaming by abandoning the season-long story arc, in favor of enabling its star, Natasha Lyonne, to solve a new mystery every week. "What if TV felt like, well, TV again?" asked *The Washington Post* reviewers, approvingly. Creator Rian Johnson fashioned it as an intentional throwback to shows like *Murder, She Wrote*, and *Magnum P.I.* that he grew up on. Johnson says, "It was typically hourlong, star-driven, case-of-the-week shows." Speaking about *Columbo*, he says, "It really is all about watching Falk be Falk every single week.

You're tuning in to see Columbo and the guest star interact with each other and hang out." Same with Natasha Lyonne. Says Craig Erwich, president of both ABC Entertainment and Hulu Originals, "The idea of a binary choice, that one show is a network show and one is a streaming show, is just not true."

In other words, the creative and structural differences between streamers and network may be breaking down, evident in the degree to which the old narrowcasting cable and streaming services, taken in aggregate, share commonalities with the networks. Taken as a whole, niche + niche + niche adds up to more than a lot of niches; it's a new monoculture, the equivalent of those four-quadrant broadcast shows. As the entertainment news guru Janice Min put it in *Time* magazine, "plurality is the new mass."

Moreover, squeezed by the economics of the business, some streamers are actively in the process of turning from narrowcasting to broadcasting. Nevins, speaking of Netflix, observes, "As it's gotten bigger and bigger and bigger, it has broadened out its programming and is racing to the mainstream. It's taken the place of the broadcasters." Adds Greenblatt, "For all intents and purposes, streamers are already broadcast television because they are infinitely broader than broadcast."

To some degree, streamers and networks are trading places. While Netflix in its infancy licensed network shows, Netflix is now licensing its shows to the networks. Many of its recent releases, both movies and series, like *The Crown* and *Bridgerton*, could have been produced by a network. In fact, some of them *were* produced by a network. The former disrupter managed to collect most of the old cast of *That '70s Show* (Ashton Kutcher, Topher Grace, Mila Kunis, et al.) which diverted fans on Fox for eight seasons from 1998 to 2006, and rerun it as *That '90s Show* with the addition of some new faces. *Manifest*, a show NBC canceled, and *Lucifer*, a show Fox canceled, are now on Netflix.

Streamers are aging up as programmers are eager to add bald pates to their shaggy-haired youth audience. Disney moved the hoary *Dancing with the Stars* from ABC to Disney+ in 2022. (Disney

wasn't worried that it was diluting Disney+—that seems impossible—but that it was weakening ABC. It moved back the following year and now it airs on both ABC and Disney+.)

Kenya Barris, who had left ABC for the freedom of Netflix in 2018, left Netflix for Paramount Global in 2021 despite his multiyear deal, explaining, "I want to do in-your-face shit," but "Netflix wants down the middle." He added, "Netflix became CBS." He may be disappointed, because Paramount+'s predecessor, as we have seen, *was* CBS (aka CBS All Access), and the streamer is saturated with CBS content, like the fledglings of *Star Trek*. *Criminal Minds* ran for fifteen seasons on CBS and did well on Netflix, and now has been revived for, guess where? Paramount+! CBS's hit *Fire Country* is also available on Paramount+, as is its 2023 show *Ghosts*.

Paramount+ is not only airing fresh CBS shows, it is injecting new life into other networks' golden oldies. It has given a series order for *Frasier*, the *Cheers* spin-off that ran on NBC for eleven seasons. Ditto *The Brady Bunch*, which premiered on ABC in 1969. *Law & Order*, the venerable network procedural, is available on several different streamers.

Nor is CBS the only network to revive zombie shows and share them with its streamer. NBC's six-season comedy *Community* will be reincarnated as a movie on Peacock, with six of its nine stars resurrecting their roles from the original. And at the end of November 2022, Peacock began to stream NBC's entire programming content live, as well as live content from NBC's affiliates. According to Channing Dungey, head of Warner TV, shows like *Friends* are comfort food, but she's trying to imagine what that might look like on a streamer.

Today, crossover is becoming the name of the game, as a plague of old network shows infects streamers of every stripe, with the distinctions between streaming and network continuing to break down, as network becomes marginally more daring, while streamers, to use Nevins's words, "race to the mainstream."

As the streamers become more heavily dependent on ads, expect that the sponsors will want to exercise control over content, just as they do on the networks. Also expect the streamers to jealously defend their prerogatives. But now that they're run by former network

and studio executives who are facing saturated markets as well as kill-or-be-killed competition, they very well may be more receptive.

The mainstreaming of the streaming audience entails a change in values. *Ted Lasso* may be less an outlier as an augury of things to come, the end of discomfort viewing. In the old network shows, morality was simple: virtue was rewarded and evil was punished. Comfort viewing, with heroes who do the right thing, valorizes the American Dream (everything's A-OK), is the revenge of the center, or what is left of it, against the discomfort viewing that has privileged extremist anti-heroes of the left and right. These are the vigilantes and revenge figures whose appeal lies in doing the wrong thing, refusing to play by the rules because their bullshit detectors tell them the American Dream is a fraud, constructed by the powerful to benefit themselves.

What will happen when the moral ambiguity of the streamers collides with the ad-supported network moralism? What will happen to the tweeners, the good-bad guys and dolls whom cable and streaming taught us to love? What will happen to the Tony Sopranos, Al Swearengens, Vic Mackeys, Raylan Givenses, Don Drapers, Bobby Axelrods, Ray Donovans, Logan Roys, Deborah Vances, and Beth Duttons? They were all James Bonds, with licenses to kill. Will they all be turned into bad-bad guys and dolls? Vince Gilligan has already told us not to expect Walter White in his show on Apple TV+. As he put it, "After fifteen years, I figured it was time to take a break from writing anti-heroes."

As networks continue to dump their shows onto the streamers, while streamers race to the mainstream, the discomfort shows that defined Peak TV are already beginning to get a lot of flak. Netflix's *Ozark* took some heat because the Byrds get away with their crimes. Laura Linney, who played Wendy Byrd, retorted, "Don't come at me with this fairy-tale thing about right and wrong, and that those who cheat get punished. Are you kidding? Watch the news." In other words, don't call it "cynicism," call it "realism."

Look too at the universal opprobrium that greeted the last episode of *Game of Thrones*. There were no ads, of course, but it didn't need any when it turned its good-bad girl Daenerys Targaryen into a bad-good girl, and punished her, while designating Ted Lasso wannabe Bran the Broken the ruler of the future, justifiably eliciting a yawn from the audience.

Once the sponsors of the ad-supported tiers start to complain, what will happen to shows like HBO Max's *White Lotus*? In Season 2, Tanya, the dumb-good-girl, shoots the baddies, who are trying to steal her fortune but, klutz that she is, she comes to a "derpy" (writer Mike White's word) end, accidentally falling between two boats and drowning. Meanwhile, her husband, the worst of the worst who has orchestrated the whole plot against her, walks away with her money, thanks to a clause in their prenup. As in *Ozark*, crime pays.

In the back to the future environment, the good news is that streaming might retain some degree of freedom denied the networks, but it's more difficult than ever to predict that future. The bad news is that the post-network streaming world could turn out to look very much like the pre-streaming broadcast world. Instead of the Big Four networks, we might see Big Five streamers—say, Netflix, Disney+, Amazon Prime, Apple+, and Max. Says J. B. Perrette, president of global streaming at WBD, "In many ways, we are seeing reincarnation of the last half a century of television for the streaming age." He also added that consumers are in a period era of "peak confusion," to say the least.

Worse, some predict that as the streamers become increasingly dependent on their ad-supported tiers, ad-free programming will simply disappear. As always, consumers pay, providers profit. Are we back where we started? Vlad Wolynetz recalls, "Matt Weiner [once] said to me, 'I'm watching TV now, and it's like *Mad Men* never happened. We're right back to where we were. Except there's more of it.'"

In other words, it's nothing, everywhere, all the time. When Iger said that content, not cash, is king, he may have gotten it backward. Cash, not content, is king.

ACKNOWLEDGMENTS

Movies, I hope, will one day make a comeback, but this book was written during the long winter when they were content to be no more than vehicles for cape-wearing superheroes deploying an array of exotic powers against an endless variety of dastardly enemies. Meanwhile, creatives with talent migrated to TV, which became the entertainment of choice for anyone with eyes in her or his head. I wish to thank Mauro DiPreta of William Morrow for giving me the opportunity to write about this age of Peak TV, as well as Andrew Yackira for steering me through the thicket of notes and copyediting, and likewise, Allie Johnston. My agent, David Halpern, gave me unfailing support and valuable advice. Chloe Currens of Penguin UK extended a helping hand, while Maggie Simmons steered articles my way, saving me subscription fees on periodicals I rarely read. And, finally, I want to thank my wife, Elizabeth Hess, for keeping my head on straight.

NOTES

Introduction: Broadcast Blues

ix *"You couldn't kill a dog":* Robin Green, in discussion with the author, January 18, 2006.

ix *The result was that TV:* Newton N. Minow, "Television and the Public Interest" (speech). May 9, 1961. Transcribed from audio recording. American Rhetoric, Online Speech Bank, https://www.americanrhetoric.com/speeches/newton minow.htm.

x *As allegation-prone Kevin Spacey:* Kevin Spacey, in discussion with the author, September 20, 2013.

x *"Network television had all these rules":* Kevin Reilly, in discussion with the author, July 27, 2021.

xii *Now, says director David Fincher:* David Fincher, in discussion with the author, August 3, 2013.

xii *"I just don't think movies matter":* "Steven Soderbergh retires from film," Ben Child, *Guardian,* January 30, 2013.

xiii *As Glenn Close put it:* Jim Halterman, "Interview: 'Damages' Star Glenn Close," *Futon Critic,* January 7, 2009, http://www.thefutoncritic.com /interviews/2009/01/07/interview-damages-star-glenn-close-29974 /20090107_damages.

xiii *Indeed, when David Milch:* Brett Martin, *Difficult Men* (New York: Penguin Press, 2013), 172.

xiii *Oh, and by the way:* Roger Cormier, "15 Incorruptible Facts About *The Shield,*" *Mental Floss,* March 12, 2017, https://www.mentalfloss.com/article/74534 /15-incorruptible-facts-about-shield.

Chapter 1: Seeding the Wasteland

3 *"It was like a blueprint":* Kevin Spacey, in discussion with the author, September 20, 2013.

4 *"If I had finished Harvard Business School":* Nina Munk, *Fools Rush In: Steve Case, Jerry Levin, and the Unmaking of AOL Time Warner* (New York: Harper Business, 2004), chap. 1, iBooks.

4 *Of course, "money-grubbers":* Ibid., 315.

5 *"Suddenly, the whole meeting began":* Ibid., chap. 1, iBooks.

5 *"There were guys at HBO":* Michael Fuchs, in discussion with the author, December 13, 2011.

5 *"I knew nothing":* Michael Fuchs, in discussion with the author, December 13, 2011.

5 *At the time, HBO was, as Fuchs describes it:* Michael Fuchs, in discussion with the author, December 13, 2011.

6 *"When I first met Michael, he was going to play tennis":* Sheila Nevins, in discussion with the author, February 9, 2022.

6 *"There was no competition"*: Sheila Nevins, in discussion with the author, February 9, 2022.

6 *Fuchs subscribed to the conventional wisdom*: Michael Fuchs, in discussion with the author, December 17, 2011.

7 *"Randy guys were a major part of our demographic"*: Michael Fuchs, in discussion with the author, December 21, 2011.

7 *"I was free to do sex shows"*: Sheila Nevins, in discussion with the author, February 9, 2022.

7 *"I thought I'd died and gone to heaven"*: Michael Fuchs, in discussion with the author, December 21, 2011.

7 *"We were in this place"*: Confidential source, in discussion with the author.

7 *"It was easy to turn HBO down"*: Bridget Potter, in discussion with the author, December 9, 2010.

7 *"They weren't saying, 'Oh, we could be smarter'"*: Bridget Potter, in discussion with the author, January 5, 2011.

7 *"If you go to HBO, you're leaving the business"*: Bridget Potter, in discussion with the author, December 16, 2016.

8 *"I liked Michael"*: Ibid.

8 *"I found it all very difficult"*: Bridget Potter, in discussion with the author, January 5, 2011.

8 *"It didn't have a rape culture like Miramax"*: Confidential source, in discussion with the author.

8 *That meant "I read* Cosmo *like it was Spock"*: Maureen Dowd, "The Grande Dame of Documentary Is Leaving Her Home at HBO," *New York Times*, December 16, 2017, https://www.nytimes.com/2017/12/16/style/sheila-nevins-leaving-hbo-documentary-films.html.

8 *Nevins thought "being touched by a man"*: Ibid.

8 *"It meant nothing to me"*: Maria Fontoura, "Sheila Nevins Is the Godmother of Modern Documentaries—and She's Not Done Yet," *Rolling Stone*, March 1, 2022, https://www.rollingstone.com/tv-movies/tv-movie-features/oscars-sheila-nevins-interview-1312443/.

9 *"I didn't approve or disapprove"*: Sheila Nevins, in discussion with the author, February 9, 2022.

9 *"I had a big mouth"*: Michael Fuchs, in discussion with the author, May 9, 2022.

9 *"His code of ethics was basically* The Godfather"*: Bridget Potter, in discussion with the author, December 9, 2010.

9 *"We'd have parties at the Bel Air Hotel"*: Confidential source, in discussion with the author.

10 *"If you didn't do cocaine"*: Ibid.

10 *At a meeting with the McKinsey team*: Bridget Potter, in discussion with the author, December 9, 2010.

10 *"The movie companies had far too much leverage"*: Michael Fuchs, in discussion with the author, December 21, 2011.

11 *"HBO spent hundreds of millions"*: Michael Fuchs, in discussion with the author, November 29, 2011.

11 *"We're not really in the television business"*: Felix Gillette and John Koblin, *It's Not TV: The Spectacular Rise, Revolution, and Future of HBO* (New York: Viking, 2022), 45.

11 *"But it was really dreadful"*: Bridget Potter, in discussion with the author, December 16, 2010.

11 *"I cannot tell you how frightening the whole thing was"*: Bridget Potter, in discussion with the author, December 9, 2010.

12 *"pushing every minute to be provocative"*: Bridget Potter, in discussion with the author, January 11, 2011.

13 *"Nobody can write better jokes"*: Lynn Hirschberg, "Garry Shandling Goes Dark," *New York Times Magazine,* May 31, 1998, https://www.nytimes.com /1998/05/31/magazine/garry-shandling-goes-dark.html.

13 *"My friends tell me that I have an intimacy issue"*: Tad Friend, "The Eighteen-Year Itch," *New Yorker,* April 6, 1998, https://www.newyorker.com/magazine /1998/04/13/the-eighteen-year-itch.

13 *Jenji Kohan, who would later create:* Emily Nussbaum, *I Like to Watch* (New York: Random House, 2019), 284.

13 *"a passively malignant emperor"*: Janis Hirsch, "Comedy Writer Reveals Lurid Details of Harassment on Set—and Why It Cost Her a Job," *Hollywood Reporter,* October 17, 2017, https://www.hollywoodreporter.com/news/general -news/comedy-writer-reveals-lurid-details-harassment-set-why-it-cost-her -a-job-guest-column-1049647/; Janis Hirsch, "I Worked for Garry Shandling, and Judd Apatow's Doc Shows a Man I Never Knew," *Hollywood Reporter,* March 26, 2018, https://www.hollywoodreporter.com/news/general-news/i -worked-garry-shandling-judd-apatow-s-doc-shows-a-man-i-never-knew -guest-column-1097157.

13 *"My whole life, I've felt like I could walk"*: Andrew Goldman, "This Is the Man Who'll Lead the Revolution?," *Esquire Classic,* October 1, 2004, https://classic .esquire.com/article/2004/10/1/this-is-the-man-wholl-lead-the-revolution.

14 *"Bernie [Brillstein] was a great, old-time Hollywood character"*: Kevin Reilly, in discussion with the author, August 5, 2021.

14 *Walk softly:* Ibid.

14 *"Never invite your artists to your house"*: Tad Friend, "The Eighteen-Year Itch," *New Yorker,* April 6, 1998, https://www.newyorker.com/magazine/1998/04 /13/the-eighteen-year-itch.

14 *"Before anyone could have a glass"*: Felix Gillette and John Koblin, *It's Not TV: The Spectacular Rise, Revolution, and Future of HBO* (New York: Viking, 2022), 111.

15 *"I start giving Ross my spiel"*: Michael Fuchs, in discussion with the author, November 29, 2011.

16 *"They were pissing all over us"*: Nina Munk, *Fools Rush In: Steve Case, Jerry Levin, and the Unmaking of AOL Time Warner* (New York: Harper Business, 2004), chap. 2, iBooks.

16 *"Nick had really lost his way"*: Michael Fuchs, in discussion with the author, November 29, 2011.

16 *"I felt that I was the attack dog Jew"*: Ibid.

16 *"[Jerry] called the board members"*: Ibid.

17 *"He was an arrogant and vindictive bully"*: Sallie Hofmeister and Chuck Philips, "Fuchs' Fall Is as Dramatic as His Rise Was Meteoric," *Los Angeles Times,* November 17, 1995, https://www.latimes.com/archives/la-xpm-1995 -11-17-mn-4093-story.html.

17 *"Jerry was like Stalin"*: Michael Fuchs, in discussion with the author, October 12, 2021.

17 *"I think that stayed in my head"*: Michael Fuchs, in discussion with the author, November 29, 2011.

17 *"Every man who was his boss"*: Bridget Potter, in discussion with the author, March 2, 2022.

17 *"HBO was an insurgency"*: Michael Fuchs, in discussion with the author, November 29, 2011.

18 *"My mistake back then was that I thought"*: Michael Fuchs, in discussion with the author, May 9, 2022.

18 *"Jeff was never an entertainment guy"*: Michael Fuchs, in discussion with the author, May 8, 2022.

18 *"HBO may have been on a mission to change television"*: Jeff Bewkes, in discussion with the author, December 20, 2006.

18 *"Chris was the right guy"*: Bridget Potter, in discussion with the author, December 16, 2010.

19 *"Both the actual riot"*: Tom Fontana, in discussion with the author, July 25, 2017.

19 *Working for the networks:* Lori Reese, "How *Oz* Hopes to Survive *Survivor*," *Entertainment Weekly*, July 11, 2000, https://ew.com/article/2000/07/11/how-oz-hopes-survive-survivor.

19 *"I was told that audiences wanted"*: John M. Higgins and Donna Petrozello, "HBO: Reaching for the Stars," *Broadcasting & Cable*, March 23, 1998.

19 *"I tried various ways"*: Tom Fontana, in discussion with the author, July 25, 2017.

19 *"They had approved all our script outlines"*: Ibid.

20 *"Get your ass out to California"*: Ibid.

20 *"I was worried about Tom"*: Bridget Potter, in discussion with the author, January 11, 2011.

20 *"I never wrote anything down"*: Tom Fontana, in discussion with the author, July 25, 2017.

21 *"One of the things that Chris"*: Ibid.

21 *"I didn't have to jack everything up"*: Ibid.

21 *"The things I'm getting away with"*: Ibid.

21 *"Oz showed what was possible"*: Chris Albrecht, in discussion with the author, December 13, 2006.

22 *"Tom and Barry Levinson were a little like Lewis and Clark"*: Ethan Alter, "Return to *Oz*: An Oral History of the Pioneering Prison Drama," *Yahoo! Entertainment*, July 12, 2017, https://www.yahoo.com/entertainment/hbo-oz-20th-anniversary-oral-history-153416770.html.

22 *"The kind of risks that are being taken now"*: Tom Fontana, in discussion with the author, July 25, 2017.

22 *"When I went to talk to Chris Albrecht"*: Stacy Lambe, *"Sex and the City* Creator Darren Star on Why the 'Up the Butt' Scene Changed the Game," *ET*, March 5, 2015, https://www.etonline.com/tv/160691_sex_and_the_city_creator_darren_star_up_the_butt_scene.

22 *"So many of the comedies out there"*: "Darren Star: Television Academy Interviews," interviewed by Adrienne Faillace, Television Academy Foundation: The Interviews, October 6, 2015, video, https://interviews.televisionacademy.com/interviews/darren-star.

23 *where Charlotte (Kristin Davis) was dating a guy:* Julie Miller, "Secrets from *Sex and the City*'s Bawdy, Outrageous Writers' Room," *Vanity Fair*, June 6, 2018, https://www.vanityfair.com/hollywood/2018/06/sex-and-the-city-20th-anniversary-writers-room-stories.

23 *"his golden retriever [is] going"*: Star, Derren Interview, Television Academy Foundation, interview by Adrienne Faillace, timestamped 8:05/51:20.

24 *"I had to spread my legs in a set of stirrups"*: Heather Kristin, "My Time Working On *Sex and the City* Drove Me to Leave the Industry. Here's Why," *HuffPost*, March 23, 2021, https://www.huffpost.com/entry/satc-actor-me-too-harassment_n_6054becbc5b6d6c2a2a6c168.

24 *Kristin also alluded to an "alpha male actor":* Jackie Strause, *"Sex and the City* Stand-In Alleges Chris Noth's On-Set Behavior Was 'Toxic,'" *Hollywood Reporter,* December 23, 2021, https://www.hollywoodreporter.com/tv/tv-news /sex-and-the-city-stand-in-essay-chris-noth-1235066894/.

24 *"slobbering all over me":* Elizabeth Wagmeister, "Chris Noth Accused of Sexual Assault by a Fifth Woman," *Variety,* December 23, 2021, https://variety .com/2021/tv/news/chris-noth-sexual-assault-allegations-gloria-allred-sex -and-the-city-beverly-johnson-1235142754.

24 *"punched [her] in the chest and ribs":* Emily Selleck, Marjorie Hernandez, and Lindsey Kupfer, "Chris Noth's Ex Beverly Johnson Once Claimed He Threatened to 'Kill' Her," *Page Six,* December 21, 2021, https://pagesix.com/2021/12 /21/chris-noths-ex-beverly-johnson-once-claimed-he-threatened-to-kill-her.

24 *An account in the* Hollywood Reporter*:* Kim Masters, "Chris Noth Accused of Sexual Assault by Two Women," *Hollywood Reporter,* December 16, 2021, https://www.hollywoodreporter.com/feature/chris-noth-accused-of-sexual -assault-1235063596.

24 *Noth denied all the allegations:* Emily Selleck, Marjorie Hernandez, and Lindsey Kupfer, "Chris Noth's Ex Beverly Johnson Once Claimed He Threatened to 'Kill' Her," *Page Six,* December 21, 2021, https://pagesix.com/2021/12/21 /chris-noths-ex-beverly-johnson-once-claimed-he-threatened-to-kill-her.

24 *"sharp, iconoclastic television":* Emily Nussbaum, "Difficult Women," *New Yorker,* July 22, 2013, https://www.newyorker.com/magazine/2013/07/29 /difficult-women.

25 *One feminist wrote:* Tanya Gold, "Sorry Sisters, But I Hate *Sex and the City,"* *Telegraph,* May 21, 2010, https://www.telegraph.co.uk/culture/film/7746119 /Sorry-sisters-but-I-hate-Sex-and-the-City.html.

25 *It "taught us that no flower is too big":* EW Staff, "100 Greatest Movies, TV Shows, and More," *Entertainment Weekly,* December 4, 2009, https://ew.com /article/2009/12/04/100-greatest-movies-tv-shows-and-more.

Chapter 2: "Be a Good Catholic for 15 Fucking Minutes"

26 *In the accompanying letter:* Caryn James, "Critic's Notebook; *The Sopranos*: Brutally Honest," *New York Times,* May 22, 2001, https://www.nytimes.com /2001/05/22/arts/critic-s-notebook-the-sopranos-brutally-honest.html.

26 *"It was an attack":* David Chase, in discussion with the author, 2006.

26 *"I thought about calling [Wright]":* Jeff Bewkes, in discussion with the author, December 20, 2006.

27 *"It made me happy":* David Chase, in discussion with the author, 2006.

27 *"There are things in* The Sopranos*":* Michael Imperioli and Steve Schirripa with Philip Lerman, *Woke Up This Morning* (New York: William Morrow, 2021), chap. 13, iBooks.

28 *"David's reputation inside the TV industry":* Larry Konner, in discussion with the author, December 20, 2006.

28 *"I felt I was out of step":* David Chase, in discussion with the author, 2006.

28 *"David was embedded in the belly of the beast":* Allen Coulter, in discussion with the author, February 22, 2019.

29 *"I didn't really watch much television":* David Chase, in discussion with the author, 2006.

29 *"You know, we believe you have a great television series":* Ibid.

29 *"Network dramas have not been personal":* Ibid.

30 *An only child, he had a lot of "issues":* Ibid.

30 *"belittled David":* Denise Kelly, in discussion with the author, January 16, 2007.

30 *"a nervous woman who dominated"*: David Chase, in discussion with the author, 2006.

30 *"She is his emotional rock"*: Larry Konner, in discussion with the author, December 20, 2006.

30 *"It's not that she is Rebecca of Sunnybrook Farm"*: Emma Brockes, "David Chase on Why He Wrote *The Sopranos*: 'I Needed Help. I Needed Therapy,'" *Guardian*, September 16, 2019, https://www.theguardian.com/tv-and-radio/2019/sep/16/david-chase-the-sopranos-best-tv-21st-century.

30 *"When Denise's younger sister died"*: Ibid.

31 *"Instead of focusing on Denise"*: David Chase, in discussion with the author, 2006.

31 *"I slept eighteen hours a day"*: Ibid.

31 *"'Who's the old guy that's writing this script'"*: Kevin Reilly, in discussion with the author, July 28, 2021.

31 *"On network, everybody says exactly"*: David Chase, in discussion with the author, 2006.

31 *"talked about cancer, cancer, cancer"*: Ibid.

32 *"Because of* The Larry Sanders Show": Confidential source, in discussion with the author.

32 *"to see if we could put the bad guy"*: Bob Greenblatt, in discussion with the author, June 22, 2020.

32 *"has an unerring system for detecting"*: David Chase, in discussion with the author, 2006.

32 *"I said to myself, This show is about a guy"*: Chris Albrecht, in discussion with the author, December 13, 2006.

33 *"But," he says, "I knew I could do it"*: James Gandolfini, in discussion with the author, January 5, 2007.

33 *"What happens every time is that people come in and read"*: David Chase, in discussion with the author, January 16, 2007.

33 *"where doing TV was a no-no"*: Edie Falco, in discussion with the author, January 13, 2006.

33 *"I'm not a Hollywood guy"*: Steven Van Zandt, in discussion with the author, November 29, 2006.

34 *"It wasn't four pretty women in Manhattan"*: Brett Martin, *Difficult Men* (New York: Penguin Press, 2013), 68.

34 *"Chris had his head in his hands"*: Kevin Reilly, in discussion with the author, August 5, 2021.

34 *"Oz was different"*: Chris Albrecht, in discussion with the author, December 13, 2006.

34 *"For us, it was a real stretch"*: Jeff Bewkes, in discussion with the author, December 20, 2006.

35 *"It was, If we're gonna get into the series business"*: Chris Albrecht, in discussion with the author, December 13, 2006.

35 *"I saw this sourpuss coming towards me"*: Robin Green, in discussion with the author, December 19, 2006.

35 *"Party of Five didn't care if we left"*: Robin Green, in discussion with the author, December 18, 2006.

35 *"They were real humans"*: Ibid.

36 *"She sat there stone-faced"*: Allen Coulter, in discussion with the author, August 17, 2019.

36 *"'Uh-huh, uh-huh, uh-huh'"*: Confidential source, in discussion with the author.

36 *"People would get very anxious"*: Carolyn Strauss, in discussion with the author, February 1, 2022.

36 *"She didn't like meeting new people"*: Confidential source, in discussion with the author.

36 *"The percentage of shows that make it from pitch to screen"*: Carolyn Strauss, in discussion with the author, February 1, 2022.

36 *"She was one of the smartest people in the building"*: Confidential source, in discussion with the author.

36 *"Carolyn would go"*: Kevin Reilly, in discussion with the author, August 5, 2021.

37 *"We were thinking, Oh, here's another television writer"*: Bob Greenblatt, in discussion with the author, June 22, 2021.

37 *"I had just discovered* The Sopranos*"*: Jennifer Wood, "'Six Feet Under': The Oral History of HBO's Beloved Landmark Series," *Rolling Stone*, August 20, 2015, https://www.rollingstone.com/feature/six-feet-under-hbo-oral-history -160927.

37 *"She said, 'Could you just make it just a little more fucked-up?'"*: *"Six Feet Under*: In Memoriam," directed by Jesse Gordon, *Six Feet Under: The Complete Series* (2005; United States: HBO Home Video), DVD.

37 *"The version of Carolyn that we got"*: Bob Greenblatt, in discussion with the author, June 22, 2021.

38 *"everybody felt like they had to give notes"*: Thomas Fahy, *Alan Ball: Conversations* (Jackson, MS: University Press of Mississippi, 2013), 49.

38 *"HBO was just completely open to this"*: Bob Greenblatt, in discussion with the author, June 22, 2020.

38 *"There was a lot of my own story in* Six Feet Under*"*: Alan Ball, in discussion with the author, August 21, 2011.

38 *"Oh, God has dealt me some blows"*: Sharon Waxman, "Alan Ball's Life After Death," *Washington Post*, May 26, 2002, https://www.washingtonpost.com /archive/lifestyle/style/2002/05/26/alan-balls-life-after-death/47492a0b -169b-4e13-8663-6d8747fc6a20/.

38 *"I had written a comedic piece"*: Joey Soloway, in discussion with the author, October 28, 2020.

39 *"'Can I direct an episode?'"*: Ibid.

39 *"Nobody had ever paid attention to us before"*: Chris Albrecht, in discussion with the author, December 13, 2006.

39 *"David was a guy who, for twenty-five years"*: Larry Konner, in discussion with the author, December 20, 2006.

40 *"'You're equating* Six Feet Under*'"*: Robin Green, in discussion with the author.

40 *"I walked in, there was a stampede"*: James Gandolfini, in discussion with the author, January 15, 2007.

40 *"We were like the Beatles"*: Ilene Landress, in discussion with the author, December 26, 2006.

40 *"I was living in the meat market district"*: James Gandolfini, in discussion with the author, January 5, 2007.

40 *"When you threw that steak at Tony"*: Annabella Sciorra, in discussion with the author, January 13, 2007.

40 *"I was getting stopped on Fifth Avenue"*: Joey Pantoliano, in discussion with the author, January 1, 2007.

40 *"less yakking, more whacking"*: Matt Zoller Seitz and Alan Sepinwall, *The Sopranos Sessions* (New York: Abrams Press, 2019), ebook, 1,129.

41 *"You know, you've created one of the best characters"*: David Chase, in discussion with the author, 2006.

41 *"I've got a picture of William Holden"*: Graham Yost, in discussion with the author, September 9, 2020.

42 *"Matt Groening said to me"*: Robin Green, in discussion with the author, December 18, 2006.

42 *"Materialism and capitalism and the failure of America"*: James Gandolfini, in discussion with the author, January 5, 2007.

42 *"The assumption in broadcast"*: David Nevins, in discussion with the author, August 9, 2021.

43 *"In one scene, he had nothing more to do"*: Allen Coulter, in discussion with the author, February 22, 2019.

43 *"What's the difference if I call him"*: Terry Winter, in discussion with the author, November 14, 2006.

43 *The actors formed a close-knit group:* Michael Imperioli and Steve Schirripa with Philip Lerman, *Woke Up This Morning* (New York: William Morrow, 2021), 45.

43 *Among the new subscribers the show attracted:* Ibid., 287.

44 *"got a phone call, and came back"*: Allen Coulter, in discussion with the author, February 22, 2019.

44 *As Chase puts it, "He didn't like"*: Michael Imperioli and Steve Schirripa with Philip Lerman, *Woke Up This Morning* (New York: William Morrow, 2021), 111.

44 *"Unlike some actors who are just plain aggressive"*: Allen Coulter, in discussion with the author, February 22, 2019.

45 *"perhaps the only storytelling on television"*: Margaret Talbot, "Stealing Life," *New Yorker*, October 14, 2007, https://www.newyorker.com/magazine/2007/10/22/stealing-life.

46 *"So much of what comes out of Hollywood"*: Ibid.

46 *"brilliant, brilliant writer"*: Dan Attias, in discussion with the author, June 24, 2022.

47 *"I'm a character actor"*: Joel Murphy, "One on One with Michael K. Williams," *HoboTrashcan*, August 23, 2005, https://www.hobotrashcan.com/2005/08/23/one-on-one-with-michael-k-williams.

47 *"I went into* The Wire *like any newly budding actor"*: Aisha Harris, "The 20 Best TV Dramas Since *The Sopranos*," *New York Times*, January 10, 2019, https://www.nytimes.com/interactive/2019/arts/television/best-drama-series.html.

47 *"I have these same tendencies as he does"*: David Chase, in discussion with the author, 2006.

47 *"We're not allowed to have a temper anymore?"*: James Gandolfini, in discussion with the author, January 5, 2007.

48 *"What was driving the show"*: Larry Konner, in discussion with the author, December 20, 2006.

48 *"He has a flame of anger"*: Allen Coulter, in discussion with the author August 17, 2019.

48 *"If he finds your Achilles' heel"*: Tim Van Patten, in discussion with the author, January 7, 2007.

48 *"I'm not running a writing school"*: Terry Winter, in discussion with the author November 14, 2006.

48 *"Every time David said something"*: Robin Green, in discussion with the author, December 19, 2006.

49 *"Until I saw* Taxi Driver*, I was a fan"*: Terry Winter, in discussion with the author, May 20, 2022.

49 *"I don't think I hung any pictures"*: Ibid.

49 *"Don't fuck with the boss"*: Robin Green, in discussion with the author, December 19, 2006.

49 *"We do not accept the use of the word":* Todd A. Kessler, in discussion with the author, July 13, 2022.

49 *"I could learn a lot from David":* Ibid.

50 *"It was time to end our relationship":* Ibid.

50 *"I just burst into tears":* Ibid.

50 *"He guarded the keys to the kingdom assiduously":* Allen Coulter, in discussion with the author, February 22, 2019.

50 *"Once in the third year":* Terry Winter, in discussion with the author, November 14, 2006.

51 *"He told us about fucking those girls":* Robin Green, in discussion with the author, January 18, 2006.

51 *"There was one episode where Tony needed to get something":* Mitch Burgess, in discussion with the author, December 19, 2006.

51 *"David is a person with a lot of rules":* Confidential source, in discussion with the author.

51 *"Nobody forgets where they buried":* Robin Green, *The Only Girl* (New York: Little, Brown, 2018), 251.

Chapter 3: Deadwood and Its Discontents

52 *According to* The Hollywood Reporter: Stephen Galloway and Scott Johnson, "How the $100 Million *NYPD Blue* Creator Gambled Away His Fortune," *Daily News*, February 17, 2016, https://www.nydailynews.com/entertainment/gossip/nypd-blue-creator-gambled-fortune-article-1.2535250.

53 *"We are all literally part of the mind of God":* Mark Singer, "The Misfit," *New Yorker*, February 6, 2005, https://www.newyorker.com/magazine/2005/02/14/the-misfit-2.

53 *"Quite honestly, I don't think I understand":* Jeffrey MacIntyre, "The Professor and the Madman," *Slate*, August 31, 2016, https://slate.com/culture/2006/08/the-genius-behind-hbo-s-deadwood.html.

53 *"David Genius":* Carolyn Strauss, in discussion with the author, January 21, 2022.

53 *"impersonating a human being":* Mark Singer, "The Misfit," *New Yorker*, February 6, 2005, https://www.newyorker.com/magazine/2005/02/14/the-misfit-2.

53 *"At least one time I pissed":* David Milch, *Life's Work: A Memoir* (New York: Random House, 2022), 61.

53 *"he would never expect me to act":* Ibid., 66.

53 *"The guys at the network loved":* Robin Green, in discussion with the author, September 17, 2019.

53 *"That's terrific, but we got one":* "David Milch Interview," interviewed by Stephen J. Abramson, Television Academy Foundation: The Interviews, December 27, 2012, video, https://interviews.televisionacademy.com/interviews/david-milch.

54 *"Don't go anywhere":* Ibid.

54 *"a degenerate gambler":* Lance Pugmire, "Q&A: David Milch on Horse Racing and Iconic TV Series," *Los Angeles Times*, December 25, 2011, https://www.latimes.com/sports/la-xpm-2011-dec-25-la-sp-pugmire-qa-20111226-story.html.

54 *"Success breeds fear as much as failure":* Tom Fontana, in discussion with the author, July 25, 2017.

54 *"I am very lucky that I have had any kind":* David Milch, *Life's Work: A Memoir* (New York: Random House, 2022), 215.

55 *"criminal enterprise":* Ibid., 156.

55 *"how people improvised the structures"*: Mark Singer, "The Misfit," *New Yorker*, February 6, 2005, https://www.newyorker.com/magazine/2005/02/14/the -misfit-2.

55 *"so soaked with obscenity"*: David Milch, *Life's Work: A Memoir* (New York: Random House, 2022), 163.

56 *"I wanted to show"*: Ibid.

56 *"Put one fuck in the wrong place"*: Stephen Phelan, "Put a 'Fuck' in the Wrong Place . . . ," first published in *The Sunday Herald*, July 2005, Stephen Phelan (website), https://www.stephenphelan.co.uk/articles/mcshanedeadwood.

56 *"You would read something"*: Terry Gross, "Revisiting *Deadwood* with Star Timothy Olyphant and Creator David Milch," NPR, May 31, 2019, in *Fresh Air*, podcast, https://www.npr.org/2019/05/31/728624943/revisiting-deadwood -with-star-timothy-olyphant-and-creator-david-milch.

56 *"The first time I saw Ian giving a speech"*: Paula Malcomson, in discussion with the author, July 31, 2020.

57 *"Of course, you couldn't say that now"*: Ian McShane, in discussion with the author, July 31, 2020.

57 *"Maybe some other actors might"*: Paula Malcomson, in discussion with the author, July 31, 2020.

57 *"You couldn't keep killing people"*: Ian McShane, in discussion with the author, July 31, 2020.

58 *"The thing about Al"*: Brian Cox, in discussion with the author, June 24, 2020.

58 *"So even against his will"*: "David Milch Interview," interviewed by Stephen J. Abramson, Television Academy Foundation: The Interviews, December 27, 2012, video, https://interviews.televisionacademy.com/interviews/david-milch.

58 *"venture capitalist catnip"*: Marc Randolph, *That Will Never Work* (New York: Little, Brown, 2019), 158.

58 *"I really loved software"*: Ken Auletta, "Outside the Box," *New Yorker*, January 26, 2014, https://www.newyorker.com/magazine/2014/02/03/outside-the-box-2.

59 *the mind of a "supercomputer"*: Marc Randolph, *That Will Never Work* (New York: Little, Brown, 2019), 6.

59 *"unencumbered by emotion"*: Shalini Ramachandran and Joe Flint, "At Netflix, Radical Transparency and Blunt Firings Unsettle the Ranks," *Wall Street Journal*, October 25, 2018, https://www.wsj.com/articles/at-netflix-radical -transparency-and-blunt-firings-unsettle-the-ranks-1540497174.

59 *"Videotapes," and Hastings responded*: Marc Randolph, *That Will Never Work* (New York: Little, Brown, 2019), chap. 2, iBooks.

60 *"Our hard drive knows"*: Ibid., chap. 9.

60 *"It's like a taxi"*: Ibid.

60 *a "shit sandwich"*: Ibid., chap. 12.

60 *"What the fuck, Reed"*: Ibid.

61 *think of a "turtle"*: Ibid., chap. 10.

61 *"lie on the floor"*: Kim Masters, "Michael Mann, David Milch Split Duties to Settle Power Struggle on HBO's *Luck*," *Hollywood Reporter*, April 21, 2011, https://www.hollywoodreporter.com/news/general-news/michael-mann -david-milch-split-181092.

62 *"I can't stress enough"*: Paula Malcomson, in discussion with the author, July 31, 2020.

62 *"They were poetic and profane"*: Robin Weigert, in discussion with the author, July 19, 2020.

62 *"He allowed us to have co-authorship"*: Paula Malcomson, in discussion with the author, July 31, 2020.

62 *"David was the only showrunner"*: Ian McShane, in discussion with the author, July 31, 2020.

62 *"I always felt like I was about five"*: Brian Cox, in discussion with the author, June 24, 2020.

62 *"Good dialogue ain't difficult"*: Matt Zoller Seitz, "Ian McShane Says Good-bye to *Deadwood*," *Vulture*, May 24, 2019, https://www.vulture.com/2019/05/ian -mcshane-deadwood-the-movie-al-swearengen.html.

62 *"Every Friday—'Good Luck Fridays'"*: Ian McShane, in discussion with the author, July 31, 2020.

63 *"He's paid for people's kids' college"*: Robin Weigert, in discussion with the author, July 16, 2020.

63 *"was very clever about how he extended"*: Brian Cox, in discussion with the author, June 24, 2020.

63 *"Deadwood was the single greatest experience"*: Will Harris, "Jim Beaver on *Supernatural*, David Milch, and How Going to Vietnam Was a Great Career Move," *AV Club*, December 4, 2017, https://www.avclub.com/jim-beaver-on -supernatural-david-milch-and-how-going-1820151940.

63 *"David Milch was known as a lunatic"*: Allen Coulter, in discussion with the author, February 22, 2019.

63 *"Working with David Milch"*: Kara Howland, "Director Adam Davidson Talks David Milch and *Deadwood*," *TV Goodness*, September 3, 2015, https://www .tvgoodness.com/2015/09/03/director-adam-davidson-talks-david-milch -and-deadwood-exclusive.

64 *"Didn't I hear somebody can juggle?"*: Ibid.

64 *"I think the pages were blank because"*: Brian Cox, in discussion with the author, June 24, 2020.

64 *"addictive as* The Sopranos*"*: Alessandra Stanley, "In a Cramped, Claustropho-bic Wild West," *New York Times*, March 4, 2005, https://www.nytimes.com /2005/03/04/arts/television/in-a-cramped-claustrophobic-wild-west.html.

65 *"There are so many good actors"*: Tom Shales, *"Deadwood*: Still Shooting from the Hip," *Washington Post*, March 5, 2005, https://www.washingtonpost .com/archive/lifestyle/2005/03/05/deadwood-still-shooting-from-the-hip /7111cb73-8ae2-4fae-bfdf-dd5293a23e9e.

65 *"Normally a 22-episode season"*: Will Harris, "Jim Beaver on *Supernatural*, David Milch, and How Going to Vietnam Was a Great Career Move," *AV Club*, December 4, 2017, https://www.avclub.com/jim-beaver-on-supernatural -david-milch-and-how-going-1820151940.

65 *"It was, 'See you next year, whatever'"*: Nick Schager, *"Deadwood* Star Ian McShane on the Lost Art of Calling Someone a 'Cocksucker,'" *Daily Beast*, May 28, 2019, https://www.thedailybeast.com/deadwood-the-movie-star-ian -mcshane-on-the-lost-art-of-calling-someone-a-cocksucker.

66 *"a Jewish pissing contest"*: Brian Cox, in discussion with the author, June 24, 2020.

66 *"That was one of the saddest days"*: David Milch, *Life's Work: A Memoir* (New York: Random House, 2022), 184.

66 *"Nothing," says McShane*: Lesley M. M. Blume, "The Glorious Tragedy of *Deadwood*," *WSJ Magazine*, May 31, 2019, https://www.wsj.com/articles /deadwood-roundtable-cast-11559313669.

66 *"I definitely felt out to sea"*: Robin Weigert, in discussion with the author, July 19, 2020.

66 *"Deadwood was lightning in a bottle"*: Paula Malcomson, in discussion with the author, July 31, 2020.

67 *"Yes, David had an expensive process"*: Carolyn Strauss, in discussion with the author, January 21, 2022.

67 *"HBO would say, 'If you want to do it with us'"*: Bob Greenblatt, in discussion with the author, June 22, 2021.

67 *"We had no back end on the show"*: Carolyn Strauss, in discussion with the author, January 21, 2022.

67 *"an echo of a poem by Stanley Kunitz"*: Rob Harvilla, "Revisiting the Strange, Occasionally Sublime *John from Cincinnati*,'" *Ringer*, August 29, 2018, https://www.theringer.com/tv/2018/8/29/17795462/revisiting-john-from-cincinnati.

68 *"if God were trying to reach out"*: Nancy Franklin, "Dead in the Water," *New Yorker*, June 18, 2007, https://www.newyorker.com/magazine/2007/06/25/dead-in-the-water-2.

68 *"The answer is no"*: Rob Harvilla, "Revisiting the Strange, Occasionally Sublime *John from Cincinnati*,'" *Ringer*, August 29, 2018, https://www.theringer.com/tv/2018/8/29/17795462/revisiting-john-from-cincinnati.

68 *"It became much more mobby"*: Mitch Burgess, in discussion with the author, January 18, 2006.

69 *"As David became more secure"*: Robin Green, in discussion with the author, September 9, 2019.

69 *"The more he got successful"*: Mitch Burgess, in discussion with the author, September 19, 2019.

69 *"Once he was anointed a genius"*: Allen Coulter, in discussion with the author, November 26, 2006.

69 *"The day you take your first tennis lesson"*: Billy Friedkin, in discussion with the author, April 19, 1996.

69 *"I don't play tennis"*: David Chase, in discussion with the author, July 29, 2017.

69 *"he doesn't play golf"*: Larry Konner, in discussion with the author, July 24, 2017.

69 *"He's not moody"*: Steven Van Zandt, in discussion with the author, November 29, 2006.

69 *"But you can't direct"*: Allen Coulter, in discussion with the author, February 22, 2019.

69 *"I would think, Go fuck yourself"*: Ibid.

70 *"It was so respected"*: Jeff Bewkes, in discussion with the author, December 20, 2006.

70 "The Sopranos *was the hammer"*: Chris Albrecht, in discussion with the author, December 13, 2006.

70 *"There's a point at which creative"*: David Chase, in discussion with the author, 2006.

71 *"David stoked the tension"*: Mitch Burgess, in discussion with the author, September 19, 2019.

71 *"Matt was so far up David's"*: Robin Green, in discussion with the author, December 18, 2006.

71 *"He was initially extremely"*: Terry Winter, in discussion with the author, May 20, 2022.

71 *"I'd be like, 'You don't like that?'"*: Brett Martin, *Difficult Men* (New York: Penguin Press, 2013), 244.

71 *"would say 'No' to me about 300 times"*: Joy Press, "Matthew Weiner in the Mirror," *Vanity Fair*, September 30, 2018, https://www.vanityfair.com/hollywood/2018/09/matthew-weiner-romanoffs-in-the-mirror.

71 *"He didn't take his ideas"*: Mitch Burgess, in discussion with the author, September 19, 2019.

72 *"If I had had any integrity"*: Robin Green, in discussion with the author, September 17, 2019.

72 *"hate-rays"*: Robin Green, *The Only Girl* (New York: Little, Brown, 2018), 214.

72 *"We never got the voice"*: Robin Green, in discussion with the author, September 17, 2019.

72 *"After six seasons"*: Todd A. Kessler, in discussion with the author, July 13, 2022.

72 *"'Cause really," she says:* Robin Green, in discussion with the author, September 17, 2019.

73 *"I didn't want to punctuate"*: Matt Zoller Seitz and Alan Sepinwall, *The Sopranos Sessions* (New York: Abrams Press, 2019), 339.

74 *"They wanted to see him go face-down"*: Scott Feinberg, "*Sopranos* Creator David Chase Finally Reveals What Happened to Tony," *Hollywood Reporter*, November 2, 2021, https://www.hollywoodreporter.com/feature/the-sopranos-david-chase-tony-ending-the-many-saints-of-newark-1235040185.

74 *"We didn't want to make"*: Terry Winter, in discussion with the author, November 14, 2006.

74 *"People went, 'What's next?'"*: Chris Albrecht, in discussion with the author, December 13, 2006.

Chapter 4: HBO's Annus Horribilis

75 *"had pissed [him] off"*: Amy Wallace, "Violence, Nudity, Adult Content: The Story of Chris Albrecht," *GQ*, November 5, 2010, https://www.gq.com/story/chris-albrecht-profile-2010.

76 *"The idea came up that I would say"*: Ibid.

76 *"Jeff [Bewkes] said to me that"*: Lindsay Powers, "Chris Albrecht Blames 2007 Arrest on 'Difficult Relationships with Women'–Not Alcoholism," *Hollywood Reporter*, October 21, 2010, https://www.hollywoodreporter.com/tv/tv-news/chris-albrecht-blames-2007-arrest-31815/.

76 *"ticking time bomb"*: Andrew Wallenstein, "HBO's CEO Steps Down," *Adweek*, May 10, 2007, https://www.adweek.com/brand-marketing/hbos-ceo-steps-down-88935.

76 *"It didn't occur to me"*: Lindsay Powers, "Chris Albrecht Blames 2007 Arrest on 'Difficult Relationships with Women'–Not Alcoholism," *Hollywood Reporter*, October 21, 2010, https://www.hollywoodreporter.com/tv/tv-news/chris-albrecht-blames-2007-arrest-31815.

76 *"In an apparent fit of jealous rage"*: Quoted in Matthew Belloni, "Chris Albrecht's Past Is Prologue," *Puck*, October 13, 2022, https://puck.news/chris-albrechts-past-is-prologue.

76 *"false, inflammatory"*: Ibid.

77 *"He couldn't keep it in his pants"*: Confidential source, in discussion with the author.

77 *"He has been protected"*: Michael Fuchs, in discussion with the author, December 8, 2022.

77 *"Violence against anybody"*: Lindsay Powers, "Chris Albrecht Blames 2007 Arrest on 'Difficult Relationships with Women'–Not Alcoholism," *Hollywood Reporter*, October 21, 2010, https://www.hollywoodreporter.com/tv/tv-news/chris-albrecht-blames-2007-arrest-31815/.

77 *"pissy little dolts"*: Amy Wallace, "Violence, Nudity, Adult Content: The Story of Chris Albrecht," *GQ*, November 5, 2010, https://www.gq.com/story/chris-albrecht-profile-2010.

78 *"If there was a showrunner on* Band of Brothers*"*: Confidential source, in discussion with the author.

78 *"The first cuts were coming in"*: Kary Antholis, in discussion with the author, September 25, 2020.

79 *"finally tumbled from its pedestal"*: Bill Carter, "HBO's Rivals Say It Has Stumbled, Though Catching Up Is Tough," *New York Times*, August 23, 2007, https://www.nytimes.com/2007/08/23/arts/23hbo.html.

80 *"Jeff didn't know the industry"*: Michael Fuchs, in discussion with the author, May 8, 2022.

80 *"Richard was creative adjacent"*: Glenn Whitehead, in discussion with the author, January 28, 2022.

80 *"While he excelled at guarding"*: Confidential source, in discussion with the author.

80 *"Nobody enjoyed being Richard"*: Confidential source, in discussion with the author.

81 *"He did it to me"*: Michael Fuchs, in discussion with the author, May 9, 2022.

81 *"He became consigliere"*: Confidential source, in discussion with the author.

81 *"When Fuchs blew himself up"*: Ibid.

81 *"'I'm young in my career"*: Ibid.

81 *"Michael Fuchs brought me to HBO"*: Richard Plepler, in discussion with the author, February 16, 2023.

82 *"If he doesn't get this"*: Ibid.

82 *"With Mike, Richard was gracious"*: Quentin Schaffer, in discussion with the author, January 7, 2022.

82 *"Mike refused to be the head of programming operations"*: Glenn Whitehead, in discussion with the author, January 28, 2022.

82 *"Wanting to be a nice guy"*: Confidential source, in discussion with the author.

82 *"Whether intentional or not"*: Quentin Schaffer, in discussion with the author, May 24, 2022.

82 *"He would leave people crying"*: Confidential source, in discussion with the author.

82 *"Mike is in many respects"*: Glenn Whitehead, in discussion with the author, January 28, 2022.

83 *"I really loved working for Mike"*: David Levine, in discussion with the author, March 7, 2021.

83 *"it didn't feel like 'HBO important'"*: Felix Gillette and John Koblin, *It's Not TV: The Spectacular Rise, Revolution, and Future of HBO* (New York: Viking, 2022), 220.

84 *"[When] I hit puberty"*: Elvis Mitchell, "David Benioff and D. B. Weiss: *Game of Thrones*," May 8, 2013, in *The Treatment*, podcast, KCRW, https://www.kcrw .com/culture/shows/the-treatment/david-benioff-and-d-b-weiss-game-of -thrones/david-benioff-and-d-b-weiss-game-of-thrones.

84 *"You have got to buy this book"*: David Benioff, in discussion with the author, March 6, 2014.

84 *"The Sopranos meets Middle-earth"*: Sarah Hughes, "'*Sopranos* Meets Middle-Earth': How *Game of Thrones* Took Over Our World," *Guardian*, March 22, 2014, https://www.theguardian.com/tv-and-radio/2014/mar/22/game-of -thrones-whats-not-to-love.

84 *"For us, it was a once-in-a-lifetime opportunity"*: Dan Weiss, in discussion with the author, March 5, 2014.

84 *"We had no money, we lived in the projects"*: George R. R. Martin, in discussion with the author, March 19, 2014.

85 *"reading a book and not knowing"*: Mikal Gilmore, "George R. R. Martin: The *Rolling Stone* Interview," *Rolling Stone*, April 23, 2014, https://www.rolling

stone.com/culture/culture-news/george-r-r-martin-the-rolling-stone -interview-242487.

85 *"We're only twenty minutes into the movie"*: George R. R. Martin, in discussion with the author, March 19, 2014.

85 *"What I'd like to do is write an epic fantasy"*: John Hodgman, "The Sound of Young America: George R. R. Martin, Author of a *Song of Ice and Fire* Series," September 19, 2011, in *Bullseye with Jesse Thorn*, produced by Kevin Ferguson, Jesus Ambrosio, and Richard Robey, podcast, https://maximumfun.org /episodes/bullseye-with-jesse-thorn/george-r-r-martin-author-song-ice -and-fire-series-interview-sound-young-america.

85 *"The producer came to me and said"*: George R. R. Martin, in discussion with the author, March 19, 2014.

86 *"like J. R. R. Tolkien with a lot fewer"*: Peter Sagal, "*Thrones* Author George R.R. Martin Plays Not My Job," September 14, 2012, in *Wait Wait . . . Don't Tell Me!*, podcast, 1:52, https://www.npr.org/transcripts/161142894.

86 *"We can't have these seventeen subplots"*: George R. R. Martin, in discussion with the author, March 19, 2014.

86 *"He wanted to write a series"*: David Benioff, in discussion with the author, March 6, 2014.

86 *"We don't know why he trusted"*: Sam Barsanti, "Based on This Benioff and Weiss Panel, It Must've Been Dumb Luck That *Game of Thrones* Happened at All," *AV Club*, October 27, 2019, https://www.avclub.com/based-on-this -benioff-and-weiss-panel-it-mustve-been-d-1839398581.

86 *"if HBO wasn't going to go for it"*: Dan Weiss, in discussion with the author, March 6, 2014.

87 *"It was an easy green light for us"*: Richard Plepler, in discussion with the author, July 20, 2018.

87 *"That was not an easy green light at all"*: Carolyn Strauss, in discussion with the author, January 21, 2022.

87 *"It's not a story with a million orcs"*: James Hibberd, "HBO Conjuring Fantasy Series," *Hollywood Reporter*, November 11, 2008, https://www.hollywood reporter.com/business/business-news/hbo-conjuring-fantasy-series-122782.

87 *"Every scene, you change two lines"*: Luka Nieto, "What Showrunners Benioff & Weiss Actually Said at Austin Film Festival About Writing and Producing *Game of Thrones*," *Watchers on the Wall* (blog), October 30, 2019, https:// watchersonthewall.com/benioff-weiss-reflect-decade-game-thrones-austin -film-festival.

87 *"within the first fifteen minutes"*: Richard Plepler, in discussion with the author, July 20, 2018.

87 *"a con job"*: Adam Clery, "*Game of Thrones*: 10 Shocking Revelations from Benioff & Weiss's Q&A," *WhatCulture*, October 29, 2019, https://whatculture .com/tv/game-of-thrones-10-shocking-revelations-from-benioff-weisss-q-a.

88 *"We knew that it was gonna turn"*: Luka Nieto, "What Showrunners Benioff & Weiss Actually Said at Austin Film Festival About Writing and Producing *Game of Thrones*," *Watchers on the Wall* (blog), October 30, 2019, https:// watchersonthewall.com/benioff-weiss-reflect-decade-game-thrones-austin -film-festival.

88 *"The firing of Carolyn Strauss"*: Glenn Whitehead, in discussion with the author, January 28, 2022.

88 *"This is the biggest mistake"*: Ibid.

88 *"I think that was something"*: Carolyn Strauss, in discussion with the author, January 21, 2022.

89 *"The feeling was that HBO"*: Quentin Schaffer, in discussion with the author, October 28, 2019.

89 *"We think it's time"*: Carolyn Strauss, in discussion with the author, January 21, 2022.

89 *"a self-fulfilling prophecy"*: Confidential source, in discussion with the author.

89 *"Do you want to go to work at HBO"*: Sue Naegle, in discussion with the author, January 27, 2020.

89 *"It's very different to sell"*: David Levine, in discussion with the author, March 14, 2021.

89 *"Now you've got three people"*: Confidential source, in discussion with the author.

89 *"HBO was very focused"*: David Nevins, in discussion with the author, August 9, 2021.

89 *"What people who don't have"*: Kevin Reilly, in discussion with the author, July 28, 2021.

90 *"It was the kind of show that most people"*: Kala Hoke, "Noah Baumbach Explains Why HBO Dropped 'The Corrections,'" *WNYC*, March 27, 2015, https://www.wnyc.org/story/noah-baumbach-explains-why-hbo-dropped-corrections.

90 *"like the Works Progress Administration"*: Joe Satran, "HBO's *The Corrections* Adaptation Is Dead–What Happens Now?," *HuffPost*, May 2, 2012, https://www.huffpost.com/entry/hbo-the-corrections_n_1469456.

90 *"schmuck insurance"*: Quentin Schaffer, in discussion with the author, January 7, 2022.

90 *"You can't just pick a name"*: Sue Naegle, in discussion with the author, January 27, 2020.

91 *"He was a bully"*: Confidential source, in discussion with the author.

91 *"I don't blame Sue"*: Confidential source, in discussion with the author.

91 *"They had all of these deals"*: Felix Gillette and John Koblin, *It's Not TV: The Spectacular Rise, Revolution, and Future of HBO* (New York: Viking, 2022), 284–85.

91 *"an actor like Redford"*: Mike Fleming Jr., "Taylor Sheridan on How the Harrison Ford–Helen Mirren Ratings Record Setter *1923* Came After Network's Shocking Realization the Cast of Freshly Renewed *1883* Was Dead," *Deadline*, December 20, 2022, https://deadline.com/2022/12/taylor-sheridan-harrison-ford-helen-mirren-yellowstone-spinoff-1923-bob-bakish-shock-1883-cast-killed-off-interview-1235202720.

91 *"We were under tremendous pressure"*: Richard Plepler, in discussion with the author, July 20, 2018.

92 *"And that would've cost us"*: Glenn Whitehead, in discussion with the author, May 25, 2022.

92 *"piss on Milton Friedman's grave"*: Michael Fuchs, in discussion with the author, December 8, 2022.

92 *"They're the minor leagues"*: Confidential source, in discussion with the author.

92 *"Is the Albanian army"*: Lindsay Powers, "Time Warner's Jeff Bewkes: Netflix Is No Threat to Media Companies," *Hollywood Reporter*, December 13, 2010.

93 *"dog tag around my neck"*: Ken Auletta, "Outside the Box," *New Yorker*, January 26, 2014.

93 *"They would stop for a week"*: David Levine, in discussion with the author, March 7, 2021.

93 *"It was just difficult to get shows made"*: Sue Naegle, in discussion with the author, February 25, 2021.

93 *"the right kind of girl"*: Joey Soloway, in discussion with the author, November 6, 2020.

94 *"It's not* Sex and the City*"*: Dave Itzkoff, "Cable's New Pack of Girls, Trying on the Woman Thing," *New York Times*, March 2, 2012, https://www.nytimes.com/2012/03/04/arts/television/lena-dunham-on-girls-her-new-hbo-comedy.html.

94 *"My question is not"*: Ta-Nahisi Coates, *"Girls* Through the Veil," *Atlantic*, April 20, 2012, https://www.theatlantic.com/entertainment/archive/2012/04/girls-through-the-veil/256154.

94 *"There could be more diversity"*: Nisha Gopalan, "Issa Rae on *Awkward Black Girl*, Her Shonda Rhimes Show, and Hating L.A. Guys," *Vulture*, February 28, 2013, https://www.vulture.com/2013/02/issa-rae-awkward-black-girl-interview.html.

94 *"It was a boys' club"*: Carolyn Strauss, in discussion with the author, January 21, 2022.

94 *"circular firing squad"*: Glenn Whitehead, in discussion with the author, January 28, 2022.

94 *"Lombardo and Ellenberg"*: David Levine, in discussion with the author, March 7, 2021.

94 *"It was not a pleasant"*: Confidential source, in discussion with the author.

95 *"I was always thinking,* You're not Carolyn.*"*: James Andrew Miller, *Tinderbox: HBO's Ruthless Pursuit of New Frontiers* (New York: Henry Holt, 2021), Chapter 13, iBooks.

95 *"You have to get out"*: Sue Naegle, in discussion with the author, January 28, 2021.

95 *"I think that if anybody had said"*: Confidential source, in discussion with the author.

95 *"I invented Plepler"*: Michael Fuchs, in discussion with the author, May 9, 2022.

95 *"They had their own little"*: Kevin Reilly, in discussion with the author, July 28, 2021.

95 *"See if there's a series in there"*: Terry Winter, in discussion with the author, May 20, 2022.

96 *"I don't need to read the book"*: Terry Gross, "As *Boardwalk Empire* Comes to a Close, Creator Reminisces About Its Start," NPR, September 11, 2014, in *Fresh Air*, podcast, https://www.npr.org/2014/09/11/347552966/as-boardwalk-empire-comes-to-close-creator-reminisces-on-how-it-started.

96 *"I was kind of disheartened"*: David Bianculli, "Down on the 'Boardwalk' with Terence Winter," NPR, September 28, 2010, in *Fresh Air*, podcast, https://www.npr.org/transcripts/130184684.

96 *"HBO told me"*: Terry Winter, in discussion with the author, May 20, 2022.

96 *"Prohibition was the single event"*: Jennifer M. Wood, "Terence Winter Says Goodbye to *Boardwalk Empire*," *Esquire*, September 6, 2014, https://www.esquire.com/entertainment/tv/interviews/a29836/terence-winter-boardwalk-empire-interview.

97 *"No one's ever given Marty"*: Terry Winter, in discussion with the author, May 20, 2022.

97 *"This is great"*: David Bianculli, "Down on the 'Boardwalk' with Terence Winter," NPR, September 28, 2010, in *Fresh Air*, podcast, https://www.npr.org/transcripts/130184684.

98 *"A lot of feature people"*: Kim Master, "HBO's High-Class Problems: $100M *Vinyl* Disappoints Amid *Westworld*, David Fincher Woes," *Hollywood Re-*

porter, February 24, 2016, https://www.hollywoodreporter.com/tv/tv-news/hbos-100m-vinyl-disappoints-westworld-868605.

98 *"We shot* The Wire *for scraps"*: Brian Lowry, "Terence Winter and the *Boardwalk Empire* Team on the Mob Men's Last Call," *Variety*, September 23, 2014, https://variety.com/2014/tv/news/boardwalk-empire-finale-terence-winter-1201311105.

98 *"started to buy these massive productions"*: Bob Greenblatt, in discussion with the author, July 15, 2021.

98 *"pushing the envelope"*: Terry Winter, in discussion with the author, May 20, 2022.

Chapter 5: FX Flips Off HBO

101 *"I have good news and bad news"*: Brett Martin, *Difficult Men* (New York: Penguin Press, 2013), 213.

102 *"I came from a place"*: Kevin Reilly, in discussion with the author, August 5, 2021.

103 *"We would have loved"*: David Madden, in discussion with the author, December 22, 2022.

103 *"Nash Bridges *was all rules"*: Aaron Pruner, "The Untold Truth of *The Shield*," *Looper*, January 26, 2023, https://www.looper.com/122869/untold-truth-shield; Derek Lawrence, "*The Shield*: Creator Shawn Ryan on the Possibility of a Revival," *Entertainment Weekly*, March 14, 2017, https://ew.com/tv/2017/03/14/the-shield-shawn-ryan-15th-anniversary.

103 *"My earliest memory working"*: Shawn Ryan, "Shawn Ryan on *The Shield*: We Got Away with 'Something Criminal,'" *Hollywood Reporter*, May 15, 2014, https://www.hollywoodreporter.com/news/general-news/shawn-ryan-shield-we-got-703515.

103 *"got me thinking a lot"*: Ben Marshall, "Out with a Bang," *Guardian*, February 13, 2009, https://www.theguardian.com/culture/2009/feb/12/michael-chiklis-the-shield.

103 *"He's not a television cop"*: Bernard Weinraub, "Police Show Has Humans, Not Heroes; In FX's Hit *The Shield*, Means Justify Ends," *New York Times*, April 3, 2002, https://www.nytimes.com/2002/04/03/arts/police-show-has-humans-not-heroes-in-fx-s-hit-the-shield-means-justify-ends.html.

104 *"what people want these days"*: "*The Shield*: Quotes," IMDB, accessed February 21, 2023, https://www.imdb.com/title/tt0286486/characters/nm0553468.

104 *Shawn Ryan will never get this:* Roger Cormier, "15 Incorruptible Facts About *The Shield*," *Mental Floss*, March 12, 2017, https://www.mentalfloss.com/article/74534/15-incorruptible-facts-about-shield.

104 *"I think there was an assumption"*: Derek Lawrence, "*The Shield*: Creator Shawn Ryan on the Possibility of a Revival," *Entertainment Weekly*, March 14, 2017, https://ew.com/tv/2017/03/14/the-shield-shawn-ryan-15th-anniversary.

105 *"'We don't fucking like that guy'"*: Walton Goggins, in discussion with the author, January 6, 2022.

105 *"No one knew what we could"*: Ibid.

105 *"We're gonna shove it"*: Brett Martin, *Difficult Men* (New York: Penguin Press, 2013), 221.

105 *"FX had shit advertising"*: Kevin Reilly, in discussion with the author, August 5, 2021.

105 *"Their business model"*: Alex Gansa, in discussion with the author, August 11, 2022.

106 *"Everybody was telling me"*: Robert Rorke, "Close Call," *New York Post*, July 22, 2007, https://nypost.com/2007/07/22/close-call.

106 *"I was offered* Dune*":* Dan Snierson, "What Glenn Close Is Doing in *The Shield*," *Entertainment Weekly*, March 11, 2005, https://ew.com/article/2005 /03/11/what-glenn-close-doing-shield.

106 *"Somehow, the audience":* Derek Lawrence, "*The Shield*: Creator Shawn Ryan on the Possibility of a Revival," *Entertainment Weekly*, March 14, 2017, https:// ew.com/tv/2017/03/14/the-shield-shawn-ryan-15th-anniversary.

106 *"When I look back":* Ben Marshall, "Out with a Bang," *Guardian*, February 13, 2009, https://www.theguardian.com/culture/2009/feb/12/michael-chiklis -the-shield.

107 *"The Shield* not only put FX*":* Maria Elena Fernandez, "Shawn Ryan: The Man Behind *The Shield*," *Los Angeles Times*, August 24, 2008, https://www.latimes .com/entertainment/la-ca-ryan24-2008aug24-story.html.

107 *"I never think of* The Shield*":* Troy L. Foreman, "Interview: Shawn Ryan," *The PC Principle*, December 16, 2018, https://thepcprinciple.com/interview -shawn-ryan.

107 *"We felt like our show was comparable":* Alan Sepinwall, "*The Shield*: Shawn Ryan Post-Finale Q&A," *What's Alan Watching?* (blog), November 25, 2008, http://sepinwall.blogspot.com/2008/11/shield-shawn-ryan-post-finale-q.html.

107 *"All the guys in power":* Sam Lansky, "How Ryan Murphy Became King of the Streaming Boom," *Time*, September 3, 2019, https://time.com/5667752/ryan -murphy-netflix.

108 *"'I have to take this'":* Stephen Tolkin, in discussion with the author, October 16, 2020.

109 *"I was just very frustrated":* KC Ifeanyi, "Inside FX's 'Fearless' Rise to TV Domination," *Fast Company*, June 1, 2017, https://www.fastcompany.com /40425927/inside-fxs-fearless-rise-to-tv-domination.

109 *"both the biggest mistake I ever made":* Ibid.

109 *"I poured a lot of David Chase":* Todd Kessler, in discussion with the author, July 13, 2022.

110 *"Oftentimes the person":* Randy Gambill, "On the Set of *Damages*," hmonthly.com, February 10, 2009, https://www.hmonthly.com/2009/02/10 /set-damages.

110 *"We want you to feel":* KC Ifeanyi, "Inside FX's 'Fearless' Rise to TV Domination," *Fast Company*, June 1, 2017, https://www.fastcompany.com/40425927 /inside-fxs-fearless-rise-to-tv-domination.

111 *"They said they needed someone":* Graham Yost, in discussion with the author, September 9, 2020.

111 *"I was a big fan of Leonard's":* Ibid.

112 *"WWED":* Ibid.

112 *"did kill a lot of people":* Ibid.

113 *"he was a liar who lied":* Ibid.

113 *"I turned down* Justified *twice":* Walton Goggins, in discussion with the author, January 6, 2022.

113 *"I said, 'Look, I'll say the things'":* David Fear, "Walton Goggins on Tarantino, Marilyn Manson and *Sons of Anarchy*," *Rolling Stone*, January 21, 2016, https://www.rollingstone.com/tv-movies/tv-movie-news/walton-goggins -on-tarantino-marilyn-manson-and-sons-of-anarchy-190797/; marakara (screen name), "*Justified* at TCA Press Tour," *LiveJournal* (blog), January 15, 2011, https://justified-fx.livejournal.com/43915.html.

113 *"The hardest thing was how":* Walton Goggins, in discussion with the author, January 6, 2022.

114 *"In the world of Elmore Leonard"*: Jeremy Egner, "Defined by a Smile and a Drawl," *New York Times*, January 5, 2012, https://www.nytimes.com/2012/01/08/arts/television/timothy-olyphant-in-elmore-leonards-justified-on-fx.html.

114 *"He's deeply insecure"*: Confidential source, in discussion with the author.

114 *"We weren't talking"*: Walton Goggins, in discussion with the author, January 6, 2022.

114 *"very special, comforting"*: The *Deadline* Team, "TCA: FX's *Justified* EP on Final Seasons, Life Without Elmore Leonard & the Late Writer's Upcoming Tribute," *Deadline*, January 14, 2014, https://deadline.com/2014/01/tca-elmore-leonard-tribute-scheduled-for-january-21-in-santa-monica-664350/; Kristi Turnquist, "Timothy Olyphant on Elmore Leonard; Harry Connick Jr. and *American Idol*; TV's Golden Age: TV Winter Press Tour 2014 (gallery)," *Oregonian*, January 15, 2014, https://www.oregonlive.com/movies/2014/01/timothy_olyphant_on_elmore_leo.html; Walton Goggins, in discussion with the author, January 6, 2022.

115 *"In a good Elmore scene"*: Graham Yost, in discussion with the author, September 16, 2020.

115 *"It's only a half joke"*: Graham Yost, in discussion with the author, September 9, 2020.

115 *"Does it feel like Elmore?"*: Kara Howland, *"TV Goodness* Q&A: *Justified* Creator/EP Graham Yost Talks Season 5 and Previews 'Restitution,'" *TV Goodness*, April 7, 2014, https://www.tvgoodness.com/2014/04/07/tv-goodness-qa-justified-creatorep-graham-yost-talks-season-5-and-previews-restitution-interview.

116 *"I was just lying constantly"*: Joe Weisberg, in discussion with the author, October 4, 2020.

116 *"read yourself to death"*: Joe Weisberg, "'The Americans' Producer Reveals His Secret CIA History," *Hollywood Reporter*, May 13, 2014, https://www.hollywoodreporter.com/news/general-news/americans-producer-reveals-his-secret-703485.

116 *"You're in this little box of a room"*: Joe Weisberg, in discussion with the author, October 4, 2020.

116 *"I saw that my job was going to entail"*: Olivia B. Waxman, "Q&A: The CIA Officer Behind the New Spy Drama *The Americans*," *Time*, January 30, 2013, https://entertainment.time.com/2013/01/30/qa-the-cia-officer-behind-the-new-spy-drama-the-americans.

116 *"I literally didn't know what CAA was"*: Joe Weisberg, *"The Americans* Producer Reveals His Secret CIA History," *Hollywood Reporter*, May 13, 2014, https://www.hollywoodreporter.com/news/general-news/americans-producer-reveals-his-secret-703485.

116 *Then, in 2010, the FBI rolled up*: Maureen Dowd, "Good Riddance, Carrie Mathison," *New York Times*, April 4, 2015, https://www.nytimes.com/2015/04/05/opinion/sunday/maureen-dowd-good-riddance-carrie-mathison.html.

117 *"Do we have any spies that hot?"*: Andrew Clark, "Anna Chapman's Call to Father Led to FBI Spy Arrests," *Guardian*, July 11, 2010, https://www.theguardian.com/world/2010/jul/12/anna-chapman-call-father-fbi-spy-arrests.

117 *"They said, 'What about making a show about this?'"*: Joe Weisberg, in discussion with the author, October 3, 2020.

117 *"They never tell you why"*: Ibid.

117 *"was the one guy"*: Matt Brennan, "How *The Americans* Became the Best Show on Television," *Paste*, March 24, 2017, https://www.pastemagazine.com/tv /the-americans/how-the-americans-became-the-best-show-on-televisi.

117 *"Scary turned him on"*: Joe Weisberg, in discussion with the author, October 3, 2020.

117 *"Maybe our desire not to do that"*: Christina Radish, "Creators Joseph Weisberg and Joel Fields Talk *The Americans* Season Finale, Crafting the Cliffhanger, Season 2, and More," *Collider*, May 3, 2013, https://collider.com/the -americans-season-1-finale-joseph-weisberg-joel-fields-interview.

118 *"In one meeting he said"*: Joe Weisberg, in discussion with the author, October 3, 2020.

118 *"Most of the stuff that seems"*: Ibid.

118 *"is absolutely based on reality"*: Ibid.

119 *"I don't believe he'd ever written a script"*: Graham Yost, in discussion with the author, September 9, 2020.

119 *"little Miss America"*: Joe Weisberg, in discussion with the author, October 3, 2020.

119 *"I was like, 'Me?'"*: Lacey Rose, "*The Americans* On- and Offscreen Couple Keri Russell and Matthew Rhys in Rare Joint Interview," *Hollywood Reporter*, August 4, 2016, https://www.hollywoodreporter.com/movies/movie-features /americans-actors-shows-graphic-sex-916725.

119 *"'I'm Steven Spielberg'"*: Confidential source, in discussion with the author.

120 *"making a bologna sandwich"*: Mark Anthony Green, "House of Spies: *The Americans*' Keri Russell and Matthew Rhys," *GQ*, January 23, 2014, https:// www.gq.com/gallery/the-americans-keri-russell-matthew-rhys.

120 *"That changed everything"*: Joe Weisberg, in discussion with the author, October 3, 2020.

120 *"They had limitations on nudity"*: Graham Yost, in discussion with the author, September 9, 2020.

120 *"When we started breaking"*: Joe Weisberg, in discussion with the author, October 3, 2020.

Chapter 6: AMC Chases Chase

122 *"Turn it into a half-hour show"*: Kevin Reilly, in discussion with the author, August 5, 2021.

122 *"lesser TCM"*: Lacy Rose and Michael O'Connell, "The Uncensored, Epic, Never-Told Story Behind *Mad Men*," *Hollywood Reporter*, March 11, 2015, https://www.hollywoodreporter.com/news/general-news/mad-men -uncensored-epic-never-780101

123 *"Charlie was an opportunist"*: Laura Michalchyshin, in discussion with the author, April 4, 2020.

123 *"Charlie and Ed and Josh"*: Mark Johnson, in discussion with the author, April 3, 2020.

123 *"Bring me* The Sopranos*"*: Rob Sorcher, in discussion with the author, February 21, 2020.

124 *"I thought AMC was"*: Christina Wayne, in discussion with the author, January 14, 2020.

124 *"Who the fuck is AMC?"*: Lacy Rose and Michael O'Connell, "The Uncensored, Epic, Never-Told Story Behind *Mad Men*," *Hollywood Reporter*, March 11, 2015, https://www.hollywoodreporter.com/news/general-news/mad-men-uncensored -epic-never-780101.

124 *"Albrecht laughed at us"*: Vlad Wolynetz, in discussion with the author, April 16, 2021.

124 *"Admen were the rock stars of that era":* Alex Witchel, *"Mad Men* Has Its Moment," *New York Times Magazine*, June 22, 2008, https://www.nytimes.com /2008/06/22/magazine/22madmen-t.html.

125 *"what we were doing":* Bruce Handy, "Don and Betty's Paradise Lost," *Vanity Fair*, September 2009, https://archive.vanityfair.com/article/2009/9/don -and-bettys-paradise-lost.

125 *"Rob Sorcher called":* Kevin Beggs, in discussion with the author, June 8, 2021.

125 *"It was probably one of the stupidest":* Christina Wayne, in discussion with the author, January 14, 2020.

126 *"They were morons":* Ibid.

126 *"the little kid who got bullied":* Vlad Wolynetz, in discussion with the author, January 21, 2020.

126 *"I do not feel any guilt":* Alex Witchel, *"Mad Men* Has Its Moment," *New York Times Magazine*, June 22, 2008, https://www.nytimes.com/2008/06/22 /magazine/22madmen-t.html.

126 *"Maybe in retrospect":* Marti Noxon, in discussion with the author, September 15, 2020.

126 *"No one cried in my room":* Kyle Buchanan, "Matthew Weiner on Life After *Mad Men*, Sexual Harassment and His New Amazon Show," *New York Times*, October 3, 2018, https://www.nytimes.com/2018/10/03/arts/television/matthew -weiner-the-romanoffs-mad-men-amazon.html.

126 *"Then there was a weird ritual":* Marti Noxon, in discussion with the author, September 15, 2020.

127 *"It was like a parent":* Brett Martin, *Difficult Men* (New York: Penguin Press, 2013), 255.

127 *"Rewriting some or a lot":* Marti Noxon, in discussion with the author, September 15, 2020.

127 *"There are showrunners":* Todd A. Kessler, in discussion with the author, July 13, 2022.

127 *"I think he thought it was big of him":* Marti Noxon, in discussion with the author, September 15, 2020.

127 *"When I found out that a guy":* Lacy Rose and Michael O'Connell, "The Uncensored, Epic, Never-Told Story Behind *Mad Men*," *Hollywood Reporter*, March 11, 2015, https://www.hollywoodreporter.com/news/general-news /mad-men-uncensored-epic-never-780101.

128 *"Women in my generation":* Christina Wayne, in discussion with the author, January 14, 2020.

128 *"Christina was the most brilliant":* Vlad Wolynetz, in discussion with the author, January 21, 2020.

128 *"It was a boys' club":* Laura Michalchyshin, in discussion with the author, April 4, 2020.

128 *"Christina was the smart one":* David Madden, in discussion with the author, December 22, 2022.

129 *"It definitely felt like Matt":* Marti Noxon, in discussion with the author, September 15, 2020.

129 *"You people are fucking assholes":* Christina Wayne, in discussion with the author, January 14, 2020.

129 *"I don't think [Don is]":* Dave Itzkoff, "Matthew Weiner Closes the Books on Season 4 of *Mad Men*," *New York Times*, October 17, 2010, https://archive .nytimes.com/artsbeat.blogs.nytimes.com/2010/10/17/matthew-weiner -closes-the-books-on-season-4-of-mad-men.

130 *"The more I think and write about* Mad Men*"*: Andrew Cracknell, "Ad Men on *Mad Men*: What the Show Got Right About the Advertising Business," *Guardian*, May 22, 2015, https://www.theguardian.com/tv-and-radio/tvandradio blog/2015/may/22/ad-men-on-mad-men-what-the-show-got-right-about -the-advertising-business.

130 *"There was often drinking"*: Marti Noxon, in discussion with the author, September 17, 2020.

131 *"she owed it to him"*: Joy Press, "Matthew Weiner in the Mirror," *Vanity Fair*, September 30, 2018, https://www.vanityfair.com/hollywood/2018/09/mat-thew-weiner-romanoffs-in-the-mirror.

131 *"Matthew's abuse of workplace"*: Steve Greene, "*Mad Men* Writer Kater Gordon Reaffirms Claims of Matthew Weiner's Alleged Workplace Harassment: "My Memory Is Intact,'" *IndieWire*, October 3, 2018, https://www.indiew-ire.com/2018/10/kater-gordon-matthew-weiner-harassment-mad-men -1202009240.

131 *"I believe Kater Gordon"*: Marti Noxon (@martinoxon), "On the subject of Matt Weiner and #MadMen . . . ," Twitter thread, November 17, 2017, 1:14 p.m., https:// twitter.com/martinoxon/status/931586350222061568?ref_src=twsrc%5Et fw%7Ctwcamp%5Etweetembed%7Ctwterm%5E931586350222061568%7Ct wgr%5E5ce241b2cc04f47b52fc03afbc53b6d7a0876365%7Ctwcon%5Es1.

131 *"devilishly clever and witty"*: Bryn Sandberg, "Marti Noxon Backs Matthew Weiner Harassment Accuser, Calls Him 'Emotional Terrorist,'" *Hollywood Reporter*, November 17, 2017.

131 *"Taking that action is one thing"*: Marti Noxon (@martinoxon), "On the subject of Matt Weiner and #MadMen . . . ," Twitter thread, November 17, 2017, 1:14 p.m., https://twitter.com/martinoxon/status/931586350222061568?ref _src=twsrc%5Etfw%7Ctwcamp%5Etweetembed%7Ctwterm%5E93 1586350222061568%7Ctwgr%5E5ce241b2cc04f47b52fc03afbc53b 6d7a0876365%7Ctwcon%5Es1.

131 *"Kater and I were shocked"*: Marti Noxon, in discussion with the author, September 17, 2020.

131 *"There was such a culture"*: Ibid.

131 *"I never felt that way"*: Joy Press, "Matthew Weiner in the Mirror," *Vanity Fair*, September 30, 2018, https://www.vanityfair.com/hollywood/2018/09 /matthew-weiner-romanoffs-in-the-mirror.

132 *"Do I think he's a difficult person?"*: Confidential source, in discussion with the author.

132 *"He was giving his acceptance speech"*: Marti Noxon, in discussion with the author, September 15, 2020.

132 *"My recollection is that"*: Vlad Wolynetz, in discussion with the author, January 21, 2020.

132 *"He apparently turned on her"*: Marti Noxon, in discussion with the author, September 15, 2020.

132 *"difficult genius"*: Marti Noxon with Kater Gordon, "Marti Noxon: How the TV Industry Can Better Protect Writers from the Next Toxic Showrunner (Guest Column)," *Hollywood Reporter*, July 29, 2020, https://www.holly-woodreporter.com/news/general-news/marti-noxon-how-tv-industry -can-better-protect-writers-next-toxic-showrunner-guest-column -1304789.

132 *"I'm sad that I might have caused"*: Kyle Buchanan, "Matthew Weiner on Life After *Mad Men*, Sexual Harassment and His New Amazon Show," *New York*

*Times,*October 3, 2018, https://www.nytimes.com/2018/10/03/arts/television/matthew-weiner-the-romanoffs-mad-men-amazon.html.

132 *"FX quickly came under fire":* Lesley Goldberg, "Matthew Weiner Dramedy Scrapped at FX (Exclusive)," *Hollywood Reporter,* February 17, 2022, https://www.hollywoodreporter.com/tv/tv-news/matthew-weiner-dramedy-scrapped-fx-4057053.

133 *"I just felt I'd never read":* Mark Johnson, in discussion with the author, April 5, 2020.

133 *"You say, 'I don't like what he's doing'":* Alan Sepinwall, "Sepinwall on TV: Bryan Cranston Talks *Breaking Bad* Season Two," *What's Alan Watching?* (blog), March 6, 2009, http://sepinwall.blogspot.com/2009/03/sepinwall-on-tv-bryan-cranston-talks.html.

134 *"Sony was going to shut":* Vlad Wolynetz, in discussion with the author, January 21, 2020.

134 *"Why don't you send it":* Melissa Bernstein, in discussion with the author, January 21, 2020.

134 *"They were basically like":* Stacey Wilson Hunt and Lacey Rose, "Bleak, Brutal, Brilliant *Breaking Bad*: Inside the Smash Hit That Almost Never Got Made," *Hollywood Reporter,* July 11, 2012, https://www.hollywoodreporter.com/tv/tv-news/breaking-bad-vince-gilligan-bryan-cranston-347082.

134 "Breaking Bad *was dead":* Emma Dibdin, "'It Had Never Been Done on Television Before': The Oral History of *Breaking Bad*," *Esquire,* January 16, 2018, https://www.esquire.com/entertainment/tv/a15063971/breaking-bad-cast-interview.

134 *"We could be licensing more John Wayne":* Vlad Wolynetz, in discussion with the author, January 21, 2020.

134 *"Actors are going to want":* Brett Martin, "The Last Stand of Walter White," *GQ,* July 15, 2013, https://www.gq.com/story/bryan-cranston-walter-white-breaking-bad-season-6.

135 *"All you have to do":* Jessica Pressler, "Cranston Comes Alive," *Esquire,* November 1, 2017, https://classic.esquire.com/article/2017/11/1/cranston-comes-alive.

135 *"When I said that you have a green light":* Vlad Wolynetz, in discussion with the author, January 21, 2020.

135 *"When I realized that the company":* Rob Sorcher, in discussion with the author, February 19, 2020.

136 *"This is* Breaking Bad*":* Dan Snierson, "'Breaking Bad': Bryan Cranston, Aaron Paul, Vince Gilligan reveal season 5 details," *Entertainment Weekly,* July 13, 2012, https://ew.com/article/2012/07/13/breaking-bad-bryan-cranston-aaron-paul-season-5.

136 *"I've lost sympathy for Walter White":* Scott Bowles, "*Breaking Bad* Shows Man at His Worst in Season 4," originally published in *USA Today,* July 27, 2011, Scott Bowles (website), https://www.scottbowles.org/breaking-bad-season-4.

136 *"Anna Gunn got a lot of hate mail":* Robin Weigert, in discussion with the author, July 19, 2020.

136 *"Thank God for basic cable":* Stephen King, "Stephen King: Why I love *Breaking Bad*," *Entertainment Weekly,* March 6, 2009, https://ew.com/article/2009/03/06/stephen-king-why-i-love-breaking-bad.

138 *"a 10% range":* Reed Hastings, as told to Patrick J. Sauer, "How I Did It: Reed Hastings, Netflix," *Inc.,* December 1, 2005, https://www.inc.com/magazine/20051201/qa-hastings.html.

138 *"We are to cable networks"*: Ken Auletta, "Outside the Box," *New Yorker*, January 26, 2014, https://www.newyorker.com/magazine/2014/02/03/outside-the-box-2.

138 *"dumbest deals ever"*: Tim Arango, "Time Warner Views Netflix as a Fading Star," *New York Times*, December 12, 2010, https://www.nytimes.com/2010/12/13/business/media/13bewkes.html.

139 *"More shows, more watching"*: Josef Adalian, "Inside the Binge Factory," *Vulture*, June 13, 2018, https://www.vulture.com/2018/06/how-netflix-swallowed-tv-industry.html.

139 "Netflix may end up being": Steven Soderbergh, in discussion with the author, April 4, 2023.

139 *"A wise investor once remarked"*: Josef Adalian, "Inside the Binge Factory," *Vulture*, June 13, 2018, https://www.vulture.com/2018/06/how-netflix-swallowed-tv-industry.html.

140 *"Studio executives [thought Netflix]"*: David Zaslav, in discussion with the author, January 25, 2022.

140 *"Everyone was scratching their heads"*: Bob Greenblatt, in discussion with the author, June 22, 2021.

140 *"saved our bacon"*: Greg Braxton, "*Breaking Bad* Cast and Fans Dread Saying Goodbye," *Cape Cod Times*, August 11, 2013, https://www.capecodtimes.com/story/entertainment/television/2013/08/11/breaking-bad-cast-fans/44371463007.

141 *"AMC was making"*: Christina Wayne, in discussion with the author, January 14, 2020.

141 *"'Do you think we should close'"*: Vlad Wolynetz, in discussion with the author, January 21, 2020.

141 *"AMC may have had"*: Kim Masters, "*The Walking Dead*: What Really Happened to Fired Showrunner Frank Darabont," *Hollywood Reporter*, August 10, 2011, https://www.hollywoodreporter.com/news/general-news/walking-dead-what-happened-fired-221449.

141 *"Can you believe they haven't"*: Vlad Wolynetz, in discussion with the author, January 21, 2020.

141 *"Josh Sapan stands to make"*: Ibid. These are Wolynetz's words, not a direct quote from the *Journal*.

142 *"He became this autonomous island"*: Ibid.

142 *"Every time I've been low"*: Ibid.

Chapter 7: Showtime's Bad-Good Girls

143 *"sucking hind tit forever"*: Michael Fuchs, in discussion with the author, January 17, 2012.

144 *"I never really considered"*: Bob Greenblatt, in discussion with the author, July 15, 2021.

144 *"I wanted to model Showtime"*: Bob Greenblatt, in discussion with the author, June 22, 2021.

144 *"Science fiction back in the early '90s"*: Bob Greenblatt, in discussion with the author, July 15, 2021.

144 *"Showtime had cultivated"*: Michael Jensen, "Interview: Robert Greenblatt Says His Being First Gay Broadcast TV President Is No Big Deal. We Beg to Differ!" *LogoTV*, April 7, 2011, https://www.logotv.com/news/ybfup9/interview-robert-greenblatt-says-his-being-first-gay-broadcast-tv-president-is-no-big-deal-we-beg-to-differ.

144 *"I also decided to develop"*: Bob Greenblatt, in discussion with the author, July 15, 2021.

145 *"Why should you feel sorry"*: Lacey Rose, *"Orange* Showrunner Jenji Kohan on Hollywood's Pay Inequality, 'F— You' Money and Her *Friends* Regrets," *Hollywood Reporter,* August 6, 2014, https://www.hollywoodreporter.com/tv/tv -news/orange-is-new-black-showrunner-723403.

145 *"white devil Jew bitch"*: Emily Nussbaum, "Jenji Kohan's Hot Provocations," *New Yorker,* August 28, 2017, https://www.newyorker.com/magazine/2017 /09/04/jenji-kohans-hot-provocations.

146 *"I have this deep-rooted"*: Lacey Rose, *"Orange* Showrunner Jenji Kohan on Hollywood's Pay Inequality, 'F—You' Money and Her *Friends* Regrets," *Hollywood Reporter,* August 6, 2014, https://www.hollywoodreporter.com/tv/tv -news/orange-is-new-black-showrunner-723403.

146 *"It's always about talent"*: Paul Hond, "The Revenge of Jenji Kohan," *Columbia Magazine,* Summer 2016, https://magazine.columbia.edu/article/revenge -jenji-kohan.

146 *"I would never want anyone"*: Debra Eckerling, "The Small Screen: *Weeds,"* *Script,* April 7, 2016, https://scriptmag.com/features/small-screen-weeds.

146 *"I think likability"*: Alison Willmore, *"Weeds* Creator Jenji Kohan on Her New Netflix Series *Orange Is the New Black* and Why 'Likability is Bullsh*t,'" *IndieWire,* July 8, 2013, https://www.indiewire.com/2013/07/weeds-creator -jenji-kohan-on-her-new-netflix-series-orange-is-the-new-black-and-why -likability-is-bullsht-37081.

146 *"I wanted to do an outlaw show"*: Garin Pirnia, "10 Facts About *Weeds,"* *Mental Floss,* November 8, 2017, https://www.mentalfloss.com/article/503233/facts -about-weeds.

147 *"Do I fucking know her?"*: Emily Nussbaum, "Jenji Kohan's Hot Provocations," *New Yorker,* August 28, 2017, https://www.newyorker.com/magazine/2017 /09/04/jenji-kohans-hot-provocations.

147 *"I didn't have the luxury"*: Bob Greenblatt, in discussion with the author, June 22, 2021.

147 *"Nobody would work at Showtime"*: Matthew Belloni, "How to Succeed Amid the Great Streaming Correction," *Puck,* June 5, 2022, https://puck.news/how -to-succeed-amid-the-great-streaming-correction.

147 *"My suspicion was that Weeds"*: Kevin Beggs, in discussion with the author, June 8, 2021.

148 *"People generally don't take to mothers"*: Kyle Ryan, "Mary-Louise Parker," *AV Club,* June 17, 2009, https://www.avclub.com/mary-louise-parker -1798216811.

148 *"'Weeds' has grabbed the kind of critical"*: Kyle Pope, "For Showtime, Suburban Angst Is Fast Becoming a Ratings Delight," *New York Times,* August 6, 2006, https://www.nytimes.com/2006/08/06/arts/television/for-showtime -suburban-angst-is-fast-becoming-a-ratings.html.

148 *"I want more fucking, everywhere"*: Christina Radish, "Creator Jenji Kohan Talks *Orange Is the New Black,* Her Research into Prison Life, and Graphic Sex Scenes," *Collider,* July 7, 2013, https://collider.com/jenji-kohan-orange-is -the-new-black-interview.

148 *"We could show the dildo"*: Mikey O'Connell, *"Orange Is the New Black*'s Jenji Kohan Details Her Frustrating Negotiations to Get Actors Naked," *Hollywood Reporter,* April 16, 2014, https://www.hollywoodreporter.com/tv/tv-news /orange-is-new-blacks-jenji-696916.

148 *"Executives, especially Bob Greenblatt"*: Emily Nussbaum, "Jenji Kohan's Hot Provocations," *New Yorker*, August 28, 2017, https://www.newyorker.com/magazine/2017/09/04/jenji-kohans-hot-provocations.

149 *"My mother can't watch this!"*: Ibid.

149 *"I didn't think I needed to be naked"*: Liz Berman, "Mary-Louise Parker Bitter over Nude Scene," *People*, May 18, 2009, https://people.com/health/mary-louise-parker-bitter-over-nude-scene.

149 *"Good luck with that"*: Lacey Rose, "*Orange* Showrunner Jenji Kohan on Hollywood's Pay Inequality, 'F—You' Money and Her *Friends* Regrets," *Hollywood Reporter*, August 6, 2014, https://www.hollywoodreporter.com/tv/tv-news/orange-is-new-black-showrunner-723403.

149 *"This isn't a director's medium!"*: Emily Nussbaum, "Jenji Kohan's Hot Provocations," *New Yorker*, August 28, 2017, https://www.newyorker.com/magazine/2017/09/04/jenji-kohans-hot-provocations.

149 *"I know it sounds like the secret diary"*: Devin Leonard, "Call-girl cable series unites rivals," *CNN Money*, March 14, 2008, https://money.cnn.com/2008/03/13/news/companies/leonard_albrecht.fortune/index.htm?source=yahoo_quote.

150 *"psychological oddities"*: David Nevins, in discussion with the author, January 15, 2021.

150 *"David wanted to take the programming"*: Bob Greenblatt, in discussion with the author, July 15, 2021.

150 *"my favorite kind of executive"*: Lesley Goldberg, "*Weeds* Creator Jenji Kohan Revisiting 'Little Boxes' as the Showtime Comedy Prepares to Sign Off," *Hollywood Reporter*, June 15, 2012, https://www.hollywoodreporter.com/tv/tv-news/weeds-jenji-kohan-final-season-spoiler-little-boxes-337979.

150 *When he became famous*: Decca Aitkenhead, "Estate of play," *Guardian*, July 11, 2008, https://www.theguardian.com/media/2008/jul/12/television.

150 *"I've had a very slow and frustrating development"*: Bob Greenblatt, in discussion with the author, July 15, 2021.

151 *"white-trash porn"*: John Hendel, "Showtime's *Shameless* New Show About Poverty," *Atlantic*, January 8, 2011, https://www.theatlantic.com/entertainment/archive/2011/01/showtimes-shameless-new-show-about-poverty/69108.

152 *"I have your next show"*: Mikey O'Connell, "*Homeland* Declassified: Battles, Backlash, CIA Meetings and a Secret Call with Edward Snowden," *Hollywood Reporter*, January 16, 2020, https://www.hollywoodreporter.com/movies/movie-features/homeland-declassified-battles-backlash-cia-meetings-a-secret-call-edward-snowden-1269957.

152 *"We just felt that our chances"*: Lacey Rose, "The Re-Birth of Showtime," *Hollywood Reporter*, March 27, 2012, https://www.hollywoodreporter.com/tv/tv-news/birth-showtime-304910.

152 *"It used to be"*: Quentin Schaffer, in discussion with the author, October 28, 2019.

153 *"Dude, make a fucking show!"*: Confidential source, in discussion with the author.

153 *"Rick Rosen called me up"*: David Nevins, in discussion with the author, August 9, 2021.

154 *"how the United States was of two minds"*: Alex Gansa, in discussion with the author, August 11, 2022.

154 *"retains the stricken look"*: Fiona Sturges, "*Homeland*: Claire Danes Sulks Her Way Through More Relentless Catastrophising," *Guardian*, February 17, 2018,

https://www.theguardian.com/tv-and-radio/2018/feb/17/homeland-claire
-danes-trump-mandy-patinkin.

154 *"We're doing this with Claire Danes"*: Alex Gansa, in discussion with the author,
August 11, 2022.

155 *The* Homeland *folks asked:* Mikey O'Connell, *"Homeland* Declassified: Battles,
Backlash, CIA Meetings and a Secret Call with Edward Snowden," *Hollywood
Reporter,* January 16, 2020, https://www.hollywoodreporter.com/movies
/movie-features/homeland-declassified-battles-backlash-cia-meetings-a
-secret-call-edward-snowden-1269957.

155 *"The first thing we got was a litany"*: Alex Gansa, in discussion with the author,
August 11, 2022.

155 *"We had [Bush's CIA head]"*: Ibid.

155 *"'There's a senior intelligence officer here"*: Mikey O'Connell, *"Homeland*
Declassified: Battles, Backlash, CIA Meetings and a Secret Call with Edward
Snowden," *Hollywood Reporter,* January 16, 2020, https://www.holly
woodreporter.com/movies/movie-features/homeland-declassified-battles
-backlash-cia-meetings-a-secret-call-edward-snowden-1269957.

156 *"That is the greatest thing that could have happened"*: Ibid.

156 "Homeland *was the 'It' show"*: Sheila Nevins, in discussion with the author,
February 9, 2022.

157 *"Even when you have a hit"*: Kim Masters, *"The Walking Dead*: What Really
Happened to Fired Showrunner Frank Darabont," *Hollywood Reporter,*
August 10, 2011, https://www.hollywoodreporter.com/news/general-news
/walking-dead-what-happened-fired-221449.

157 *"Fuck you all for giving me chest pains"*: Laura Bradley, "Have You Ever Sent
an E-mail as Profane as This Former *Walking Dead* Showrunner?," *Vanity
Fair,* July 13, 2017, https://www.vanityfair.com/hollywood/2017/07/frank
-darabont-walking-dead-emails.

157 *"hunted down and fucking killed them"*: Cynthia, Littleton, "Frank Darabont's
Firing Detailed in Latest *Walking Dead* Lawsuit Filings," *Variety,* July 13,
2017, https://variety.com/2017/tv/news/the-walking-dead-frank-darabont
-1202494548.

158 *"AMC was always in the habit"*: Vlad Wolynetz, in discussion with the author,
December 2, 2022.

158 *"They had nothing to do with it"*: Confidential source, in discussion with the
author.

158 *"Jim was born on third base"*: Vlad Wolynetz, in discussion with the author,
December 2, 2022.

158 *"Jimmy whisperer"*: Confidential source, in discussion with the author.

159 *"insulate everyone from the whims"*: Vlad Wolynetz, in discussion with the au-
thor, December 2, 2022.

159 *The* New York Times *reports:* Kashmir Hill and Corey Kilgannon, "Madison
Square Garden Uses Facial Recognition to Ban Its Owner's Enemies," *New
York Times,* December 22, 2022, https://www.nytimes.com/2022/12/22
/nyregion/madison-square-garden-facial-recognition.html.

159 *On Thanksgiving weekend in 2022:* Kashmir Hill, "Lawyers Barred by Madi-
son Square Garden Found a Way Back In," *New York Times,* January 16, 2023,
https://www.nytimes.com/2023/01/16/technology/madison-square-garden
-ban-lawyers.html.

159 *"Jimmy's not stupid"*: Vlad Wolynetz, in discussion with the author, Decem-
ber 2, 2022.

159 *"AMC Networks is the walking dead"*: Benjamin Mullin, "Want to Understand

Television's Troubles? Look at AMC," *New York Times*, December 18, 2022, https://www.nytimes.com/2022/12/18/business/media/amc-networks-streaming-cable.html.

160 *"Collaborate to death?"*: Alexis Soloski, *"Yellowjackets* Leans In to Savagery," *New York Times*, November 10, 2021.

160 "couldn't ride in the same van!": Emily Longeretta, *"Yellowjackets* Cast Defend 'Logical' Group Decision in Episode 2, Explain What [Spoiler] Tasted Like," *Variety*, March 31, 2023.

160 *"You will have no part"*: Sridhar Pappu, "How Taylor Sheridan Created America's Most Popular TV Show," *Atlantic*, November 10, 2022, https://www.theatlantic.com/magazine/archive/2022/12/yellowstone-tv-series-taylor-sheridan/671897.

161 *"They refer to it as 'the conservative show'"*: Ibid.

161 *As James Poniewozik puts it:* James Poniewozik, "This Land Is His Land," *New York Times*, November 10, 2022, https://www.nytimes.com/2022/11/10/arts/television/yellowstone-taylor-sheridan.html.

Chapter 8: Out of Luck and Off-Key, HBO Gets Game

162 *"a lot of confusion"*: Ginia Bellafante, "A Fantasy World of Strange Feuding Kingdoms," *New York Times*, April 14, 2011, https://www.nytimes.com/2011/04/15/arts/television/game-of-thrones-begins-sunday-on-hbo-review.html.

162 *"groggy slog"*: Hank Stuever, "HBO's *Game of Thrones*: A Lot to Sword Out," *Washington Post*, April 14, 2011, https://www.washingtonpost.com/entertainment/television/hbos-game-of-thrones-a-lot-to-sword-out/2011/04/11/AFIbEYdD_story.html.

162 *"They've struck out right and left"*: Lisa de Moraes, "Losing an Inside Job at HBO," *Washington Post*, March 18, 2008, https://www.washingtonpost.com/wp-dyn/content/article/2008/03/17/AR2008031703138.html.

163 *"was infatuated with Mann"*: Confidential source, in discussion with the author.

163 *"David [too] was very much in favor"*: Richard Plepler, in discussion with the author, February 16, 2023.

163 *"If you try to get a straight answer"*: Kim Masters, "Michael Mann, David Milch Split Duties to Settle Power Struggle on HBO's *Luck*," *Hollywood Reporter*, April 21, 2011, https://www.hollywoodreporter.com/news/general-news/michael-mann-david-milch-split-181092.

163 *"I was surprised they were put together"*: Dan Attias, in discussion with the author, June 24, 2022.

163 *"Michael Mann wants to meet"*: Allen Coulter, in discussion with the author, June 24, 2022.

163 *"Don't try to mix these two chemicals"*: Allen Coulter, in discussion with the author, February 22, 2019.

164 *"What am I supposed to say"*: Ibid.

164 *"I was seeing David at that time"*: Ian McShane, in discussion with the author, July 31, 2020.

164 *"Of course, it ended up horribly"*: Brian Cox, in discussion with the author, June 24, 2020.

164 *"No, no, no, no"*: Confidential source, in discussion with the author.

164 *"There was a day that David was going to kill Michael"*: Geoff Boucher, "'Luck': Angry David Milch Brought Baseball Bat to Edit Bay?," *Show Tracker* (blog), *Los Angeles Times*, March 14, 2012, https://www.latimes.com/archives/blogs

/show-tracker/story/2012-03-14/luck-angry-david-milch-brought-baseball
-bat-to-edit-bay.

165 *"When he busted into the editing room"*: Allen Coulter, in discussion with the
 author, February 22, 2019.

165 *"I went to his office a couple of times"*: Ibid.

165 *"was zoning out"*: Confidential source, in discussion with the author.

165 *"He was known to be indifferent"*: Allen Coulter, in discussion with the author,
 February 22, 2019.

165 *"Usually, the creative executive on the show"*: Confidential source, in discus-
 sion with the author.

166 *"They were massively over budget"*: Allen Coulter, in discussion with the
 author, February 22, 2019.

166 *"He had to be appreciated"*: Confidential source, in discussion with the author.

166 *"I'd happily be in business with him"*: Bryn Sandberg, "HBO Goes Back to
 Drawing Board With *Lewis and Clark* Miniseries," *Hollywood Reporter*,
 February 3, 2016, https://www.hollywoodreporter.com/tv/tv-news/hbo-goes
 -back-drawing-board-861767.

167 *"When production is run"*: Confidential source, in discussion with the author.

167 *"It wasn't like Lombardo"*: Ibid.

168 *"We couldn't get anything moving"*: Vlad Wolynetz, in discussion with the au-
 thor, December 6, 2022.

168 *"longest months of both of our lives"*: Kim Renfro, "How *Game of Thrones* Nearly
 Ended Before It Began Thanks to a Disastrous Plot," *Insider*, September 17,
 2020, https://www.insider.com/game-of-thrones-failed-pilot-hbo-chapter--
 kim-renfro-book.

169 *"We could have shot this in Burbank"*: James Hibberd, "Inside *Game of Thrones'*
 Disastrous Original Pilot: 'Nobody Knew What They Were Doing,'" *Enter-
 tainment Weekly*, September 14, 2020, https://ew.com/tv/game-of-thrones
 -original-pilot-fire-cannot-kill-a-dragon-excerpt.

169 *"I was just staring at Mike's face"*: Jim Windolf, "The Gathering Storm,"
 Vanity Fair, April 2004, https://archive.vanityfair.com/article/2014/4/the
 -gathering-storm.

169 *"was mulling whether or not"*: Michael Mechanic, "*Game of Thrones* Has
 Succeeded Beyond Its Creators' Wildest Dreams," *Mother Jones*, March 4,
 2013, https://www.motherjones.com/media/2013/03/hbo-game-thrones-season-
 3-interview-david-benioff-dan-weiss.

169 *"I got no more than fifty pages"*: Tim Van Patten, in discussion with the author,
 March 8, 2014.

169 *"We had to start from scratch"*: Alik Sakharov, in discussion with the author,
 March 15, 2014.

169 *"That first year felt very probationary"*: Kim Renfro, "How *Game of Thrones*
 Nearly Ended Before It Began Thanks to a Disastrous Plot," *Insider*, Sep-
 tember 17, 2020, https://www.insider.com/game-of-thrones-failed-pilot-hbo
 -chapter-kim-renfro-book.

170 *"I put the phone down"*: Terry Winter, in discussion with the author, May 20,
 2022.

171 *"Vinyl was shoved up his ass"*: James Andrew Miller, *Tinderbox: HBO's Ruthless
 Pursuit of New Frontiers* (New York: Henry Holt, 2021), Chapter 15, iBook.

171 *"Neither Lombardo nor Jagger"*: Allen Coulter, in discussion with the author,
 February 22, 2019.

171 *"Mike Lombardo found out about this"*: Terry Winter, in discussion with the
 author, May 20, 2022.

172 *"No one can really tell Marty":* Allen Coulter, in discussion with the author, February 22, 2019.

172 *"That's head-to-head":* Terry Winter, in discussion with the author, May 20, 2022.

172 *"fucking Martin Scorsese movie":* Ibid.

172 *"The whole thing was a bad marriage":* Allen Coulter, in discussion with the author, February 22, 2019.

172 *Under the headline, "Martin Scorsese: HBO's* Vinyl*":* Ariston Anderson, "Martin Scorsese: HBO's *Vinyl* Failed Because I Didn't Direct Everything," *Hollywood Reporter,* October 25, 2018, https://www.hollywoodreporter.com/news/general-news/martin-scorsese-says-hbos-vinyl-failed-because-he-didnt-direct-episode-1154946.

173 *"Our reaction would be":* Allen Coulter, in discussion with the author, February 22, 2019.

173 *"If I expressed frustration":* Terry Winter, in discussion with the author, May 20, 2022.

173 *"Lombardo hated* Vinyl*":* Ibid.

173 *"It was really sad":* Terry Winter, in discussion with the author, May 20, 2022.

174 *"I was stupid":* Sheila Nevins, in discussion with the author, February 9, 2022.

174 *"Richard was really good at blowing smoke":* Confidential source, in discussion with the author.

174 *"It wasn't until I left":* Sheila Nevins, in discussion with the author, February 9, 2022.

175 *"If you want to do something for television":* Josh Donen and Eric Roth, in discussion with the author, August 3, 2013.

175 *"Francis Urquhart is not a character":* David Fincher, in discussion with the author, August 3, 2013.

175 *"I wasn't particularly keen to write":* Beau Willimon, in discussion with the author, July 28, 2013.

176 *"I went, 'Phew!'":* David Fincher, in discussion with the author, August 3, 2013.

176 *"It was one of those things":* Ibid.

176 *"I couldn't imagine working":* Ibid.

177 *So far as the networks went:* Jon Nathanson, "The Economics of a Hit TV Show," *Priceonomics,* October 17, 2013, https://priceonomics.com/the-economics-of-a-hit-tv-show.

177 *"If we're going to go from a pitch":* John Landgraf, in discussion with the author, July 25, 2018.

177 *"MRC made a handshake":* Quentin Schaffer, in discussion with the author, October 28, 2019.

177 *"I'm asking Kevin and Robin":* David Fincher, in discussion with the author, August 6, 2013.

178 *"We had a big ask":* Beau Willimon, in discussion with the author, July 28, 2013.

178 *"We were bemoaning this whole notion":* Josh Donen, in discussion with the author, September 13, 2013.

178 *"The idea of creating a piece of content":* Ted Sarandos, in discussion with the author, September 23, 2013.

179 *"MRC didn't honor the handshake":* Quentin Schaffer, in discussion with the author, October 28, 2019.

179 *"hubris, thinking that people would take":* Confidential source, in discussion with the author.

179 *"I'm building a team that's oriented":* Josef Adalian, "Inside the Binge Factory," *Vulture,* June 13, 2018, https://www.vulture.com/2018/06/how-netflix-swallowed-tv-industry.html.

179 *"After David Fincher directs a series for Netflix"*: Lacey Rose, "Netflix's Ted Sarandos Reveals His 'Phase 2' for Hollywood," *Hollywood Reporter*, May 22, 2013, https://www.hollywoodreporter.com/tv/tv-news/netflixs-ted-sarandos -reveals-his-526323.

180 *"When somebody offers you exactly"*: Dawn C. Chmielewski, "Ted Sarandos Upends Hollywood with Netflix Revolution," *Los Angeles Times*, August 25, 2013, https://www.latimes.com/entertainment/envelope/cotown/la-et-netflix -ted-sarandos-20130825-dto-htmlstory.html.

180 *"Can't kill [her] dog"*: Michael Imperioli and Steve Schirripa, *Woke Up This Morning* (New York: William Morrow, 2021), chap. 6, iBook.

181 *"Look, do you care if we lose half"*: Beau Willimon, in discussion with the author, July 28, 2013.

181 *"I don't think the show is cynical"*: David Fincher, in discussion with the author, August 6, 2013.

181 *"they didn't understand that feature directors"*: Allen Coulter, in discussion with the author, February 22, 2019.

181 *"Fincher is tough"*: Ibid.

181 *"Kevin Spacey was rude"*: Allen Coulter, in discussion with the author, October 26, 2020.

182 *"The basic thing was watching"*: Reed Hastings, as told to Patrick J. Sauer, "How I Did It: Reed Hastings, Netflix," *Inc.*, December 1, 2005, https://www .inc.com/magazine/20051201/qa-hastings.html.

183 *"No one is safe"*: Sean T. Collins, "*Game of Thrones* Q&A: Richard Madden on Robb Stark's Endgame," *Rolling Stone*, June 3, 2013, https://www.rolling stone.com/tv-movies/tv-movie-news/game-of-thrones-qa-richard-madden -on-robb-starks-endgame-129013.

183 *"They killed three principal characters"*: Tim Van Patten, in discussion with the author, March 8, 2014.

183 *"wanted to explore with Jaime Lannister"*: Mikal Gilmore, "George R. R. Martin: The *Rolling Stone* Interview," *Rolling Stone*, April 23, 2014, https://www .rollingstone.com/culture/culture-news/george-r-r-martin-the-rolling -stone-interview-242487.

183 *"You suddenly wake up to it"*: Alex Morris, "*Game of Thrones*: Emilia Clarke, the Queen of Dragons, Tells All," *Rolling Stone*, June 28, 2017, https://www .rollingstone.com/tv-movies/tv-movie-features/game-of-thrones-emilia -clarke-the-queen-of-dragons-tells-all-201327.

183 *"I'd come fresh from drama school"*: Adam White, "*Game of Thrones* Star Emilia Clarke Says She Was Pressured to Perform Nude Scenes," *Independent*, November 19, 2019, https://www.independent.co.uk/arts-entertainment/films /news/emilia-clarke-game-of-thrones-nude-scenes-dax-shepard-daenerys -a9208471.html.

183 *Eventually, however, she began to wonder*: Zack Sharf, "Emilia Clarke Was Told to Get Nude So *Thrones* Fans Wouldn't Be Disappointed," *IndieWire*, November 19, 2019, https://www.indiewire.com/2019/11/emilia-clarke-pressured -game-of-thrones-nudity-1202190609.

184 *"I've had fights on the set"*: Adam White, "*Game of Thrones* Star Emilia Clarke Says She Was Pressured to Perform Nude Scenes," *Independent*, November 19, 2019, https://www.independent.co.uk/arts-entertainment/films /news/emilia-clarke-game-of-thrones-nude-scenes-dax-shepard-daenerys -a9208471.html.

184 *"There are a lot of people in that position"*: Dawn C. Chmielewski, "Ted Sarandos Upends Hollywood with Netflix Revolution," *Los Angeles Times*,

August 25, 2013, https://www.latimes.com/entertainment/envelope/cotown /la-et-netflix-ted-sarandos-20130825-dto-htmlstory.html.

185 *"played his politics by being apolitical"*: Quentin Schaffer, in discussion with the author, January 7, 2022.

185 *"When we got through with the how's"*: Terry Winter, in discussion with the author, May 20, 2022.

185 *"There was a lot of development"*: Casey Bloys, in discussion with the author, November 1, 2021.

186 *"Look, even if you get it right"*: Ibid.

186 *"It did not resonate well"*: Debra Birnbaum, "Network Chiefs on Difficult Decisions, Increased Competition and Diversity Initiatives," *Variety*, March 12, 2018, https://variety.com/2018/tv/news/network-chiefs-hbo-show time-turner-fox-intv-1202723996.

186 *"Looking back, people in general"*: Allen Coulter, in discussion with the author, February 22, 2019.

186 *"Let's do another series"*: Terry Winter, in discussion with the author, May 20, 2022.

187 *"HBO was not feeling the latest draft"*: Jessica Herndon, "Issa Rae Embraces Her Role as a Hollywood Trailblazer: 'You Can't Be Polite or Modest,'" *Hollywood Reporter*, August 19, 2020, https://www.hollywoodreporter.com/movies /movie-features/issa-rae-embraces-her-role-as-a-hollywood-trailblazer -you-cant-be-polite-or-modest-4047809.

188 *"watching white people dictate"*: Brittany Spanos, "Issa Rae Can't Stop, Won't Stop," *Rolling Stone*, April 15, 2021, https://www.rollingstone.com/tv-movies /tv-movie-features/issa-rae-insecure-hbo-1155867.

188 *"trying to convey that people of color"*: Greg Braxton, "Issa Rae Takes HBO from White *Girls* to Black Women with *Insecure*," *Los Angeles Times*, July 30, 2016, https://www.latimes.com/entertainment/tv/la-et-st-hbo-insecure -20160730-snap-story.html.

188 *"focused on specific struggle stories"*: Jessica Herndon, "Issa Rae Embraces Her Role as a Hollywood Trailblazer: 'You Can't Be Polite or Modest,'" *Hollywood Reporter*, August 19, 2020, https://www.hollywoodreporter.com/mov ies/movie-features/issa-rae-embraces-her-role-as-a-hollywood-trailblazer -you-cant-be-polite-or-modest-4047809.

189 *"I want the benefits of gentrification"*: Mekeisha Madden Toby, "Emmy Nominee Issa Rae Sheds Light on *Insecure* Season 4 and Her Los Angeles Legacy," *Parade*, September 16, 2020, https://parade.com/1019235/mekeisha-madden -toby/issa-rae-insecure-season-4.

189 *"When I'm driving to work on Crenshaw"*: Angelique Jackson, "Issa Rae's Next Chapter: How *Insecure* Creator Is Becoming a Media Mogul with Production Banner Hoorae," *Variety*, March 24, 2021, https://variety.com/2021/tv/news /issa-rae-insecure-hbo-hoorae-1234936020.

190 *"ripped from under us"*: Ibid.

190 *"still being here"*: Jessica Herndon, "Issa Rae Embraces Her Role as a Hollywood Trailblazer: 'You Can't Be Polite or Modest,'" *Hollywood Reporter*, August 19, 2020, https://www.hollywoodreporter.com/movies/movie-features /issa-rae-embraces-her-role-as-a-hollywood-trailblazer-you-cant-be-polite -or-modest-4047809.

Chapter 9: Netflix's Albanian Army

193 *"'You have to stretch it out'"*: Conor Friedersdorf, "The Philosophy of Netflix: Its Chief Content Officer Champions Storytelling," *Atlantic*, June 29, 2013,

https://www.theatlantic.com/technology/archive/2013/06/the-philosophy
-of-netflix-its-chief-content-officer-champions-storytelling/277354.

194 *"When you buy a book"*: Reed Hastings, as told to Patrick J. Sauer, "How I Did
It: Reed Hastings, Netflix," *Inc.*, December 1, 2005, https://www.inc.com
/magazine/20051201/qa-hastings.html.

195 *"Exposition is the writer's enemy"*: Bob Verini, "Binge Viewing Is Forcing
Showrunners to Evolve," *Variety*, June 19, 2014, https://variety.com/2014/tv
/awards/binge-viewing-is-forcing-showrunners-to-evolve-1201221668.

195 *"When you can give the filmmaker"*: Andrew Romano, "Why You're Addicted
to TV," *Newsweek*, May 15, 2013, https://www.newsweek.com/2013/05/15
/why-youre-addicted-tv-237340.html.

195 *"A simple, linear story"*: A. O. Scott, *"La Flor* Review: Four Women in Search of
a Movie," *New York Times*, August 1, 2019, https://www.nytimes.com/2019/08
/01/movies/la-flor-review.html.

196 *"Streaming is like most things"*: Robert King, in discussion with the author,
March 17, 2022.

196 *"With* Money Heist*"*: Erik Barmack, in discussion with the author, March 28,
2022.

196 *"In the early years there was more"*: Ibid.

197 *"We were getting all this research back"*: Jenna Boyd, in discussion with the
author, May 21, 2021.

197 *"Hire, reward, and tolerate"*: Patty McCord, "How Netflix Reinvented HR,"
Harvard Business Review, January–February 2014, https://hbr.org/2014/01
/how-netflix-reinvented-hr.

197 *"The volume ambitions were massive"*: Jenna Boyd, in discussion with the
author, May 21, 2021.

198 *"helping her would put a target"*: Shalini Ramachandran and Joe Flint, "At
Netflix, Radical Transparency and Blunt Firings Unsettle the Ranks," *Wall
Street Journal*, October 25, 2018, https://www.wsj.com/articles/at-netflix
-radical-transparency-and-blunt-firings-unsettle-the-ranks-1540497174.

198 *"Maxing up candor"*: Maureen Dowd, "Reed Hastings Had Us All Staying
Home Before We Had To," *New York Times*, September 4, 2020, https://www
.nytimes.com/2020/09/04/style/reed-hastings-netflix-interview.html.

198 *"complainers and pessimists"*: Reed Hastings and Erin Meyer, *No Rules Rules:
Netflix and the Culture of Reinvention* (New York: Penguin Press, 2020), chap-
ter 1, iBooks.

198 *"not that hard"*: Maureen Dowd, "Reed Hastings Had Us All Staying Home Be-
fore We Had To," *New York Times*, September 4, 2020, https://www.nytimes
.com/2020/09/04/style/reed-hastings-netflix-interview.html.

199 *"We're not trying to do truth"*: Joshua Caplan, "Netflix CEO Reed Hastings on
Bowing to Saudi Censorship: 'We're Not Trying to Do Truth to Power,'" *Bre-
itbart*, November 6, 2019, https://www.breitbart.com/entertainment/2019
/11/06/netflix-ceo-reed-hastings-on-bowing-to-saudi-censorship-were-not
-trying-to-do-truth-to-power.

199 *"It's actually taking funds"*: Confidential source, in discussion with the author.

199 *But as of 2023, Netflix is shooting*: CJ Johnson, "Here's The List of Movies Be-
ing Filmed in Atlanta, Georgia Right Now," *AtlantaFi*, April 1, 2023, https://
atlantafi.com/heres-the-list-of-movies-being-filmed-in-atlanta-georgia.

200 *"If you go to a network and say"*: Christina Radish, "Creator Jenji Kohan Talks
Orange Is the New Black, Her Research into Prison Life, and Graphic Sex
Scenes," *Collider*, July 7, 2013, https://collider.com/jenji-kohan-orange-is-the
-new-black-interview.

200 *"said 'No.'"*: Jackie Strause, *"Orange Is the New Black* Creator and Cast Talk Binge-Era Breakthrough and Series Finale in Unfiltered Oral History," *Hollywood Reporter*, July 29, 2019, https://www.hollywoodreporter.com/tv/tv-features/orange-is-new-black-creator-cast-series-finale-oral-history-1227380.

200 *"When I first heard about it"*: David Nevins, in discussion with the author, August 9, 2021.

200 *"I had come through decades of the pilot system"*: Jackie Strause, *"Orange Is the New Black* Creator and Cast Talk Binge-Era Breakthrough and Series Finale in Unfiltered Oral History," *Hollywood Reporter*, July 29, 2019, https://www.hollywoodreporter.com/tv/tv-features/orange-is-new-black-creator-cast-series-finale-oral-history-1227380.

200 *"It's the Wild West"*: Christina Radish, "Creator Jenji Kohan Talks *Orange Is the New Black*, Her Research into Prison Life, and Graphic Sex Scenes," *Collider*, July 7, 2013, https://collider.com/jenji-kohan-orange-is-the-new-black-interview.

201 *"That was miraculous"*: Terry Gross, *"Orange* Creator Jenji Kohan: 'Piper Was My Trojan Horse,'" NPR, August 13, 2013, in *Fresh Air*, podcast, https://www.npr.org/2013/08/13/211639989/orange-creator-jenji-kohan-piper-was-my-trojan-horse.

201 *"Their opening statement was: 'You've done TV before'"*: Lesley Goldberg, "*Weeds* Creator Jenji Kohan Revisiting 'Little Boxes' as the Showtime Comedy Prepares to Sign Off," *Hollywood Reporter*, June 15, 2012, https://www.hollywoodreporter.com/tv/tv-news/weeds-jenji-kohan-final-season-spoiler-little-boxes-337979/.

201 *"pissing in the corners"*: Jackie Strause, *"Orange Is the New Black* Creator and Cast Talk Binge-Era Breakthrough and Series Finale in Unfiltered Oral History," *Hollywood Reporter*, July 29, 2019, https://www.hollywoodreporter.com/tv/tv-features/orange-is-new-black-creator-cast-series-finale-oral-history-1227380.

201 *"was enormously challenging"*: Christina Radish, "Creator Jenji Kohan Talks *Orange Is the New Black*, Her Research into Prison Life, and Graphic Sex Scenes," *Collider*, July 7, 2013, https://collider.com/jenji-kohan-orange-is-the-new-black-interview.

201 *"The pools of talent are so deep"*: Ibid.

201 *"character actors, women who weren't stick-thin"*: Jackie Strause, *"Orange Is the New Black* Creator and Cast Talk Binge-Era Breakthrough and Series Finale in Unfiltered Oral History," *Hollywood Reporter*, July 29, 2019, https://www.hollywoodreporter.com/tv/tv-features/orange-is-new-black-creator-cast-series-finale-oral-history-1227380.

201 *"I would have given my left nut"*: Diane Anderson-Minshall, "Why You Should Watch *Orange Is the New Black*," *Advocate*, July 10, 2013, https://www.advocate.com/print-issue/current-issue/2013/07/10/why-you-should-watch-orange-new-black.

202 *"You are not your crime"*: Emily Nussbaum, "Jenji Kohan's Hot Provocations," *New Yorker*, August 28, 2017, https://www.newyorker.com/magazine/2017/09/04/jenji-kohans-hot-provocations.

202 *"We have no makeup on"*: Gabriel Mac, "*Orange Is the New Black*: Caged Heat," *Rolling Stone*, June 12, 2015, https://www.rollingstone.com/tv-movies/tv-movie-news/orange-is-the-new-black-caged-heat-65164.

203 *"It seemed to be a show about"*: Emily Nussbaum, "Jenji Kohan's Hot Provocations," *New Yorker*, August 28, 2017, https://www.newyorker.com/magazine/2017/09/04/jenji-kohans-hot-provocations.

203 *"They can all fuck themselves"*: Gabriel Mac, *"Orange Is the New Black"*: Caged Heat," *Rolling Stone*, June 12, 2015, https://www.rollingstone.com/tv-movies /tv-movie-news/orange-is-the-new-black-caged-heat-65164.

203 *"There was some expectation that* House of Cards": Jackie Strause, *"Orange Is the New Black* Creator and Cast Talk Binge-Era Breakthrough and Series Finale in Unfiltered Oral History," *Hollywood Reporter*, July 29, 2019, https:// www.hollywoodreporter.com/tv/tv-features/orange-is-new-black-creator -cast-series-finale-oral-history-1227380.

203 *"At some point, Netflix told us that* Bloodline": Todd Kessler, in discussion with the author, July 13, 2022.

204 *"Netflix didn't really understand"*: Ibid.

205 *"When we win a Golden Globe"*: Dade Hayes and Dawn Chmielewski, *Binge Times: Inside Hollywood's Furious Billion-Dollar Battle to Take Down Netflix* (New York: William Morrow, 2022), xv.

205 *"It was as if Walmart had set up"*: Roy Price, in discussion with the author, March 5, 2020.

205 *"If we're talking about the golden age"*: Casey Bloys, in discussion with the author, November 1, 2021.

205 *"Roy's big thing for the first year"*: Ted Hope, in discussion with the author, July 21, 2020.

206 *"We hired no one from the broadcast networks"*: Roy Price, in discussion with the author, March 5, 2020.

206 *"Roy really wanted bold movies"*: Ted Hope, in discussion with the author, July 21, 2020.

206 *"Amazon was happy to have Roy"*: Ted Hope, in discussion with the author, July 21, 2020.

206 *"They'd move in one direction"*: Ibid.

206 *"Still," says an Amazon Studios executive*: Confidential source, in discussion with the author.

207 *"In a data-driven company"*: Bob Berney, in discussion with the author, October 21, 2020.

207 *"I felt like there wasn't a future"*: Ibid.

207 *"We have all these customers"*: Roy Price, in discussion with the author, March 5, 2020.

208 *"Roy had little to do with series selection"*: Confidential source, in discussion with the author.

208 *"once or twice briefly"*: Debra Birnbaum, "Amazon Showrunners React to Roy Price's Ouster," *Variety*, October 16, 2017, https://variety.com/2017/tv/news /amazon-roy-price-jill-soloway-tig-notaro-1202590969.

208 *"'Oh, Shonda wants Jill!'"*: Joey Soloway, in discussion with the author, December 1, 2020.

208 *"There are kids in school who if they"*: Marti Noxon, in discussion with the author, September 15, 2020.

208 *"Shonda called me into her office"*: Joey Soloway, in discussion with the author, December 1, 2020.

208 *"I couldn't get my shows on the air"*: Joey Soloway, in discussion with the author, November 6, 2020.

209 *"My dad phoned me and told me"*: Ariel Levy, "Dolls and Feelings," *New Yorker*, December 6, 2015, https://www.newyorker.com/magazine/2015/12/14/dolls -and-feelings.

209 *"women to feel like they're the subject"*: Jessie Katz, "Dynamic Duos: Jill Soloway and Gaby Hoffmann Are Ready to Inhabit Your Brain," *Hollywood*

Reporter, March 11, 2014, https://www.hollywoodreporter.com/news/general-news/dynamic-duos-jill-soloway-gaby-687730.

209 *"My agent got the word"*: Joey Soloway, in discussion with the author, October 28, 2020.

210 *"It wasn't like going to CBS or NBC"*: Joey Soloway, in discussion with the author, November 6, 2020.

210 *"I was like, 'Oh, my God.'"*: Ibid.

210 *"The consensus view was"*: Joe Lewis, in discussion with the author, December 3, 2020.

211 *"goddamn disaster"*: Jane Martinson, "*Breaking Bad* Network Chief Calls Using Data to Pick Shows a 'Disaster,'" *Guardian*, September 17, 2015, https://www.theguardian.com/media/2015/sep/17/breaking-bad-network-chief-calls-using-data-to-pick-shows-a-disaster.

211 *"surveillance capitalists"*: Ken Auletta, "How the Math Men Overthrew the Mad Men," *New Yorker*, May 21, 2018, https://www.newyorker.com/news/annals-of-communications/how-the-math-men-overthrew-the-mad-men.

211 *"Netflix set the bar with a fire hose"*: Kevin Reilly, in discussion with the author, August 13, 2021.

212 *"I thought I would literally be buried"*: Joe Otterson, "Ryan Murphy on Fox-Disney Merger: 'I Thought I Would Be Buried on the Fox Lot,'" *Variety*, January 4, 2018, https://variety.com/2018/tv/news/ryan-murphy-fox-disney-merger-1202653472.

212 *"it's money coming at you"*: Lacey Rose and Bryn Sandberg, "FX's John Landgraf on Streaming Competition: 'It's Like Getting Shot in the Face with Money,'" *Hollywood Reporter*, August 9, 2017, https://www.hollywoodreporter.com/tv/tv-news/fxs-john-landgraf-competing-netflix-amazon-like-getting-shot-face-money-day-1028106.

212 *"My whole life has been in search"*: Sam Lansky, "How Ryan Murphy Became King of the Streaming Boom," *Time*, September 3, 2019, https://time.com/5667752/ryan-murphy-netflix.

213 *"The buck stops with Ted"*: Lesley Goldberg, Natalie Jarvey, and Kim Masters, "Inside Netflix's Surprising TV Chief Shake-Up," *Hollywood Reporter*, September 10, 2020, https://www.hollywoodreporter.com/tv/tv-news/inside-netflixs-surprising-tv-chief-shake-up-4058148.

213 *"backend theft"*: Nellie Andreeva, "Jeff Sagansky Says New Streaming Business Model 'Has to Be Relegated to the Dust Bin' Now," *Deadline*, July 6, 2022, https://deadline.com/2022/07/jeff-sagansky-new-streaming-business-model-1235058955.

213 *"We are in a golden age of content"*: Anousha Sakoui, "A Golden Age of Content? How Producers Are Looking for Their Share," *Los Angeles Times*, September 6, 2022, https://www.latimes.com/entertainment-arts/business/newsletter/2022-09-06/wide-shot-newsletter-the-wide-shot.

213 *"Without syndication, you can't monetize"*: Steven Soderbergh, in discussion with the author, April 4, 2023.

214 *"No one has ever made money selling"*: Rob Long, "Pod: The Case for Broadcast TV," *Ankler*, April 30, 2022, podcast, https://theankler.com/p/pod-the-case-for-broadcast-tv.

215 *"It's Harry Potter"*: Nicole Sperling, "'Harry Potter for Adults': Netflix Lures *Bridgerton* Fans with Live Events," *New York Times*, March 22, 2022, https://www.nytimes.com/2022/03/22/business/media/bridgerton-netflix-live-events.html.

215 *"first-ever multi-title immersive"*: Wendy Lee, "Vecna Comes to the Grove as Netflix Debuts Pop-up Store," *Los Angeles Times*, October 11, 2022, https://www.latimes.com/entertainment-arts/business/story/2022-10-11/lat-et-ct-netflix-the-grove-shopping.

215 *"It's now just commerce"*: Nicole Laporte, "The Squeeze: Producers on 'No Trust,' Anger, Struggle," *Ankler*, November 18, 2022, https://theankler.com/p/the-squeeze-producers-on-no-trust.

Chapter 10: Amazon's Women in the High Castle

216 *"the father of three adult children"*: Joey Soloway, in discussion with the author, November 6, 2020.

216 *"Roy wasn't working creatively"*: Joey Soloway, in discussion with the author, December 1, 2020.

217 *"I'm not saying destroy the category"*: Jackie Strause, "Blowing Up the Binary: How *Transparent* Season 4 Is Personal for Jill Soloway," *Hollywood Reporter*, September 25, 2017, https://www.hollywoodreporter.com/tv/tv-news/transparent-season-4-jill-soloway-gender-binary-1042629.

218 *"That's one of the things I got"*: Aisha Harris, "The 20 Best TV Dramas Since *The Sopranos*," *New York Times*, January 10, 2019, https://www.nytimes.com/interactive/2019/arts/television/best-drama-series.html.

218 *"the reason Amazon needs"*: Sam Wollaston, "*Transparent* Review–The Best Thing on TV at the Moment," *Guardian*, September 26, 2016, https://www.theguardian.com/tv-and-radio/2016/sep/26/transparent-review-the-best-thing-on-tv-at-the-moment.

219 *"had had trouble getting Apple"*: Shalini Ramachandran and Daisuke Wakabayashi, "Apple's Hard-Charging Tactics Hurt TV Expansion," *Wall Street Journal*, July 28, 2016, https://www.wsj.com/articles/apples-hard-charging-tactics-hurt-tv-expansion-1469721330.

219 *Here is a partial list of further security directives*: Confidential source, in discussion with the author.

221 *the TV experience "sucked"*: Husain Sumra, "Eddy Cue: It's 'Complicated' Solving Problems with TV," *MacRumors*, May 28, 2014, https://www.macrumors.com/2014/05/29/cue-apple-tv-complicated.

221 *"Zack and Jamie are terrific widget factory"*: Vlad Wolynetz, in discussion with the author, January 21, 2020.

221 *"Zack and Jamie have a good reputation"*: Confidential source, in discussion with the author.

221 *"Your job at a studio"*: Joe Lewis, in discussion with the author, December 3, 2020.

221 *"The guiding word is 'humanity'"*: Cynthia Littleton, "Apple TV Plus Chiefs on Building the Ambitious Video Venture From Scratch," *Variety*, October 29, 2019, https://variety.com/2019/tv/news/apple-tv-plus-jamie-erlicht-zack-van-amburg-interview-1203386227.

222 *"Zack and I knew how to create a premium"*: Ben Travers, "Apple TV+ Makes Its Hollywood Debut with Lavish *For All Mankind* Premiere," *IndieWire*, October 16, 2019, https://www.indiewire.com/gallery/apple-tv-for-all-mankind-premiere-photos.

222 *"vaginal hygiene"*: Lucas Shaw, "Apple's Billion-Dollar Bet on Hollywood Is the Opposite of Edgy," *Bloomberg Businessweek*, October 25, 2017, https://www.bloomberg.com/news/articles/2017-10-25/apple-s-billion-dollar-bet-on-hollywood-is-the-opposite-of-edgy.

222 *"Netflix is just soooo Android"*: Entertainment Strategy Guy, "Worst-Case Scenario: Apple TV+," *Ankler*, July 21, 2022, https://theankler.com/p/worst-case-scenario-apple-tv.

222 *"Don't be so mean"*: Alexandra Steigrad and Nicolas Vega, "Apple's Hollywood Venture Marred by 'Intrusive' Execs, Including Tim Cook," *New York Post*, March 3, 2019, https://nypost.com/2019/03/03/appless-hollywood-venture-marred-by-intrusive-execs.

222 *"There's never been one note"*: Stuart McGurk, "Can Apple Hack It in Hollywood? We Talk to the Man Behind Apple TV+," *GQ* (UK), July 1, 2019, https://www.gq-magazine.co.uk/article/apple-tv-eddy-cue-interview.

223 *"Apple isn't interested in the types of shows"*: Lucas Shaw, "Apple's Billion-Dollar Bet on Hollywood Is the Opposite of Edgy," *Bloomberg Businessweek*, October 25, 2017, https://www.bloomberg.com/news/articles/2017-10-25/apple-s-billion-dollar-bet-on-hollywood-is-the-opposite-of-edgy.

223 *"expensive NBC"*: Tripp Mickle and Joe Flint, "No Sex Please, We're Apple: iPhone Giant Seeks TV Success on Its Own Terms," *Wall Street Journal*, September 22, 2018, https://www.wsj.com/articles/no-sex-please-were-apple-iphone-giant-seeks-tv-success-on-its-own-terms-1537588880.

224 *"shares customer data with the Chinese"*: Jack Nicas, "Apple's Compromises in China: 5 Takeaways," *New York Times*, May 17, 2021, https://www.nytimes.com/2021/05/17/technology/apple-china-privacy-censorship.html.

224 *three years elapsed:* Tyler Sonnemaker, "Apple knew a supplier was using child labor . . ." *Business Insider*, December 31, 2020.

224 *"unrest" among its employees:* Jack Nicas and Kellen Browning, "Tim Cook Faces Surprising Employee Unrest at Apple," *New York Times*, September 17, 2021, https://www.nytimes.com/2021/09/17/technology/apple-employee-unrest.html.

225 *"I think that what's most chilling"*: Shirley Li, *"The Man in the High Castle* Creator Frank Spotnitz Talks Series' Themes, Plus Two Exclusive Photos," *Entertainment Weekly*, August 22, 2015, https://ew.com/article/2015/08/22/man-high-castle-creator-frank-spotnitz-themes-photos.

225 *"You will love my dick"*: Kim Masters, "Amazon TV Producer Goes Public with Harassment Claim Against Top Exec Roy Price (Exclusive)," *Hollywood Reporter*, October 12, 2017, https://www.hollywoodreporter.com/news/general-news/amazon-tv-producer-goes-public-harassment-claim-top-exec-roy-price-1048060.

225 *"I never said that"*: Roy Price, in discussion with the author, November 25, 2020.

225 *"She came up to me and was jokingly"*: Ibid.

225 *"In the end, if you're found guilty"*: Ibid.

226 *"was suspended"*: John Koblin and Nick Wingfield, "Amazon Studios Chief Suspended After Sexual Harassment Claim," *New York Times*, October 12, 2017, https://www.nytimes.com/2017/10/12/business/media/amazon-roy-price-isa-dick-hackett.html.

226 *"It's one thing if you're a bank robber"*: Roy Price, in discussion with the author, November 25, 2020.

226 *"If Amazon was so sexist"*: Lynda Obst, in discussion with the author, November 17, 2020.

226 *"He was only as sexist and misogynist"*: Joey Soloway, in discussion with the author, November 6, 2020.

227 *"Your head's down, working"*: Graham Yost, in discussion with the author, October 26, 2022.

227 *"everything [was] in chaos"*: Jackie Strause and Kate Stanhope, "David E. Kelley Calls Amazon Studios 'A Bit of a *Gong Show*,'" *Hollywood Reporter*, October 6, 2017, https://www.hollywoodreporter.com/news/general-news/david-e-kelley-calls-amazon-studios-a-bit-a-gong-show-1046453.

228 *"a puddle of mediocrity"*: Hank Stuever, "In Apple TV+'s Initial Smattering of Shows, Only *Dickinson* Is a Delicious Surprise," *Washington Post*, October 31, 2019, https://www.washingtonpost.com/entertainment/tv/in-apple-tvs-initial-smattering-of-shows-only-dickinson-is-a-delicious-surprise/2019/10/31/d0fba890-fb31-11e9-8906-ab6b60de9124_story.html.

229 *"a swollen snoozefest"*: Lucy Mangan, "*Lisey's Story* Review–A Swollen Snoozefest from Stephen King," *Guardian*, June 4, 2021, https://www.theguardian.com/tv-and-radio/2021/jun/04/liseys-story-review-stephen-king-julianne-moore.

229 *"overstuffed epic"*: James Poniewozik, "Review: The Math of *Foundation* Doesn't Add Up," *New York Times*, September 23, 2021, https://www.nytimes.com/2021/09/23/arts/television/review-foundation.html.

229 *"It has a weak creative team"*: Confidential source, in discussion with the author.

229 *"If it disappeared tomorrow"*: Confidential source, in discussion with the author.

230 *"a sunshine enema"*: Jeremy Egner, "'Ted Lasso' Is Back, but No Longer an Underdog," *New York Times*, July 15, 2021, https://www.nytimes.com/2021/07/14/arts/television/ted-lasso-jason-sudeikis.html.

230 *"If people could look at this show"*: Patricia Puentes, "*Ted Lasso*: You don't need to love soccer to love Jason Sudeikis' new comedy," *CNET*, August 15, 2020, https://www.cnet.com/culture/entertainment/ted-lasso-you-dont-need-to-love-soccer-to-love-jason-sudeikis-new-comedy.

230 *"engineered by Pixar"*: Doreen St. Félix, "*Ted Lasso* Can't Save Us," *New Yorker*, August 9, 2021, https://www.newyorker.com/magazine/2021/08/16/ted-lasso-cant-save-us.

230 *"sentimentality triumphing"*: Manohla Dargis and A. O. Scott, "Does the Academy Hold Movies in Contempt? Our Critics Wonder," *New York Times*, March 28, 2022, https://www.nytimes.com/2022/03/28/movies/academy-awards-oscars-critics.html.

230 *"In a time of crisis, the Academy"*: Nate Jones, "How *CODA* Won Best Picture," *Vulture*, March 29, 2022, https://www.vulture.com/2022/03/how-coda-won-best-picture-at-the-2022-oscars.html.

231 *"a slobbering puppy"*: Manohla Dargis, "'Cha Cha Real Smooth' Review: The Boy in the Bubble," *New York Times*, June 16, 2020, https://www.nytimes.com/2022/06/16/movies/cha-cha-real-smooth-review.html.

231 *"where heart wins out over cynicism"*: Mike Fleming Jr., "Duffer Brothers Launch Netflix Shingle Upside Down Pictures," *Deadline*, July 6, 2022, https://deadline.com/2022/07/stranger-things-duffer-brothers-netflix-upside-down-pictures-deal-spinoff-series-stephen-daldry-stage-play-manga-death-note-the-talisman-1235058665.

231 *"a giant bowl of mac and cheese"*: Lorraine Ali, "Last year, we turned to TV for comfort. Emmy voters followed suit," *Los Angeles Times*, July 13, 2021, https://www.latimes.com/entertainment-arts/tv/story/2021-07-13/2021-emmy-nominations-the-crown-mandalorian-wandavision-ted-lasso.

232 *"Plepler literally walked up"*: Confidential source, in discussion with the author.

232 *"the worst executive I have ever met"*: Ibid.

233 *Raeden Greer says he tried:* Cheyenne Roundtree, "'Bond' Director Joji Fukunaga Pressured Me into Going Nude," *Daily Beast,* October 13, 2021, https://www.thedailybeast.com/bond-director-cary-joji-fukunaga-pressured-me-into-going-nude.

233 *According to a lengthy exposé in* Rolling Stone: Cheyenne Roundtree, "'He Needs to Be Stopped': Source Say Cary Fukunaga 'Abused His Power' to Pursue Young Women on Set," *Rolling Stone,* May 31, 2022, https://www.rollingstone.com/tv-movies/tv-movie-features/cary-fukunaga-no-time-to-die-1359656.

233 *"I want this to be* Top Gun*":* Confidential source, in discussion with the author.

234 *"Who's in charge here?":* Graham Yost, in discussion with the author, October 26, 2022.

234 *"Cary wouldn't do anything":* Confidential source, in discussion with the author.

234 *"was very near and dear to my heart":* Graham Yost, in discussion with the author, October 26, 2022.

234 *"at least $35 million":* Confidential source, in discussion with the author.

235 *It used to be said that strengthening:* Kara Swisher, "AT&T's Sorry Retreat From Digital Media," *New York Times,* May 21, 2021, https://www.nytimes.com/2021/05/21/opinion/att-discover-merger.html.

235 *"until they drown":* Steven Soderbergh, in discussion with the author, April 4, 2023.

236 *"My back was against the wall":* Maggie Astor, "Jeffrey Tambor Leaves *Transparent* After Sexual Misconduct Allegations," *New York Times,* November 19, 2017, https://www.nytimes.com/2017/11/19/arts/television/jeffrey-tambor-transparent.html.

236 *"I have never been a predator":* Seth Abramovitch, "'Lines Got Blurred': Jeffrey Tambor and an Up-Close Look at Harassment Claims on *Transparent,*" *Hollywood Reporter,* May 7, 2018, https://www.hollywoodreporter.com/movies/movie-features/lines-got-blurred-jeffrey-tambor-an-up-close-look-at-harassment-claims-transparent-1108939.

236 *"It was almost like, 'Who on earth'":* Christina Binkley, "How Jennifer Salke Turned Amazon Studios into a Storytelling Powerhouse," *Elle,* October 14, 2019, https://www.elle.com/culture/movies-tv/a29461367/jennifer-salke-amazon.

236 *"Years ago, people would say":* Ibid.

237 *"We're not going for something":* Brooks Barnes and John Koblin, "Amazon Studios' New Boss Is Reshaping Its Strategy. Step One: Lure New Talent.," *New York Times,* June 11, 2018, https://www.nytimes.com/2018/06/11/business/media/amazon-studios-jennifer-salke.html.

237 *"Salke's is the opposite":* Ted Hope, in discussion with the author, July 21, 2020.

237 *"World-changing events":* Jeremy Egner, "'House of the Dragon,' Season 1, Episode 5 Recap: Wedding Crashers," *New York Times,* September 18, 2022, https://www.nytimes.com/2022/09/18/arts/television/house-of-the-dragon-season-1-episode-5-recap.html.

238 *"global event . . . most expensive show":* Borys Kit, "Russo Bros.' Amazon Series *Citadel* Creative Overhaul Balloons Budget to $200M-Plus (Exclusive)," *Hollywood Reporter,* September 1, 2022, https://www.hollywoodreporter.com/movies/movie-features/russo-bros-amazon-series-citadel-1235210256.

238 *"offensively dull":* Kyle Fowle, "Amazon's Spy Thriller Is Offensively Dull," *TV Guide,* April 28, 2023.

238 *"In a world of many"*: Kevin Beggs, in discussion with the author, June 14, 2021.

239 *In 2019, the last prepandemic year:* Jamie Lauren Keiles, *"Avatar* and the Mystery of the Vanishing Blockbuster," *New York Times,* November 30, 2022, https://www.nytimes.com/2022/11/30/magazine/avatar-franchise .html.

239 *"vast, deep catalogue"*: Alex Weprin, "MGM's Amazon Era Begins with Big, Unaswered Questions," *Hollywood Reporter,* March 23, 2022, https://www .hollywoodreporter.com/business/business-news/mgms-amazon-era -begins-with-big-unanswered-questions-1235116671.

239 *"We thought there was a lane"*: Aditya Talwar, "MGM President Pamela Abdy Preaches Virtues of Originality," *Animated Times,* September 26, 2021, https://www.animatedtimes.com/mgm-president-pamela-abdy-preaches -virtues-of-originality.

240 *"We still want to push the boundaries"*: Confidential source, in discussion with the author.

240 *"I would like to think it would"*: Christina Sperling, in discussion with the author, October 15, 2020.

240 *"Maybe not"*: Confidential source, in discussion with the author.

241 *"Reed Hastings and Ted Sarandos and the team"*: Jeff Bezos (@JeffBezos), ".@ReedHastings and Ted Sarandos and the team at @Netflix . . . ," Twitter, October 2, 2021, 6:39 p.m., https://twitter.com/jeffbezos/status /1444431829214248960.

241 *"Amazon does not have an ethos"*: Confidential source, in discussion with the author.

Chapter 11: Disney's Empire Strikes Back

242 *"occupies a sofa well"*: Michael Wolff, "Executives at the Gate," *Vanity Fair,* April 30, 2008, https://www.vanityfair.com/news/2004/12/wolff200412.

242 *"When he calls I don't spend time thinking"*: Brooks Barnes, "Is Disney's Chief Having a Cinderella Moment?," *New York Times,* April 10, 2010, https://www .nytimes.com/2010/04/11/business/11iger.html.

242 *"We view them . . . as competitors"*: Kara Swisher, "Disney's Former C.E.O. Gave Me the Exit Interview I Asked For," *Sway,* podcast, *New York Times,* December 27, 2022, https://www.nytimes.com/2022/01/27/opinion/sway-kara -swisher-bob-iger.html.

243 *"Netflix-Loving Kids Are Killing Cable TV"*: Lucas Shaw, "Netflix-Loving Kids Are Killing Cable TV," *Bloomberg,* April 25, 2018, https://www.bloomberg .com/news/articles/2018-04-25/netflix-loving-tykes-tune-out-nickelodeon -in-kid-tv-s-worst-year.

243 *According to* Cord Cutters News: Michael Schneider, "Most-Watched Television Networks: Ranking 2019's Winners and Losers," *Variety,* December 26, 2019, https://variety.com/2019/tv/news/network-ratings-top-channels-fox -news-espn-cnn-cbs-nbc-abc-1203440870/; Luke Bouma, "As Cord Cutting Grows the Disney Channel Has Lost 72% of Its Average Audience," *Cord Cutters News,* April 11, 2019, https://cordcuttersnews.com/as-cord-cutting -grows-the-disney-channel-has-lost-72-of-its-average-audience.

243 *"an alarm bell"*: Natalie Jarvey, "Disney over the Top: Bob Iger Bets the Company (and Hollywood's Future) on Streaming," *Hollywood Reporter,* October 16, 2019, https://www.hollywoodreporter.com/movies/movie-features /bob-iger-bets-company-hollywood-s-future-streaming-1247663.

243 *"You don't really have a choice"*: Kara Swisher, "Disney's Former C.E.O. Gave Me the Exit Interview I Asked For," *Sway,* podcast, *New York Times,*

December 27, 2022, https://www.nytimes.com/2022/01/27/opinion/sway
-kara-swisher-bob-iger.html.

243 *"I woke up one day and thought"*: Ibid.

244 *"The Pixar deal gave Iger"*: Confidential source, in discussion with the author.

245 *"Thank God that Disney bought us"*: Josef Adalian, "'We Had to Learn Every-
thing Over Again': How FX Survived the Streaming Wars," *Vulture*, Janu-
ary 12, 2023, https://www.vulture.com/article/fx-john-landgraf-interview
-streaming-evolution.html.

245 *"Nobody expected Bob Iger"*: Maureen Dowd, "The Slow-Burning Success of
Disney's Bob Iger," *New York Times*, September 22, 2019, https://www.ny-
times.com/2019/09/22/style/disney-bob-iger-book.html.

245 *Disney's Dumbo-size chunk*: Ibid.

246 *AT&T employees referred to Stephenson*: James B. Stewart, "Was This $100
Billion Deal the Worst Merger Ever?," *New York Times*, November 19, 2022,
https://www.nytimes.com/2022/11/19/business/media/att-time-warner
-deal.html.

246 *"fit together very well"*: Felix Gillette and John Koblin, *It's Not TV: The Spec-
tacular Rise, Revolution, and Future of HBO* (New York: Viking, 2022), 296.

246 *"a Chinese wall between the creative"*: John Koblin, "Media's Odd Couple:
Proudly Freewheeling HBO and Buttoned-Up AT&T," *New York Times*, Oc-
tober 30, 2016, https://www.nytimes.com/2016/10/31/business/media/new
-media-odd-couple-hbo-att.html.

246 *"We don't have the tech platform"*: Cecilia Kang, "Time Warner C.E.O. Testi-
fies That AT&T Merger Is Needed to Battle Silicon Valley," *New York Times*,
April 18, 2018, https://www.nytimes.com/2018/04/18/business/time-warner
-att-merger.html.

247 *"a superlative businessman"*: "WarnerMedia New York Town Hall at HBO,"
conversation between Richard Plepler and John Stankey, HBO, June 27, 2018,
YouTube, video, https://youtu.be/pA68mz7qUhk.

247 *"It's going to be a tough year"*: Edmund Lee and John Koblin, "HBO Must Get
Bigger and Broader, Says Its New Overseer," *New York Times*, July 8, 2018,
https://www.nytimes.com/2018/07/08/business/media/hbo-att-merger.html.

247 *"Are our jobs secure?"*: Ibid.

248 *"I'm sick of hearing this!"*: Alexandra Steigrad, "HBO Staffers Clash with Di-
vision Chief over Streaming Plans: Sources," *New York Post*, August 18, 2019,
https://nypost.com/2019/08/18/execs-style-puts-hbo-streaming-plan-in
-peril-critics.

248 *"We do that," Stankey retorted*: Edmund Lee and John Koblin, "HBO Must Get
Bigger and Broader, Says Its New Overseer," *New York Times*, July 8, 2018,
https://www.nytimes.com/2018/07/08/business/media/hbo-att-merger.html.

248 *"direct-to-consumer platforms"*: Todd Spangler, "AT&T CEO: *Game of Thrones*
Episodes May Be Better Cut Down to 20 Minutes for Mobile," *Variety*, May 23,
2017, https://variety.com/2017/digital/news/game-of-thrones-mobile-episodes
-att-time-warner-merger-1202441208.

248 *"bits in pipes"*: Elaine Low, "Drop the 'HBO.' Just 'Max.' It's Cleaner (Wait—Is
It?)," *Ankler*, April 12, 2023, https://theankler.com/p/drop-the-hbo-just-max
-its-cleaner#details.

248 *"AT&T understands that we have"*: Richard Plepler, in discussion with the
author, July 20, 2018.

249 *"absolutely determined not to turn"*: Maureen Dowd, "The Slow-Burning
Success of Disney's Bob Iger," *New York Times*, September 22, 2019, https://
www.nytimes.com/2019/09/22/style/disney-bob-iger-book.html.

249 *"The Disney version becomes"*: Aisha Harris, "Rewriting the Past Won't Make Disney More Progressive," *New York Times*, May 27, 2019, https://www.nytimes.com/2019/05/27/movies/aladdin-disney-diversity.html.

249 *When* Toy Story 2 *was released:* Jazz Tangcay, "Disney Plus Censors Casting Couch Joke in *Toy Story 2* and Other Subtle Edits," *Variety*, April 16, 2020, https://variety.com/2020/artisans/news/disney-plus-censors-toy-story-2-1234582535.

250 *"The prevailing wisdom was that"*: Chris Nee, in discussion with the author, April 22, 2021.

251 *"The level of malpractice"*: James B. Stewart, "Was This $100 Billion Deal the Worst Merger Ever?," *New York Times*, November 19, 2022, https://www.nytimes.com/2022/11/19/business/media/att-time-warner-deal.html.

252 *"No strategic thinker"*: Bob Greenblatt, in discussion with the author, July 15, 2021.

252 *"took out a huge chunk"*: Confidential source, in discussion with the author.

252 *"Executives get more credit"*: Richard Plepler, in discussion with the author, February 16, 2023.

252 *"I also have to protect"*: Aubrey Carlson, Maya Salam, et al., "#MeToo Brought Down 201 Powerful Men. Nearly Half of Their Replacements Are Women.," *New York Times*, October 29, 2018, https://www.nytimes.com/interactive/2018/10/23/us/metoo-replacements.html; Anna Nicolaou, "Culture Clash Takes Richard Plepler out of the Picture at HBO," *Financial Times*, March 2, 2019, https://www.ft.com/content/bba1791e-3c66-11e9-b72b-2c7f526ca5d0.

253 *"the ultimate white guy"*: Confidential source, in discussion with the author.

253 *"dismissive, borderline offensive"*: Ibid.

253 *Many screens were sited in "zombie malls"*: Brooks Barnes, "Movie Theaters Had a Great Summer. But There's a Plot Twist," *New York Times*, September 4, 2022, https://www.nytimes.com/2022/09/04/business/movie-theaters-closing-bankruptcy.html.

253 *"under the bus"*: A. O. Scott, "Steven Spielberg Gets Personal," *New York Times*, November 9, 2022, https://www.nytimes.com/2022/11/09/movies/steven-spielberg-the-fabelmans.html.

253 *"Without question, Kilar"*: Kim Masters, "Kim Masters on Hollywood's Year of Wishful Thinking," *Hollywood Reporter*, December 20, 2022, https://www.hollywoodreporter.com/business/business-news/kim-masters-hollywoods-2022-year-1235282889.

254 *"Ricky's expertise, outside of marketing"*: Confidential source, in discussion with the author.

254 *"To be successful in making content"*: Brooks Barnes, "Disney's Streaming Service Starts to Come Into Focus," *New York Times*, August 5, 2018, https://www.nytimes.com/2018/08/05/business/media/disney-streaming-service-ricky-strauss.html.

254 *"Everything had to bubble up to Ricky"*: Confidential source, in discussion with the author.

255 *"Disney is filled with people"*: Nancy Kanter, in discussion with the author, January 18, 2021.

256 *Terri Minsky wrote the pilot:* Terri Minsky, in discussion with the author, January 5, 2021; Julia Boorstin, "Disney's 'Tween Machine How the Disney Channel Became Must-See TV—and the Company's Unlikely Cash Cow," *Fortune*, September 29, 2003, *CNN Money*, https://money.cnn.com/magazines/fortune/fortune_archive/2003/09/29/349896/index.htm.

257 *"There was never any discussion"*: Confidential source, in discussion with the author.

257 *"There were literally three rows"*: Ellie Woodward, "The Cast of *Lizzie McGuire* Spoke Out About Disney's 'Ridiculous' Decision to Cancel the Reboot and It's Pretty Shady," *BuzzFeedNews*, January 15, 2021, https://www.buzzfeed .com/elliewoodward/lizzie-mcguire-cast-spoke-out-disney-decision-cancel -reboot.

257 *"You don't give notes"*: Confidential source, in discussion with the author.

257 *"What Netflix is doing is making"*: Maureen Dowd, "The Slow-Burning Success of Disney's Bob Iger," *New York Times*, September 22, 2019, https:// www.nytimes.com/2019/09/22/style/disney-bob-iger-book.html.

257 *"I was ready to play outside"*: Nancy Kanter, in discussion with the author, January 18, 2021.

258 *"To get a same-sex family"*: Chris Nee, in discussion with the author, April 22, 2021.

258 *"didn't require you to make a show"*: Josef Adalian, "Shonda Rhimes on Moving to Netflix: 'We Know a Large Amount of What We're Going to Be Making,'" *Vulture*, June 11, 2018, https://www.vulture.com/2018/06/shonda-rhimes -netflix-unscripted-tv.html.

258 *"For the most part I found the Netflix"*: Chris Nee, in discussion with the author, April 22, 2021.

259 *"so it's 'so far so good'"*: Ibid.

259 *"There was one creator there"*: Confidential source, in discussion with the author.

259 *"No. I would consider that"*: Ibid.

259 *The magnitude of the layoffs caused*: Meredith Woerner, "Abigail Disney Calls Bob Iger's $65 Million Compensation 'Insane,'" *Variety*, April 21, 2019, https://variety.com/2019/biz/news/abigail-disney-bob-iger-salary-insane -1203194159.

260 *"Let's not pretend"*: Alex Welprin, "Disney 'Needs to Be Saved From Itself,' Says Abigail Disney," *Hollywood Reporter*, December 18, 2020, https://www .hollywoodreporter.com/business/business-news/disney-needs-to-be -saved-from-itself-says-abigail-disney-4107369.

260 *"forage for food"*: Shannon Liao, "Abigail Disney Visited Disneyland. She Is 'Livid' About What She Saw," *CNN Business*, July 17, 2019, https://www.cnn .com/2019/07/16/media/abigail-disney-disneyland-undercover/index.html; Jordan Valinsky, "Abigail Disney on Disney Furloughs: 'What the Actual F—?,'" *CNN Business*, July 22, 2020, https://www.cnn.com/2020/04/22/business/ abigail-disney-furloughs-bonus-pay-coronavirus-trnd/index.html.

260 *"Top filmmakers are dying"*: Matthew Belloni, "It's Time to Take *Star Wars* Movies Away from Kathy Kennedy," *Puck*, November 14, 2021, https://puck .news/its-time-to-take-star-wars-movies-away-from-kathy-kennedy.

261 *"borderline corporate negligence"*: Matthew Belloni, "The Next *Star Wars* Movie Terrifies Lucasfilm," *Puck*, October 23, 2022, https://puck.news/the -next-star-wars-movie-terrifies-lucasfilm.

262 *recommended rewatching five films:* Sarah Bahr, "What to Know Before Seeing *Doctor Strange in the Multiverse of Madness*," *New York Times*, May 4, 2022, https://www.nytimes.com/2022/05/04/movies/doctor-strange-multiverse -of-madness-preview.html.

262 *"pixel-fucked" by the studio's:* Chris Lee, "I'm a VFX Artist and I'm Tired of Getting 'Pixel-F—ked' by Marvel," *Vulture*, July 26, 2022, https://www .vulture.com/article/a-vfx-artist-on-what-its-like-working-for-marvel.html.

263 *"Sundance to spandex"*: Ann Hornaday, "Comic Books Have Taken Over the Movies. Must They Take Our Indie Auteurs, Too?," *Washington Post*, July 8, 2021, https://www.washingtonpost.com/entertainment/black-widow-auteur-director/2021/07/07/aff5a978-de67-11eb-9f54-7eee10b5fcd2_story.html.

264 *"Things had been quite good"*: Kara Swisher, "Disney's Former C.E.O. Gave Me the Exit Interview I Asked For," *Sway*, podcast, *New York Times*, December 27, 2022, https://www.nytimes.com/2022/01/27/opinion/sway-kara-swisher-bob-iger.html.

264 *"a person who never held"*: Alex Weprin, "Disney 'Needs to Be Saved From Itself,' Says Abigail Disney," *Hollywood Reporter*, December 18, 2020, https://www.hollywoodreporter.com/business/business-news/disney-needs-to-be-saved-from-itself-says-abigail-disney-4107369.

264 *"Historically, it has been easier for CEOs"*: Rick Rosen, in discussion with the author, September 1, 2022.

264 *"essentially abandoned the middle class"*: Hannah Sampson, "Disney Parks Are Raising Prices Again," *Washington Post*, October 12, 2022, https://www.washingtonpost.com/travel/2022/10/12/disney-world-genie-plus-price.

265 *"sad and distressing in its callous disregard"*: Brooks Barnes and Nicole Sperling, "Scarlett Johansson Sues Disney over *Black Widow* Release," *New York Times*, July 29, 2021, https://www.nytimes.com/2021/07/29/business/media/scarlett-johansson-black-widow-disney-lawsuit.html.

265 *"it seemed like Iger wouldn't"*: Meg James, "Behind the Stunning Exit of Disney CEO Bob Chapek," *Los Angeles Times*, November 21, 2022, https://www.latimes.com/entertainment-arts/business/story/2022-11-21/bob-chapek-disney-ouster-bog-iger.

Chapter 12: Can WBD's Kid Stay in the Picture?

266 *"the worst media strategist"*: Seung Lee, "The Cold War Between Yahoo and Kara Swisher," *Newsweek*, November 9, 2015, https://www.newsweek.com/yahoo-kara-swisher-392206; Kara Swisher, "AT&T's Sorry Retreat from Digital Media," *New York Times*, May 21, 2021, https://www.nytimes.com/2021/05/21/opinion/att-discover-merger.html.

267 *"Laid-Off HBO Max Execs"*: Adam Manno, "Laid-Off HBO Max Execs Reveal Warner Bros. Discovery Is Killing Off Diversity and Courting 'Middle America,'" *Daily Beast*, August 25, 2022, https://www.thedailybeast.com/laid-off-hbo-max-execs-reveal-warner-bros-discovery-is-killing-off-diversity-and-courting-middle-america.

268 *"I think Zaslav sees"*: Confidential source, in discussion with the author.

268 *"He's really, really tough"*: Kim Masters, "As David Zaslav Takes Deal Crown, How Will He Rule His Discovery-WarnerMedia Empire?," *Hollywood Reporter*, May 18, 2021, https://www.hollywoodreporter.com/business/business-news/david-zaslav-discovery-warnermedia-plans-1234955316.

268 *"a revolving door"*: Confidential source, in discussion with the author.

268 *"Right away I thought"*: David Zaslav, in discussion with the author, January 18, 2021.

268 *"How a Golf Tournament"*: Kenneth Li and Krystal Hu, "How a Golf Tournament Led to the Merger of Discovery, WarnerMedia," Reuters, May 17, 2021, https://www.reuters.com/technology/how-canceled-golf-tournament-led-merger-discovery-warnermedia-2021-05-17.

268 *"You don't buy a company"*: David Zaslav, in discussion with the author, January 18, 2021.

269 *"Netflix and Disney seem to be running"*: Ibid.

269 *"If you were in Sun Valley"*: Michael Fuchs, in discussion with the author, May 8, 2022.

269 *According to the* New York Times*, Zaz*: Benjamin Mullin, "'Cable Cowboy' John Malone Sees More Streaming Bundles Ahead," *New York Times*, August 21, 2022, https://www.nytimes.com/2022/08/21/business/media/john-malone-streaming-bundles-cable.html.

269 *"You opened up the closet"*: Jill Goldsmith, "David Zaslav on DC Rising, Ad Market Tanking, HBO's Losses & WBD's New Streaming Playbook," *Deadline*, November 15, 2022, https://deadline.com/2022/11/dc-david-zaslav-warner-bros-discovery-hbo-max-1235172584.

270 *was "fucked up"*: Ryan Faughnder, "DC Studios Slate Unveiled: James Gunn and Peter Safran's Plan to Unify the Comic Book Empire," *Los Angeles Times*, January 31, 2023, https://www.latimes.com/entertainment-arts/business/story/2023-01-31/dc-warner-bros-presentation-boctatman-superman-james-gunn.

270 *"Zaslav is like a joke"*: Michael Fuchs, in discussion with the author, December 8, 2022.

270 *"will not overspend to drive"*: Jennifer Maas, "David Zaslav Vows Warner Bros. Discovery 'Will Not Overspend to Drive Subscriber Growth,'" *Variety*, April 26, 2022, https://variety.com/2022/tv/news/warner-bros-discovery-not-overspend-streaming-david-zaslav-1235240905.

270 *"'the top of the funnel'"*: Claudia Eller and Cynthia Littleton, "How David Zaslav Plans to Combine Discovery and WarnerMedia to Unleash 'Shock and Awe' on the Streaming Wars," *Variety*, December 8, 2021, https://variety.com/2021/biz/entertainment-industry/david-zaslav-warner-bros-discovery-1235127820.

271 *"If they are old Discovery"*: Confidential source, in discussion with the author.

271 *"Home to the World's Best Storytellers"*: "Warner Bros. Discovery," careers webpage, Warner Bros. Discovery, accessed March 1, 2023, https://careers.wbd.com/global/en.

271 *"There was a time when"*: Ryan Faughnder, "As Streaming Services Get Frugal, Programming Changes Throw Hollywood Creators for a Loop," *Los Angeles Times*, August 16, 2022, https://www.latimes.com/entertainment-arts/business/newsletter/2022-08-16/streaming-services-programming-changes-wide-shot-newsletter-the-wide-shot.

272 *"Hi there, new business daddy"*: Savannah Walsh, "John Oliver Takes Shots at 'New Business Daddy' Warner Bros. Discovery," *Vanity Fair*, August 8, 2022, https://www.vanityfair.com/hollywood/2022/08/john-oliver-takes-shots-at-new-business-daddy-warner-bros-discovery.

272 *"A recession is coming"*: Brooks Barnes, "After #MeToo Reckoning, a Fear Hollywood Is Regressing," *New York Times*, October 24, 2022, https://www.nytimes.com/2022/10/24/business/media/hollywood-metoo.html.

272 *"doesn't know what he doesn't know"*: Kim Masters, "Megabanter 2022: Wall St. ditches streaming, Disney undergoes a shakeup," *KCRW*, December 23, 2022, https://www.kcrw.com/culture/shows/the-business/mega-banter-2022-wall-street-ditches-streaming-disney-suffers-major-shakeup.

272 *"He knows what he doesn't know"*: Lucia Moes, "How David Zaslav is transforming Warner Bros. Discovery, from layoffs and a major reorg to launching a new mega-streaming app, Max," *Insider*, April 13, 2023, https://www.businessinsider.com/warner-bros-discovery-merger-compete-netflix-disney-streaming-david-zaslav.

272 *"on Airbnb"*: Matthew Belloni, "Hollywood's Worsening Catch-22," *Puck*, November 3, 2022, https://puck.news/hollywoods-worsening-catch-22.

273 *"This is going to be about finding"*: Matthew Belloni, *What I'm Hearing . . .* (newsletter), *Puck*, August 14, 2022, https://puck.news/newsletters/what-im-hearing.

273 *"hateful bill"*: Kim Masters, "Why Disney Won't Say Much About Florida's 'Don't Say Gay' Bill," *Hollywood Reporter*, March 2, 2022, https://www.hollywoodreporter.com/business/business-news/disney-florida-dont-say-gay-bill-1235103165.

273 *"political football"*: Ryan Faughnder, "As Chapek Weathers Disney Drama, Board Gathers in Florida," *Los Angeles Times*, June 26, 2022, https://www.latimes.com/entertainment-arts/business/story/2022-06-26/after-a-rocky-tenure-disney-board-must-weigh-chapeks-future.

273 *donating to the war chest:* Andrew Stanton, "Disney Gave at Least $250K to Senators That Voted for 'Don't Say Gay' Bill," *Newsweek*, March 8, 2022, https://www.newsweek.com/disney-gave-least-250k-senators-that-voted-dont-say-gay-bill-1686128.

273 *"Disney Censors Same-Sex Affection"*: Adam B. Vary and Angelique Jackson, "Disney Censors Same-Sex Affection in Pixar Films, According to Letter From Employees," *Variety*, March 9, 2022, https://variety.com/2022/film/news/disney-pixar-same-sex-affection-censorship-dont-say-gay-bill-1235200582.

274 *"to find therapists!"*: Jedd Legum, Tesnim Zekeria, and Rebecca Crosby, "The inside story of how Disney turned its back on the LGBTQ community," *Popular Information*, March 8, 2022.

274 *"We were opposed to the bill"*: Sarah Whitten, "Disney CEO Says Company Opposes 'Don't Say Gay' Bill in Florida, Seeks Meeting with DeSantis," *CNBC*, March 9, 2022, https://www.cnbc.com/2022/03/09/disney-ceo-says-company-opposes-dont-say-gay-law-in-florida.html.

274 *"I am sorry"*: Ryan Faughnder, "Disney Is Not Alone. Young Employees in Revolt Are Holding Bosses' Feet to the Fire," *Los Angeles Times*, March 12, 2022, https://www.latimes.com/entertainment-arts/business/story/2022-03-12/employees-demand-social-activism-disney-spotify-netflix-chappelle.

274 *"should not be used to determine"*: Kara Swisher, "Disney's Former C.E.O. Gave Me the Exit Interview I Asked For," *Sway*, podcast, *New York Times*, December 27, 2022, https://www.nytimes.com/2022/01/27/opinion/sway-kara-swisher-bob-iger.html.

275 *"magical memories"*: Brooks Barnes, Benjamin Mullin, and James B. Stewart, "Iger's Sudden Return to Disney Shocks a Discontented Kingdom," *New York Times*, November 21, 2022, https://www.nytimes.com/2022/11/21/business/media/disney-bob-iger.html.

275 *"Daddy's back!"*: Ibid.

277 *"This is a fifty-year-old company"*: Michael Fuchs, in discussion with the author, May 8, 2022.

277 *"The thesis was"*: Jay Stowe, "On *Succession,* a Media Mogul Gets the Conniving Family He Deserves," *New York Times*, May 30, 2018, https://www.nytimes.com/2018/05/30/arts/television/succession-hbo-jesse-armstrong-brian-cox.html.

277 *"Since the 1980s, we as a country"*: Ibid.

278 *"At HBO, we make our own stars"*: Mary McNamara, "HBO's Casey Bloys Isn't Worried About AT&T, Netflix or the End of *Game of Thrones,*" *Los Angeles Times*, August 9, 2019, https://www.latimes.com/entertainment-arts/tv/story/2019-08-09/hbo-casey-bloys-game-of-thrones-netflix.

278 *"There's another . . . succession"*: Bryn Sandberg, *"Succession* Showrunner Talks HBO Show's 'Dramatic' Finale, Season 2 Plans," *Hollywood Reporter*, August 5, 2018, https://www.hollywoodreporter.com/tv/tv-news/succession -showrunner-talks-hbo-shows-dramatic-finale-season-2-plans-1132215.

278 *"the big news companies"*: Ibid.

278 *"After taking a backseat"*: Seth Abramovitch, "Media, Money and Murdochs: How *Succession* Became the Perfect Show for the Trump Era," *Hollywood Reporter*, July 31, 2019, https://www.hollywoodreporter.com/movies/movie -features/how-hbos-succession-became-perfect-show-trump-age-1227997.

278 *"The beginning is inevitable"*: Brian Cox, in discussion with the author, September 4, 2021.

279 *"from a roar to whisper"*: Brian Cox, *Putting the Rabbit in the Hat* (New York: Grand Central Publishing, 2022), chap. 32, iBooks.

279 *"It's wonderful when you see an actor"*: Brian Cox, in discussion with the author, September 4, 2021.

279 *"The cast, as veteran a unit as you could find"*: Ibid.

279 *"[Kieran] is an actor"*: Brian Cox, *Putting the Rabbit in the Hat* (New York: Grand Central Publishing, 2022), chap. 41, iBooks.

279 *"a writers' show"*: Brian Cox, in discussion with the author, September 4, 2021.

279 *"If I wanted to change a word"*: Brian Cox, *Putting the Rabbit in the Hat* (New York: Grand Central Publishing, 2022), 204.

279 *"nancy," he recalls:* Brian Cox, in discussion with the author, September 4, 2021.

280 *"Who gives a shit about these rich"*: Seth Abramovitch, "Media, Money and Murdochs: How *Succession* Became the Perfect Show for the Trump Era," *Hollywood Reporter*, July 31, 2019, https://www.hollywoodreporter.com/movies /movie-features/how-hbos-succession-became-perfect-show-trump-age -1227997.

280 *"we live in this age of wealth"*: Brian Cox, in discussion with the author, September 4, 2021.

280 *"White, essentially male"*: Ibid.

281 *"the show sans Logan"*: Brian Cox, in discussion with the author, April 11, 2023.

281 *"all the work I've done"*: Christi Carras, "Brian Cox hasn't seen the 'Succession' finale: 'When I'm over, it's over,'" *Los Angeles Times*, June 4, 2023, https:// www.latimes.com/entertainment-arts/tv/story/2023-06-04/brian-cox -succession-finale-didnt-watch-logan-roy.

281 *"Made a lot of news"*: James Poniewozik, "In 'Succession,' Democracy Goes Up in Smoke," *New York Times*, May 15, 2023, https://www.nytimes.com/2023 /05/15/arts/television/succession-election.html.

281 *"corrupted our political economy"*: Kurt Andersen, "'Succession' Nailed the Unreal Way We Live Now," *New York Times*, May 29, 2023, https://www.ny times.com/2023/05/29/opinion/succession-finale.html.

282 *"In my opinion, they're not likely"*: Kevin Reilly, in discussion with the author, August 13, 2021.

282 *"HBO, if people haven't noticed"*: Angelique Jackson, "Issa Rae's Next Chapter: How *Insecure* Creator is Becoming a Media Mogul With Production Banner Hoorae," *Variety*, March 24, 2021, https://variety.com/2021/tv/news/issa-rae -insecure-hbo-hoorae-1234936020.

283 *"no idea this council"*: Michaela Coel, "Michaela Coel: MacTaggart Lecture in Full," *Broadcast*, August 23, 2018, https://www.broadcastnow.co.uk/broad casters/michaela-coel-mactaggart-lecture-in-full/5131910.article.

283 *"We were one of four black families"*: Ibid.
284 *"elephant in the room"*: Ibid.
284 *"Oh yes, nice to meet you"*: Ibid.
284 *"looking like a privileged piggy"*: Ibid.
284 *"important that the voices"*: Sonia Rao, "Michaela Coel Is in Control," *Washington Post*, July 21, 2020, https://www.washingtonpost.com/arts -entertainment/2020/07/21/michaela-coel-i-may-destroy-you-interview.
285 *"And when the answer was"*: Lanre Bakare, "Michaela Coel on MacTaggart Lecture: 'I Feel Better Having Shared,'" *Guardian*, August 23, 2018, https:// www.theguardian.com/tv-and-radio/2018/aug/23/michaela-coel-on -mactaggart-lecture-i-feel-better-having-shared; E. Alex Jung, "Michaela the Destroyer," *Vulture*, July 6, 2020, https://www.vulture.com/article /michaela-coel-i-may-destroy-you.html.
286 *"mesmerizing"*: Doreen St. Félix, "Michaela Coel's Chaos and Charisma in *I May Destroy You*," *New Yorker*, June 29, 2020, https://www.newyorker.com /magazine/2020/07/06/michaela-coels-chaos-and-charisma-in-i-may -destroy-you.
287 *"This woman [is] at the mercy"*: Meredith Blake, "How 'House of the Dragon' Pulled Off the Premiere's 'Extreme' Childbirth Scene," *Los Angeles Times*, August 21, 2022, https://www.latimes.com/entertainment-arts/tv/story/2022 -08-21/house-of-the-dragon-childbirth-scene-aemma-viserys-targaryen.
288 *"franchise extinction event"*: Meredith Blake and Mary McNamara, "How Terrible Is the *Sex and the City* Reboot? We Duke It Out," *Los Angeles Times*, December 10, 2021, https://www.latimes.com/entertainment-arts/tv/story /2021-12-10/sex-and-the-city-and-just-like-that-hbo-max.

Chapter 13: Cash Is King

291 *"TV is analogous to some"*: John Landgraf, in discussion with the author, July 25, 2018.
292 *"a fax machine five years"*: Cydney Contreras, "Andy Samberg and John Mulaney to Fill In for Jimmy Kimmel as Host Recovers from COVID," NBC10 Boston, May 18, 2022, https://www.nbcboston.com/entertainment /entertainment-news/andy-samberg-and-john-mulaney-to-fill-in-for -jimmy-kimmel-as-host-recovers-from-covid/2724122.
292 *primetime grid*: Matt Brennan, "Don't Think of This as the End of Our TV Listings. Think of It as a New Beginning," *Los Angeles Times*, May 2, 2022, https://www.latimes.com/entertainment-arts/tv/story/2022-05-02/tv -listings-a-note-to-readers.
292 *"I hope so"*: Maureen Dowd, "Ted Sarandos Talks About That Stock Drop, Backing Dave Chappelle, and Hollywood Schadenfreude," *New York Times*, May 28, 2022, https://www.nytimes.com/2022/05/28/style/ted-sarandos -netflix.html.
295 *"It is true that, not just Apple"*: Casey Bloys, in discussion with the author, November 1, 2021.
295 *"We've been . . . raped"*: Lacey Rose, "HBO Boss on *Big Little Lies* Impact, 'Earned' Raises and Addressing Pay Parity," *Hollywood Reporter*, April 9, 2018, https://www.hollywoodreporter.com/tv/tv-news/hbo-boss-big-little -lies-impact-earned-raises-addressing-pay-parity-1100847.
295 *"Some day* The Crown*"*: Alex Ritman, "Reed Hastings Says Amazon Outbid Netflix for *Fleabag*," *Hollywood Reporter*, September 20, 2019, https://www .hollywoodreporter.com/news/general-news/reed-hastings-says-amazon -outbid-netflix-fleabag-1241322.

295 *"Disney and Apple are pushing"*: Adam Epstein, "Disney and Apple are Pushing Us into the Era of the $25 Million TV Episode," *Quartz*, October 26, 2019, https://qz.com/1735700/apple-and-disney-are-creating-an-explosion-of-tv-series-budgets.

295 *"We're paying too much for the return"*: Lacey Rose, "David Nevins: The Paramount Global Chief's Exit Interview," *Hollywood Reporter*, December 20, 2022, https://www.hollywoodreporter.com/business/business-news/david-nevins-paramount-global-chief-exit-interview-1235283199.

295 *"You don't make art"*: John Landgraf, in discussion with the author, July 25, 2018.

296 *He's entering his sixties*: Matthew Belloni, *What I'm Hearing . . .* (newsletter), *Puck*, August 14, 2022, https://puck.news/newsletters/what-im-hearing.

297 *"Multiple worlds are"*: Brian Hiatt, "An Endless Supply of Spider-Men: Why the Multiverse Is Taking Over Hollywood," *Rolling Stone*, July 7, 2022, https://www.rollingstone.com/culture/culture-features/multiverse-dr-strange-everything-everywhere-flash-ezra-miller-recast-across-the-spiderverse-1371253.

299 *"more widely engaging stories"*: Anthony D'Alessandro, "Amazon Ups Julie Rapaport to Co-head of Movies as Studio Looks to Build Wide Audience Feature Slate," *Yahoo! Finance*, September 26, 2018, https://finance.yahoo.com/news/amazon-ups-julie-rapaport-co-180435368.html.

299 *"The official word from Netflix"*: Josef Adalian, "Netflix Just Disrupted Itself. Why?," *Vulture*, September 10, 2020, https://www.vulture.com/2020/09/netflix-executive-changes.html.

299 *"That service was built on the back"*: Kim Masters, "Netflix's Big Wake-Up Call: The Power Clash Behind the Crash," *Hollywood Reporter*, April 27, 2022, https://www.hollywoodreporter.com/business/digital/netflixs-big-wake-up-call-the-power-clash-behind-the-crash-1235136004.

300 *"She would call Ted out"*: Lesley Goldberg, Natalie Jarvey, and Kim Masters, "Inside Netflix's Surprising TV Chief Shake-Up," *Hollywood Reporter*, September 10, 2020, https://www.hollywoodreporter.com/tv/tv-news/inside-netflixs-surprising-tv-chief-shake-up-4058148.

300 *"works well peer to peer"*: Confidential source, in discussion with the author.

300 *"It's not easy for Ted to admit"*: Ibid.

300 *"is aiming straight for what the old-line"*: Nicole Sperling, "Netflix Turns Its Attention to Films It Hopes Everyone Wants to See," *New York Times*, November 22, 2021, https://www.nytimes.com/2021/11/22/business/media/netflix-movies-theaters.html.

301 *"We were a business that was"*: Nicole Sperling, "Netflix, Still Reeling, Bets Big on *The Grey Man*," *New York Times*, July 17, 2022, https://www.nytimes.com/2022/07/17/business/media/netflix-the-gray-man-subscribers.html.

301 *"theatrically, is impossible"*: Steven Soderbergh, in discussion with the author, April 4, 2023.

301 *"In fact," the source continues*: Confidential source, in discussion with the author.

302 *"ten times as much great art"*: Steven Soderbergh, interview, April 4, 2023.

302 *"It's much better for us that movies"*: Casey Bloys, in discussion with the author, November 1, 2021.

303 *"Streaming first"*: Pamela McClintock, "Cinema Owners Blindsided by Ted Sarandos Comments Diminishing Netflix's Theatrical Ambitions," *Hollywood Reporter*, October 20, 2022, https://www.hollywoodreporter.com/movies/movie-news/knives-out-drama-theater-owners-blindsided-netflix-1235245506.

303 *"couldn't care less about exhibition"*: Ibid.

303 *"This is probably one of the biggest gaffes"*: Wendy Lee, "Should Netflix's *Glass Onion* Stay in Theaters Longer?," *Los Angeles Times*, November 29, 2022, https://www.latimes.com/entertainment-arts/business/story/2022-11-29/netflix-glass-onion-movie-theaters.

303 *"Releasing a new season of a new show"*: Casey Bloys, in discussion with the author, November 1, 2021.

303 *"There's millions of people"*: Wendy Lee and Ryan Faughner, "Layoffs at Netflix Have Some Staffers Questioning Company Strategy and Culture," *Los Angeles Times*, April 29, 2022, https://www.latimes.com/entertainment-arts/business/story/2022-04-29/netflixs-turmoil-causes-staffers-to-question-its-culture.

304 *"There's an entire ecosystem"*: Casey Bloys, in discussion with the author, November 1, 2021.

305 *"a world of hurt"*: Natalie Jarvey, "High Anxiety in Hollywood: 'Everyone Is Totally Drained and Burnt Out,'" *Vanity Fair*, September 28, 2022, https://www.vanityfair.com/hollywood/2022/09/high-anxiety-in-hollywood-warner-bros-discovery.

305 *"These companies are absolutely destroying"*: John Koblin and Brooks Barnes, "Hollywood Writers Go on Strike, Halting Production," *New York Times*, May 2, 2023, https://www.nytimes.com/2023/05/01/business/media/hollywood-writers-strike.html.

305 *"You've just blown out"*: Yvonne Villarreal, Sonaiya Kelley, and Nicholas Ducassi, "'It's just pure chaos': Top Hollywood showrunners explain the writers' strike," *Los Angeles Times*, May 2, 2023, https://www.latimes.com/entertainment-arts/business/story/2023-05-02/television-showrunners-writers-strike.

305 *"puppy named "Maxi"*: Angela Watercutter, "HBO Continues to Have the Worst Timing," *Wired*, May 19, 2023, https://www.wired.com/story/hbo-max-launch-bad-timing-wga-strike.

306 *"It's not right"*: Graham Yost, in discussion with the author, October 26, 2022.

306 *"Every broadcaster is grappling"*: Bob Greenblatt, in discussion with the author, July 15, 2021.

307 *"familiar archetypes, paint-by-numbers"*: Matt Brennan and Meredith Blake, "'Yummie Mummies with Predatory Husbands' Took Over TV. Blame David E. Kelley," *Los Angeles Times*, April 15, 2022, https://www.latimes.com/entertainment-arts/tv/story/2022-04-15/anatomy-of-a-scandal-netflix-sienna-miller-ruper-friend-michelle-dockery-david-e-kelley.

307 *"Big Little Lies Lite"*: Brian Lowry, "'The Undoing' features Nicole Kidman in a mystery that feels like 'Big Little Lies Lite,'" *CNN Entertainment*, November 23, 2020, https://www.cnn.com/2020/10/23/entertainment/the-undoing-review/index.html.

307 *"blander and grayer"*: Judy Berman, "ABC's Twisty, Mountainous Thriller *Big Sky* Is No Prestige Masterpiece, But It's Still a Lot of Fun," *Time*, November 17, 2020, https://time.com/5912447/big-sky-abc-review.

307 *"We're sort of doing a streaming"*: Kate Aurthur, "As *Evil* Moves to Paramount Plus, Creators Robert and Michelle King Give Season 2 a More Sinful Spin," *Variety*, June 17, 2021, https://variety.com/2021/tv/news/evil-paramount-plus-robert-and-michelle-king-1234998707.

307 *"feels fresher than a lot of the buzzy"*: Doreen St. Félix, "*Bel-Air* and *Abbott Elementary* Reboot and Revive the Network Sitcom," *New Yorker*, March 14, 2022, https://www.newyorker.com/magazine/2022/03/21/bel-air-and-abbott-elementary-reboot-and-revive-the-network-sitcom.

307 *"flawed tools in need of rethinking"*: Daniel D'Addario, *"East New York* Sets a New Course for the Broadcast Cop Drama," *Variety*, September 29, 2022.

308 *"We had footage that was a little"*: Kate Aurthur, "As *Evil* Moves to Paramount Plus, Creators Robert and Michelle King Give Season 2 a More Sinful Spin," *Variety*, June 17, 2021, https://variety.com/2021/tv/news/evil-paramount -plus-robert-and-michelle-king-1234998707.

308 *"freedom in terms of format"*: Michelle King, in discussion with the author, March 17, 2022.

308 *"not cutting new paths"*: Jonathan Abrams, *"The Wire* at 20: 'This Show Will Live Forever,'" *New York Times*, May 31, 2022, https://www.nytimes.com /2022/05/31/arts/television/david-simon-ed-burns-the-wire-anniversary .html.

308 *"What if TV felt like"*: *Washington Post* reviewers, "The best television of 2023 so far," *Washington Post*, April 4, 2023, https://www.washingtonpost.com /arts-entertainment/2023/best-tv-shows-2023/.

308 *"case-of-the-week shows"*: Dave Itzkoff, "Natasha Lyonne and Rian Johnson Trace the TV Origins of *Poker Face," New York Times*, January 19, 2023.

309 *"is just not true"*: Josef Adalian, "How 'Abbott Elementary' Reinvigorated the Network Sitcom," *Vulture*, April 13, 2022, https://www.vulture.com/article /how-abbott-elementary-reinvigorated-the-network-sitcom.html.

309 *"plurality is the new mass"*: Janice Min, "The Hollywood Escape Economy Is Just Around the Corner," *Time*, January 11, 2021, https://time.com/5928518 /janice-min-hollywood-post-pandemic.

309 *"As it's gotten bigger and bigger and bigger"*: David Nevins, in discussion with the author, August 9, 2021.

309 *"For all intents and purposes, streamers"*: Bob Greenblatt, in discussion with the author, July 15, 2021.

310 *"I want to do in-your-face"*: Lacey Rose, "'I Want to Do In-Your-Face S***': Kenya Barris on Why He Left His $100M Netflix Deal to Launch BET Studios," *Hollywood Reporter*, June 23, 2021, https://www.hollywoodreporter .com/tv/tv-features/kenya-barris-studio-netflix-1234971965.

311 *"After fifteen years, I figured"*: Jason P. Frank, "Vince Gilligan Is Developing a New Show," *Vulture*, September 22, 2022, https://www.vulture.com/2022/09 /better-call-saul-creator-vince-gilligan-new-series.html.

311 *"Don't come at me with this fairy-tale"*: Hugh Hart, "Jason Bateman and Laura Linney Break Down That Wild *Ozark* Ending," *Los Angeles Times*, June 8, 2022, https://www.latimes.com/entertainment-arts/awards/story/2022-06 -08/ozark-ending-jason-bateman-laura-linney.

312 *"In many ways, we are seeing reincarnation"*: John Koblin and Tiffany Hsu, "And Now, a Word from Your Streaming Sponsor . . . ," *New York Times*, April 19, 2022, https://www.nytimes.com/2022/04/19/business/media /netflix-amazon-disney-ads.html.

312 *"peak confusion"*: Elaine Low, "Drop the 'HBO.' Just 'Max.' It's Cleaner (Wait—Is It?)," *Ankler*, April 12, 2023, https://theankler.com/p/drop-the-hbo -just-max-its-cleaner#details.

312 *"Matt Weiner [once] said to me"*: Vlad Wolynetz, in discussion with the author, January 21, 2020.

INDEX